Photopoetry 1845–2015,
a Critical History

Photopoetry 1845–2015, a Critical History

Michael Nott

BLOOMSBURY VISUAL ARTS
NEW YORK • LONDON • OXFORD • NEW DELHI • SYDNEY

BLOOMSBURY VISUAL ARTS
Bloomsbury Publishing Inc
1385 Broadway, New York, NY 10018, USA
50 Bedford Square, London, WC1B 3DP, UK
29 Earlsfort Terrace, Dublin 2, Ireland

BLOOMSBURY, BLOOMSBURY VISUAL ARTS and the Diana logo are
trademarks of Bloomsbury Publishing Inc

First published in the United States of America 2018
This paperback edition first published 2022

Cover design: Irene Martinez Costa
Cover image: Collage of Figures, see pp. viii–xii for information and individual credits

Library of Congress Cataloging-in-Publication Data
Names: Nott, Michael, author.
Title: Photopoetry, 1845–2015: a critical history/Michael Nott.
Description: New York, NY, USA: Bloomsbury Academic, animprint of
Bloomsbury Publishing Inc, 2018. | Revision of author's theses
(Ph. D.–Universityof St. Andrews, Scotland, 2015) |
Includes bibliographical references andindex.
Identifiers: LCCN 2017049177 (print) | LCCN 2018022439 (ebook) |
ISBN 9781501332258 (ePDF) | ISBN 9781501332241 (ePub) |
ISBN 9781501332234 (HB: alk. paper)
Subjects: LCSH: Literature and photography. | Englishpoetry–Illustrations. |
Americanpoetry–Illustrations. | Photography, Artistic. |
Photography–United States. | Photography–Great Britain. | Photobooks.
Classification: LCC PN1069 (ebook) | LCC PN1069.N68 2018 (print) |
DDC 821/.809–dc23
LC record available at https://lccn.loc.gov/2017049177

ISBN: HB: 978-1-5013-3223-4
PB: 978-1-5013-8872-9
ePub: 978-1-5013-3224-1
ePDF: 978-1-5013-3225-8

Typeset by Newgen KnowledgeWorks Pvt. Ltd., Chennai, India
Printed and bound in Great Britain

To find out more about our authors and books visit www.bloomsbury.com
and sign up for our newsletters.

This may leave you without an all-embracing theory, or the conveniences of a creed, but to me that's the name of the game.

<div align="right">Tony Tanner</div>

Contents

Figures

Acknowledgements

First and foremost, I am indebted to my PhD supervisors Robert Crawford and Tom Normand for their assiduous tutelage, firm guidance, and intellectual stimulation over the course of this project. Both were encouraging and meticulous from the outset. Likewise my examiners, Luke Gartlan and David Kinloch, whose careful advice has been invaluable for the reshaping of thesis into book.

My editor at Bloomsbury Margaret Michniewicz and her assistants Katherine De Chant and Erin Duffy deserve particular thanks for their diligence and perseverance, from taking on the project to seeing it through to production. All three have been extraordinarily patient and, from time to time, have put up with more burdens than they might reasonably have been expected to bear.

Research for this project was made possible by a doctoral fellowship from the Arts and Humanities Research Council (AHRC). I received grants from the Stuart A. Rose Manuscript, Archives, and Rare Book Library at Emory University, and the School of Art History at the University of St Andrews, which allowed me to conduct archival research. For their assistance I would like to thank Kathy Shoemaker and Kevin Young at the Stuart A. Rose Library, James Eason, David Faulds, Dean Smith, and Shannon Supple at the Bancroft Library, the University of California, Berkeley, and David Mackie and Rebecca Marr at the Orkney Library and Archive.

Special thanks should go to rightholders who have given generously of their time and materials: Rachel (Giese) Brown, Norman McBeath, and Sean Mayne Smith. Likewise estates, with special thanks owed to Suzie Dummett and her siblings for the estate of Mabel Eardley-Wilmot; Julie Shrine on behalf of The Universal Order; Ben Whitaker for the estate of Robert Whitaker; and Paula Steichen Polega, John Steichen, and the Barbara Hogenson Agency on behalf of the Carl Sandburg Estate.

Material from the second chapter of this book originally appeared, in a slightly different form, in *Victorian Studies*. Material from the fourth chapter appeared, at considerably greater length, in *Word & Image*. I extend my thanks to both journals for permission to include versions of those articles in this book

and to Lara Kriegel (at *Victorian Studies*) and Michèle Hanoosh (at *Word & Image*) for their editorial guidance and support.

It is difficult to think of colleagues at the University of St Andrews Library who were not somehow involved in this project. It was a great pleasure to work with Alice Crawford and Callum Kenny on the 'Developing Photopoetry' digital humanities project. Their enthusiasm for illustrated editions of Walter Scott was often greater than I myself could muster. It is no exaggeration to say that the project would have been impossible without their skills and expertise. I would also like to thank Rachel Nordstrom, Elizabeth Henderson, Moira Mackenzie, and Hilda McNae at the University of St Andrews Library, as well as Marc Boulay and Daryl Green, who were instrumental to the development of the photopoetry collection at St Andrews.

For their help and support at St Andrews, I would like to thank Lynn Ayton, Margaret Hall, Mary Kettle, and Dawn Waddle in the School of Art History; and Jane Gordon, Laura Mackintosh, Andrea Marr, and Sandra Wallace in the School of English. I would also like to thank Douglas Dunn for his time, and Rachel Brown and Norman McBeath (again) for taking the time to answer all my questions.

In the absence of a 'photopoetic' field or community, I made friends where I could. I would like especially to thank James Finch and Rachel Rose Smith, who co-chaired the terrific 'Having Words' panel at the Association of Art Historians' annual conference in Edinburgh, 2016, and to Linda Goddard and Oona Lochner for their insightful questions and comments on my Burckhardt/ Denby presentation.

The stimulation of friends, ardent and cool, academic and (especially) non-academic, was more important than words might reasonably reflect. For encouragement and support, in many forms, I am grateful to Kristen Adhloch, Lee, Sue, and Tristan Carlyle, Caitlin Flynn, Karin Koehler, Craig Lamont, Eadaoin Lynch, and Sarah Sands Rice. I am indebted to Hannah Britton and Liz Hanna, whose kindness, rigour, and tolerance as office mates knew very few bounds indeed. We learned the limits of the calm we keep.

I dedicate this book to my parents, who have always been there for me, and who have always maintained a healthy scepticism as to whether photopoetry is, indeed, 'a thing'. For better or worse, it is now.

The author and publishers are grateful to the following for permission to reproduce copyright material:

Excerpts from letters from George Mackay Brown to Gunnie Moberg. Reprinted by permission of the Orkney Library and Archive, and Jenny Brown Associates on behalf of the Literary Estate of George Mackay Brown.

'Aton' and excerpts from 'Lux Aeterna' from *Light Box* by Robert Crawford and Norman McBeath. Reprinted by permission of Easel Press.

'Dunter' from *Simonides* by Robert Crawford and Norman McBeath. Reprinted by permission of Easel Press.

'Deer Pairk' from *Chinese Makars* by Robert Crawford and Norman McBeath. Reprinted by permission of Easel Press.

Excerpts from 'Adjoining Entrances to Office Buildings in Renaissance Styles', 'The Climate of New York', 'Five Reflections', 'Mid-day Crowd', and 'Paestum' from *Edwin Denby: The Complete Poems* by Edwin Denby. Reprinted by permission of Random House.

Excerpts from 'Ankor Wat' from *Ankor Wat* by Allen Ginsberg. Reprinted by permission of the Wylie Agency.

'He rides up and down, and around', and excerpts from 'Syon House' from *Positives* by Thom Gunn. Reprinted by permission of Faber and Faber.

'He rides up and down, and around', and excerpts from 'Syon House' from *Positives* by Thom Gunn. Reprinted by permission of the University of Chicago Press.

Excerpts from 'Note on History of Calder Valley' by Ted Hughes (Ted Hughes Papers, Stuart A. Rose Manuscript, Archives, and Rare Book Library, Emory University). Reproduced by kind permission of the Ted Hughes Estate and Faber and Faber.

Excerpts from 'The Travels of Fa-hsien' from *The Autonomous Region* by Kathleen Jamie. Reprinted by permission of Bloodaxe Books.

Excerpts from letters from Norman McBeath to Paul Muldoon. Reprinted with the kind permission of Norman McBeath.

'Alba', 'Fan-Piece, for Her Imperial Lord', and 'Ts'ai Chi'h' from *Selected Poems and Translations* by Ezra Pound. Reprinted by permission of Faber and Faber.

'Alba', by Ezra Pound, from *Personae*, copyright ©1926 by Ezra Pound. Reprinted by permission of New Directions Publishing Corp.

'Fan-Piece, for Her Imperial Lord', by Ezra Pound, from *Personae*, copyright ©1926 by Ezra Pound. Reprinted by permission of New Directions Publishing Corp.

'Ts'ai Chi'h', by Ezra Pound, from *Personae*, copyright ©1926 by Ezra Pound. Reprinted by permission of New Directions Publishing Corp.

Excerpt from a letter from Carl Sandburg to Archibald MacLeish, 17 March 1938 (Box 20, Archibald MacLeish Papers, Manuscript Division, Library of Congress, Washington, DC). Reproduced by kind permission of Paula Steichen Polega and John Steichen, and The Barbara Hogenson Agency, Inc.

Excerpts from SWEENEY ASTRAY by Seamus Heaney. Copyright © 1984 by Seamus Heaney. Reprinted by permission of Farrar, Straus and Giroux.

Excerpts from "Plan B" and "Francois Boucher: Arion on the Dolphin" from MAGGOT by Paul Muldoon. Copyright © 2010 by Paul Muldoon. Reprinted by permission of Farrar, Straus and Giroux.

Images for most of the photopoetry books discussed, and many more besides, from 1856 to 1921 can be viewed for free on the 'Developing Photopoetry' website, at arts.st-andrews.ac.uk/photopoetry/static/about.html.

While every effort has been made to locate copyright holders, the publishers would be grateful to hear from any person(s) not acknowledged here.

Introduction

Photopoetry: Forms, Theories, Practices

In the summer of 2007, photographer Norman McBeath met poet Paul Muldoon for lunch during the Edinburgh International Book Festival. They met to discuss an incipient collaborative project where Muldoon would respond to McBeath's photographs. Much of his work in the early 2000s, McBeath recalls, 'was social documentary, reportage, non-intervention, people just out there, black and white.'[1] As their discussion deepened, it dawned on Muldoon that *reportage* would not work as the photographic half of a collaboration. 'The reason that didn't work,' McBeath notes, 'was because Paul felt [the photographs] were too good! He said the story's been told, and so you have the frames there, it's all in there, so there's no room for evocation and story.'[2] The poems, in essence, would be derivative. It seemed as though they were back to square one.

As they were leaving the restaurant, McBeath gave Muldoon a gift – a box containing a small photogravure – and as he drove Muldoon and his wife back to their hotel, an argument developed in the back of the car. 'I was driving back up Leith Walk,' McBeath recalls,

> and Paul's saying, 'Oh, I'd like to open this, I'd like to see it', and his wife is saying 'No no no no no Paul, you should save it until we get back', and he's saying 'No, no, I'd really like to open it.' So there's this great big barney going on on our way up Leith Walk, and he opened it and he said, 'Great! That's it. That's what I can do with!'[3]

The photogravure showed a statue of Apollo wrapped in polythene, an image that became central to their eventual collaboration *Plan B* (2009). It appealed to McBeath and Muldoon because of Apollo's connection to light and poetry. 'That, for me, was a real revelation,' McBeath remembers, 'and because we'd known each other for a while, I could see what he was after. ... I sent him stuff that would tie in with that, and that's how *Plan B* came about.'[4]

This is a book about how and why poets and photographers work together. The aim of the study is to demonstrate how the relationship between poem and photograph has always been one of disruption and serendipity, appropriation and exchange, evocation and metaphor. From the mid-nineteenth to the early twenty-first century, the book investigates how working practices between poets and photographers have changed, and situates the photopoetic medium within the contexts of economics, book history, and photo-history. In postulating the existence of 'photopoetry', I intend to examine how different working practices between poets and photographers inform and affect the resultant relationships between poem and photograph.

Defining photopoetry

What is photopoetry? Its neglect is such that the Oxford English Dictionary records no definitions of 'photopoetry' or 'photopoem', or comparable terms such as 'photoetry' or 'photoverse'. Such terms do exist, however, and the first use of the word 'photopoem' occurs in *Photopoems: A Group of Interpretations through Photographs* (1936), photographed and compiled by Constance Phillips. Pairings of poems and photographs in book form had existed for almost a century prior to *Photopoems*, though Phillips's anthology is important for its suggestion that the form deserved to be recognized and given a distinct name. In adopting the term, I do not mean to privilege photography over poetry in my conception of these collaborations; I choose it because, of the few terms used to define the relationship between poetry and photography – in both practice and criticism – it is the most common.

That said, critiques and theories of photopoetry are few and far between. In her article on Paul Éluard and Man Ray's *Facile* (1935), Nicole Boulestreau invented the term *photopoème* to describe the slim volume combining Éluard's poems and Man Ray's photographs. 'In the photopoem,' writes Boulestreau, 'meaning progresses in accordance with the reciprocity of writing and figures: reading becomes interwoven through alternating restitchings of the signifier into text and image.'[5] Poem and photograph encounter each other, and Boulestreau appears to suggest that the *photopoème* should be defined not by its production but its reception, as a practice of reading and looking that relies on the reader/viewer to make connections between, and create meaning from, text and image. Against these 'restitchings', Andy Stafford uses the term 'photo-poetry' to describe the

'tightly linked (though not fused)' images and texts of Philippe Tagli's *Paradis sans espoir* (1998), though he prefers 'photo-graffiti' as a conceptual label for Tagli's work.[6] Most recently, Robert Crawford and Norman McBeath have included 'Photopoetry: A Manifesto' in their collaboration *Chinese Makars* (2016). Their twelve points range from the dependence and interdependence of poems and photographs; the importance of 'revealing' in order to '[engage] the reader's imagination'; the need for a variety of connective strands between text and image; and, first and foremost, an assertion that 'Poems and photographs encourage each other's obliquity.'[7] Literal illustrations and descriptions are not engaging, according to Crawford and McBeath, and they suggest that the relationship between poetry and photography, at its deepest and most engaging, is serendipitous and requires the reader/viewer to reach, work, and imagine in order to make productive connections between text and image.

With these discussions in mind, I propose a generous definition of photopoetry as a form of photo-text that takes, for its primary components, poetry and photography. It is the product of some form of working practice between poet and photographer, be it retrospective or collaborative; or, on occasion, a sole poet-photographer or photographer-poet. Poems or photographs may precede the other, or be conceived in conjunction around a central topic or theme. I make no demands on the arrangement of poetry and photography in the photopoetic work: poems and photographs may form separate, discrete sequences; be entwined throughout the work in pairings or sections; or be in the form of collages or montages. Similarly, the number of poems or photographs may not be precisely equal, and while I make no strict demands on balance or proportion, I would argue that a photographic frontispiece of a poet would not, to my mind, make the subsequent six hundred pages of un-photographed poetry in any sense photopoetic. Likewise, I make no exclusions on the basis of photographic process (e.g. collotype, photogravure, inkjet) or style (e.g. fine art, documentary, snapshot), nor poetic form or school: this study engages with diverse forms and styles of poetry, from long narrative poems and translations to sonnets and haiku; from metre to free verse and back again. Format, too, is no prompt for exclusion: photopoetic works include photobooks, scrapbooks, combination prints with verse extracts as captions, artist's boxes, museum and gallery exhibitions, and stereographic sequences.[8] That poem and photograph interact is my sole demand.

I am hesitant to define photopoetry primarily by what it is not. On occasion, photopoetic works will also feature prose, captions, poetic prose, and other such

components not strictly poetry or photography. More often than not these are textual rather than visual. I have limited the inclusion of such works on account of space, since to privilege works such as the poetic prose of Roy DeCarava and Langston Hughes's *The Sweet Flypaper of Life* (1955) and the jointly prose and verse work of Les Murray's *The Australian Year* (1985) would be to dilute the primarily photopoetic encounters on which this study focuses. More pertinently, however, I have distinguished between the photographing of visual material (i.e. paintings, drawings) for inclusion in a book, and images that maintain their photographic integrity. Only these latter images are photopoetic, as production rather than content defines the photographic image. This distinction includes, for example, *Hiding in Full View* (2011), a photobook collaboration between poet Don Paterson and painter Alison Watt, which combines photographic reproductions of Watt's paintings with a poem by Paterson, each inspired by the work of Francesca Woodman.

What, then, are the advantages of considering photopoetry as a distinct form of photo-literature? What does poetry bring to photography that prose, for example, does not? I would argue that, in most cases, poems and photographs function as self-contained realities. They are, at first, separate, whole. As John Fuller writes, a poem is 'gradually constructed in words and images that has to pass muster as an alternative reality. But the photographer is exploiting reality itself, almost directly.'[9] Both are concerned with images: the visual immediacy of the photographic image against the unravelling, modifying, accumulating verbal images that emerge from the poem. In conjunction, such visual and verbal images blend, clash, contradict, embolden, evoke, and resist each other, creating photopoetic images that seem, in Crawford and McBeath's terms, to encourage the 'obliquity' and 'serendipity' of text and image. Now, this is obviously not the case for certain types of poem. Walter Scott's long narrative poems, for example, are not image-based in the way that Paul Muldoon's lyric about a statue of Apollo wrapped in polythene and duct tape revolves around a central image. Indeed, there is perhaps a reason that long poems became less common in photopoetry once poets and photographers began to collaborate, when the immediate visual focus of photopoetry reduced in scale but let loose numerous thoughts, questions, and ideas beyond the photopoem itself. I engage with several photopoetic theorists across this study, from Crawford and McBeath to John Fuller, Seamus Heaney, Ted Hughes, and David Hurn, all of whom have practised photopoetic collaboration. Insofar as poetry differs to prose or captions in connection with photography, I would argue that captions, as their main function, tend to describe photographs and provide a source of

information. Prose, on the other hand, comes in numerous shapes and sizes: from novels and short stories to essays, tracts, and propaganda. Each relationship is different, just as, in conjunction with a photograph, we read a haiku differently to a long narrative poem in couplets. This is not to suggest that links between prose and photography are uninteresting or unworthy of critical discussion, only that poetry and photography seem uniquely suited as analogues to each other. Both, independently, deal with the seen and the unseen. The tightness and concision of the lyric poem, for example, reminds the reader of the photographic frame: What is happening just out of shot? One might argue the lyric poem is 'taken' in a way similar to the photograph. As Roland Barthes writes:

> We say 'to develop a photograph'; but what the chemical action develops is undevelopable, an essence (of a wound), what cannot be transformed but only repeated under the instances of insistence (of the insistent gaze). This brings the Photograph (certain photographs) close to the Haiku. For the notion of a haiku, too, is undevelopable: everything is given, without provoking the desire for or even the possibility of a rhetorical expansion. In both cases we might (we must) speak of an *intense immobility*.[10]

Barthes was not thinking specifically of poems and photographs in conjunction, and we must ask what happens to the 'intense immobility' when two 'undevelopable' poems and photographs engage in dialogue. Even in seemingly illustrative connections, for example, a poem may draw the reader/viewer beyond the frame of the photograph. A photograph, likewise, may challenge or confirm the reader/viewer's impression of a landscape found in the poem. Such challenges and difficulties, to paraphrase Barthes, only increase the desire for, and possibilities of, imagination, revelation, and rhetorical expansion when we consider poem and photograph to be analogous.

Photopoetry in context

While there is a growing body of work on the intersections of literature and photography, photopoetry represents a new field of study for scholars of text and image. In writing the first critical account of photopoetry, I intend to examine its history from beginnings in nineteenth-century photographic illustration to photobooks such as McBeath and Muldoon's *Plan B* (2009) that typify contemporary collaborative practice. In the absence of a distinct critical literature on photopoetry, it is necessary to situate photopoetry within several

existing fields of study: literature and photography, pertaining to photo-texts and photobooks; the history of collaborations between artists and writers more generally; and the history of relationships between visual and verbal representation.[11]

An indispensable resource in photo-textual studies is the three-volume *Photobook: A History* (2004–2014) by Martin Parr and Gerry Badger.[12] This work provides unrivalled exegesis on the most common format that poets and photographers have adopted in their collaborations, as well as the contiguous issue of photo-literary evolution. Indeed, Parr and Badger note that the photobook occupies an important place in photographic history, residing 'at a vital interstice between the art and the mass medium, between the journeyman and the artist, between the aesthetic and the contextual'.[13] They situate a number of early photopoetic books – though they are not called such – in the contexts of photobook history and practice, examining their cultural, editorial, and socio-economic circumstances, and articulating their relationship to the above-quoted parameters. Insofar as photopoetry is a type of photo-text that takes the photobook for its most common form, I have no desire to narrow an already narrow field of study by becoming entangled in issues of definition surrounding photo-texts that would delimit the photopoetic text as anything more specific or unique than that which includes – and is limited primarily to – poetry and photography. More pertinent to my study than the intricacies involved in defining the 'photo-text' are the currents of book history and photo history that inform the conception and production of photopoetry. Following Parr and Badger, my study will articulate the place of photopoetry in photo-literary history through close consideration of the technological advances in, and growing economic opportunities of, photography, and how these informed the conceptual and physical development of the photobook. The first photobooks were illustrated with original photographs, each laboriously pasted in by hand. Come the 1870s, attempts at combining photography with traditional graphic printing techniques were encountering some success, and soon 'the development of the halftone block and the rotogravure press made the cheap and seamless reproduction of actual photographs in ink a daily reality'.[14] An awareness of such labours allows us, for example, to understand better McBeath's emphasis on the photograph's materiality in *Plan B* (2009) and *Simonides* (2011), when he prints his photographs with light shone through the negative, leaving them uncropped, with marks around the edges: their 'unique thumbprint'.[15] These unique frames

were included in both photobooks and gesture towards the history of the format. I cite this example to demonstrate how practitioners have taken inspiration from the history of their form. Local examples abound throughout works of photopoetry, and my study will articulate the intersections and overlaps between histories of the book, photography, and photopoetry.

Exploring relationships between poems and photographs necessarily involves studying the working practices of poets and photographers in the creation of photopoetic texts. One key theoretical study concerning forms of working practice is Andy Stafford's *Photo-texts: Contemporary French Writing of the Photographic Image* (2010). While Stafford's study is much broader in photo-textual scope and takes the francophone rather than anglophone world for its focus, his typology of photo-texts has proved an important model for my own study. Stafford identifies 'three distinct types of photo-text' – collaborative, self-collaborative, and retrospective – that broadly mirror the types of photopoetry, insofar as photopoems are a type of photo-text.[16] These types are useful in that they enable us to understand better the kind of work photograph and poem do together, once we are aware if they have been conceived mutually (collaborative) or in isolation (retrospective).

Self-collaborative photopoetry is uncommon and, as a result, seldom features in this study. One of the most important self-collaborative works is T. R. Williams's stereographic sequence *Scenes in Our Village* (1857), which emphasizes both the visual and aural components of photopoetry. As Stafford notes, self-collaborative work is perhaps the 'trickiest' to discuss, given questions surrounding the sole artist's potential privileging of one medium over the other.[17] Given the problematic nature of self-collaboration, and its relative scarcity, I have omitted Anne Brigman's *Songs of a Pagan* (1949) and Janet Sternburg's *Optic Nerve* (2005), which would otherwise warrant inclusion in an encyclopaedic history of photopoetry.

The most common type of photopoetry in the nineteenth and early twentieth centuries is retrospective. Here, photographers provide illustrations to poems that have already been written, and whose authors are usually no longer alive. Rarely does the reverse relationship occur, with poems written to accompany already existent photographs.[18] Retrospective photopoetry is also the most discussed, and the majority of identifiably photopoetic scholarship to date focuses on the nineteenth century. Scholars including Carol M. Armstrong, Helen Groth, and Lindsay Smith all examine, from a variety of perspectives, the relationship between Victorian poetry and photography.[19] In *Victorian*

Photography and Literary Nostalgia (2003), Groth examines how the desire to arrest time yoked together poetry (as an idealized concept of tradition) and early photography in a variety of commercial forms that illuminated the growing diversity of visual and literary experience. In *Victorian Photography, Painting and Poetry* (1995), Smith explores Victorian notions of seeing and perceiving, and the impact of the camera on nineteenth-century social, aesthetic, and philosophical concerns.[20] Absent from Smith's study are collaborative works between poets and photographers, although she is far from alone in this omission. Where analyses of collaborations between poets and photographs occur, they tend to focus on Julia Margaret Cameron's photographs of Alfred Tennyson's *Idylls of the King* (1875). Armstrong's *Scenes in a Library: Reading the Photograph in the Book, 1843–1875* (1998) offers the most detailed and illuminating reading to date of Cameron's *Idylls*, demonstrating the importance of the volume in the context of photobook history. While Armstrong's work has prompted a raft of literature on Cameron's *Idylls* – which has become, by far, the most analysed photopoetic text – the overwhelming focus on this high-profile work has eclipsed other collaborations between poets and photographers.[21]

Collaborative photopoetry became the most common type of photopoetry from the mid-twentieth century. With the occasional exception of Cameron's *Idylls* and the Gunn brothers' *Positives*, few studies of literature and photography devote attention to these collaborations. François Brunet in *Photography and Literature* (2009) examines the shaping of photography by scientific and literary culture, and the development of the photo-text, all without recourse to collaborations between poets and photographers. Similarly, David Cunningham, Andrew Fisher, and Sas Mays's collection *Photography and Literature in the Twentieth Century* (2005) recognizes the growth of this interdisciplinary area of study, but photopoetic collaborations are again absent. Most recently, Karen Beckman and Liliane Weissberg's collection *On Writing with Photography* (2013), while breaking new ground in the interdisciplinary study of text and image, fails to engage with the rich history of photopoetic collaborations. Most discussions of literature and photography focus squarely on prose, from Marsha Bryant's edited collection *Photo-Textualities: Reading Photographs and Literature* (1996) and Jane M. Rabb's anthology *The Short Story and Photography, 1880's–1990's* (1998) to Nancy Armstrong's *Fiction in the Age of Photography* (1999) and Michael North's *Camera Works: Photography and the Twentieth-Century Word* (2005).

Traces exist elsewhere. Jefferson Hunter devotes a chapter of *Image and Word* (1987) to the study of poems about photographs. 'Going back and forth from photograph to poem,' Hunter writes, 'can be a destructive exercise.'[22] He compares the 'arbitrariness' of Aaron Siskind and John Logan's collaboration *Photographs and Poems* (1976) to the poems Seamus Heaney wrote in response to the photographs of P. V. Glob's *The Bog People* (1969): Heaney is called 'an extraordinary describer', a neat summary of Hunter's dismissive attitude towards the potential connections between poetry and photography. Though Hunter's discussion of Bertolt Brecht's *Kriegsfibel* (1955) and Yevgeny Yevtushenko's *Invisible Threads* (1981) attempts to lend nuance to his position, it is significant that he omits renowned photopoetic collaborations such as Godwin and Hughes's *Remains of Elmet* (1979), or pioneering American work like Rudy Burckhardt and Edwin Denby's *In Public, in Private* (1948). Of Yevtushenko's self-collaboration, for example, Hunter writes that the poet in his photographs 'offers an easily available reality'.[23] This kind of condescension, dismissive of the potential for metaphor, serendipity, and symbiosis, is common to most accounts of photopoetic work and has proven useful to my study in that such attitudes provide bases for more sophisticated analyses.

In his recent book *Poetry, Photography, Ekphrasis* (2015), Andrew Miller is the first scholar to consider the lyrical ekphrasis of photographs. He examines several texts that I would term 'photopoetic', most notably Thom and Ander Gunn's *Positives* (1966). Rather than considering photopoetic collaboration as a distinct form, Miller situates it as the 'ekphrastic calligram', one of nine 'subclasses' of the 'chronotype of the photograph'.[24] 'Such texts,' Miller writes,

> can therefore be seen as captioning the accompanying photographs and forming what Michel Foucault terms calligrams (*textimage* bonds). These bonds alter the function of the poems, shifting away from the work of description and allowing the speakers to address and even interact with the photographic subjects. Thus, such poems are the fullest manifestation of the chronotype of the photograph, in that text and image encounter one another.[25]

While I agree with Miller that connections more sophisticated than description and illustration are created in the encounter between poem and photograph, I would argue that this 'encounter' fundamentally alters the ekphrastic relationship between poem and photograph. When poem and photograph are seen side by side on the page, the verbal does not represent the visual, nor the

visual the verbal. This reverses Miller's position: photopoetry is not one example of ekphrasis, but ekphrasis can be one example of photopoetry.

Several important works of photopoetry do exhibit ekphrastic connections between poem and photograph, and I draw attention to these examples when appropriate. As a result, W. J. T. Mitchell's concept of 'iconology' and the study of ekphrasis from Murray Kreiger to Elizabeth Bergmann Loizeaux have a limited place in this book.[26] Loizeaux distances her own work from the study of photopoetry, suggesting that 'one might well write a book on photographic ekphrasis', a book in which she would like to see discussions of Ted Hughes's collaborations with Fay Godwin and Peter Keen.[27] While Miller has now written such a book (though Hughes's collaborations are curiously absent), my work argues that photographic ekphrasis is not the only 'encounter' photopoetry renders possible.

Ekphrasis is most relevant to photopoetry in its concerns with rivalry and symbiosis. James Heffernan's definition of ekphrasis as 'the verbal representation of visual representation' has long proven useful, but his ideas about the 'paragone' – the 'rivalry' between visual and verbal arts as a struggle for 'supremacy' – are currently being contested in contemporary ekphrastic theory.[28] Models of collaboration more symbiotic than hierarchical are being proposed and analysed. As David Kennedy writes, 'The idea of representation as a choice that produces a relationship between two things that, in effect, changes both is another point that has received little critical attention.'[29] The kind of symbiotic relationships that Kennedy posits are more applicable to photopoetry than ideas of rivalry: one need only look at the generosity of the collaborations throughout this study, particularly those between Fay Godwin and Ted Hughes, and George Mackay Brown and Gunnie Moberg, to perceive currents of exchange, not competition. Where conflict and rupture do occur, they are thematic concerns accentuated, for example, by antagonistic pairings of poem and photograph in Godwin and Hughes's *Remains of Elmet*, or the structural mischiefs of McBeath and Muldoon's *Plan B*. Each photopoetic text is shaped by the circumstances of its conception and production, and each raises its own unique questions as to how poems and photographs interact. This study pays acute attention to these nuances in order to plot the continuities and turning points of photopoetic history, in both products and practices.

One final thought. Parr and Badger quote the Dutch designer Ralph Prins, who writes, 'A photobook is an autonomous art form, comparable with a piece of sculpture, a play or a film. The photographs lose their own photographic character

as things "in themselves" and become parts, translated into printing ink, of a dramatic event called a book.'[30] Prin's language is provocative, and I would argue that the most sophisticated photopoetry retains the independence of both poems and photographs, while their interdependence creates something new and often divergent from what they signify in isolation. Having it both ways, in my study, means that attention will be paid, on the one hand, to the 'autonomous' forms of photopoetry and, on the other, the histories of photographic and poetic meaning.

Methodology and chapter outlines

It would be impossible to consider every photopoetic work of the last 170 years. Not only would an encyclopaedic approach produce an unwieldy volume, it would also not be useful for those encountering photopoetry for the first time. By eschewing this approach, this study examines key works that have shaped photopoetic history. While it would have been possible to proceed either geographically or thematically, a chronological approach is most appropriate for a foundational study of photopoetry. That said, it is not without potential pitfalls. It is not my intention, for example, to present a version of photopoetic history that parallels the evolutionary perspective of traditional photographic histories. Only comparatively recently has this evolutionary tradition begun to be exploded and the protean nature of photography incorporated into accounts of its history. 'Photographs can function as historical documents,' write Parr and Badger, 'as political propaganda, as pornography, as repositories for personal memories, as works of art, as fact, fiction, metaphor, poetry. The medium has such a diversity of aims and ambitions … that a single shared history would seem to be an impossible pursuit.'[31] Accounts such as Mary Warner Marien's *Photography: A Cultural History* (2002) and Christopher Pinney and Nicolas Peterson's *Photography's Other Histories* (2003) began to decentre the narrative outlined by photography's first eminent historians, such as Beaumont Newhall and Helmut Gernsheim, by engaging with cultural, historical, and regional perspectives beyond the notion that photography is a Western technology centred around, and furthered by, individuals. By examining work from the United Kingdom, United States, India, and Ireland from a range of critical perspectives including ecological, queer, and urban that elucidate how and why poets and photographers have worked, and continue to work, together, this

study demonstrates how photopoetry, too, has a broad range of histories that defy the strictures of the traditional evolutionary framework.

On a related note, it is likewise not my intention to suggest that photopoetry comes to its perfection as a medium over time. In demonstrating how the relationship between poem and photograph has always been symbiotic and serendipitous, I hope to avoid the implication that works of the past are being judged by the standards of the present, or that photopoetry has undergone anything as trite as 'development' or 'improvement' towards a contemporary apotheosis. This study locates continuities and turning points across the histories of photopoetry, broadly defined, to demonstrate the various encounters of poem and photograph since they were first placed side by side on the pages of Victorian scrapbooks. To address the question of format, for example, the nuances of photopoetry across almost two centuries are to be found in the differing working relationships between practitioners, and the cultural, economic, and historical currents from which these photopoetic texts emerged. For example, many formats of photopoetry have been produced since 1845, among them scrapbooks, stereographs, postcards, and artists' boxes, but the most common has been, without question, the photobook. Experimentation in format occurred mostly in the early years of photopoetry, but Crawford and McBeath's *Light Box* (2015) demonstrates that the photobook is not the sole surviving format for photopoetic collaboration. There has been no progression towards the perfect format. The photobook is privileged in this study because it is the most common format, not because it is the perfect or only format. While discussion of other formats is limited primarily to the first and last chapters, I draw on pertinent examples where they illuminate important aspects of photopoetic history, and they are discussed on their own merits and in their appropriate historical contexts.

My central principles of selection are twofold. First, I have chosen photopoetic works on their cultural, formal, and historical significance, not on the artistic merit of the poems and photographs themselves. T. R. Williams, for example, was not an especially good poet, but his inclusion of verses on the back of his stereographic slides was formally innovative. The photographs of Constance Phillips have been all but forgotten, but her pairings of urban photography and romantic verse provide insight into the cultural and historical imaginations of early twentieth-century America. This principle has the benefit of reviving texts that are non-canonical in terms of both photography and poetry – with photographers and poets who are unknown and sometimes anonymous – thus

demonstrating that significant works of photopoetry – and, by extension, the photobook – are not necessarily the same thing as significant works of photography or poetry in isolation.

Second, I have restricted the scope of this study to work produced in the English language, primarily from the United Kingdom and United States. This is already ambitious in scope, though not without reason: my discussions of British and American material are integrated, given the dialogue between photopoetry on both sides of the Atlantic and how, in the twentieth century, changing cultural crosscurrents have prevented the development of insular traditions. It would be impossible to produce a one-volume critical history of worldwide photopoetry, similar in length to this study, without sacrificing detail to breadth. While reasons of scope have led me to exclude a wealth of worldwide material that would otherwise merit detailed discussion, I have attempted to imbue the book with a global flavour. Where appropriate I allude to European photopoetry and suggest points of overlap or connection with anglophone collaborations, most significantly pertaining to interwar surrealism with Paul Éluard and Man Ray's *Facile* (1935), a photo-text amply discussed elsewhere.[32] Likewise, many of the chosen texts focus on places beyond the United Kingdom and United States, from rural Ireland to Afghanistan, India, Italy, Kosovo, and Tibet. I am aware that the history of photopoetry is not monolingual either in its production or its networks of influence, nor is the field of photo-literary studies limited to English-language publications.

As I have suggested, this study of photopoetry will focus both on the interactions between poem and photograph, and the nature of working practices between poets and photographers, from retrospective and collaborative projects to their socio-economic and editorial conditions. For a critical history of the form, it would be impossible to marginalize, in Stafford's neat summary, the questions that surround the 'temporal, conceptual, political, ethical, rhetorical and even financial discrepancies between writer and photographer.'[33] Matters such as the evolving technical possibilities of photography, and its changing economic opportunities, are often as important to innovations in photopoetry as authorial intent. This study does not attempt to excavate authorial 'intentions' but to address different photopoetic practices in order to elucidate the encounter between poem and photograph. An awareness of method and practice often illuminates the work: a sense, for example, of how subjects and themes were conceived; whether poems or photographs came first or emerged concurrently; and how the order of poems and photographs was decided.

The first two chapters explore the beginnings of photopoetry in Britain and America. Chapter 1 examines the origins of British photopoetry, from vernacular forms such as scrapbooks and photograph albums to the enormously popular photographically illustrated poetry books of the late nineteenth century. Two key photopoetic themes quickly emerge: the 'theatrical' and the 'picturesque'. This chapter explores these themes, and demonstrates how they provided different challenges to photographers seeking to illustrate poetry. Through case studies including photographically illustrated editions of Walter Scott and William Wordsworth, Henry Peach Robinson's composite photographs, and a specifically photopoetic analysis of Cameron and Tennyson's *Idylls*, the chapter addresses the encounter between text and image when photographers illustrate already existing poems. Through the 'retrospective' work under discussion, I challenge the idea that 'photographic illustration' is literal and reductive, instead positioning it as a symbiotic combination of poem and photograph that places the reader/viewer at the centre of the work. I explore how the most engaging works of photographically illustrated poetry combine the visuality of photography and the textuality of poetry to create multisensory sites reliant upon the independence and interdependence of text and image.

Chapter 2 focuses on the emergence of American photopoetry, which did not proliferate as early in the nineteenth century as British work. Concerned, typically, with people rather than landscapes, American photographers tended to conceive of their photographs as visual 'translations' of existing poetic texts. Key work in this period includes the six photographically illustrated books of Paul Laurence Dunbar's poetry, and Adelaide Hanscom Leeson's pictorialist photographic translation of Edward FitzGerald's *Rubáiyát of Omar Khayyám*. Turn-of-the-century American photopoetry constructed and deconstructed representations of gendered and racialized identities, and I examine these representations through ideas of masks and masquerades, aspects of mythology and ethnography, and the tension created between photographic eye and poetic voice(s).

The third chapter continues to focus on American material. It investigates how American practitioners in the early twentieth century moved away from retrospective illustration and translation towards more reciprocal collaborative relationships between poets and photographers. Beginning with an analysis of Ezra Pound's imagist poetry, the chapter traces how analogues between photography and poetry in Pound's work shaped twentieth-century ideas about the connections between text and image. From this basis, the chapter

discusses how collaborations between photographers and poets explored ideas of 'America' in general, and the American city in particular, in works such as George Sterling and Francois Bruguière's *The Evanescent City* (1915), Hart Crane and Walker Evans's *The Bridge* (1930), and Rudy Burckhardt and Edwin Denby's *Mediterranean Cities* (1956). The emergence, in such works, of mutual collaborative relationships enhanced the metaphorical, symbiotic encounter between poem and photograph. For example, in their scrapbook *New York, N. Why?* (1938), Burckhardt produced cityscapes and photographs of faceless citizens in response to Denby's poems about the experiences of a gay man living in New York City.

Chapter 4 returns the focus to Britain, where poets and photographers began to collaborate on book-length projects from the mid-1950s. The majority of British photopoetry in this period centres on the relationships between people and place. These collaborations reshape the initial focus on picturesque and pastoral themes, and introduce new concerns such as home, exile, and dwelling. Landscapes become active participants in more immersive, topographically engaging photopoetry, and I relate this development to the emergence of collaboration, examining how different working practices impinge upon the symbiotic relationship between poem and photograph. Ted Hughes emerges as a key theorist of photopoetic practice, and his work with Fay Godwin provides the main focus of this chapter, alongside collaborations between George Mackay Brown and Gunnie Moberg, and Thom and Ander Gunn.

The final chapter develops the idea of photopoetic symbiosis discussed in the previous chapter. It explores how contemporary photopoetry has begun to focus on objects rather than people or places – 'The traces of what [people have] done', in McBeath's phrase – and examines how this development allows readers to approach relationships between text and image in a non-linear manner.[34] Beginning with *Sweeney's Flight* (1992), Seamus Heaney's collaboration with photographer Rachel Giese, I discuss how contemporary photopoetry creates a theatrical space in which the reader, no longer steered along a prescribed route by poet or photographer, creates their own narrative through their responses to poem and photograph. Contemporary practitioners have created formats that enable readers to make connections between all photographs and poems in a collection, rather than insisting on specific 'pairings'. This chapter discusses innovations in the photobook format, as well as alternative forms such as the artist's box, and investigates how formal experiments will continue to challenge how we perceive the photopoetic relationship.

Together, these five chapters constitute the first book-length account of photopoetry and call for its recognition as a new form of art with a rich and complicated history.

Notes

1 Norman McBeath, interview by the author, Edinburgh, 13 February 2015.

2 McBeath, interview by the author.

3 McBeath, interview by the author.

4 McBeath, interview by the author.

5 Nicole Boulestreau, 'Le Photopoème *Facile*: Un Nouveau Livre dans les années 30', *Le Livre surréaliste: Mélusine IV* (Lausanne, 1982), 164.

6 Andy Stafford, *Photo-texts: Contemporary French Writing of the Photographic Image* (Liverpool: Liverpool University Press, 2010), 156–158. Two chapters in *Photo-texts* explore poetry and photography in the work of Tahar Ben Jelloun (106–121), and Philippe Tagli (156–168).

7 Robert Crawford and Norman McBeath, 'Photopoetry: A Manifesto', in *Chinese Makars*, by Crawford and McBeath (Edinburgh: Easel Press, 2016), 68–69.

8 Regrettably, I am unable to detail the history of vernacular photopoetry – following Geoffrey Batchen's definition of vernacular photography – beyond the scrapbooks produced in the nineteenth century. To do so would be, on the one hand, stymied by conditions of scope and, on the other, render most works under discussion inaccessible to the majority of readers despite recent advances in digitization and online exhibitions on the part of libraries and archives. In focusing for the most part on published works of photopoetry, this study aims to identify a field of study with a readily available corpus. See Geoffrey Batchen, 'Vernacular Photographies', *History of Photography* 4, no. 3 (Autumn 2000), 262–271.

9 John Fuller and David Hurn, 'A Conversation by Way of Introduction', in *Writing the Picture*, by Fuller and Hurn (Bridgend, UK: Seren, 2010), 8.

10 Roland Barthes, *Camera Lucida: Reflections on Photography*, trans. Richard Howard (London: Vintage, 2000), 49.

11 Three bibliographical texts also proved crucial, and led to the discovery of some important photopoetic works. They were Paul Edwards, *Soleil Noir: La Photographie & Littérature: des origines au surréalisme* (Rennes: Presses Universitaires de Rennes, 2008); Eric Lambrechts and Luc Salu, *Photography and Literature: An International Bibliography of Monographs* (London: Mansell, 1992); and Jane M. Rabb, ed., *Literature and Photography: Interactions,*

1840–1990, a Critical Anthology (Albuquerque: University of New Mexico Press, 1995).

12 See Martin Parr and Gerry Badger, *The Photobook: A History*, 3 vols (London: Phaidon, 2004–2014). All further quotations refer to vol. 1.

13 Parr and Badger, *Photobook*, 11.

14 Parr and Badger, *Photobook*, 19.

15 Norman McBeath and Robert Crawford, interview with Jessica Hughes, *Practitioners' Voices in Classical Reception Studies* 3 (2012), http://www.open.ac.uk/arts/research/pvcrs/2012/mcbeath-crawford.

16 Stafford, *Photo-texts*, 6.

17 Stafford, *Photo-texts*, 7.

18 Perhaps the most famous example of this form is Archibald MacLeish, *Land of the Free* (New York: Harcourt, Brace, 1938). MacLeish calls the poems 'The Sound Track' to the photographs, and describes the work as 'the opposite of a book of poems illustrated by photographs. It is a book of photographs illustrated by a poem. The photographs … existed before the poem was written.' (89)

19 Carol Armstrong, *Scenes in a Library: Reading the Photograph in the Book, 1843–1875* (Cambridge, MA; London: MIT Press, 1998); Helen Groth, *Victorian Photography and Literary Nostalgia* (Oxford; New York: Oxford University Press, 2003); Lindsay Smith, *Victorian Photography, Painting and Poetry: The Enigma of Visibility in Ruskin, Morris and the Pre-Raphaelites* (Cambridge: Cambridge University Press, 1995).

20 See also Kate Flint, *The Victorians and the Visual Imagination* (Cambridge; New York: Cambridge University Press, 2000).

21 See, most recently, Jeff Rosen, *Julia Margaret Cameron's 'Fancy Subjects': Photographic Allegories of Victorian Identity and Empire* (Manchester: Manchester University Press, 2016), 230–265.

22 Jefferson Hunter, *Image and Word: The Interaction of Twentieth-Century Photographs and Texts* (Cambridge, MA; London: Harvard University Press, 1987), 189.

23 Hunter, *Image and Word*, 175.

24 Andrew Miller, *Poetry, Photography, Ekphrasis* (Liverpool: Liverpool University Press: 2015), 5.

25 Miller, *Poetry, Photography, Ekphrasis*, 6.

26 See W. J. T. Mitchell, *What Do Pictures Want? The Loves and Lives of Images* (Chicago: Chicago University Press, 2005); Murray Krieger, *Ekphrasis: The Illusion of the Natural Sign* (Baltimore; London: Johns Hopkins University Press, 1992); and Elizabeth Bergmann Loizeaux, *Twentieth-Century Poetry and the Visual Arts* (Cambridge: Cambridge University, 2010).

27 Loizeaux, *Twentieth-Century Poetry*, 27.

28 James Heffernan, *Museum of Words: The Poetics of Ekphrasis from Homer to Ashbery* (Chicago: University of Chicago Press, 1993), 3. See Stephen Cheeke, *Writing for Art: The Aesthetics of Ekphrasis* (Manchester: Manchester University Press, 2008); David Kennedy, *The Ekphrastic Encounter in Contemporary British Poetry and Elsewhere* (Farnham, UK: Ashgate, 2012); and Loizeaux, *Twentieth-Century Poetry*.

29 Kennedy, *Ekphrastic Encounter*, 2.

30 Quoted in Parr and Badger, *Photobook*, 7.

31 Parr and Badger, *Photobook*, 6.

32 See, for example, Renée Riese Hubert, *Surrealism and the Book* (Berkeley: University of California Press, 1988), 73–83.

33 Stafford, *Photo-texts*, 7.

34 Norman McBeath and Robert Crawford, interview by Jessica Hughes.

'... with Photographic Illustrations'
The Birth of British Photopoetry, 1845–1875

From illustrated novels to the popular press, the Victorian obsession with relationships between text and image is often discussed without mention of poetry. Accordingly, these discussions overlook the subtle interplay between verse and perhaps its least likely artistic bedfellow: photography.

In the early years of photographically illustrated books, grave doubts were expressed about the subjects and forms of writing most suitable for photographic accompaniment. As the editor of the *Gentleman's Magazine* wrote in 1867,

> The class of illustration to which photography can be applied is obviously limited. It cannot create, it can only copy; its results are descriptive rather than suggestive. Its subjects must be real, and we cannot therefore illustrate poetry or fiction by it.[1]

Photopoetry as we know it today emerged from the refutation of such attitudes. Already by 1867 some thirteen books of photographically illustrated poetry had been published, and a further twenty-eight would be in print by the turn of the century. These are books, remarks Jennifer Green-Lewis, 'about which it is remarkably hard to say anything, and yet in which something profoundly interesting seems to be going on'.[2] This 'something' is a more symbiotic connection between poem and photograph than the summary 'descriptive rather than suggestive' or the term 'photographically illustrated' are generous enough to conceive. An exploration of this 'something' is the purpose of my first chapter.

Writing in 2017, in a culture saturated as never before with visual images and information, it is difficult to comprehend the kind of epistemic rupture caused by photography and its forbears. For Victorians seeing a daguerreotype, calotype, stereograph or photograph for the first time, their appreciation of representational time and space would have been transformed beyond any conceivable modern-day equivalent: Elizabeth Barrett Browning, for example,

extolled the daguerreotype's 'mesmeric disembodiment of spirits', and how 'the *very shadow of the person* lying there [is] fixed for ever!'[3] The place and importance of photography in the evolution of human consciousness is beyond the scope of this book, let alone this chapter, yet I hope to suggest the significance of 'photopoetry' to one of the most significant upheavals in consciousness since the development of literate culture. The formal, stylistic, and thematic development of photographically illustrated poetry in the nineteenth century brought together two seemingly incompatible modes of expression into a new, multisensory way of capturing the past, of memorializing people and places.

While Helen Groth has identified nostalgia as a fundamental dynamic of Victorian interrelations between poetry and photography – and Victorian literary culture in general – what her work overlooks is twofold.[4] First, Groth's study of memory is not situated within a nexus of visual, verbal, and haptic roots governing the dissemination and consumption of poetry and photography. Hence the second absence: while compelling, her analyses of early photographically illustrated poetry books exclude a much more common practice of photopoetic combination in Victorian Britain, that of the domestic scrapbook. These represent some of the most fertile exploratory sites in nineteenth-century text/ image experiments. This chapter expands the sensory and cultural scope of Groth's argument, exploring the emergence of photopoetry in the public and private worlds of the nineteenth century. Only with an understanding of these early roots will meaningful discussion of later, twentieth-century innovations become possible and, indeed, fruitful.

Similarly, Groth discusses only one format of nineteenth-century photopoetry: the photobook. While this would become the standard photopoetic format from around 1880, only by considering other experiments with stereography and combination photographs can we gain a richer understanding of photopoetic history. This first chapter examines these formats in order to elucidate fully the chief thematic strands of photopoetry in the nineteenth century, the picturesque and the theatrical. While the picturesque proved most commercially popular, the theatrical encounter shaped the most innovative photopoetry. While the frame embodies the division between humans and nature, the aesthetics of staging attempt to collapse this division and, in photopoetry, place the reader/viewer at the centre of the network of visual and verbal images.[5] This is the case in theatrical and picturesque photopoetry: this chapter traces the development of both strands, and concludes with a discussion of their comparative importance to later photopoetry. Attempting to define the

place and importance of photopoetry is to stake a claim for the importance of a hitherto overlooked aspect of Victorian visual culture; and, more boldly, to suggest an origin of sorts for a radical, nineteenth-century innovation that remained central to modernist aesthetics and beyond.

Framing the body

An important aspect of domestic life, scrapbooks and commonplace books acted as repositories for much cultural experience of middle- and upper-class women. The centuries-old practices of scrapbooking and commonplacing changed dramatically in the nineteenth century because of the growing dissemination of images. Driven by the diminishing costs of the illustrated press, a raft of image-driven periodicals such as the *Illustrated London News* and the *Graphic* emerged in which image was given as important a representational purpose as text.[6] Text and image clippings thus existed on scrapbook pages alongside handwritten fragments, sketches, pasted-in photographs, watercolours, locks of hair, and other ephemera. These multisensory albums, in Roland Barthes's terms, are 'multi-dimensional space[s] in which a variety of writings, none of them original, blend and clash', and can be read, alongside poetry albums and friendship books, as more private and solitary texts than the familial structure of storytelling in photograph albums, a distinction that becomes more important when we consider photopoetry and publication.[7]

The compilation essential to scrapbooks and commonplace books necessitates an approach to text/image studies focusing on the relationship between reading, writing, and touching. In scrapbooks, photographs are primarily sources of information and enjoyment, as one important but little-known album testifies. The album, held at the University of St Andrews, contains six pasted-in calotypes, each accompanied by a handwritten quatrain.[8] The anonymous verse appears never to have been published.[9] Five photographs show a female figure either sitting or kneeling; in the sixth she stands, the culmination of a narrative in which she remains loyal to her absent lover and is rewarded with marriage upon his return.

As for the album's provenance, William Henry Fox Talbot (1800–1877), inventor of the calotype process, had several Scottish disciples including John Adamson (1809–1870), the renowned St Andrews physician who produced the first calotype portrait in Scotland in 1841.[10] Adamson's younger brother, Robert

(1821–1848), became a professional photographer in Edinburgh and formed, with David Octavius Hill (1802–1870), perhaps the first canonical partnership in photographic history. It has been suggested that we might attribute the St Andrews album to Hill and Adamson, and tentatively date it c.1845. This is for two reasons: first, the quality of the calotypes is very similar to other Hill and Adamson work of this period. Second, the album's narrative is potentially biographical, evoking the ties between Hill and Adamson and the St Andrews photographic community. Baillie W. Tulloch, the grandson of John Tulloch (1823–1886), former professor of Systematic Theology and Apologetics at St Andrews, donated the album to the university in 1948. In July 1845, John Tulloch married Jane Anna Sophia Hindmarsh in Jersey, following a courtship during which the couple faced numerous periods of separation.[11] It is possible Hindmarsh is the young woman in the photographs.

The title of the album, *A Little Story for Grown Young Ladies, Illustrated Photographically*, is one of the first uses of the phrase 'illustrated photographically' to describe a book or scrapbook containing photographs. This phrase became commonplace in the titles of such works from the mid-to-late nineteenth century, and often implies a scrupulously literal connection between poems and photographs that restricts our understanding of these early experimental works. Use of the phrase implies textual superiority over the image, in which the photograph is taken to possess a merely 'descriptive' function. In fact, however, it is often difficult to tell whether poem 'illustrates' photograph or vice versa, or whether 'illustration' itself is a reductive term for any combination of text and image. The term 'photographic illustration' is enriched when we consider the visual, verbal, and tactile manners in which the reader/viewer interacts with works of photopoetry, and how, in the process of assimilating photographs into the reading experience, image can challenge, complicate, and combine with the text.

Through this approach, we are able to intuit more about early photopoetic relations than the album's title implies. In each photograph, the model either touches something or makes an exaggerated gesture, aligning the album with the theatrical photography common from the mid-nineteenth century onwards. In the first and fifth she holds a letter, and the reader/viewer sees her reaction: the first disconsolate (her lover is absent), the fifth elated (his return is imminent). The structural unity of the photographs derives from their dependence on oral events occurring 'offstage': the reading aloud of letters, proposals of marriage, arguments, and repudiations. There is a similar oral insistence in the poetry,

evoking Barthes's observation that 'the Photograph is never anything but an antiphon of "Look," "See," "Here it is"'.[12] For example:

> And friends are heartless, in her love
> They have no sympathie.
> They urged this girl, until at last
> Behold a supplicant she.
>
> Now see her in a bridal wreath
> She dreams her cares are o'er:
> Her future, bright in sunshine glows
> So be it, evermore.
>
> (*A Little Story*, np)

The imploration to the reader/viewer to 'see' and 'behold' is an important aspect in the dynamics of early photopoetry, especially works in which the poems and photographs were conceived in conjunction, as is likely the case here. The poet acts as guide, gesturing towards the important features of the photographs. In this album the quatrains are not descriptive or literal – rather, they provide a narrative for the photographs. Rather than exhaustively listing visual details, the verse mentions occasional changes such as the 'bridal wreath' and encourages the reader/viewer simply to look. Photographic technology necessitated a re-evaluation of thought similar to the emergence of literate consciousness: the verse refers to the photographic information but need not verify it because of the presence of the visual referent itself, just as the mnemonic structures of oral language diminished because language could be recorded visually, in writing. The quatrains interpret rather than describe the photographs, and the photographs add to and enhance the quatrains.

The St Andrews album provides an early example of the connection Barthes draws between theatre and photography. He writes,

> However 'lifelike' we strive to make it (and this frenzy to be lifelike can only be our mythic denial of an apprehension of death), Photography is a kind of primitive theater, a kind of *Tableau Vivant*, a figuration of the motionless and made-up face beneath which we see the dead.[13]

The connection between death and photography is an important feature of the album's verse. 'Her future, bright in sunshine glows' alludes to the process of photographic development (in which her image is literally written in light), the memorializing nature of photography and, perhaps, Talbot's *Sun Pictures*

in Scotland (1845). Her image is preserved 'evermore', and the material object of the photograph becomes her 'future' beyond death. The verse acts like a voiceover to a *tableau vivant*, and the portraits are performative, framing the story through the tension between likeness and narrative. As costume portraits in a narrative sequence, the album reflects what Lara Perry identifies as the 'serial dynamic of photographic likeness' seen later in *carte-de-visite* albums, though with several complicating factors.[14] For one, the St Andrews photographs were not mechanically reproduced elsewhere, thus the idea of person as commodity (as with *cartes-de-visite*) becomes moot. Similarly, while the portraits can be enjoyed for their likeness to the model, this was not the sole purpose of the album: otherwise the posing, staging, and narrative would not have been included. Like the theatre, the St Andrews album provides a fascinating separation of person and character, who share only a likeness.

Situating the St Andrews album in the history of photography only reaffirms its importance. Dating it to c.1845, the album recalls the kind of photographic horseplay enacted by, among others, Hugh Lyon Playfair (1787–1861), whose taste for amateur theatricals was well known.[15] Its photographs predate the *carte-de-visite* craze that swept Britain and France from 1858 to 1863 – the first sustained period of interest in photographic portraits – in which 'photography and the theatre came to prosper through a mutually beneficial relationship'.[16] This early instance of sequential narrative portraiture in a staged environment predates the desire, in subsequent Victorian portraiture, to create a likeness of the sitter and, more intriguingly, to frame identity from social and psychological perspectives. The album engages in Victorian middle-class entertainments, and creates a dramatic likeness to an event rather than a person: the event, it would seem, of Tulloch's courtship of, and marriage to, Hindmarsh. From a gender perspective, a female sitter and a presumably male narrator reflect how women were often photographed objects, and men the creative, 'director' figures. 'However,' notes Marta Weiss, 'many nineteenth-century staged photographs were made in social situations in which the sitters were not necessarily passive models in the hands of the photographer, but were more likely to have been active participants in an exchange of ideas.'[17] Although there is no evidence to suggest that Hindmarsh had any creative control over the album, the suggestion of an oral exchange of ideas creates an additional, verbal layer to the design and use of the album, the poetry proving central to both the creation and performance of the photography.

If the album's oral foundations require excavation, its tactility is more immediate. The verse draws attention to the materiality of the photographic image. The variable quality of the calotypes attests both to the erratic nature of early photographic practice and to sloppy handling not uncommon among nineteenth-century photographers: such haptic traces, for example, occur frequently in the work of Julia Margaret Cameron. The vernacular history of photography, how photographs 'can be handled, framed, cut, crumpled, caressed, pinned on a wall, put under a pillow, or wept over', has long been overlooked.[18] In the St Andrews album, the focus on gesture and touch alludes to this vernacular history. The most striking of the six photopoetic combinations is the sequence's second, titled 'Another Man Proposes' (Figure 1.1). The model is posed in what the verse describes as 'Horror', and although the album's theatrical nature creates an intentionally playful tone, this particular photograph is made unintentionally humorous, it seems, thanks to protracted exposure times. The quatrain reads,

> And then another suitor came
> Who thought he now might woo –
> That gaze of Horror plainly speaks
> For once, a woman, true.

The poem and photograph entwine oral and haptic experience, reflected here in the position of the reader/viewer. While the photograph might be said simply to illustrate 'That gaze of Horror' upon the suitor's proposal, the optical dynamics are much more complex. The photograph makes the reader/viewer see through the photographer's eyes and, given the likelihood the photographer was male, there is a certain predatory aspect to the gaze within the context of the poem. The reader/viewer is positioned, then, as the potential suitor. By extension, the reader orally delivers the proposal by reading the quatrain aloud (remembering the likely social use of the photo album), recreating the oral event to which the photograph purportedly bears witness. Likewise, the model's gaze 'speaks' rather than shows 'Horror', evoking the oral rather than visual quality of the photopoem.[19] Here the tactile nature of the album becomes apparent: the carefully posed gesture of the model reacts, we suppose, to the gesture of the suitor, who has perhaps moved towards, or reached out, to her. The photographer's act in photographically possessing the model ('taking' her picture) marks the gesture, and the reader/viewer's tactile relationship to the album recreates it. The reader/viewer is obligated to touch the album, if only in the most reductive manner, to turn the pages. For the outsider, this represents an invasion of the seemingly

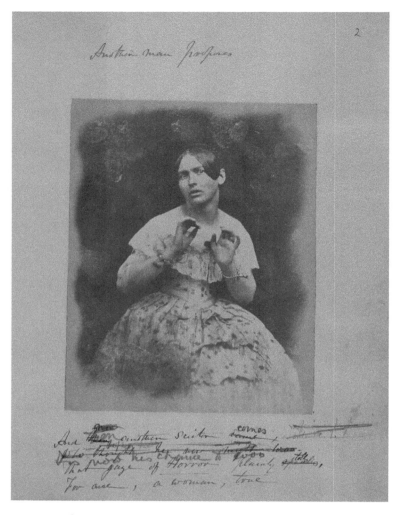

Figure 1.1 David Octavius Hill and Robert Adamson, 'Another Man Proposes', in *A Little Story for Grown Young Ladies, Illustrated Photographically*, c.1845. Courtesy of the University of St Andrews Library, ALB-37-2.

female space; for the lover or family member recalling how the album was made, the identity of the model, or any associated stories, the haptic experience will perhaps be erotic, nostalgic, or melancholic.

The aesthetic design behind the emotional states of the model in the St Andrews album appears to support the argument that the 'object of modern vision ... is not the world out there, but the inner world of the body as a subjective producer

of visual sensations'.[20] The photographs do not illustrate the poem but visualize emotions and scenes central to the 'story'. They lend additional interest to what is banal verse, and create a multisensory photopoem combining sight, sound, and touch. As photographic consciousness changed throughout the nineteenth century, people became aware that the truth of photography existed in its capture of fleeting impressions, not in any inherent 'truth' to the things in the world to which they refer. The staging of the St Andrews album photographs – that is, their evocation of a fiction – proved an important precursor both to Henry Peach Robinson's combination photographs and Julia Margaret Cameron's *Illustrations to Alfred Tennyson's Idylls of the King and Other Poems* (1875). While nineteenth-century photography had originally distorted the biblical credo of *to touch is to know* into *to see is to know*, photopoetry highlighted how photography could also represent fictional spaces, as opposed to its primary use, at the time, as a methodology for gathering facts. The resultant friction demonstrates the complicated dynamics of how photopoetry was read, seen, spoken, and touched, and gestures towards how photopoetry was metaphorical and evocative, suggestive rather than descriptive, from its earliest incarnations.

* * *

The following decade, staged photopoetry emerged from the family album into the public eye. Henry Peach Robinson's (1830–1901) composition photograph 'Fading Away' (1858) (Figure 1.2) is perhaps the most discussed 'staged photograph' of the Victorian period, illustrating, Weiss notes, 'that photography is capable not only of recording facts, but also of representing fiction'.[21] In his article 'The Poets and Photography', Robinson strings together 'a few passages from the poets, in which it scarcely requires a lively imagination to trace allusions to our art'.[22] For Robinson, photography was as much an art as painting or poetry.

From 1858 to 1868, Robinson exhibited five combination prints accompanied by quotations from Arnold, Shelley, Spenser, Tennyson, and Wordsworth. To understand fully Robinson's use of poetry, it is necessary to place the quotations within the *ut pictura poesis* tradition, from Joshua Reynolds's *Discourses* (1769–1790) to exhibition catalogues at the Royal Academy in which painters, including Constable and Turner, used poetic epigraphs.[23] While it would be easy to suggest that Robinson appropriated an existing custom, the use of literary quotation to emphasize the fictional space of a medium so 'lifelike' as photography was progressive, especially in the exhibition print form. Photographic precedents for images paired with literary and historical quotations existed in both album

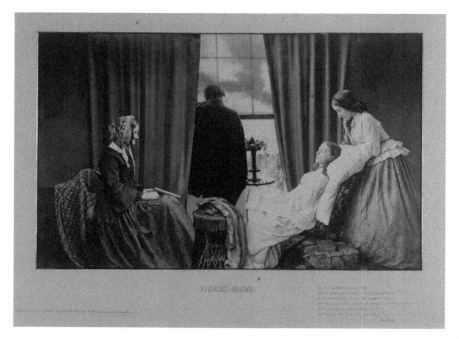

Figure 1.2 Henry Peach Robinson, 'Fading Away', 1858. © Science & Society Picture Library.

form – such as the *Photographic Album for the Year* series in the mid-1850s, produced by and circulated within the Photographic Exchange Society – and early photobooks including *The Sunbeam: A Book of Photographs from Nature* (1859). Robinson's work is notable, therefore, for using literary quotation as a legitimizing strategy outwith an album or photobook.

Compared to the sequential nature of the photographs in the St Andrews album, Robinson's work, as Lori Pauli remarks, 'seeks to tell a complete story in one image', using poetic quotations (not specially composed verse) as gloss rather than as an integral narrative component.[24] The singularity of photographs such as 'Fading Away' and 'Bringing Home the May' (1862) marks them out as important to the history of photopoetry, combining the theatrical techniques I have already discussed with a narrative condensed into a single image. Robinson's work reverses the idea of 'photographic illustration': photographs aspired to artistic status while poetic quotations bore the supposedly illustrative burden. Lines from Shelley's *Queen Mab* (1813), excised from their original context, caption Robinson's fictional scenario in *Fading Away*, beginning,

> Must then that peerless form
> Which love and admiration cannot view
> Without a beating heart, those azure veins
> Which steal like streams along a field of snow,
>> That lovely outline, which is fair
>> As breathing marble, perish![25]

<div align="right">(Shelley, Queen Mab, 1.12–17)</div>

'Just as the poem likens death to the transformation of a live body into a marble statue,' Weiss notes, 'the photograph seems to immobilize the dying girl into a picture', creating a more metaphorical than illustrative link between poem and the memorial function of photography.[26] Complicating this, however, are the intricate layers of Robinson's photographs: his own imagined spaces (already fictive through his combination practices), with his own titles and glossed with poetry, stage elaborate fictions rather than facts. Such stagings were not without problems: audiences were discomforted by the suggestion Robinson had actually witnessed the death of a young girl in such circumstances, even though the sentimental overtones of the image appealed to the romantic association of consumption in the Victorian imagination. Conversely, as Pauli notes, 'there was consternation at the revelation that he had seen no such thing, that the episode had been invented and that this picture too was staged and put together by means of combination printing'.[27] Such oppositional concerns demonstrate how Victorians were still developing their understanding of what photography could and could not represent.

Robinson's use of poetic quotations varies between his photographs and, although the Shelleyan 'Fading Away' shows arguably the deepest connection, his other fictive spaces are also noteworthy. 'The Lady of Shalott' (1861) borrows Tennyson's title, and the photograph closely resembles the fictive space and narrative of the poem. 'Bringing Home the May' (1862) is a genre scene drawn from, and captioned by, Spenser's 'The Shepheard's Calendar' (1579): Robinson is said to have visualized the scene 'almost as plainly as if it had been already photographed', creating an intricate blend of the photographic and poetic without the same narrative drive of 'Fading Away'.[28] Similarly generic, and illustrating scene rather than fiction, is Robinson's collaboration with Nelson Cherrill (1845–1916), 'Watching the Lark, Borrowdale' (1868), with Wordsworth's 'The Skylark' as its lyric referent. Lastly, 'Sleep' (1867), coupled with lines from Arnold's 'Tristram and Iseult' (1852) stages an aspect of the poem not central to its narrative: it is a tableau, illustrating how the children 'sleep in shelter'd rest / Like

helpless birds in the warm nest' (327–328).[29] Preceding the excerpt in its original context, Iseult approaches the bedside, a role now played by the reader/viewer. While 'Sleep' is tied to a specific poetic extract, the photograph does not depend upon the narrative of the poem, as did 'The Lady of Shalott', but balances the poetic referent with a separately imagined photographic space. The poem resonates; it does not invade. Robinson's title, too, does not draw on specific details in the extract.

Victorian staged photography was a more pervasive practice than exhibition prints like 'Fading Away' suggest, and the use of literary quotation as a key element of staging theatrical photography, narrative or otherwise, was similarly widespread. That Robinson eventually abandoned his experiments suggests a representational problem. The painterly suspension of disbelief, Robinson writes, is a '[convention] to which we agree without trying to make believe much'. For a photograph, he continues, in what might be a criticism of Cameron's *Idylls*, 'however much we may call the picture King Arthur, it is only a portrait of a dressed-up model'.[30] In its anachronisms, he concludes, painting is easier to believe than photography. Though poems such as Thomas Gray's 'Elegy in a Country Churchyard' are, in Robinson's words, 'full of picture-giving lines', photography was not yet capable of creating believable, fictional scenarios that were equal to the poetic captions with which they were partnered.[31]

<p style="text-align:center">* * *</p>

Elements of scrapbooking persisted in theatrical photopoetry until the last decades of the nineteenth century, culminating in what should have been a significant critical and commercial success between two leading figures in poetry and photography: the poet laureate Alfred Tennyson (1809–1892), and fine art photographer Julia Margaret Cameron (1815–1879). Cameron's *Idylls of the King* (1875), however, was neither a critical nor commercial success in its own time, and it is common today, as Pauli notes, to consider the *Idylls* among Cameron's less accessible work when compared to her insightful portraits.[32] While *Idylls* is the most discussed collection of photopoems to date, its reputation suffers from not being located within the specific contexts of photopoetic history, creating the impression that the collection was anomalous within Victorian text/ image experiments, and that its innovations were not furthered in subsequent collaborations between poets and photographers. This concluding section on theatrical photopoetry explores Cameron's *Idylls* in light of its competing visual and verbal modes, the bridge between public and private photopoetic practices,

and its place in the emergence of artistic photography as a sister of, and rival to, poetry.

The two volumes of *Illustrations to Tennyson's Idylls of the King, and Other Poems* appeared in May 1875, published by Henry S. King, whose imprint of predominantly religious and literary texts was bought by Kegan Paul in 1878. Unusually, a cabinet edition preceded them, aiming beyond the niche market for sumptuously illustrated books to a new audience, appealing visually to the domestic practices of commonplacing and scrapbooking.[33] Cameron, however, was appalled at the reduction of her photographs into cabinet-sized woodcuts: the original commission, Groth relates, was for a number of illustrative frontispieces, the 'humble nature' of which Cameron somewhere lost sight.[34] It is significant, to literary-influenced staged photography, that the three images King selected for the cabinet edition were close-ups, not *tableaux*. Groth notes that these 'engravings erased the ambiguities of Cameron's focal effects', and the cabinet edition effectively 'reinforce[d] the structural possibility inherent not only in photography but also in poetry; the possibility of reproducibility'.[35] The cabinet edition appears like a *carte-de-visite* album, concerned more with celebrity than the artistic worth of Cameron's photographs, a seeming indictment of the compatibility of poetry and staged photography in the literary marketplace.

The subsequent two-volume edition of *Idylls*, however, propelled the predominantly private practice of scrapbooking into the public arena, as Cameron selected handwritten excerpts from *Idylls* to accompany her photographs.[36] Carol Armstrong's illuminating study of *Idylls* focuses on Cameron's reading of Tennyson's women, her excisions from the poem, and the consequent authorial usurpation of poet by photographer.[37] Cameron treated Tennyson's 'mass published text as a privately owned book that she is licensed as a reader to underline, mark up, and copy out, dreaming the text and envisioning it as she chooses'.[38] Further blurring author and reader is Cameron's decision to underline excerpts within excerpts. As Amelia Scholtz remarks,

> Cameron underscores the description of Arthur as one 'who seem'd the phantom of a Giant in it,' thus implying that certain parts of the excerpts are of greater significance than others. Yet, the inclusion of the surrounding, non-underlined text further suggests that the 'excerpts within excerpts' cannot be understood without reference to their surrounding narrative context. At the same time, Cameron's edition does precisely what it seems to warn us not to do; that is, it offers us excerpts deprived of their context.[39]

This blurring echoes the blurred space in which *Idylls* exists between retrospective and collaborative photopoetry: while the poems and photographs were not written and taken in conjunction, Tennyson invited Cameron to make the photographs for a new edition. Cameron's work diverged from the common, retrospective tendency in the mid-nineteenth century to pair poems with topographical photographs. These works are the subject of the second half of my chapter, and represent the 'picturesque' trend of photopoetry. In one respect, they stage the lives of poets such as Walter Scott and William Wordsworth through their work; Cameron, conversely, enters into the framing of narrative, of event, of the tension between movement and stillness available in the dramatic tableau. *Tableau vivant* and dramatic tableau were each, Martin Meisel notes, 'a readable, picturesque, frozen arrangement of living figures; but the dramatic tableau arrested motion, while the *tableau vivant* brought stillness to life'.[40] Clearly Cameron recognized the potential both of artistic photography to go beyond the static illustrations common to Victorian photobooks, and the manner in which text and image could function symbiotically if one was not used simply to describe the other. This was a crucial moment for photopoetry: Cameron realized that photography could be the artistic equal of poetry, and that, before a fully symbiotic relationship could occur, photography had to be accepted as an art form in its own right. It is unsurprising, however, that in 1875 a consensus formed among King, Tennyson, and the wider Victorian public that Cameron's photographs 'defied easy consumption. Amateurish and elusive, they disrupted rather than facilitated fantastic identification with Tennyson's medievalized English types by making photography itself visible through the use of self-consciously aesthetic techniques'.[41] They are photographs as much about the state and practice of photography as they are about Tennyson's poetry, and they hint towards the potential of photopoetry as collaboration between equals.

One especially interesting aspect of Cameron's *Idylls* from a photopoetic perspective is the attraction of the Victorian epic for photographic attention. The intense visual detail of Victorian poetry, and Tennyson's work in particular, has been discussed elsewhere, though the importance of photography to the Victorian visual imagination, and the repercussions of this for literature, are only now attracting critical attention.[42] Even so, the Victorian epic is a curious thing. Herbert Tucker questions how, 'so long after notices of generic expiration had been clearly posted by Milton, then Dryden and Pope' the Victorian epic persisted, 'its traditional functions having been taken over by the newer narratives of science, history and above all realist fiction'.[43] A modern technology capable

of capturing the past, photography seemed the ideal visual accompaniment for a poetic form caught between antiquity and modernity. Victorian poets 'had to try the resources of the genre', Tucker notes,

> submitting its antique conventions to the stress of an accelerating modernity, and they had conversely to test the worth of modern experience by the standard which was held up for emulation by the formidable virtues of epic grandeur, comprehensiveness and permanence.[44]

Idylls seems a provocative choice for photographic illustration. Cameron blurs the supposedly realist dynamic of photography to the extent that Tennyson's defamiliarization of Victorian society is given a further twist, for two related reasons. First, Cameron's domestication of the epic, creating the spaces of Arthurian England in the rooms of her house with all the jarring anachronisms of costumes, props, and incidental details, returns Tennyson to the very living rooms he professes to condemn. The staged family album is seen as inconsequential, a product of the society Tennyson critiques. Second, recent scholarship has questioned the view that the poems and photographs comprising the *Idylls* are 'incongruous'.[45] Scholtz explores the distance created between the scenes presented and the reader/viewer, 'the ways in which both Tennyson's poetry and Cameron's photographs destabilize any notion that a particular moment in time can be isolated and described'.[46] While we might think the instantaneity of photography replaces the grandeur of epic, Scholtz emphasizes how, with exposure times of between eight and fifteen minutes, Cameron's photographs refute Barthes's notion that the photograph proves a particular moment existed. 'The moment to which the photograph appears to attest never actually occurred,' Scholtz writes, 'at least not in the way that the photograph depicts it. For what we are seeing is not one isolated instance, but the accretion of countless instants.'[47]

Scholtz's analysis of faces is important from a photopoetic perspective. In the St Andrews album the model faces the camera, whereas Cameron's models avoid looking directly into it: most turn their backs to the lens or pose side-on. In not meeting the viewer's gaze into the Arthurian past, 'all that is available', Scholtz suggests, 'is dead or otherwise inaccessible', accentuating the distancing strategies Cameron introduces to make her characters ethereal or unworldly: in other words, antithetical to photography's realist agenda.[48] In a sense this illustrates Tennyson's distancing of the reader through a general exclusion of facial description. Cameron's choice of excerpts is consistent with this: whenever a rare facial description is offered, such as that of Arthur in 'The

Passing of Arthur', 'forehead like a rising sun' (385), his 'face ... white / And colourless ... like a withered moon' (380–381), the description, Scholtz notes, 'contributes little to the construction of a mental picture', and instead 'works to efface identity'.[49] The inclusion of natural elements in facial descriptions emphasizes the inability of staged photography to, in effect, stage the natural world. While theatrical photopoetry often stages a past alien to the reader/viewer, picturesque photopoetry is more apt at preserving tradition, 'of deferral and deceleration in the midst of the flux and chaos of modern life'.[50]

The photograph 'And Enid Sang' recalls the tactility of the photograph album, as well as the potentially erotic aspect of touch (Figure 1.3). Armstrong comments on the complementarity of the oral and visual modes in Cameron's *Idylls*, accentuating the oral formulae behind the overtly visual enterprise. 'In one way', Armstrong begins,

> this photograph is as committed as the previous illustration ['Enid'] to the exteriorization of the interior and the making-visible of the invisible: it is, after all, according to the excerpt that accompanies it, an image of Enid's voice and of Geraint's imagining of her, his transformation in thought of the sound into the sight of Enid.[51]

The oral supplants the visual. That Geraint has been excluded from the photograph thrusts the holder of the album into the role not only of viewer but also of listener, which comes, in sensory terms, before the imagined image of Enid is held in Geraint's mind. The image delivers the text's 'existential contexts', locating a situation, tone and interiority for the song that the image cannot provide. 'The text', Armstrong notes,

> provides a voice that cannot be heard in the patently silent image, and gives the contents of the song. The photograph visualizes what the text cannot, literally calling up the vision of Enid that the brief three words of the caption index but cannot provide.[52]

The power of text and image exist in unison. In terms of authorship, however, it is not a new idea to suggest Cameron's voice usurped that of Tennyson; that the oral voice continued to resist the overtures of what Cameron called the 'voice' of the camera is perhaps a more pertinent observation.[53] Cameron's album is a direct challenge to the eye, a challenge to construct something not purely visual but multisensory in scope, to conjure a visual image that does not supplant the sensory imagination. Cameron's photographs locate the interiority of her

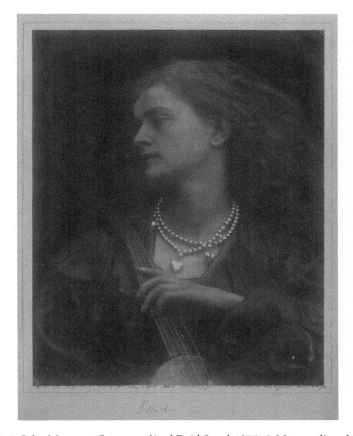

Figure 1.3 Julia Margaret Cameron, 'And Enid Sang', 1875. © Metropolitan Museum of Art, New York.

characters on a phenomenological level made possible through mechanical technology together with the inherent orality of poetry, as the photographic imagination sought a legitimizing poetic tradition to inform and develop its own artistic aspirations. Therefore, the tension between antiquity and modernity came to focus on the intimacies and details that Victorian domesticity and photography briefly elevated to subjects worthy of epic treatment. As Scholtz argues, however, the overarching message of *Idylls* is that the past is presented as 'irretrievably lost' while simultaneously 'deny[ing] the viewer any sense of a stable, definable present', a condition inherent to theatrical photopoetry.[54] Cameron's attempt to transform the album into a commercial product only emphasized this, while accentuating the haptic qualities of the album missing

from the mechanically reproduced commodity of the photobook. Touch created a more stable link to the past, as a compilatory practice in album creation, than the mere turning of the pages of a mass-produced book, no matter how identifiable the faces. It was the picturesque landscape, while possessing similar scrapbook origins to theatrical photopoetry, which provided the reader/viewer with a more appropriate space in which to repossess the past; or, rather, perpetuate it.

Framing the land

This section develops Groth's discussion of Victorian literary nostalgia, and Bruce Graver's work on the stereoscopic representations of the life and poetry of Scott and Wordsworth, to explore the development of picturesque photopoetry from scrapbook to photobook.[55] Applying ideas of framing and staging to picturesque representation elucidates how visual technologies, photobook formats, and the nuances of poetic quotation furthered and transformed the development of photopoetry. Scott Hess's identification of Wordsworth's 'photographic subjectivity' will inform my concluding analysis of how photopoetry staged the landscape.[56]

In 1845, Talbot published *Sun Pictures in Scotland*, a volume of twenty-three calotypes, most of which, as described on the book's publication notice, 'represent' scenes connected with the life and writings of Sir Walter Scott'.[57] The volume bears great resemblance to the scrapbook form and arguably codified what came to be the standard relationship between, and thematic of, poetry and photography in nineteenth-century photobooks. Unlike Talbot's concurrent six-part *The Pencil of Nature* (1844), *Sun Pictures* contained no text. Given its publication notice and list of plates, the contemporary reader was made explicitly aware of the relationship of its photographs to Scott.[58] The scrapbook nature of *Sun Pictures* derived from technological constraints: original photographs had to be pasted in to each copy of the book. A process for simultaneous text and image printing would not be developed for another thirty years, although pasted-in photographs remained in some photopoetry books into the twentieth century. Before the mechanical reproduction of photographs, their inclusion in book form mirrored the compilatory practice of domestic scrapbooking: the oral and haptic narratives surrounding composition complement what is seen and read on the page. This was still the case for some of the earliest photopoetry books concerned with framing nature. Talbot published *Sun Pictures* during Scott's mid-nineteenth-century apotheosis, recognized in the reverence shown

to his prose and poetical works, the growth of the tourist industry in the Trossachs, and monumentalized in the Scott Monument and Sir John Robert Steell's sculpture. Talbot sought to publicize the calotype process and align it to an existing artistic tradition. Scott's popularity afforded such legitimization as the lack of accompanying quotations allowed the reader/viewer to form more personal impressions of great literary scenes. This caused, and was strengthened by, what Smith identifies as 'a general growth in interest in Scottish architecture and scenery, and particularly in the sublime, tremendous, and even terrifying aspects of the landscape of Scotland'.[59] Talbot allowed the topography to stand alone in a new, modern artistic medium, its levels of support dependent on the literary knowledge and tastes of the reader/viewer. Smith suggests *Sun Pictures* is the first photographic essay in history: true, certainly, but important also for its role in creating connections between photography and poetry that would lead, eventually, to photopoetry.

While the uncaptioned *Sun Pictures* began the vogue for literary-inspired photobooks, quotation subsequently became the most common practice for creating a relationship between poem and photograph. In Britain, *The Sunbeam: A Photographic Magazine*, edited by amateur photographer Philip Henry Delamotte (1821–1889), paired albumen prints of landscape and architectural subjects with antiquarian or poetic texts. Its four issues were published in book form as *The Sunbeam: A Book of Photographs from Nature* (1859), the first example of what Martin Parr and Gerry Badger term the 'pictorial photobook', a tangible bridge between commonplacing and scrapbooking culture and the development of photographically illustrated books.[60] The commonplace book was an especially important progenitor of *The Sunbeam*. Dating back to Aristotle's *Topics*, commonplacing came to connote an intimate connection to oratory, with Cicero defining the 'topic' as 'the region of an argument, and an argument as a course of reasoning which firmly establishes a matter about which there is some doubt'.[61] Cicero advocated harvesting quotations and examples from existing sources; it was this 'technical refinement', David Allan suggests,

> explicitly foregrounding an advantageous compositional strategy that directly linked reading, through the practice of systematic note-taking, to the activities of writing and speaking, which was to provide the principal rationale for commonplacing as the practice subsequently evolved.[62]

Though the possibilities of photographic vision were the intended purpose of *The Sunbeam*, as was the somewhat oxymoronic celebration of the unspoilt

natural world through this new, mechanical technology, two of its combinations emphasize the potential haptic and oral dynamics of photopoetry. The poems centre on instances of sound, and the accompanying photographs stage aural scenes, demonstrating early instances of theatrical photography in potentially picturesque settings. Beneath the title 'Sunshine and Shade' (Figure 1.4), a photograph by Frederick Richard Pickersgill (1820–1900) accompanies an extract from Henry Wadsworth Longfellow's (1807–1882) 'The Spirit of Poetry':

> Hence gifted bards
> Have ever loved the calm and quiet shades;
> For them there was an eloquent voice in all –
> The sylvan pomp of woods – the golden sun –
> The flowers – the leaves – the river on its way –
> Blue skies – and silver clouds – and gentle winds
> ...
> Groves, through whose broken roof the sky looks in –
> Mountain – and shattered cliff – and sunny vale –
> The distant lake – fountains – and mighty trees –
> In many a lazy syllable repeating
> Their old poetic legends to the wind.[63]
>
> (Longfellow, 'The Spirit of Poetry', 24–29, 32–36)

Longfellow expresses synaesthetic tension through his use of an oral structure – the list – to represent the poem's accretion of visual images. He privileges both sight and sound, allowing their entwinement just as poem and photograph are paired in *The Sunbeam*. The agency of the voice in the poem belongs to nature: the poet acts as conduit, 'repeating / [Nature's] old poetic legends to the wind'. The purpose of *The Sunbeam*, then, is to align the purposes of poet and photographer. 'The linked photographs and quotations,' writes Mark Haworth-Booth, 'make of the book an apologia for photography as a natural poetics, spontaneous, directly imprinted by nature.'[64] The Longfellow extract frames a picturesque idea, locating natural wonder in the specifics of landscape. The photograph stages a reflective scene: the man focuses on a book (perhaps reading aloud), while the woman adopts the thoughtful posture of a tourist viewing a picturesque vista. Paired in this way, the reader/viewer is led to believe that the woman is imagining the list of natural wonders that the man reads aloud from Longfellow's poem. The reader/viewer of photobooks like *The Sunbeam*, however, will be able to see himself or herself through the art of the photographer. Here, the photograph and

Figure 1.4 F. R. Pickersgill, 'Sunshine and Shade', in *The Sunbeam: A Book of Photographs from Nature*, 1857. © The British Library Board, 1753.b.29.

poem are not mutually illustrative but evoke a self-reflexive scene of the reader/viewer engaging with photographic vision.

As editor of *The Sunbeam*, Delamotte acted as compiler, combining and recontextualizing existing material, juxtaposing image and text to create new bonds and connections. Reinterpreting relationships between the practices of writing, speaking, and reading, Delamotte questioned the nature of authorship: his compilation practice effectively made him the surrogate author. One instance of this is the pairing that Delamotte titled 'The Young Audubon', a Henry Taylor (1800–1886) photograph (Figure 1.5) accompanying an excerpt from the 'Thirteenth Song' of Michael Drayton's (1563–1631) *Poly-Olbion* (1612, 1622):

When Phoebus lifts his head out of the winter's wave;
No sooner doth the earth her flowery bosom brave,

At such a time as the year brings on the pleasant spring
But hunts-up to the morn the feathered sylvans sing;
...
 the mirthful choirs, with their clear, open throats,
Unto the joyful morn so strain their warbling notes
That hills and valleys ring, and even the echoing air
Seems all composed of sounds about them everywhere.[65]

(Drayton, *Poly-Olbion*, 13.41–44, 51–54)

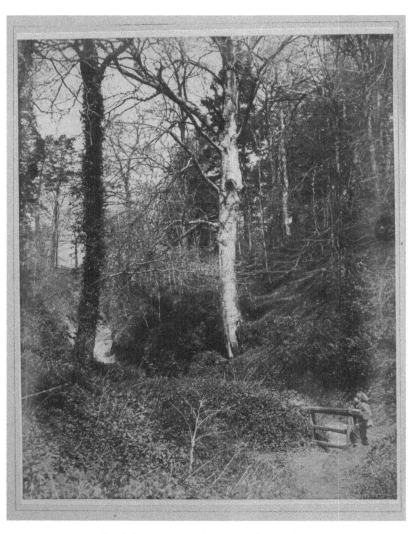

Figure 1.5 Henry Taylor, 'The Young Audubon', in *The Sunbeam: A Book of Photographs from Nature*, 1857. © The British Library Board, 1753.b.29.

While the poem and photograph bear illustrative parallels (the vertical images and hints of light and shade in the poem juxtapose the photograph's visual imagery while adding a soundtrack), the editorial imagination resists this binary structure and instead includes a title, creating a triangular relationship that posits the photopoem as something beyond its constituent parts. The photograph depends upon the title 'The Young Audubon' to elucidate its connection to the poem: birdsong, which our written and visual codes are fundamentally unable to record and, by extension, understand. The 'sylvans' sing independently of the poet; Drayton can record the fact of their singing, not the song itself. The photograph relies here, to some extent, on textual accompaniment (nowhere is a bird present in the image) as the title elucidates the actions of the young boy, recalling the renowned French-American ornithologist John James Audubon (1785–1851). The title itself enacts a kind of staging: Audubon's childhood predated photography, and the educated Victorian reader/viewer would have recognized that the title was metaphorical, not literal. Similarly, Delamotte's excision of this extract from Drayton's *Poly-Olbion*, a topographical work exploring the landscapes, histories and traditions of English and Welsh counties, is an act of framing: Delamotte excises a static, picturesque moment to demonstrate how photography can directly capture the natural world. The concluding line, 'Sounds about them everywhere', situates the reader/viewer within the landscape through sound, rather than as an outside observer. The ephemeral nature of sound means that the written word records only its trace note, to be re-enacted as the poem is read aloud. The photograph, contrarily, is a moment of time represented in space, for continual visual reference. This pairing enacts the moment of silence when faced with natural wonder (birdsong), just as the Longfellow/Pickersgill pairing demonstrates picturesque beauty in both sound and vision. As these examples show, early combinations of poem and photograph adumbrate metaphorical and symbiotic connections beyond the restrictive purview of description or illustration. Although *The Sunbeam* is an especially early example of photopoetry, it nevertheless demonstrates that close attention to the interplay of the aural and visual can create dynamic pairings in which poem and photograph become dependent on one another for meaning.

* * *

The growth of commercial photography in the mid-nineteenth century expanded the imaginative resources of the middle class, enabling them to see places and landscapes they might never physically visit. Responding to the antiquarian, orientalist, biblical, and broadly topographical agenda of their

French counterparts, British photographers travelled to the Middle East and produced photobooks such as Francis Frith's *Egypt and Palestine* (1858–1859) and, later, Francis Bedford's *The Holy Land, Egypt, Constantinople, Athens* (1865), the titles of which indicate the tour-like aspect of their endeavours. Similarly, the stereograph craze from the mid-1850s led to stereographic sequences from all over the world creating an entire generation of armchair travellers, for whom the pyramids of Egypt and the temples of India could be viewed, in three dimensions, 'at your leisure, by your fireside, with perpetual fair weather, when you are in the mood'.[66] Against this thirst for the antiquarian and the exotic, the relationship between photography and poetry developed in a more nostalgic direction. In 1857, stereographer T. R. Williams (1824–1871) published the bucolic photopoetic project *Scenes in Our Village*. The sequence comprises around fifty-nine original views (eighty with variants), each with a short poem by Williams himself on the reverse of the stereographic card. The title alludes to a literary genre of pastoral village life very popular around this period, encompassing both poetry and prose, with publications including Owen Blayney Cole's *Our Village: Variously Delineated* (1858) and the anonymous *Sketches of Our Village: And Other Rhymes* (1852). In documenting village life, Williams memorialized the familiar, a more local, nostalgic kind of tourism that anticipated the documentary photographic surveys of the late nineteenth century. Williams's sequence is an early work of self-collaborative photopoetry, and the connections it draws between sound and vision elucidate how poem and photograph can work together to stage a multisensory scene.

Stereographic photopoetry was inevitable given the rise in popularity of the stereoscope in the mid-1850s. The stereoscope split vision with a double lens, reconfiguring two images of the same scene or object specifically for the left and right eyes and combining them in a three-dimensional image. Its illusion of depth is what Bruce Graver terms 'stereoscopic hyperspace', a phrase accentuating both the ability of the stereoscope to create a virtual reality unavailable to visual artists such as painters, and the potential issues surrounding the disembodiment of the picturesque viewer.[67] By realigning two retinal images, the stereograph creates a three-dimensional image that exists only in the brain: it implicitly questions the power and veracity of the unaided eye.[68] The stereograph stages an illusion of presence, situating the reader/viewer seemingly in the middle of things while making a phantom or apparition of him/her. While Williams engaged with the illusory, virtual reality created by the stereographic image, he also placed a poem on the reverse of the stereocard, forcing the reader/viewer to turn it

over, thereby reemphasizing the tactile nature of the card itself. This complicates 'stereographic hyperspace', in that the poem sought to embody, not disembody, the human figure in relation to the stereographic image. The 'eventual triumph' of vision through photography, Crary notes, 'depends on the denial of the body, its pulsings and phantasms, as the ground of vision'.[69] The poetic speaker of *Our Village* sought to capture these 'pulsings and phantasms', and embody, not disembody, the reader/viewer. The inclusion of poetry on the reverse of the stereographic cards questions the supposed sensory primacy of vision. With no prescribed order to the stereocards, and no linear order to the sequence, *Our Village* ensured the primacy of the reader/viewer in formulating their own reading/viewing experience. In the loss of a centralized point of observation, it became the responsibility of the poem to ground the reader/viewer in a sensory rather than spectral reality.

Yet *Our Village* does create a sensory hierarchy. With text and image on opposite sides of the stereocard, a conscious choice is required: read the poem first, or view the stereographic image. Both could not be seen concurrently, a problem not necessarily encountered in the scrapbook or commonplace book. Only with the social aspect of the stereoscope was parity perhaps possible. Like scrapbooks and photograph albums, stereographs were a popular form of nineteenth-century social entertainment, and the stereoscope became a fixture in drawing rooms across Britain. The construction of the Holmes stereoscope allowed the reverse of the stereocard to remain unobstructed, inviting a situation in which one person views the image while another reads aloud the accompanying poem. Otherwise, it was perhaps a case of memorizing Williams's poem before viewing the image. The awkwardness of this arrangement, however, appears to have curtailed the photopoetic experiment in stereography: while it remained common for stereocards to carry inscriptions of the monuments or vistas shown, no other sequence seems to have emerged with accompanying poems.

Our Village is an early example of self-collaborative photopoetry, in which poet is photographer, photographer poet. Williams conceived text and image symbiotically: he was not asked to provide photographs for poems, as was the case with Cameron's *Idylls*, nor did he recontextualize existing material in the manner of Delamotte in *The Sunbeam*. While the poems are Williams's own and appear not to have been published elsewhere, they posit similar connections to *The Sunbeam* in that photography – or stereography, in this case – is as viable and worthwhile an art as poetry. The stereopoem 'Lane Leading to the Farm' posits a pedagogical relationship between stereoscopy, art, and an appreciation

of nature. Making his point in verse, Williams identifies the figure of the 'artist'
as much poet as he does stereographer. He writes,

> Seen with the artist's eye, how many a spot
> On nature's face that seems a simple blot,
> Teems with rich images and beauties rare!
> Taught to appreciate, the traveller there
> Marvels that he so often hath before
> Unknowing, unadmiring, passed it o'er:
> Thus, what is cultivation to the eye
> Of the taught artist – stereoscopes supply.[70]

Williams aligns the 'traveller' figure with that of the 'artist' – both halting, they
see different things. In the space of the photopoem, the reader/viewer adopts
the traveller persona, and is challenged to see how, through the stereographic
image, 'a simple blot / Teems with rich images and beauties rare'. Quite
why Williams chose this stereograph for a reflective rather than descriptive
verse is something of a mystery. The majority of Williams's pairings evoke
the 'traveller' halted before various village scenes and sights – the church,
the blacksmith's shop, rick making (Figure 1.6) – and 'Lane Leading to the
Farm' is no different. It represents a similarly 'static' moment, with the verbal
description of the poem drawing particular attention to a detail within
the stereograph. It may be that 'Lane Leading to the Farm' seemed like an
appropriate juncture at which to confirm the purpose of the sequence: in
this instance, Williams makes the reader/viewer pause, not in front of a
stereographic scene, but in front of the stereoscope itself, asking the reader/
viewer to consider whether stereoscopic vision improves and enhances one's
experience of nature.

Williams achieves his most successful stereopoems through the visual and
verbal staging of an oral event: the short narrative poem guides the reader/viewer
through the event of the stereographic image, as is the case with cards such as
'John Sims at his Pigstye' (8) and 'A Gossip by the Way' (10). With the reader/
viewer reading the poem aloud in a social situation, the oral event visualized in
the stereograph is recreated verbally, ensuring that the photopoetic experience
is not purely visual. This helps to re-embody the reader/viewer and reduces the
sense of detachment and isolation that the reader/viewer can feel in 'stereoscopic
hyperspace'. Such pairings centre on interactions between people and bring to
life unheard conversations through the act of reading aloud. While *Our Village*

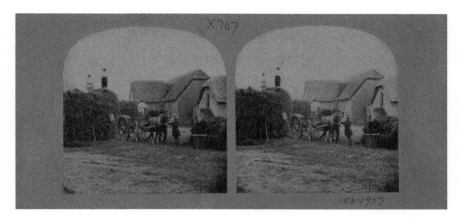

Figure 1.6 T. R. Williams, 'Rick Making', in *Scenes in Our Village*, c.1857. © Victoria and Albert Museum, London.

in general represents a stereoscopic variant of the connection between nostalgia and photographic illustration, these 'oral' moments suggest that the purpose of the sequence is not merely illustrative. Rather, poem and photograph rhetorically deepen each other. To preserve the idyllic village (which Brian May and Elena Vidal locate to Hinton Waldrist, Oxfordshire), Williams allows the reader/viewer to wander metaphorically through its streets by rearranging the stereocards into different sequences.[71] Williams avoided the potential disembodiment of 'stereoscopic hyperspace', however, through his desire to record the voices of 'our village': here, the photopoetic connection between sound and vision allowed him, on several occasions, to stage scenes that the reader/viewer could re-enact. This demonstrates how Williams's attention to the oral and visual dynamics of photopoetry deepened what might seem, to modern eyes, a purely descriptive and nostalgic project.

* * *

Our Village, however, was a formal anomaly in nineteenth-century photopoetry. More prevalent was its cousin, the photobook, which quickly became the preferred medium for photographically illustrated poetry in the literary marketplace. This was a predominantly British phenomenon that, as Groth notes,

> returned the images of this first generation of photographers to their literary and cultural sources in a format that ... encouraged the consumer not only to read, but to re-enact Wordsworth's reflective wanderings through the Lake District or Scott's mythic encounters with the ancient inhabitants of the Scottish Border.[72]

The tone of such books was nostalgic, their themes picturesque, their purpose commercial. Broadly speaking, photopoetry books of the 1860s can be divided into three categories: anthologies, selected shorter poems or excerpts from a single author, and long poems by a single author (almost exclusively Scott). It was not until the late 1870s that collected editions of poets such as Tennyson (1878) were photographically illustrated, most prevalently in the series published by R. & A. Suttaby with photographs by Payne Jennings (1843–1926).[73] These books enact picturesque tours of their relevant locales, and persisted at least into the 1930s with *The English Landscape* (1932), which, 'collected and arranged' by Kathleen Conyngham Greene (1885–1957), demonstrates the persistence of compilatory techniques first seen in scrapbooks and Delamotte's *The Sunbeam*. Across these three categories, photographically illustrated poetry enacted what Armstrong terms the 'verbal framing of the photograph' typical of the first instances of photographs being incorporated into books: a framing that, to the modern reader, 'seems natural, even invisible'.[74] The remainder of this chapter examines how the photobook became the most common photopoetic form in the second half of the nineteenth century, and what this meant for the relationship between poem and photograph.

William Morris Grundy (1806–1859), a respected stereographer from Sutton Coldfield, photographed and edited the first anthology of photographically illustrated poetry. The posthumously published *Sunshine in the Country* (1861) celebrates idyllic village life and traditions such as angling, apiculture, and hunting.[75] Its twenty albumen prints accompany verse by a range of poets including Mary Howitt, Longfellow, Alexander Pope, Samuel Rogers, and Thomas Warton. Ideas of reading and commonplacing are enmeshed in *Sunshine*'s composition. As Allan writes, the 'anthology' as we know it today derives from a genre of medieval literature called the *florilegium*. In the Middle Ages, commonplacing in its classical sense declined in popularity, but leading writers transformed the anthology from 'a repository of Greek or Latin poems … into a compendium of revealing citations and illuminating passages taken overwhelmingly from scripture and from other leading theological texts'.[76] Its scope broadened throughout the sixteenth and seventeenth centuries to include all aspects of human life, and the commonplace book became a 'regular focus for English discussions about reading [and] a reliable fixture in the everyday practice of many readers'.[77] One reviewer of *Sunshine* commented on how 'photography [is] introduced as much for its beauty as for its truth' and, echoing the capturing and recording of one's own reading, suggested 'how perfectly, in the hands of an artist, the most delightful aspects of nature, with

all the variations due to the influence of light and shadow, may be caught and preserved'.[78] As with *Sun Pictures* and *The Sunbeam*, *Sunshine* accentuates the centrality of light to photography, emphasizing its inherently 'natural' poetics: as its subtitle remarks, the volume is 'embellished with photographs from nature'. In these instances, light is bucolic, typifying the nostalgic relationship Groth identifies between Victorian literature and photography. In its ability to capture 'the most delightful aspects of nature', photography seemed like the perfect form in which to preserve the idyll of rural England.

Sunshine exhibits a compilatory practice reminiscent of *The Sunbeam*. Of the volume's 102 poems, twenty are photographically illustrated. Of these twenty, only five are printed in what seems their entirety. The remaining fifteen are excerpts from longer works, including Pope's 'Windsor Forest', Crabbe's 'The Borough', and Rogers's 'The Pleasures of Memory'. Like the photopoetic combinations of *The Sunbeam*, the *Sunshine* pairings commonly have titles different to those of the original poems, creating a triangular relationship. These titles are presumably the work of Grundy, and tend to focus on specific details of the poetic excerpts: an extract from William Browne's *Britannia's Pastorals* is titled 'The Squirrel-Hunt', and from Rogers's 'The Pleasures of Memory', 'The Bee'. Compared to those in *The Sunbeam*, Grundy's titles attempt a more literal harmonization of text and image, directing the attention of the reader/viewer towards the specific image that connects poem and photograph.

This harmony is most often staged. The photograph accompanying 'Haddon Hall' (33–34) verifiably shows the aforementioned hall; or, rather, the terrace steps and lawn to its rear, on which two young boys recline (Figure 1.7). When Grundy took the photograph in the mid-1850s, Haddon Hall had been unoccupied since the early eighteenth century. By excluding the hall itself from the photograph, Grundy stages a scene, not of an abandoned mansion but of the natural splendour of its gardens, and the apparent harmony of man in the natural world. This staging is further emphasized when we consider how Grundy paired his photograph with an extract from Charles Mackay's poem 'Lullingsworth' about a fictional estate in disrepair. Mackay (1812–1899) was also a journalist, most successfully as New York correspondent for the *Times* during the American Civil War. On an earlier US tour he met Longfellow, Emerson, and Wendell Holmes, and lectured on 'Songs National, Historical and Popular'.[79] 'Lullingsworth' was first published in Mackay's collection *Under Green Leaves* (1857). In the same year, a longer extract appeared in the *Illustrated London News* (for whom Mackay at the time worked) accompanied by an engraving.[80]

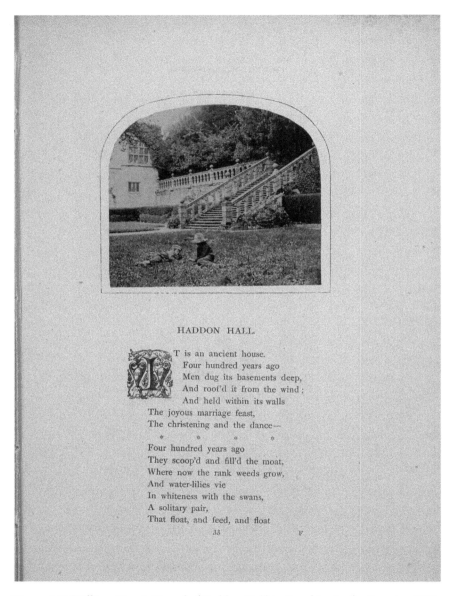

Figure 1.7 William Morris Grundy, 'Haddon Hall', in *Sunshine in the Country*, 1861.
© The British Library Board, 1347.f.9.

The first thirty lines of 'Lullingsworth' suit Grundy's purpose of framing the dilapidated house in terms of the Romantic ruin, with its 'rank weeds' growing in the moat, and its 'crumbling bridge'. Beyond this excerpt, however, poem and photograph diverge. The human presence in Grundy's excerpt is restricted to the hall's construction: 'Four hundred years ago / Men dug its basements deep'. Later in 'Lullingsworth', we are introduced to 'Their last descendant', who

> dwells
> Childless and very old,
> Amid its silent halls:
> He loves the lonely place,
> Its furniture antique,
> Its panels of rich oak
> Worm-eaten and grotesque . . .[81]

Compared to this bleak scene, Grundy's photographic staging of the poem shows two young boys reclining on the grass, providing his poetic excerpt with a happier ending than the remainder of the excised poem: 'No children in its courts / ... like happy birds.' Beneath the new title of 'Haddon Hall', Grundy uses a photograph to rewrite/reframe Mackay's 'Lullingsworth', staging a scene that relies upon the interaction of poem and photograph. Grundy's practice of compilation demonstrates how poetry could be manipulated and excerpted to suit a particular photographic vision, and serves to show that the practice of recontextualization, as it evolved from domestic commonplacing to a marketable strategy for nostalgic photographically illustrated poetry, was at times a more complicated process than the term 'illustration' implies.

The poetic excerpts in *Sunshine* function as what Groth terms 'illuminating fragment[s]'.[82] They legitimize the photographs, connecting them with the existing pastoral tradition in poetry. As a sequence, these pairings of poem and photograph create an annotated tour of the idyllic English countryside. Just as commonplace books, scrapbooks, and photographic albums represent multiple viewpoints, photobooks such as *Sunshine* offer moments of spatial and temporal distortion. Of the twenty photopoems in *Sunshine*, four have illustrations not on an adjacent page but between stanzas: this breaks the linear poetic temporality with an invitation to view the scene represented visually in the photograph. Such moments refocus the experience of 'seeing' from reading to looking, and create greater referentiality between text and image. In James Montgomery's (1771–1854) 'A Landscape' (21–22), the photograph occurs between two lines separated

by a colon: with the inclusion of the photograph at this juncture, the colon encourages the reader to look over the vista Montgomery has just described. This creates a photopoetic equivalent of the 'halted traveller' motif Geoffrey Hartman identifies in Wordsworth's poetry, with the reader/viewer pausing to observe picturesque views.[83] Pausing to look, the reader/viewer encounters a perceptive problem when the detail of the poem is compared to the detail possible in the albumen photograph. Culled from Grundy's stereographs, the single image cannot capture the detail and clarity possible (though not inevitable) in 'stereoscopic hyperspace', nor does it compare to daguerreotypes or ambrotypes for detail.[84] The reader/viewer is unlikely to see Montgomery's 'insect myriads' in the photograph. Embedded within the poems, these photographs express what Groth terms 'the dialogic nature of early photographic illustration'.[85] Likewise, in Mary Howitt's 'Little Streams' (57–59), the embedded photograph completes the phrase 'where all day', which enjambs from one line, through the photograph, into the next. Analogous to the revealing citations of commonplacing, poems and photographs have been excerpted from elsewhere, and form a record of Grundy's reading and looking. *Sunshine* is a good example of the practices and structures that inform early photographically illustrated poetry, and the manner in which such photobooks attempted to demonstrate the natural poetics of photography.

Like many other examples of photographically illustrated poetry, *Sunshine* glosses over the evident tension between the pastoral tradition it captures and the modern technology used to capture it. Such books enabled the Victorian literary tourist to glance back into the past. This is the crux of Grundy's photobook: while he exhibited some innovative approaches to the pairing of poems and photographs, the pairings themselves are imbalanced. Their scales are tipped too much in the way of nostalgia, which to modern eyes obscures the experimental practice of pairing poetry with photographs in the first place. Early editors of photographically illustrated poetry, like Grundy and Delamotte, were the first to make an important realization concerning the effective pairing of poetry and photography: illustration was a mutually beneficial relationship, not an embellishment of text by image or vice versa.

Staging photopoems

'Literary illustration and the tourism industry', Graver notes, 'are implicated with each other, and as the [nineteenth] century goes on, their mutual involvement

grows even tighter'.[86] One repercussion of this relationship, as Groth remarks, is that 'the rapid rise in the circulation of commercial photographic images played its part in the standardization of visual imagery and of visual experience in the nineteenth century'.[87] It is not difficult to locate much nineteenth-century photopoetic imagery within this narrative of standardization. Commercial photographers such as Thomas Ogle, Russell Sedgfield, and George Washington Wilson were the main contributors to photographically illustrated poetry, providing a corpus of landscape images against which the works of Scott and Wordsworth were set. In these books, writes Groth, 'poetry, or strategically placed poetic references, provided a sequence and a legitimizing aesthetic tradition, transforming otherwise unremarkable landscape photographs or street scenes into collectible mementos'.[88] This body of work reached its apotheosis in the early twentieth century with Anna Benneson McMahon's series of books devoted to poets such as the Brownings (1904), Shelley (1905), Byron (1907), and Wordsworth (1907). Of McMahon's book on the Brownings, Groth writes, 'This painstakingly literal matching of image and text demonstrates the nexus between close reading and nostalgia that photographic illustration encouraged.' The excerpts from the Brownings's poetry 'function in this context as an associative trigger and a sign of history to be uncovered by the dedicated curiosity of the would-be literary tourist on vacation, whether literally or imaginatively'.[89]

Publishers who sought to market photographic illustration as a unique form effectively invented their ideal reader: the literary tourist. One of the main nineteenth-century publishers of photographically illustrated poetry was A. W. Bennett. In his introduction to *Our English Lakes, Mountains, and Waterfalls, as seen by William Wordsworth* (1864), Bennett suggests that the photopoetic relationship is dependent on the reader/viewer's imaginary assimilation of photograph and poem. Bennett writes,

> not only will the Reader be able, with the assistance of the Photographic illustrations ... to appreciate the more fully Wordsworth's wonderfully true descriptions of the beauties of Nature; but the Tourist will have the additional pleasure of identifying with his own favourite spot any of the Poet's verses which refer especially to it.[90]

Bennett, the introduction notes, is 'the Compiler', a role in which he classified the short poems and extracts from Wordsworth's longer works 'under the heads of the different Lakes or other objects of interest in each locality'.[91] The phrase 'wonderfully true descriptions of the beauties of Nature' sounds like a Victorian

description of photography: to Bennett, though, it is Wordsworth's poetry that captures such truths, with the photographs functioning as visual confirmation.

This supposes the objectivity of the photographic perspective: in the nineteenth century, it was supposed that the photograph occupied a privileged representational space with regard to objective reality, a notion that lingers into the present day. On this basis, the reader need never visit the Lake District when its natural beauty is presented here, in photography (Figure 1.8). Bennett's reader, however, is the literary tourist, and the compilation of the anthology enacts a guided tour of the Lake District: the photographs each have a caption and a page number, explicitly pairing the photographic image with one of Wordsworth's poetic images. In likening the activity of reading the book to walking through the Lake District, Bennett encourages the reader to follow in the footsteps of Wordsworth, 'literature's most famous walker'.[92] One can see the Lake District, it is supposed, through Wordsworth's eyes. The inclusion of photographic illustrations, however, actually suggests the reader is following in the footsteps of Thomas Ogle, the photographer.

The significance of this lies in the final sentence of the Bennett quotation. What Bennett means to suggest is that his compilatory practice will enable readers to identify more accurately the scenes of Wordsworth's poetry. Given the photographic illustrations, however, there is a sense that such 'favourite spot[s]' should be framed and remembered photographically. While this invites the reader to conjure their own experiences and memories – and affirms the responses of the reader as being at the centre of Bennett's book – it also posits a specifically photographic manner of seeing and remembering, in which the 'favourite spot[s]' are framed according to the conventions of picturesque photography. As Groth remarks, the book encourages 'the sequencing of personal memories into an aesthetic order', and shifts the emphasis of photographically illustrated poetry from 'isolated images to illustrative sequences'.[93] Sequences would become an important component of twentieth-century photopoetry, but in Bennett's photobook the sequence serves only to reaffirm how the literal connection between poem and photograph could be emphasized through a journey-like frame, much like the composition of a photograph album. 'In this context', writes Groth, 'Wordsworth's poetry combined with Ogle's photographs to produce an amplification of the sensual pleasure of the reader in which the rhetorical and aural aspects of Wordsworth's language were marginalized in an effort to intensify its visual and mnemonic impact'.[94] Bennett's book was an important formal experiment in the early history of photopoetry. Its attempt

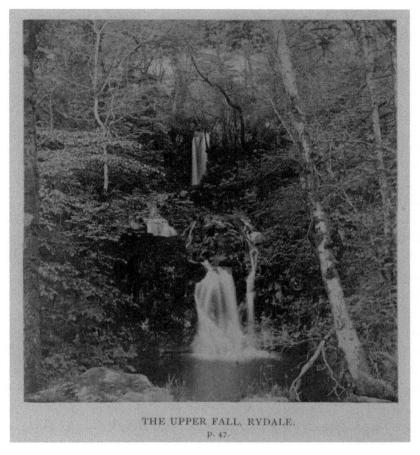

THE UPPER FALL, RYDALE.
p. 47.

Figure 1.8 Thomas Ogle, 'The Upper Fall, Rydale', in *Our English Lakes, Mountains, and Waterfalls, as seen by William Wordsworth*, 1864. Courtesy of the University of St Andrews Library, photo PR5869.O8E64.

to combine poems with photographs in order to conjure the experiences of the reader was a novel idea: for picturesque photopoetry, it used the landscape as a stage rather than a frame, suggesting how the reader could immerse themselves in the Lake District, rather than looking inwards from the periphery.

Similar ideas are at work in the numerous photographically illustrated editions of Scott's narrative poems that were published in the 1860s and 1870s. These works provide a fitting concluding discussion on the nature of 'photographic illustration' and the direction of British photopoetry in the late nineteenth century.[95] Scott's apotheosis in the Victorian era was important to publishers of

photobooks because it encouraged them to align their innovative practice with an enormously popular literary source.[96] What is most interesting, however, about the Scott volumes is that, unlike Bennett's Wordsworth anthology, they are book-length narrative poems. The conscious choice to illustrate them with picturesque rather than theatrical images requires explanation insofar as it reveals much about how 'photographic illustration' was conceived. 'Retrospective' photopoetry in this period enacts a reversal of the ekphrastic encounter, turning James Heffernan's standard description of ekphrasis on its head: photographic illustration is the visual representation of verbal representation.[97] While this formulation might lead to charges of literalism, the presence of the photographs next to the poetic text negates the supposed purpose of image as authenticating or describing text. Neither representation conjures the other; they are both present. Creating a relationship *on the page*, this interplay of visual and verbal modes of expression gestures towards the development of photopoetic collaboration when, come the twentieth century, poem and photograph were conceived in conjunction with one another.

In the Scott volumes, landscape photographs function as a stage for poetic narratives. The narratives themselves are not staged – unlike Cameron's *Idylls*, the Scott volumes leave their characters and scenes to the reader's imagination. This was the case for all four poems: *The Lady of the Lake* (1863) with illustrations by Thomas Ogle and a frontispiece by George Washington Wilson, *Marmion* (1866) with illustrations by Thomas Annan, *The Lord of the Isles* (1871) with illustrations by Russell Sedgfield and Stephen Thompson (Figure 1.9) and *The Lay of the Last Minstrel* (1872) with illustrations by Sedgfield. Such photographers introduced visions of Scott's Scotland into the middle-class Victorian home, notes Groth, as 'part of a broader transformation of landscape into popular culture', mimicking the expansion of the railway network in allowing greater potential for travel and a greater sense of national geography.[98] Modern innovations themselves, however, were scrupulously excluded from such photographs, not only in the Scott volumes but in all photographically illustrated poetry volumes hitherto mentioned. This strategy maintained a picturesque illusion of modern Britain while locating the photographs within the narrative past: for example, the photographs accompanying *Last Minstrel* sought to situate the reader in the landscapes of the Scottish Borders in the sixteenth century.

In Wilson's frontispiece to *The Lady of the Lake* (Figure 1.10), Groth identifies a 'dynamics of approach' that reflects how the reader/viewer scans the photograph for details, and acts as a metaphor for their passage through

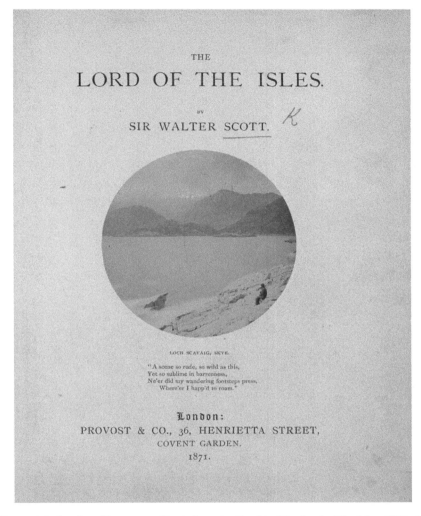

Figure 1.9 Stephen Thompson, 'Loch Scavaig, Skye', in *The Lord of the Isles*, 1871. © The British Library Board, 11642.bb.50.

the photobook.[99] Sedgfield, too, exhibits a similar dynamic in his *Last Minstrel* images. Views of Abbotsford and Newark Castle are framed with foliage, and are taken from angles reflecting subsequent movement: the reader looks down on Abbotsford, preparing to descend into its grounds (Figure 1.11). At Newark Castle, the descent has already been accomplished: the castle rears up in the distance, and the reader prepares to approach it. Focusing particularly on architectural structures that would have held resonance for the literary tourist,

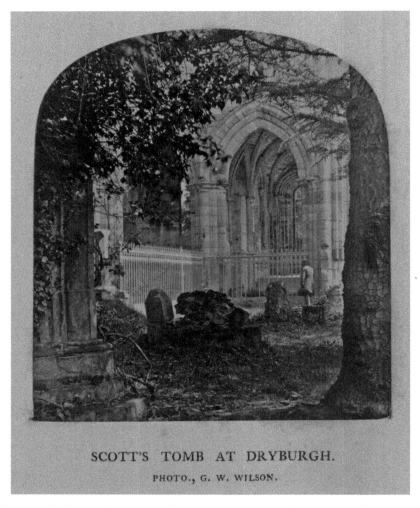

SCOTT'S TOMB AT DRYBURGH.

PHOTO., G. W. WILSON.

Figure 1.10 George Washington Wilson, 'Scott's Tomb at Dryburgh', in *The Lady of the Lake*, 1863. Courtesy of the University of St Andrews Library, photo PR5308.E63.

Sedgfield provides moments for pause and reflection, breaks in Scott's narrative during which the reader can remark upon their own experiences of the scene. The photographs allow the reader/viewer to return to such memories again and again. Likewise, they enable the reader/viewer a visual space in which to imagine the events of Scott's narrative, and provide doorways onto the stage of the poem. Photograph and poem work together, challenging what Hess calls 'the securely detached consciousness of the photographic observer'.[100] The reader/viewer

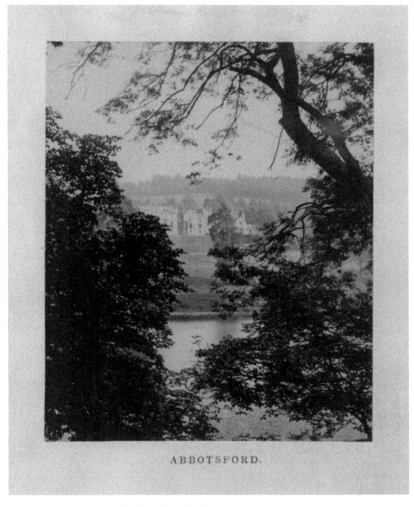

ABBOTSFORD.

Figure 1.11 Russell Sedgfield, 'Abbotsford', in *The Lay of the Last Minstrel*, 1872. Courtesy of the University of St Andrews Library, photo PR5309.E72.

becomes imaginatively invested in how the poem and photograph combine and elucidate each other, the journey-like form of the photobooks conferring on the reader/viewer a personal investment in the represented places. In this way, photographically illustrated poetry is one of the earliest examples of a central photopoetic tenet according to Robert Crawford and Norman McBeath: 'The pairing should be about revealing rather than explaining.'[101] Using the narrative drive of Scott's poetry, these photobooks demonstrate the confluence of

visual and verbal storytelling. Transcending the descriptive implications of 'photographic illustration', the Scott photobooks prefigure the rise of actual collaborations between poets and photographers that characterize twentieth-century photopoetry.

This chapter has examined the complicated origins of photopoetry, exploring the dialogues between its domestic and public forms, the dynamics and nuances of 'photographic illustration', and the two central thematic and structural strands – theatrical and picturesque – through which sophisticated relationships between poems and photographs occurred. In the thirty years from Talbot's *Sun Pictures* to Cameron's *Idylls*, photopoetry adapted to developments in photographic technology to stage both theatrical and picturesque interpretations of poetry. While Hess centres on the photographic frame to suggest that photographic vision 'disembodies and disconnects us from nature through the very processes by which we seek to commune with it', the power of photopoetry is to reconnect the reader/viewer with nature through a staging concocted in multisensory terms, that is, between sound and vision.[102] As I have discussed, the roots of photopoetry exist in scrapbooks and stereograph sequences: where scrapbooks tend to be more solitary, encouraging the viewer to interiorize everything just as the viewer, and photographer, of a picturesque landscape interiorizes the scene, stereograph sequences tend to be more reliant on an oral staging, in a social environment, of whatever journey or story they represent.

To return to Green-Lewis's suggestion at the beginning of this chapter, what does 'seem to be going on' in the photographically illustrated texts I have discussed? That 'something interesting' to which Green-Lewis alludes is the hesitant, experimental growth of photopoetry from the first pairings of poem and photograph in scrapbook form, to Cameron's retrospective work on Tennyson's *Idylls*. Despite definite developments in this thirty-year period, British photopoetry remained very much in its infancy. Reliant on a commercial agenda that sought to take advantage of the strong ties in the nineteenth century between photography and the picturesque, photographically illustrated poetry remained something of a curiosity: only Cameron had realized the potential of photography as an artistic form that could engage with the sounds, structures, and themes of poetry.

What did occur in this period, however, was one of the earliest innovations that would later define photopoetry: the centrality of the reader/viewer and a growing concern with the physical body, both in terms of its representation and in how the photobook as object was handled by the reader/viewer. The centrality of the

reader/viewer develops throughout photopoetic history as the collaborative ties between poet and photographer become stronger and the theatrical structures of photopoetry become more sophisticated. Though photography was yet to emerge as an art form in its own right, its role within photopoetry gradually became closer to being the aesthetic equal of poetry. Such innovations – both in format and theme – meant photopoetry was a sophisticated, if overlooked, site of Victorian experiments in text and image, one whose increasingly aesthetic potential to explore the boundaries of imaginative and sensory experience would shape not only a parallel tradition in the United States but also the cultural crosscurrents informing a central tenet of transatlantic modernism.

Notes

1 Anonymous editor, 'Photography Applied to Book-Illustration', *Gentleman's Magazine* 3 (February 1867), 174.

2 Jennifer Green-Lewis, review of *Victorian Photography and Literary Nostalgia*, by Helen Groth, *Victorian Studies* 46 (Summer 2004), 715.

3 Elizabeth Barrett Browning to Mary Russell Mitford, 7 December 1843, in *Elizabeth Barrett to Miss Mitford: The Unpublished Letters of Elizabeth Barrett Browning to Mary Russell Mitford*, ed. Betty Miller (London: Murray, 1954), 208–209.

4 Helen Groth, *Victorian Photography and Literary Nostalgia* (Oxford; New York: Oxford University Press, 2003).

5 See Scott Hess, *William Wordsworth and the Ecology of Authorship: The Roots of Environmentalism in Nineteenth-Century Culture* (Charlottesville; London: University of Virginia Press, 2012), 21.

6 For a full discussion of publishing innovations in the nineteenth century, see Aileen Fyfe, *Steam-Powered Knowledge: William Chambers and the Business of Publishing, 1820–1860* (Chicago; London: University of Chicago Press, 2012).

7 Roland Barthes, *Image Music Text*, ed. and trans. Stephen Heath (London: Fontana Press, 1977; New York: Hill and Wang, 1977), 146.

8 Anonymous, *A Little Story for Grown Young Ladies, Illustrated Photographically*, Album 37, General Album Collection, University of St Andrews Special Collections Library.

9 There is no recording of any of the six quatrains in the Literature Online poetry database.

10 For a full history of St Andrews's role in the history of photography, see Robert Crawford, *The Beginning and the End of the World: St. Andrews, Scandal, and the Birth of Photography* (Edinburgh: Birlinn, 2011).

11 See Margaret Oliphant, *A Memoir of the Life of John Tulloch* (Edinburgh; London: William Blackwood and Sons, 1888), 42–45.

12 Roland Barthes, *Camera Lucida: Reflections on Photography*, trans. Richard Howard (London: Vintage, 2000), 5.

13 Barthes, *Camera Lucida*, 31–32.

14 Lara Perry, 'The Carte de Visite in the 1860s and the Serial Dynamic of Photographic Likeness', *Art History* 35, no. 4 (September 2012), 728–749.

15 Crawford, *Beginning and End*, 76–77.

16 Peter Hamilton and Roger Hargreaves, *The Beautiful and the Damned: The Creation of Identity in Nineteenth Century Photography* (Aldershot; Burlington, VT: Lund Humphries, 2001), 45. For a fuller discussion of photography, carte-de-visite, and theatre, see 43–54.

17 Marta Weiss, 'Staged Photography in the Victorian Album', in *Acting the Part: Photography as Theatre*, ed. Lori Pauli (Ottawa: National Gallery of Canada, 2006; London: Merrill, 2006), 82.

18 Elizabeth Edwards, 'Photographs as Objects of Memory', *Material Memories: Design and Evocation*, ed. Marius Kwint, Christopher Breward, and Jeremy Aynsley (Oxford; New York: Berg, 1999), 226. See also, Geoffrey Batchen, 'Vernacular Photographies', *History of Photography* 24, no. 3 (Autumn, 2000), 262–271.

19 In a handwritten correction, dating possibly from the album's composition, 'tells' replaces 'speaks', diluting the photopoem's overt orality.

20 Patrizia Di Bello, *Women's Albums and Photography in Victorian England: Ladies, Mothers and Flirts* (Aldershot: Ashgate, 2007), 148. See also, Jonathan Crary, *Techniques of the Observer: On Vision and Modernity in the Nineteenth Century* (Cambridge, MA: MIT Press, 1990).

21 Weiss, 'Staged Photography', 81.

22 Henry Peach Robinson, 'The Poets and Photography', *The Photographic News* (5 February 1864), 62. Predominantly from Shakespeare, Robinson's quotations also include Cowper and Milton.

23 See Chauncey Brewster Tinker, *Painter and Poet: Studies in the Literary Relations of English Painting* (Cambridge, MA: Harvard University Press, 1939); and David L. Coleman, 'Pleasant Fictions: Henry Peach Robinson's Composition Photography' (PhD diss., University of Texas at Austin, 2005), 114–163.

24 Lori Pauli, 'Setting the Scene', in *Acting the Part: Photography as Theatre*, ed. Lori Pauli (Ottawa: National Gallery of Canada, 2006; London: Merrill, 2006), 16.

25 Percy Shelley, *Shelley's Poetry and Prose: Authoritative Texts, Criticism*, ed. Donald H. Reiman and Neil Fraistat (New York; London: Norton, 2002), 17.

26 Weiss, 'Staged Photography', 82n4.

27 Pauli, 'Setting the Scene', 26.

28 Quoted in Margaret Harker, *Henry Peach Robinson: Master of Photographic Art, 1830–1901* (Oxford: Basil Blackwell, 1988), 34.

29 Matthew Arnold, *Poems* (London: Macmillan, 1885), 211.

30 Henry Peach Robinson, 'Impossible Photography', *Photographic Quarterly* 3, no. 10 (January 1892), 103.

31 Henry Peach Robinson, *Picture Making by Photography* (London: Piper and Castle, 1884), 68. Robinson was perhaps alluding to a photographic illustration of 'Elegy' in Thomas Gray, *Poems and Letters* (London: Chiswick Press, 1863), 73.

32 Pauli, 'Setting the Scene', 60.

33 See Groth, *Victorian Photography*, 148–184 for a more detailed discussion of the publication history of the two volumes, and what Groth terms the 'luxury of reminiscing'.

34 Groth, *Victorian Photography*, 153.

35 Groth, *Victorian Photography*, 153.

36 There remains critical discussion as to whether the excerpts are in Cameron or Tennyson's hand.

37 Carol Armstrong, *Scenes in a Library: Reading the Photograph in the Book, 1843–1875* (Cambridge, MA; London: MIT Press, 1998), 361–421.

38 Armstrong, *Scenes*, 369.

39 Amelia Scholtz, 'Photographs before Photography: Marking Time in Tennyson's and Cameron's Idylls of the King', *Lit: Literature Interpretation Theory* 24, no. 2 (2013), 124.

40 Martin Meisel, *Realizations: Narrative, Pictorial, and Theatrical Arts in Nineteenth-Century England* (Princeton, NJ: Princeton University Press, 1983), 47.

41 Groth, *Victorian Photography*, 153.

42 See Carol T. Christ, *The Finer Optic: The Aesthetic of Particularity in Victorian Poetry* (New Haven, CT: Yale University Press, 1975), and Owen Clayton, *Literature and Photography in Transition, 1850–1915* (Basingstoke: Palgrave Macmillan, 2015).

43 Herbert F. Tucker, 'Epic', in *A Companion to Victorian Poetry*, ed. Richard Cronin, Alison Chapman, and Antony H. Harrison (Malden, MA: Blackwell Publishing, 2002), 25.

44 Tucker, 'Epic', 28.

45 Helmut Gernsheim, *Julia Margaret Cameron: Her Life and Photographic Work* (Millerton, NY: Aperture, 1975), 81.

46 Scholtz, 'Photographs before Photography', 113–114.

47 Scholtz, 'Photographs before Photography', 132.

48 Scholtz, 'Photographs before Photography', 116.

49 Alfred Tennyson, *Idylls of the King*, ed. J. M. Gray (London: Penguin, 2004), 298; Scholtz, 'Photographs before Photography', 116.

50 Groth, *Victorian Photography*, 17.

51 Armstrong, *Scenes*, 384.

52 Armstrong, *Scenes*, 385.

53 Julia Margaret Cameron, 'Annals of My Glass House', in Gernsheim, *Julia Margaret Cameron*, 180.

54 Scholtz, 'Photographs before Photography', 113, 132.

55 Bruce Graver, 'Wordsworth, Scott, and the Stereographic Picturesque', *Literature Compass* 6, no. 4 (2009), 896–926.

56 See Hess, *Ecology of Authorship*, 21–67.

57 Quoted in Graham Smith, 'William Henry Fox Talbot's Views of Loch Katrine', *Bulletin: Museums of Art and Archaeology, The University of Michigan* 7 (1985), 50.

58 Smith, 'Loch Katrine', 50.

59 Smith, 'Loch Katrine', 51. Several photopoetry books based in Scotland were published during the nineteenth century, including the anthology *Scotland: Her Songs and Scenery, as Sung by Her Bards, and Seen in the Camera* (London: A. W. Bennett, 1868), Alexander Maclagan's *Balmoral: Lays of the Highlands and Other Poems* (London; Glasgow; Edinburgh: Blackie & Son, 1871), and Cora Kennedy Aitken's *Legends and Memories of Scotland* (London: Hodder and Stoughton, 1874).

60 Martin Parr and Gerry Badger, *The Photobook: A History*, vol. 1 (London: Phaidon, 2004), 61.

61 Quoted in David Allan, *Commonplace Books and Reading in Georgian England* (Cambridge: Cambridge University Press, 2010), 36.

62 Allan, *Commonplace Books*, 36.

63 Henry Wadsworth Longfellow, *The Complete Poetical Works of Henry Wadsworth Longfellow* (Boston: Houghton Mifflin, 1893), 10.

64 Mark Haworth-Booth, *The Golden Age of British Photography, 1839–1900* (New York: Aperture, 1984), 18.

65 Michael Drayton, *The Poly-Olbion*, in *The Works of the British Poets*, ed. Robert Anderson, vol. 3 (London: John and Arthur Arch, 1795), 386.

66 Oliver Wendell Holmes, 'Sun Painting and Sun Sculpture', *Atlantic Monthly* 8, no. 45 (July 1861), 16.

67 Graver, 'Stereographic Picturesque', 903.

68 For a fuller discussion of stereoscopic vision, see Isobel Armstrong, ' "The Lady of Shalott": Optical Elegy', in *Multimedia Histories: From the Magic Lantern to the Internet*, ed. James Lyons and John Plunkett (Exeter: University of Exeter Press, 2007), 179–193.

69 Crary, *Techniques of the Observer*, 136.

70 T. R. Williams, 'Lane Leading to the Farm', in *Scenes in Our Village* (London: London Stereoscopic, 1857), stereocard 33.

71 Brian May and Elena Vidal, eds., *A Village Lost and Found: 'Scenes in Our Village' by T.R. Williams. An Annotated Tour of the 1850s Series of Stereo Photographs* (London: Frances Lincoln, 2009), 9.

72 Groth, *Victorian Photography*, 8.

73 Other poets in the R. & A. Suttaby series include Milton (1879), Scott (c.1880), Shakespeare (c.1880), Wordsworth (c.1880), Longfellow (c.1882), Elizabeth Barrett Browning (1884), Byron (c.1889), and Thomas Moore (c.1890).

74 Armstrong, *Scenes*, 1.

75 William Morris Grundy, ed., *Sunshine in the Country: A Book of Rural Poetry Embellished with Photographs from Nature* (London: Richard Griffin, 1861). All further quotations in this discussion derive from Grundy's anthology.

76 Allan, *Commonplace Books*, 38.

77 Allan, *Commonplace Books*, 45.

78 Unsigned review of *Sunshine in the Country* by William Morris Grundy, *The Art-Journal*, 1 February 1861.

79 *Oxford Dictionary of National Biography*, s. v. 'Mackay, Charles', by Angus Calder, accessed 2 February 2015, http://www.oxforddnb.com/view/article/17555.

80 See Charles Mackay, 'Lullingsworth', in *Under Green Leaves* (London; New York: G. Routledge, 1857), 17–44; and Charles Mackay, '"Under Green Leaves;" – Lullingsworth', *Illustrated London News*, 31 January 1857.

81 Mackay, 'Lullingsworth', *Under Green Leaves*, 19.

82 Groth, *Victorian Photography*, 43.

83 See Geoffrey H. Hartman, *Wordsworth's Poetry, 1787–1814* (New Haven, CT: Yale University Press, 1964), 12–18.

84 Graver, 'Stereographic Picturesque', 911.

85 Groth, *Victorian Photography*, 48.

86 Graver, 'Stereographic Picturesque', 920–921.

87 Groth, *Victorian Photography*, 15.

88 Groth, *Victorian Photography*, 4.

89 Groth, *Victorian Photography*, 4.

90 A. W. Bennett, introduction to *Our English Lakes, Mountains, and Waterfalls, as seen by William Wordsworth*, 4th ed. (London: A. W. Bennett, 1864), v–vi.

91 Bennett, introduction, v.

92 Paul H. Fry, *Wordsworth and the Poetry of What We Are* (New Haven, CT: Yale University Press, 2008), 97.

93 Groth, *Victorian Photography*, 61.

94 Groth, *Victorian Photography*, 61.

95 For a full discussion of these editions, see Groth, *Victorian Photography*, 81–111.

96 See Roger Taylor, *George Washington Wilson: Artist and Photographer 1823–93* (Aberdeen: Aberdeen University Press, 1981), 53–56.

97 See James Heffernan, *Museum of Words: The Poetics of Ekphrasis from Homer to Ashbery* (Chicago: University of Chicago Press, 1993), 3.

98 Groth, *Victorian Photography*, 89–90.

99 Groth, *Victorian Photography*, 84.

100 Hess, *Ecology of Authorship*, 56.

101 Robert Crawford and Norman McBeath, 'Photopoetry: A Manifesto', in *Chinese Makars*, by Crawford and McBeath (Edinburgh: Easel Press, 2016), 68.

102 Hess, *Ecology of Authorship*, 66.

'Illustratable with a Camera'

The United States and Beyond, 1875–1915

'I cannot recall with any exactitude the "first beginnings" of the compilation called "Riley Love Lyrics", writes Clara Laughlin of the 1899 photopoetry book that paired verse by the American 'Hoosier' poet James Whitcomb Riley (1849–1916) and pictorial photographer William B. Dyer (1860–1931).[1] Laughlin's account, while perhaps overplaying her own importance to these 'first beginnings', adumbrates how the relationship between poetry and photography was conceived in the United States at the turn of the century:

> It was probably my suggestion that [Dyer's] pictures would beautifully illustrate certain poems ... I believe I selected the poems – subject to Mr. Riley's approval and to Mr. Dyer's acceptance of them as illustratable with a camera. And for further contribution, I posed for some of the pictures and acted as consulting 'authority' on the types to be used for others.[2]

Despite the governing tenet of illustrative harmony, what makes Riley and Dyer's 'compilation' of interest to the history of photopoetry is its use of figures rather than landscapes as the illustrative focus. In the United Kingdom, Julia Margaret Cameron's *Idylls of the King* had hinted at the possibilities of figure-centric photopoetry as early as 1875, but it took another twenty-four years for the human body to play a central role in a work of photopoetry. By this time, pictorialism was beginning to shape photographic innovation in the United States. In the early twentieth century, this would lead to new directions for photopoetry.

Without the pastoral, nostalgic tradition that contributed to an identifiable body of photographically illustrated poetry in the United Kingdom, early US photopoetry lacked a commercially viable central focus. As I explore in Chapter 1, the photobook became the orthodox format – and photographic

illustration the orthodox model – for British photopoetry in the mid-to-late nineteenth century. These orthodoxies were copied in the United States from the 1870s, with Clement Biddle's *Airdrie and Fugitive Pieces* (1872) one of the first to combine poems and photographs in what we might call the British manner. Other works followed: Christine Alexander's *Airdrie, Scotland* (1875) and Biddle's *Poems* (1876) both in Philadelphia, Zilpha Spooner's edited collection *Poems of the Pilgrims* (1882) in Boston, and John Alleyne Macnab's *Song of the Passaic* (1890) in New York. Given the dearth of US material from the period in which British photographically illustrated poetry books were commercially popular and comparatively prevalent – by the 1890s, almost every renowned romantic and Victorian poet had a photographically illustrated 'Collected Works' – it is even more surprising that photopoetry's cosmopolitan evolution occurred in the United States and with great spontaneity. Its British cousin, meanwhile, foundered at the turn of the century and struggled to move beyond the nostalgic pastoral that had shaped its mid-nineteenth-century beginnings.

What should also be clear from the previous chapter is that, come the 1880s, photography – still in its infancy and prone to fluxes in style, apparatus, and theory – was entering a period of considerable upheaval. The emergence of cheaper technology and the snapshot, the continuing development of photography as an artistic medium in its own right through pictorialism, and a competing ethnographic trend all challenged the photopoetic orthodoxy that had grown up around nostalgia and illustration. While picturesque photopoetry was still the prevailing trend in Britain at the turn of the century, it represented something of a false start in the United States, never taking root as deeply in the photopoetic imagination as it had in Britain. In its place, the human body came to occupy the central poetic and photographic focus of the work, entering the mechanically reproduced photopoetry book for the first time with Riley and Dyer's *Riley Love-Lyrics* (1899), and prompting the stylishly cosmopolitan and international global evolution of photopoetry. This chapter explores photopoetry of the early twentieth century as a site of conflict between languages, cultures, and ideologies, both in the United States and further afield, with work also situated in India. Photopoetry of this period, while remaining broadly illustrative in design, represents an important moment for the genre: for the first time, it began to engage with questions that had shaped literature and the visual arts for centuries: questions of gender, identity, and race.

Representing women

The majority of Dyer's figure work for *Riley Love-Lyrics* is pastoral in tone, and does not approach the pictorial aesthetic of his best work.[3] In the 1899 edition, for example, the poem 'The Old Year and the New' (72–75) is accompanied by a portrait of a young woman whose expression is the visual, tonal equivalent of the 'one in sorrow' in the opening line (Figure 2.1). The photograph is superimposed over a drawing of a church in a wintery, evening landscape, 'the dim light of a New Year's dawn'. In the 1905 edition, however, this photograph and drawing have been replaced. In their stead is a soft-focus photographic portrait that is more a character study than a *tableau vivant*, one that does not so easily evoke lines such as 'The eyes that once had shed their bright / Sweet looks like sunshine, now, were dull.' Although the reason and responsibility for the change remain unclear, such a subtle alteration demonstrates the difference between literal and figurative equivalents in poem and photograph, with figurative pairings allowing for disjuncture and interruption as well as accordance and harmony.

Several photopoetry books of this period copied Riley and Dyer's blend of pictorialism and sentiment. *Songs of All Seasons* (1904), with photographs by Clarence H. White and poems by his aunt, Ira Billman, is tonally similar to *Riley Love-Lyrics*, pairing pictorially influenced portraits and landscape scenes with sentimental verse. Both volumes were, relatively speaking, lavishly illustrated – *Lyrics* has seventy-eight photographs, *Songs* forty-two – demonstrating how photographs were becoming not just occasional illustrations but central components of photopoetry books, which in turn reflected the diminishing costs of photographic reproduction. Now almost every poem had a photographic illustration, not just a select few. Though the two compilations are not especially radical in photographic approach and poetic subject, they demonstrate how representations of the human figure – and women in particular – became central to early US photopoetry and led to work that engaged more closely with the politics of identity.

Women at this time were not only photographic subjects but also photographic practitioners. In the late nineteenth century, female photographic activity was increasing exponentially. Technological developments allowed more women from different social classes access to photography as a hobby, and camera clubs created networks of photographers (male and female) across the United States and United Kingdom. Women joined photographic societies and exhibited at

Figure 2.1　William B. Dyer, 'The Old Year and the New – Tailpiece', in *Riley Love-Lyrics*, 1899. Courtesy of the University of St Andrews Library, photo PS2704.L7E99.

galleries. Their work could be found in both photographic journals and the popular press. Social constraints meant that middle-class women photographed the familiar – family, friends, interiors – though as Judith Fryer Davidov writes, they were also drawn to 'picturing what was strange', evident in the work of Julia Margaret Cameron and Lady Clementina Hawarden.[4] The new opportunities that photographic activity afforded demonstrate the problems women faced at the turn of the century. Kathleen Pyne writes:

The feminine had been placed outside modernity in a separate, premodern domain, [and] in the early years of the twentieth century women had to negotiate their way out of that enclosure into modernity, to make space for themselves there as producers, not just as consumers or public women of a demimonde.[5]

The aggressive marketing strategies of George Eastman brought many women to photography, and the consumerist nature of this relationship threatened to solidify existing gender roles. The nadir of photography perpetuating the domestic, servile roles of women was avoided, however, in part through the late nineteenth-century phenomenon of the New Woman, a figure who represented agency and liberation that threatened upholders of traditional values. As Linda Nochlin writes, 'It was liberation from the ideal of true womanhood, the bondage of marriage and self-sacrifice.'[6] The social and cultural innovations of the New Woman informed pictorial photography of and by women. Photography, therefore, became a powerful piece of visual apparatus in women's escape from the 'premodern domain'.

Preceding this photographic reappraisal of female identity was the development of strong and perceptive female characters by female writers. This occurred in response to the constraints imposed by a patriarchal society in the mid-nineteenth century. Foreshadowing how turn-of-the-century photographers adopted distancing strategies such as masking and role-playing, nineteenth-century female poets frequently used dramatic monologues to achieve a similar effect. 'The adoption of a mask appears to involve a displacement of feminine subjectivity,' writes Isobel Armstrong, 'almost a travestying of femininity, in order that it can be made an object of investigation.'[7] In the hands of women photographers, masquerade became a pertinent formal component of late nineteenth- and early twentieth-century photopoetry, much of which considered ideas of mythology and role-playing. This can be linked to the Cambridge Ritualists' concern with Greek antiquity from the 1880s to 1920s, during which artists, classicists (such as Jane Harrison and Gilbert Murray), and philosophers claimed modern drama and art were rooted in the myths and rituals of ancient Greek culture. This led to connections between classical scholarship and dance, exemplified by the Hellenic style of Isadora Duncan (1877–1927). The Greeks, Duncan noted, 'were the greatest students of the laws of nature, wherein all is the expression of unending, ever-increasing evolution, wherein are no ends and no stops'.[8] A photopoetic precursor to Duncan's philosophy exists in *In Arcadia* (1892), compiled by photographer Emma Justine Farnsworth (1860–1952).

In Farnsworth's photographs, women adopt poses reminiscent of both Greek sculpture and modern dance. These subjects appealed to amateur female photographers, writes Naomi Rosenblum, because of 'a desired liberation in dress and spirit not possible in actuality'.[9] In critiquing the strictures nineteenth-century women's clothing imposed on movement, Farnsworth undermined a narrative genre favoured by male pictorialists in the late 1880s, adding a sense of female agency to costume pieces in which young women dressed in flowing, Hellenic garments.[10]

The addition of poems to her photographic work created a more complex and subversive critique of a centuries-old male-inscribed discourse than was possible through her photographs alone. Farnsworth paired one photograph with 'To a Greek Girl' by the conservatively tempered English poet Austin Dobson (1840–1921). The poem's central conceit is an apparition of a Greek girl before the speaker: 'Across the years you seem to come ... / A girlish shape'.[11] The irony, of course, is that the girl in the photograph is unlikely to be Greek. Farnsworth's use of masquerade turns the poem on its head, undermining the objectification of women in male-authored histories from the classical era to the present day. That Dobson's final stanza consigns his vision of the Greek girl to his 'dreams' emphasizes the irony in Farnsworth's choice of poem: Dobson's 'Greek girl' is a mere fantasy, while Farnsworth playfully challenges photography's claims to visual truth.

Farnsworth's pairings often manipulate the assumed gender of the poetic speakers in order to emphasize female agency and creativity. In 'The Monochord' by Dante Gabriel Rossetti, the monochord itself is mentioned only in the title, but its symbolism permeates the poem.[12] Although Farnsworth's photograph is illustrative in that it pictures a monochord, it places the instrument in female hands (Figure 2.2). This gesture focuses the monochord's allusive energies on female creativity, and genders the speaker, whom we associate with the figure in the photograph, as female. In the poem, the speaker encounters a kind of spiritual emergency that reveals something about her condition or inner life. As photography can allude to inner life only through appearances, Farnsworth creates this pairing to emphasize how female creative expression was still predominantly confined to the domestic realm. In Farnsworth's pairing, the monochord comes to symbolize photography, a creative art that, in female hands, renders the expression of female identity as something more than a mere conduit for male creativity.

Likewise, Farnsworth paired three photographs with Thomas Moore's translations of Anacreon, the Greek lyric poet, whose fragments suit myriad

Figure 2.2 Emma Justine Farnsworth, 'The Monochord', in *In Arcadia*, 1892. Courtesy of the Photography Collection, Miriam and Ira D. Wallach Division of Art, Prints and Photographs, The New York Public Library, Astor, Lenox and Tilden Foundations.

situations and, more pertinently, myriad speakers.[13] Ode XIV encourages the listener to 'count' the speaker's lovers among 'Athenian maids', 'Syrian dames', and the women of other Greek islands. A reference to 'Lesbos' isle' evokes Sappho's poetry and homoerotic female desire. This allusion undermines

the assumption that the speaker is male. Given the regularity with which photographs were used in this period to connote authorial or narratorial identity, Farnsworth's accompanying photograph of the singular young woman stresses the photopoetic instability of woman as subject and object. Furthermore, the dramatic aspect of Anacreon's odes complements the performative element of Farnsworth's photographs, and the odes were likely chosen in part for their literary equivalence to photographic *tableaux*. In Farnsworth's work, the symbiosis of poem and photograph acts as a kind of masquerade, re-authoring male discourse from a female perspective, and placing women at the centre of creative expression. Her photographs stage female identity in order to subvert the male-authored poems with which they are paired, subjecting the voice of the poetic persona to the vision of the female photographer.

Tensions between voice and vision proved crucial to the development of photopoetic representations of identity. Just as a mythological undercurrent had informed Farnsworth's Greek-inspired photographs, the relationship between myth and modern identity continued to shape photopoetic production. Masquerade and role-playing remained central aspects of this trend, yet female empowerment was not always the aim, as evidenced in *Bypaths in Arcady* (1915) (hereinafter referred to as *BA* in citations), a collaborative adaptation of classical myth and stock pantomimic characters by poet Kendall Banning (1879–1944) and photographer Lejaren À Hiller (1880–1969).[14] *Bypaths* represents a late photopoetic blossoming of the *fin-de-siècle* obsession with characters of the Commedia dell'Arte, common to European and North American visual art throughout the late nineteenth and early twentieth centuries. Structured in five discrete sections, *Bypaths* amounts to five short performances or pantomimes, most of which stage relationships between male and female characters. The photographs themselves are reminiscent of stills from a theatre or Duncan-esque dance production, and the poems perform the role of narrative voiceover. Section two, 'The Garden of Punchinello', was originally a musical pantomime before it became a photopoem: the American composer Harvey Worthington Loomis set the poem cycle to music in 1914.

While Hiller followed Farnsworth in using costumes as part of a mythological apparatus, he also used the nude as a trope of masquerade. John Berger notes that 'a naked body has to be seen as an object in order to become a nude', and while the idea of woman as 'object' resonates throughout *Bypaths*, male characters are also pictured partially nude.[15] Hiller's preference for black backdrops foregrounds the characters themselves, free from any connotations of landscape or interior that might affect our perception. Such backdrops, however,

are often more threatening than liberating. The male character emerges from the black space in photographs such as 'Unconquered' and 'Devotion'. The gestures of the male nude combined with Hiller's lighting suggest that the darkness envelops the female nude. One critic called this effect Hiller's 'night quality', emphasizing 'the unreality of everything save dreams' in his photographs.[16] Compared to halftone processes, the enhanced tonal range of photogravure adds to this dreamlike landscape, providing rich details of facial expressions that had been otherwise impossible to render in earlier photomechanical processes. In 'Devotion', an apparently male speaker objectifies his devotion for a woman, beginning with abstracts such as 'Thou art my being ... / My passion ... my joy', and progressing to

Thou art the shrine where truth adores,
My heaven thou, where true love soars.
Thou art the tomb where depths enclose,
Till endless time, my store of woes. (*BA* 45)

The rapid accumulation of contradictory images complements the 'masquerade' of nudity, and almost disguises the fact that the subject of the poem is a woman. The structure of the quatrain enacts the gradual envelopment of the female nude, evoking how the darkness seems to enshroud her in Hiller's photograph. Verbs complete the first three lines, evoking the enshrouding process, while its completion is sealed in the entirely verbless final line. The symbiosis of verbal and visual masquerade demonstrates how the poem and photograph work together to represent the 'object' of the female nude.

The first section of *Bypaths*, 'The Pipes of Pan', appropriates a musical metaphor similar to Farnsworth's monochord. The story derives from the mythological tale of Pan's desire for the 'remarkable naiad' Syrinx. Pan pursues Syrinx to Ladon's stream. Syrinx appeals to the stream-nymphs to help her escape and is transformed into reeds. In various retellings of the myth, the precise cause of the reed music is ambiguous:

Instead of her held naught but marsh reeds in his arms; and while he sighed in disappointment, the soft air stirring in the reeds gave forth a low and complaining sound.[17]

He fill'd his Arms with Reeds, new-rising on the place.
And while he sighs, his ill success to find,
The tender Canes were shaken by the Wind;
And breath'd a mournful Air, unheard before . . .[18]

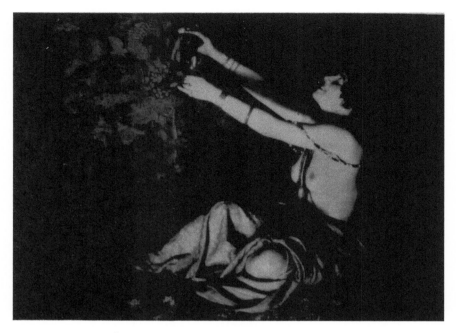

Figure 2.3 Lejaren À Hiller, 'The Wine of Columbine', in *Bypaths in Arcady*, 1915. Courtesy of the University of St Andrews Library, photo PS3503.A56B9.

> But while he was sighing in disappointment, the
> > movement of air
> in the rustling weeds awakened a thin, low, plaintive
> > sound.[19]

It is insinuated that Pan's breath causes the reeds to make a sound, yet a natural wind is seen as an equally likely source. This ambiguity is lost in Banning's version:

> As he drew the tender tubes to his lips, and sighed –
> Lo! a plaintive melody to his grief replied! (*BA* 15)

Syrinx is portrayed as a conduit for music discovered and played by Pan. This is reflected photographically: the female nude personifies the reeds and the male figure presses his lips to hers. Banning and Hiller combine to represent women in a passive, muse-like role, disregarding the subtleties of Ovid's original and subsequent efforts on the part of numerous translators to retain the ambiguity.

The acute attention Farnsworth paid to the nuances of female agency and identity is generally missing from *Bypaths*. In 'The Garden of Punchinello' sequence, repetitions between stanzas create an initial balance between Pierrot and Columbine as speakers. In 'Love Is As the Wind Is', both narrate a stanza before combining as

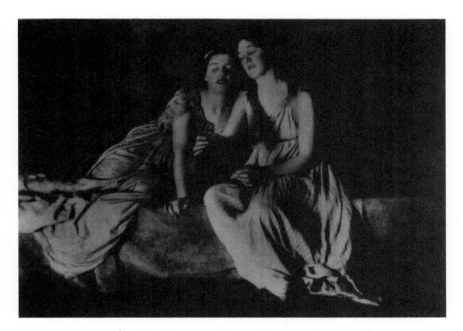

Figure 2.4 Lejaren À Hiller, 'The Rose of Pierrot', in *Bypaths in Arcady*, 1915. Courtesy of the University of St Andrews Library, photo PS3503.A56B9.

'they' in the concluding stanza. Pierrot narrates 'The Wine of Columbine', yet its partner poem, 'Rose of Pierrot', is given to an anonymous third-person narrator. This mirrors the photographic imbalance: while a semi-nude model and the wine symbol represent Columbine (Figure 2.3), only a rose represents Pierrot, held by two partially nude female models (Figure 2.4). A reluctance to engage solely with the male nude when it was emerging as a key pictorial figure in both photography and painting demonstrates how the photographs in *Bypaths* sought to objectify women, a strategy supported through the use of male poetic speakers to emphasize male creative agency and the passivity of the female 'muse'. Considered alongside one another, *In Arcadia* and *Bypaths* demonstrate the different strategies open to photopoetic practitioners in terms of representing identity, from photopoetic pairings that possess subversive qualities to arrangements that perpetuate and reinforce conventional narratives and constructions of gender.

Dunbar and the American South

Another strand of early twentieth-century photopoetry perpetuated, and in some cases subverted, gendered and racial stereotypes, using images of the

body both to appropriate and enable the objectified other. Photographically illustrated poems account for more than half the oeuvre of the African American poet Paul Laurence Dunbar (1872–1906). The six photopoetic volumes published by Dodd, Mead & Co. between 1899 and 1906 contain around ninety poems – the vast majority in dialect – and more than 450 photographs, in itself one of the largest bodies of photographs of African Americans hitherto published.[20] These books represent one of the most sustained interactions between poem and photograph, one borne by the Hampton Institute Camera Club (HICC), an amateur photographic group of predominantly white members at Virginia's Hampton Institute – 'A white dream for black people'.[21] The HICC photographically illustrated the first three volumes, *Poems of Cabin and Field* (1899), *Candle-Lightin' Time* (1901), and *When Malindy Sings* (1903), while its lead photographer, Leigh Richmond Miner (1864–1935), photographed the final three: *Li'l' Gal* (1904), *Howdy, Honey, Howdy* (1905), and *Joggin' Erlong* (1906). This is an important distinction.

In the fall of 1899, Frances Benjamin Johnston made a number of promotional images of the Hampton Institute for the 1900 Paris Exposition. These images demonstrate the institute's paternalism, its rigorous doctrine of self-improvement, and the enriching aspects of a Hampton education. Johnston's influence is discernible in the rigid, documentary nature of the *Cabin and Field* photographs, against which the poems read like historical testimonies rather than expressions of African American literary culture. Johnston's images provide one example of a Jim Crow-era attempt to manufacture an African American national identity, one that complemented the rise of white mimicry and role-playing in dialect literature and its central trope of the 'disappearing Negro'.[22] The work of the HICC photographers should be considered in this light, in addition to the ideologies of proponents of black education. As Andrew Heisel has noted, such proponents often 'sought to rescue African Americans from a supposedly depraved racial nature with the same gestures with which they consigned them to it'.[23] These strategies of representational dominance create what Duncan Bell terms a 'mythscape', a space in which 'the multiple and often conflicting nationalist narratives are (re)written: it is the perpetually mutating repository for the representation of the past for the purposes of the present'.[24] Dunbar's role in these 'conflicting nationalist narratives' is hotly debated. Recent critical reappraisals have improved his reputation, yet the authenticity of his dialect poetry as an

expression of African American literary culture remains contested, as does the potentially negative impact of the photographic illustrations. To Gavin Jones, Dunbar's work reflects the 'fractured consciousness of a poet fundamentally unsure about which language to use'; to Emily Oswald, he 'allow[ed] his work to be published in ... a blatantly racist format'.[25] Dunbar's photographically illustrated books gravitate between these two poles, and the remainder of my discussion attempts to further the paradigm Heisel identifies, that the volumes 'demonstrate a complex interplay between photos and text that can alternately coerce the poetry into alignment with paternalistic, racist ideologies and help the text subvert them'.[26]

The primarily commercial purpose of the first three volumes meant the photographs tended not to reflect the subtleties of Dunbar's poems. In conforming to existing African American stereotypes, nostalgia and racism were apt to be confused. Oswald writes:

> The [HICC] had only to offer a rough sketch of a visual idea that would correspond to some vague nostalgic notion of the Old South in order to produce a positive response from the reader. The fact that many of the illustrations from *Poems of Cabin and Field* are literal visual translations of images from Dunbar's poems indicates as much, and reveals that the illustrations were not the result of a serious engagement with the poetry, but instead the simple translation from poetic to visual image.[27]

The HICC, Oswald notes, made changes to their photographic subjects in order to give subtle impressions of poverty and rusticity. Such alterations included the removal of children's shoes and the use of the most ramshackle, dilapidated cabins at Hampton. The supposed authenticity of these images is discredited, however, when compared to Johnston's Hampton photographs, which show much better conditions in a documentary rather than aesthetic manner.[28] In photographically illustrated poetry, a literal aesthetic is often complicit with an ideological agenda: the HICC used photographs to re-author Dunbar's poems, drawing on easily illustratable poetic images to reinforce the stereotypes of African American life that held popular commercial appeal.

This photographic 're-authorship' had a significant impact on Dunbar's role as poet. The subject of the most popular photograph among HICC members, 'Dan', was used as the frontispiece of *Poems of Cabin and Field* (Figure 2.5). Dan, Heisel writes, fits the 'type' of African American wanted by the HICC, a 'stereotypical, unflattering' portrayal of an African American that would 'cater

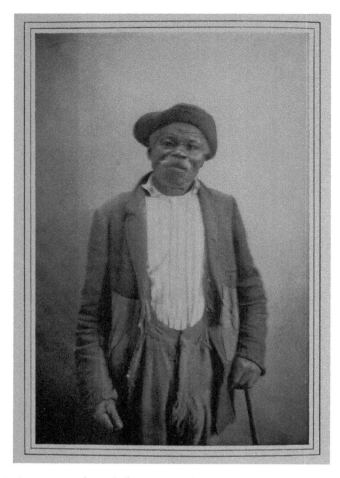

Figure 2.5 Anonymous, 'Untitled', in *Poems of Cabin and Field*, 1899. Courtesy of the University of St Andrews Library, photo PS1556.P6F00.

to a popular interest in the Southern, rural African American'. The HICC's agenda here, Heisel concludes, 'is revealed in the club's list of goals for the year 1900. The third goal on this list is to "make booklets of photographs of Southern Negro types for sale"'.[29] That this saleable image was chosen as a frontispiece demonstrates the degree to which the HICC undermined Dunbar's verse and alluded to the common photographic trend of anthropological taxonomy. Heisel explains that modern and contemporary audiences 'often assume that Dan, the scruffy figure appearing before the title page, is Dunbar.... The same prejudices that led to the appreciation of "Southern Negro types" were brought to bear on

Dunbar's dialect poetry, and indeed were the reason this poetry was so popular.'[30] The implied veracity of the photographic image was used to appropriate dialect poetry for both political and commercial ends. Dunbar the poet, then, became an expendable figure.

Most authors of dialect literature were, in fact, white. Among them was Leigh Richmond Miner, who published eleven poems in journals the *Outlook* and the *Southern Workman* between 1900 and 1919. Interestingly, his five non-dialect poems were unillustrated, whereas photographs accompanied five of his six dialect poems. Miner photographed the final three Dunbar volumes himself, and also provided photographic illustrations for *Ben King's Southland Melodies* (1911), a book of dialect verse written by the white poet and parodist Benjamin Franklin King Jr (1857–1894). Given that *Southland Melodies* was a posthumous volume, it is reasonable to assume King wrote the poems without a view to photographic illustration. The poems themselves range from gross parodies of the kind of dialect verse Dunbar would popularize (titles include 'Ole Bossie Cow' and 'De Watahmellon Splosion') to abhorrently racist verse such as 'De Cushville Hop'.

Miner's sympathies with African Americans (his three Dunbar volumes subtly discredit reductive racial iconographies) have been discussed elsewhere.[31] His collaborator on *Southland Melodies*, Essie Collins Matthews, herself an African American, would later write a book on slavery, suggesting that 'the tie of love that bound the black man to the white man has never been understood'.[32] It might be argued that Miner and Matthews sought to dignify King's imitation of what Ray Sapirstein calls 'conventional plantation dialect and humor', albeit for different reasons.[33] Part of their dignifying strategy was to manipulate the volume's frontispiece to emphasize dialect literature as a broadly white exercise in mimicry (Figure 2.6). There is a strange disconnect between the name of the author, prominent in the title, and the photograph that effectively stands in for the white humourist – an elderly African American man with a thick white beard, photographed in dim, sympathetic lighting. Looking away from the camera, the man undermines King's racial agenda and disclaims authorial responsibility on behalf of African Americans. Miner's placement of this photograph at the beginning of *Southland Melodies* parodies white mimicry and ridicules how these dialect works were passed off as part of an African American literary tradition. The volume questions what is acceptable in terms of poetry 'inhabiting' the voices of others, just as Miner, in his role as sole photographer for three Dunbar volumes, would go on to question the re-authorship of African American dialect verse through the lenses of white photographers.

Figure 2.6 Leigh Richmond Miner, 'Untitled', in *Ben King's Southland Melodies*, 1911. Courtesy of the University of St Andrews Library, photo PS2169.K8S7F11.

While the figure of the poet became increasingly marginalized as a result of the photographic illustrations, the representation of women was another area in which the photographs provided a particular interpretation that Dunbar's verse did not wholly support. In Dunbar's 'The Photograph' (*Li'l' Gal* [hereinafter *LG* in citations] 109–113) the speaker's lack of description excludes the reader from mutually admiring his pictured lover. In her analysis of this poem, Deborah March writes that the lack of description

> also signals a larger issue regarding the place of women in Dunbar's dialect work and visual iconography. Female bodies are often invoked to personify rural black experience, which was increasingly, at the turn of the century, figured as a relic from a past swiftly giving way to urban industrial life.[34]

While female embodiments of the landscape and African American experience are common to Dunbar's dialect poetry, the effects of the accompanying photographs on these orthographic portraits is often overlooked. Christopher Pinney notes that a photographic ' "salvage" paradigm' emerged in India during the nineteenth century, in which a primitive aesthetic inflected an ethnographic desire to record disappearing cultures and communities: in Pinney's words, 'Vigorous efforts were often made to construct a different reality for the camera.'[35] This paradigm resonates with photopoetry when we consider its similarities to dialect literature in the United States. Michael North has identified that the beginnings of dialect literature occurred during the dismantling of Reconstruction and the birth of Jim Crow: its main trope, the ' "disappearing Negro" … fed nostalgia for a time when racial relationships had been simple and happy'.[36] Parallels exist in the period's photography: Johnston's Hampton images demonstrate pupils 'before and after' a Hampton education, and how institutionalization could help African Americans emerge into modernity. Hampton was complicit in recording the 'disappearing Negro' and creating the 'New Negro' through the modern apparatus of photography, employing the salvage paradigm alongside technological innovations aimed at facilitating modern subjecthood. Though the dialect movement was primarily a vehicle for white mimicry and masquerade, Dunbar's dialect poems appealed to the HICC because, photographically, they could salvage the 'disappearing Negro' while appearing to cultivate the modern African American.

Women in Dunbar's poetry provided an important focus for the HICC's salvage project. This was partly due to the importance in turn-of-the-century African American class distinction, as Kevin Kelly Gaines notes, of 'conformity

to gender conventions of respectability – to bourgeois family structures of patriarchal authority and female domesticity'.[37] This conditioned their photographic representation: only Miner's photographs in the last three volumes present African American women as being distinct from domestic roles. Given the HICC's predominantly white, male membership, Susan Schoelwer's argument concerning American Indians is equally applicable to African American women: 'To the degree that both women and American Indians represented difference, against which European American males defined their own identities, then Native American women were doubly other.'[38] The first poem of *Candle-Lightin' Time* (*CLT*) demonstrates the relationship between African American women, landscape, and the salvage paradigm. One of only two non-dialect poems across the six Dunbar books, 'Dinah Kneading Dough' (*CLT* 11–19) was included, Heisel speculates, because its domestic, servile themes characterized African American women in the eyes of the HICC.[39] The poem begins:

> I have seen full many a sight
> Born of day or drawn by night;
> Sunlight on a silver stream,
> Golden lilies all a-dream,
> Lofty mountains, bold and proud,
> Veiled beneath the lacelike cloud;
> But no lovely sight I know
> Equals Dinah kneading dough. (*CLT* 15)

The speaker stands before Dinah as though she is a picturesque vista: he passively observes the 'lovely sight' of her kneading dough – a typical example, in Dunbar's verse, of women embodying particular domestic roles. Dinah's gendered body is performative: she has no agency beyond this act.[40] Indeed, Dinah's kneading maintains her 'domestic rhythm', and while 'Girls may draw, or paint, or sew' – other, more personal and creative pursuits – the speaker is fixated on her domestic activity. The HICC's photographs encourage this reading, placing a landscape photograph beside three references to Dinah in a domestic situation (Figure 2.7). While the speaker is convinced that Dinah's charms surpass those of naturally beauteous landscapes, the use of standard English rather than dialect implies that Hampton itself has made her a 'lovely sight'. The poem forms the 'after' image of an orthographic comparison of African Americans 'before and after' a Hampton education.

Figure 2.7 Anonymous, 'Dinah Kneading Dough (II)', in *Candle Lightin' Time*, 1901. Courtesy of the University of St Andrews Library, photo PS1556.C2F01.

'Dinah' contrasts in imagery and tone from Dunbar's dialect work. *L'il' Gal*, the first volume in which Miner was sole photographer, also begins with a love poem in which the speaker invokes nature to describe the 'l'il' gal'. We are presented with an entirely different voice to the strict metres and rhymes of 'Dinah':

> Oh, de weathah it is balmy an' de breeze is sighin' low,
>> Li'l' gal,
> An' de mockin' bird is singin' in de locus' by de do',
>> Li'l' gal; (*LG* 8)

As a result of the dialect, nature becomes active, and there is no comparison between the charms of a picturesque vista and those of the speaker's suitor. Instead, the agitation present in the natural world is attributed to the 'trouble brewin' an' a-stewin'' in the speaker's heart as he attempts to articulate his love, 'a-sighin' an' a-singin''. The 'li'l' gal' is invoked through the songlike refrain, but is not described anywhere in the poem. Miner adopted this distancing in his photographs: neither of his photographs picture the 'li'l' gal', but instead focus on the speaker and the natural world. Interestingly, however, the volume begins with a frontispiece of a young girl, one of Miner's finest portraits. While *Candle-Lightin' Time* had also featured a frontispiece portrait of a woman, the tone of that image is nostalgic and redolent of the poverties and hardships of plantation life. Miner's portrait in *Li'l' Gal*, however, is the complete opposite. By placing this portrait at the beginning of his first Dunbar book, Miner makes clear that his representations of African American women will reinstate the agency denied them in HICC photographs and, to an extent, Dunbar's poems themselves. He would interpret Dunbar's poems, not illustrate them.

Compared to the HICC, Miner was less willing to represent women in performative roles. Possessing great interest in African American and indigenous cultures, Miner typically engaged with the minutiae of cultural difference, not overarching and reductive stereotypes: in his Hampton photographs he rejected individuals as 'types' of African American life or culture. One example of individual self-worth despite hardship is the titular poem of the fifth Dunbar volume, 'Howdy, Honey, Howdy', a poem previously illustrated by HICC members in *When Malindy Sings*. The poem describes a suitor peeking into the cabin of his beloved, the 'Do' a-stand'in a jar': she beckons him inside with the

phrase 'Howdy, honey, howdy, won't you step right in?' This is a frequent image in Dunbar's poetry: young women commonly stand in doorways or at gates, deciding whether or not to admit their suitors. Miner interpreted such moments as examples of female agency in Dunbar's verse, and dignified the substantial presence of women in the poems with sympathetic, individual portraits. March writes:

> The photo-texts are, in a sense, a visual and textual invitation to the doorstep of Southern black culture – the doorstep, though, and no further. Through this simultaneous invitation and refusal, the volumes reclaim representational dignity for rural African Americans.[41]

Miner is more sensitive than the HICC to Dunbar's threshold metaphor. The book jacket photograph features a young woman standing in a doorway, inviting the reader/viewer inside with an outstretched hand and, above the photograph, the phrase ' "Howdy, Honey, Howdy" ' (Figure 2.8). The photograph 'is cropped around the door to make the door's frame coextensive with the picture's frame', and 'presents the volume as a gracious invitation into the interior life of the Southern Negro'.[42] The two photographs accompanying the poem record the suitor's tentative approach and entry into his beloved's cabin: in not visualizing the courtship itself, Miner respects the privacy of the African American home (Figures 2.9–2.10). That the HICC went beyond the poem to stage the courtship scene in their version of the poem is indicative of the commercial trends surrounding the representation of African American vernacular culture, as seen in 'the allure of ethnographic display of racial others that drew so many spectators to the Paris Exposition's native villages'.[43] Breaching the poem's visual space refocuses attention to the cabin interior, demonstrating the desire of the photographers to show 'Southern negro types' and their behaviours (Figure 2.11). Although Miner's images are not beyond criticism, their sympathetic and dignified engagement with Dunbar's poetry presents a distinct contrast with the HICC's romanticization of African American private domestic life for commercial gain. Their importance in the development of photopoetry derives from their willingness to diverge from Dunbar's poems, to interpret rather than illustrate – an aesthetic that resonates all the more given the HICC's work in literalizing Dunbar's poems in accordance with a commercial agenda based on racial and gendered stereotypes.

Figure 2.8 Leigh Richmond Miner, 'Untitled', in *Howdy, Honey, Howdy*, 1905. Courtesy of the University of St Andrews Library, photo PS1556.H6F05.

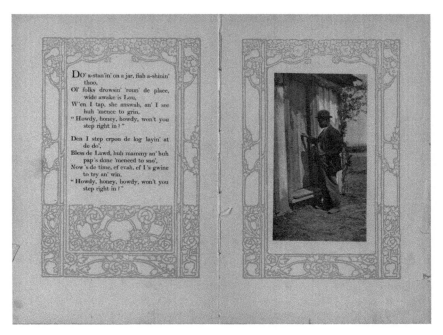

Figure 2.9 Leigh Richmond Miner, 'Howdy, Honey, Howdy (I)', in *Howdy, Honey, Howdy*, 1905. Courtesy of the University of St Andrews Library, photo PS1556.H6F05.

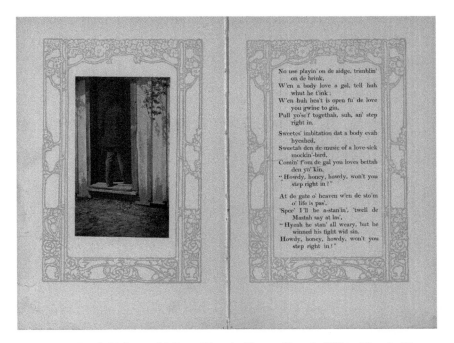

Figure 2.10 Leigh Richmond Miner, 'Howdy, Honey, Howdy (II)', in *Howdy, Honey, Howdy*, 1905. Courtesy of the University of St Andrews Library, photo PS1556.H6F05.

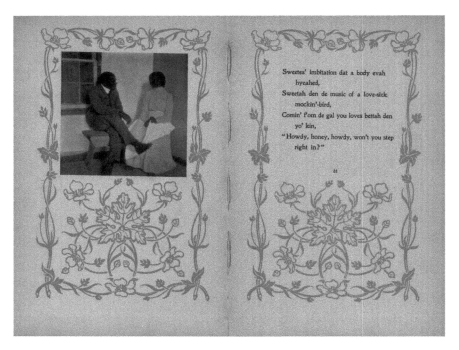

Figure 2.11 Anonymous, 'Howdy, Honey, Howdy (III)', in *When Malindy Sings*, 1903. Courtesy of the University of St Andrews Library, photo PS1556.W4F03.

Nicolson and British India

The racial and gendered connotations of nonstandard orthography are also evident in the work of Anglo-Indian poet Adela Nicolson (1865–1904). Her collection *The Garden of Kama* (1901) – spurious translations of Indian verse – was posthumously republished in a photographically illustrated edition, *Songs from the Garden of Kama* (1908). Under the pseudonym 'Laurence Hope', Nicolson projected a feminine voice and decadent aesthetic at odds with the common masculine genealogy of turn-of-the-century colonial poetry, gaining popularity beyond the cool reception granted to most female Anglo-Indian poets. Her verse, writes Anindyo Roy, 'constituted a significant act of translation: a practice aimed at reconceptualizing notions of national poetic legacy under colonialism and at reworking gender and identity in relation to poetic voice'.[44] Dressed as a young Afghan groom, Nicolson would follow her husband, a commander in the Bombay army, to the military camps along the north-west frontiers of India.[45] Gender and cultural cross-dressing characterize her poetic voice: Edward Marx portrays her verse as a 'decadent exoticism'

within turn-of-the-century British aestheticism, a trend immured in imperial expansion.[46] Nicolson's exposure to 'exotic' India prompted verse that, while dealing with 'decadent fascinations: opium smoking, erotic cruelty, the cult of youth, slaves and despotic rulers, dancing girls, and, above all, passion', also insisted on female sexuality and the capacity of women for intense emotional and physical experiences, representing a radical expansion 'of the emotional range of women's poetry in the period'.[47]

This blend of the erotic and exotic made Nicolson's poetry tremendously popular in the early twentieth century. *The Garden of Kama* was reprinted eleven times in the seven years before it appeared as the photographically illustrated *Songs*. James Elroy Flecker neatly articulates Nicolson's popularity as a 'world of admirers, a multitude of initiants – a Public'.[48] The term 'initiants,' Roy suggests, 'is significant because it evokes a particular history of the relationship, in the metropolis, between the reading public and the "Orient".'[49] Citing the publication of Richard Burton's *Kama Shastra* (1873) and Edward FitzGerald's *Rubáiyát of Omar Khayyám* (1879), Roy notes that 'the Orient had been constructed as the source of new knowledge about sexual practices and norms previously unknown in the metropolis'.[50] The modern reader would be forgiven for thinking a photographic edition of Nicolson's *Garden of Kama* would contain images similar to exotic, colonial postcards. However, Nicolson's poems were paired with a photographic vision of India they did not even remotely endorse: a picturesque vision more redolent of the nineteenth-century photographic editions of Scott and Wordsworth than the 'decadent exoticism' of her verse.

Beyond her work in book illustration, little is known about the photographer in question, Mabel Eardley-Wilmot (1866–1958). She often accompanied her husband, an officer in the Indian Forest Service, on tours through the forests of Oudh in northern India. She took up photography as a hobby, as was common among the wives of colonial officials.[51] An active participant in the amateur arts scene of Anglo-Indian society, Eardley-Wilmot contributed photographs to the annual Simla art exhibition in 1906 and 1908, and was lamented for her absence in 1909.[52] Returning to Britain in 1908, she became engaged in book illustration, lending her photographs to three volumes of poetry – Edwin Arnold's *The Light of Asia* (1908), Nicolson's *Songs* (1908), and Edward FitzGerald's *Rubáiyát of Omar Khayyám* (1912), as well as four prose works by her husband – all of which were shaped, at least to some degree, by a fascination with the Orient. Containing around 150 unique images, Eardley-Wilmot's books constitute a significant collection of Orient-based photography, and is one of the largest such collections by a female photographer.

As its association with government and bureaucracy developed, photography became a tool for understanding and classifying India. This coincided with a 'remarkable upsurge' in amateur photographic activity in India during the mid-nineteenth century, as many of the photographers were employees of either the military or civil service.[53] Situating Eardley-Wilmot's work in this context is important to our understanding of her photographic style and influences. Links between photographic practice and officialdom shaped how colonial India was visually represented. There was also a concern with target audience. British commercial photographers in 1860s India, such as Samuel Bourne in his photographs of Barrackpore Park, created images amenable to their viewing public by imposing a picturesque doctrine more redolent of British landscapes than those of India. 'The picturesque,' writes Gary Sampson,

> as applied to a program of photography aiming to please, may at once suppress associations of racial confrontation, cultural assimilation, and radical topographical alteration, and thus serve the purposes of empire by affirming the colonized site as an emblem of political authority and racial dominance.[54]

The erotic, exotic manifestation of female identity in Nicolson's poetry undermines the India of Eardley-Wilmot's 'colonial picturesque'. Representing contrary approaches to colonial subjecthood, Nicolson's verse engages with colonial space while Eardley-Wilmot's photographs, when used in this context, refuse and deny it. Photographic illustration became a conduit for political ideologies and identity politics, and the inscription of a photographic vision over a poetic voice could dilute the latter, conscripting it to a visual representation of the Orient that it did not remotely endorse.

Eardley-Wilmot's photographs locate the voices of the poems, though not their physical embodiments, within picturesque locations. Captions are used to emphasize landscape features of the photographs, such as 'the hillside camp' and 'fields of millet and rice', and their attention to landscape emphasizes their relationship to the surface of the photographic image. Given the links between early photography and European travel, Pinney notes that 'the "normative" photograph encoded a practice of photography, which encoded a practice of travel'.[55] In countless histories of photography, this led to 'the powerful preoccupation with the changing location of the photographers and their equipment in real time/space conjunctions'.[56] Eardley-Wilmot's engagement with British India represents photography-centric foreign travel rather than an attempt to engage with Nicolson's poems. Her photographs form an overarching

narrative of a distinctly photographic trip, a visual cataloguing of India that blends both travel narrative and amateur photographic survey.[57] That captions are yoked from the poems to highlight generic aspects of the landscape, such as 'Across the yellow Desert, looking forth, / I see the purple hills towards the north' (*Songs from the Garden of Kama* (hereinafter *SGK* in citations) 23), demonstrates how the photographer figure usurps the voice of the poetic speakers and asserts visual supremacy over the poems. This disconnection from the verse establishes the presence of the woman photographer at the expense of the woman poet, and constructs a photopoetic space that, bearing no resemblance to any identifiable reality, heightens the reader's sense of disembodiment.

Perhaps the starkest contrast between poems and photographs in the volume is the representation of people. Nicolson's poems pulse with individual subjectivity and psychology, whereas Eardley-Wilmot's photographs feature human figures only as occasional *staffage*, an inheritance from picturesque theory, which implies an objective, documentary perspective. Furthermore, given the self-image of Nicolson's metropolitan audience as consumers of the colonial market, it is surprising that none of Nicolson's speakers are represented photographically. Rather than a glimpse into the decadent and erotic Orient, consumers were afforded a travel narrative in which the subtleties of Nicolson's colonial landscape were lost. The world Nicolson creates, notes Roy, 'is simultaneously idyllic and troubled, often demonstrating an acute awareness of an imperial subjectivity caught between the desire to reclaim an idyllic past and the consciousness of present reality marked by conflict and dissent'.[58] It is possible, however, to argue that Eardley-Wilmot's photographs respond to the difficult and contradictory relationship between the idyllic, exotic qualities of Nicolson's poetry and actual, identifiable places. That her photographs appear to disembody the voices of the poems is perhaps a response to the use of masquerade in Nicolson's work, a spirit captured in her use of a male pseudonym and that extends to her spatial construction of an Orient that is neither mappable nor easily navigable. Although Nicolson names specific locations – many with overtures of British military campaigns – her poems of yearning, desire, and loss also offer ambiguous, indeterminate sites. Some titles refer to Udaipore, Baltistan, and Tamarind, while others invoke 'The Window Overlooking the Harbour', 'Palm Trees by the Sea', and 'The Garden by the Bridge'. Nicolson translates colonial India into a space at once everywhere and nowhere: a playfulness regarding space and place was one aspect of the mask she employed to write transgressive poetry championing female identity and agency.

When bodies themselves are explored in *Songs*, they most often feature in relation to landscape. In the early twentieth century, female photographers were beginning to explore the photographic possibilities of the relationship between landscape and the female body. The poem 'Sunstroke' (82–83) evokes a communion from which man is ultimately excluded. The male speaker's child bride dies of sunstroke en route to their wedding: her death is intricately tied to the moment of proposed union. This is evoked in the speaker's emphasis on landscape in the first and final stanzas:

> Oh, straight, white road that runs to meet,
> > Across green fields, the blue green sea,
> You knew the little weary feet
> > Of my child bride that was to be!
> ...
> I walk alone; the air is sweet,
> > The white road wanders to the sea,
> I dream of those two little feet
> > That grew so tired in reaching me. (83)

The speaker's voice follows the road, first in his bride's path from the sea, then his own lonely walk back towards the water, and his dreams of his bride are not abstract; rather, they are rooted in her relationship with the land, the impress of her feet in the grassy road. While Nicolson evokes a delicate symbiosis between women and the landscape, Eardley-Wilmot's 'Sunstroke' photograph, like many of her images, functions best as an evocation of absence: not the absence of figures, for this undermines the psychological timbre of the verse, but the absence between speaker and implied listener when we consider Nicolson's poems as dramatic monologues. Visually translated, such an absence portrays colonial landscapes – and, by extension, female bodies – as conquerable sites open to Western re-authorship.

As the title of the volume implies, voices rather than bodies are at the centre of *Songs*. A multiplicity of voices complicates her formal schemes and, subsequently, the accompanying photographs. Nicolson remodels the colonial discourse of translation by inserting gendered, Eastern names into her poems' titles: ' "In the Early, Pearly Morning": Song by Valgovind', 'Story of Udaipore: Told by Lalla-Ji, the Priest', and 'Zada Khan's Song on the Hillside'. Female names appear in two poems ('Zira: In Captivity' and 'Ojira, to Her Lover'), plus the gendered 'Second Song: The Girl from Baltistan'. Nicolson's ventriloquism rejects the idea of a sole speaker. These voices, Roy argues,

suggest an indefinable ground between the purely lyrical, the elocutionary and the performative: in some of these poems, the 'of' signals the hiatus between the primary lyrical 'I' and its repetition through performance: in other words, is Mahomed Akram merely the singer or is the poem an expression of his voice?[59]

Pairings of captions and photographs create 'an indefinable ground' of their own, one that often obscures the voices and personas of the poems. Pronouns either locate the 'speaker' within the photograph or suggest the photographic view is seen through the speaker's eyes. The poem 'Afridi Love' (42–46) encapsulates this doubleness: the first photographic view creates the impression that captive and captor see through the same eyes – 'Lie still! Lie still! In all the empty village / Who is there left to hear or heed your cry?' – and the pronoun 'our' in the caption for the second view apparently confirms this: 'Look at the pale, pink peach trees in our garden'. Conversely, captions that implore the viewer to *look* or *see* – for example, 'Across the Yellow Desert, looking forth, I see the purple hills towards the north' in 'Zira: In Captivity' (22–25) – demonstrate how the photographer seizes control of the poet's narrative. These imploratory captions are used to support the photographic travel narrative of Eardley-Wilmot on her journey through India. In this light, captions reductively emphasize a single persona rather than the confusions of voice and perspective in Nicolson's poems themselves.

Such confusions are necessary to a full understanding of Nicolson's poems and, on occasion, a photograph adds to the confusion. The photograph accompanying 'Reverie of Mahomed Akram at the Tamarind Tank' (6–11) shows a female figure sitting on a wall overlooking a large body of water (Figure 2.12): its caption reads, 'Sitting alone, / The tank's deep water is cool and sweet.' If the speaker is Mahomed Akram himself, this is a disturbing connotative relationship between caption and photograph. We might infer from the militaristic context of the lines 'But the sand is passed, and the march is done, / We are camping here to-night' that the 'I' of the poem is male. Yet the stereotypically feminine sensibility of lines such as 'I cannot forget / That, just as my life was touching its fullest flower, / Love came and destroyed it all' appears to reinforce the photographic suggestion of a female speaker. This ambiguity suggests the voices implied in the titles are performative expressions rather than personal elocutions, and act as the poet's imaginative masks: masculine and feminine, Laurence Hope and Adela Nicolson.

Acts of naming in Nicolson's poems accentuate problems of voice and gender. Using Eastern names and seemingly non-referential pronouns to blur the boundaries of identity, Nicolson rejected performative bodies that

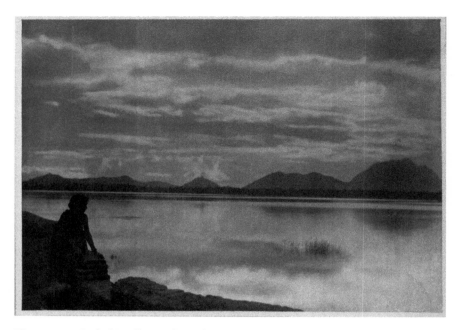

Figure 2.12 Mabel Eardley-Wilmot, 'Reverie of Mahomed Akram at the Tamarind Tank', in *Songs from the Garden of Kama*, 1908. Reproduced with the permission of the Dummett family. Courtesy of the University of St Andrews Library, photo PR6027.I37F09.

have 'no ontological status apart from the various acts which constitute [their] reality'.[60] Nicolson prevents the photographer from assigning such gender-performative roles to her speakers by switching between pronouns with an abandon indicative of a philosophy that, Roy suggests, 'plays with the very idea of "origin"'.[61] Playing with ideas of translation and authenticity, Nicolson's dramatic monologues collapse the personas of speaker and implied listener into a continuum in which each gendered 'identity' is present in every utterance. The poem 'Golden Eyes' (34–37) accentuates the importance of naming:

> Oh, you whom I name 'Golden Eyes',
> Perhaps I used to know
> Your beauty under other skies
> In lives lived long ago. (34)

Continuously switching the indefinitely gendered 'you' and 'I', Nicolson consummates this ungendered act of naming as the speaker recounts various

imaginative 'lives lived long ago'. 'Eyes' symbolize this transgressive androgyny, focusing on images of captivity and death:

> Maybe you were an Emperor then
>> And I a favourite slave;
> Some youth, whom from the lions' den
>> You vainly tried to save!
> Maybe I reigned, a mighty King,
>> The early nations knew,
> And you were some slight captive thing,
>> Some maiden whom I slew. (35)

These implied histories for 'you' and 'I' are expressed through distinct power relationships and sexual metaphors. The subtext is colonial domination: from a photographic perspective, the submissive partner symbolizes the picturing of colonial spaces ripe for civilization and expansion. Eardley-Wilmot's image depicts the simile 'Eyes like a little limpid pool' in a picturesque scene of a *large* body of water (Figure 2.13). This is not a literal representation at all: the image implies that the photographic eye exists in a similar power relationship with verse, overwriting poetic images whenever desirable. Against this prescriptive photographic eye, the loss of a stable poetic 'I' resonates with Nicolson's recurring theme of estrangement. In the semantic instability she creates, the binaries of speaker/listener, I/you, and self/other collapse. Nicolson's poems reject the idea of gender-performative personas, whereas the implied objectivity of Eardley-Wilmot's images means that her presence in the photobook is entirely dependent on her role as 'the photographer'. Landscape is an imaginative construct defined subjectively by individual viewers, and while Nicolson's poems leave open the issue of perception (self/other, male/female, you/I), Eardley-Wilmot's documentary photographs promise objectivity. Their picturesque nature negates individual perception: they are photographs of the landscape *as it should be.*

The coupling of Nicolson's repetitive yearning for sexual possession and the photograph as an object of conservation – an object in which memories, people, and places can be possessed – is a good catalyst for evaluating *Songs*. The addition of photographs inflects ideas of remembering and recording in Nicolson's work. In 'Reverie of Mahomed Akram', a photographic illustration complements an apparent invocation of photography:

> Alas you drifted away from me,
> And Time and Space have rushed in between,

Figure 2.13 Mabel Eardley-Wilmot, 'Golden Eyes', in *Songs from the Garden of Kama*, 1908. Reproduced with the permission of the Dummett family. Courtesy of the University of St Andrews Library, photo PR6027.I37F09.

> But they cannot undo the Thing-that-has-been,
> Though it never again may be. (8–9)

Nicolson's 'Thing-that-has-been' foreshadows Roland Barthes's construction 'That-has-been' as the *noeme* of photography. 'I call "photographic referent" not the *optionally* real thing to which an image or a sign refers,' writes Barthes, 'but the *necessarily* real thing which has been placed before the lens, without which there would be no photograph.'[62] Eardley-Wilmot's photographs are Barthes's 'experiential order of proof' only in the travel narrative of their own creation: they attest only to her photographic journey through India. Of the verse itself, they connote virtually nothing: the photographic illustration does not reflect the poem's own 'Thing-that-has-been'. Barthes's essay 'The Photographic Message' comments on the 'communication' between the 'contiguous but not "homogenized"' structures of photograph and text.[63] Barthes emphasizes that, because words cannot '"duplicate" the image', a new space of signification is created 'in the movement from one structure to the other'.[64] These 'second signifieds' can amplify or contradict the set of connotations already imbued in

the photograph.[65] This is especially true of photopoetry. While Roy writes that Nicolson's poems 'allow for new structural possibilities to emerge whereby fixed notions about identity can be reimagined', we can extend this reimagination to the space created between her verse and Eardley-Wilmot's photographs.[66] *Songs* constitutes an experiment in literary form and textual format, one whose dialogue between two opposing representations of the Orient creates new ways of thinking about both the poems and the photographs. Such an ingrained ideological contrast complicates the position of the reader: the discord between poetic voice and photographic vision creates a treacherously navigable space between the two.

Photographing FitzGerald's *Rubáiyát*

For a poem that engages so intently with optical technologies and the idea of 'writing with light', it is surprising that only two editions of Edward FitzGerald's *Rubáiyát of Omar Khayyám* have been published with accompanying photographs, as opposed to drawings or etchings. After all, the *Rubáiyát* is 'probably the most widely illustrated of all literary works' according to William H. Martin and Sandra Mason, whose survey of its illustrated history encompasses more than three hundred editions published since Elihu Vedder's seminal work in 1884.[67] The 'golden age' of illustrating the *Rubáiyát* occurred in the first fifteen years of the twentieth century, and formed one aspect of the 'Omar Craze', a period in which the poem became tremendously popular and inspired innumerable artistic, cultural, and commercial responses, from literary parodies and dramatic production to chocolate wrappers and an entire brand of cigarettes.[68] The two photographic editions were products of, and responses to, the 'Craze'. In 1905, American photographer Adelaide Hanscom Leeson (1875–1931) produced a pictorial version of the *Rubáiyát's* fourth edition (1879). Seven years later, Kegan Paul, Trench, Trübner & Co. built on Heinemann's success with Eardley-Wilmot and Nicolson's *Songs* and published a version of the *Rubáiyát's* first edition (1859). With quatrains and photographs printed separately on subsequent pages, or printed side by side and linked explicitly through captions excised from the poem, these photobooks are the first attempts to arrest the 'Magic Shadow-shapes' of the *Rubáiyát* in photographic form.

Coinciding with the main period of the 'Craze', as Martin and Mason record, was the introduction of 'a more orientalist element' into many of the illustrated

editions.[69] While many scholars have considered the *Rubáiyát* an orientalist text, Annmarie Drury has recently argued the reverse, citing FitzGerald's own dim view of imperial expansion, his kinship with Khayyám as a literary attraction rather than an orientalist appropriation, and his celebration of the hybridity of the poem through his practice of imitation rather than strict translation.[70] That said, it is not difficult to perceive how the poem might lend itself to orientalist responses, and this is especially true of Hanscom Leeson and Eardley-Wilmot's photographic editions. While Hanscom Leeson's photobook reflects the 'free-floating mythology of the Orient', to borrow Edward Said's phrase about texts like the *Rubáiyát*, Eardley-Wilmot's edition places the poem at the centre of a colonial enterprise.[71] Such engagements were not necessarily deliberate attempts to produce imperial propaganda, however, but were likely the result of an ingrained worldview: Eardley-Wilmot was married to a high-ranking official in the Indian Forest Service; Hanscom Leeson, on the other hand, lived and worked as pictorial photography flourished in California.

The connections between the history of photography and Europe's knowledge and understanding of the Middle East clearly inform the 'orientalist element' of the two photobooks. As Ali Behdad and Luke Gartlan write,

> photography was key to the evolution and maintenance of Europe's distinctively Orientalist vision of the Middle East, where Orientalism is broadly understood as a Western tradition and style of thought, imagery, and language used to represent the Middle East for European audiences.[72]

Building on an orientalist tradition of photography, the photobooks contain an orientalist vision that FitzGerald himself had not intended to create in his translation of the *Rubáiyát*. The manner in which the two photographers attempted to 'translate' FitzGerald's literary vision into a photographic, sometimes oriental, one reflects trends within Victorian translation practice, and challenges the reader to question how the poetic and photographic representations coexist or relate to one another. Their responses shed light on the poem's concern with the interplay between authenticity and factitiousness, and between literal and metaphorical truth. Examining the two photographically illustrated versions enriches our appreciation of the *Rubáiyát* as a reflection on the practices of appropriating, translating, and understanding other cultures. Each photographic edition evinces a distinctive approach to 'translating' FitzGerald's poem into photographs: Hanscom Leeson engaged with the mythology and symbolism of the *Rubáiyát*, producing a highly personal and metaphorical

portfolio of images using nude models and manipulation techniques common to photographic pictorialism; Eardley-Wilmot, conversely, uprooted the poem from medieval Persia to the landscapes of British India, staging the *Rubáiyát* as a colonial, oriental space. In their vastly divergent responses to the poem, the two photobooks neatly represent the differences between transatlantic photopoetry in the early twentieth century: while British photopoetry was still hung up on landscape and the picturesque, American photopoetry was breaking new ground in its theatrical representations of the human figure. Experimenting with different ways of achieving a 'true' representation, Hanscom Leeson and Eardley-Wilmot's photobooks offer fascinating insights into the connection between photography and translation in an orientalist context. While Eardley-Wilmot sought to translate the *content* of FitzGerald's poems – its landscapes, caravanserais, towers – Hanscom Leeson translated FitzGerald's *approach* to the *Rubáiyát* itself, a looseness of style that led to the poet's famous analogy concerning translation: 'Better a live Sparrow than a stuffed Eagle.'[73]

* * *

Praising Eardley-Wilmot's edition of the *Rubáiyát*, one reviewer tellingly remarked that 'Such views ... tell the reader more about Omar Khayyám's environment than whole chapters of commentary.'[74] Ironically, the photographs were taken in India, not Persia. This transference demonstrates how editorial practice could make photography complicit in creating an Orient bearing little relation to actual places and regional specificities. Placed alongside the *Rubáiyát*, Eardley-Wilmot's images demonstrate how photography in the British Empire, 'despite claims for its accuracy and trustworthiness', as James Ryan notes, 'did not so much record the real as signify and construct it'.[75] This is the central conflict of her photobook: the photographs both engage with and challenge the agency of FitzGerald's poem, signifying its scenes but constructing it from an orientalist perspective.

While Hanscom Leeson, like FitzGerald, saw Omar as a kind of kindred spirit, Eardley-Wilmot saw him as a convenient spectator through whom to visualize the scenes of the poem. Except for occasional figures appearing as accessories, lending either perspective or a sense of movement to her photographs, Eardley-Wilmot employs a depopulating aesthetic common to orientalist photography, centralizing the reader/viewer as the sole holder of the photographic gaze. In order to foreground this singularly orientalist vision, a focus on singular perspective became an important feature of Eardley-Wilmot's photobook. The reader/viewer's passage through the photobook echoes the passage of

the photographer through the Indian forests, extending the journey we first witnessed in *Songs*. The use of a photographic frontispiece illustrating a caption drawn from quatrain XXXVIII, 'The Caravan / Starts for the Dawn of Nothing', represents a moment of departure, and indicates the journey-like structure of the ensuing photobook. The phrase 'Dawn of Nothing' suggests this is both a geographical and temporal journey, as though Eardley-Wilmot will guide us back into a mythical past, one as supposedly pre-photographic as it is colonial.

Most pairings in the photobook are literal attempts to match Eardley-Wilmot's photographs to the content of FitzGerald's poem. As a result, concrete nouns of FitzGerald's quatrains are afforded more attention than the metaphorical connotations of the poem. The cock and snake, of quatrains III and LVIII respectively, provide the sole focus of illustrative photographs: in the poem, however, they are minor elements serving no metaphorical or symbolic function. This approach heightens the spectatorial mode of Eardley-Wilmot's photobook, in which the reader/viewer looks inwards on a framed, managed space, and in turn becomes complicit in the representation and construction of orientalist space. Her photographs allow the armchair traveller to step into the place of the photographer-explorer and indulge in moments of discovery. Through the blurring of poetic speaker and photographic spectator, the reader/viewer often comes to assume the role and space of the Omar-like figure as speaker and observer. For example, the accompanying photograph to the first quatrain of the 'Kúza-Náma' section, does not stage the Omar-like speaker when he proclaims 'I stood alone / With the clay Population round in Rows' (LIX). Rather, Eardley-Wilmot represents the 'old Potter's Shop' with a display of earthenware. The photographer's eye serves as a conduit through which the reader/viewer can adopt the space of the poetic speaker. By drawing on the perspective offered by this particular quatrain, Eardley-Wilmot's photograph sought to legitimize the position of the viewer in constructing an orientalist vision. Her photobook encourages the reader/viewer to possess the photographic vista, FitzGerald's poem, and the imperial space itself.

Beneath each photograph is an excerpt from the matching quatrain. These captions imply that some poetic images are of greater significance than others. For example, quatrain XXVI takes the reader to its apparent centre by reprinting the line 'The Flower that once has blown for ever dies' beneath the accompanying photograph. By drawing the reader's attention to a photograph of an actual flower rather than the metaphorical implications of the verse, the photobook reveals the desirable interpretation of the poem as a literal vision of the Orient.

This is an example of what Ali Behdad calls the 'excessive textual anchorage' of the orientalist photograph, in which such labels 'demonstrat[e] a profound anxiety about the potential for the plurality of signifieds in it'.[76] The caption insists too much on the literal image, especially when the quatrain is printed in full on the adjacent page: in attempting thereby to fix the meaning of the poem, the remaining lines of the *Rubáiyát* become almost superfluous. Examining the photobook with Behdad's remarks in mind, we can recognize how it participates in an orientalist strategy. With its style of captioning, it attempts to locate the poem in the organized and appropriated spaces of orientalist photography, demonstrating how an orientalist approach to photography came to affect the illustration of poetry that engages with the spaces, cultures, and histories of the Middle East and beyond.

One likely reason for this 'anchorage' strategy is that Eardley-Wilmot's photographs were not taken with the *Rubáiyát* in mind, but added to the text later. Inevitably, this made it difficult for the images to interact with the *Rubáiyát* beyond a literal, surface-level engagement. Paradoxically, though, the literalism of Eardley-Wilmot's approach resonates with a desire for literalism that, as Herbert Tucker persuasively argues, underlies FitzGerald's poetic language in the *Rubáiyát*. According to Tucker, the fact that metaphors follow each other in quick succession, only to be discarded, serves to 'bankrupt the allegorical tendencies of metaphor by overindulgence'.[77] By sheer multiplication of metaphoric images, these images cancel each other out and reinforce the truth that lies behind the metaphorical representation: the subversion of metaphor informs the 'recycling of identity' that underscores the central themes of transience and mutability in the *Rubáiyát*.[78] This strengthens the impression that Eardley-Wilmot's photobook sought a literal translation of the poem's content. Quatrain I, which describes a sunrise, is accompanied by a photograph of a sunrise:

> Awake! for Morning in the Bowl of Night
> Has flung the Stone that puts the Stars to Flight:
> > And Lo! the Hunter of the East has caught
> The Sultán's Turret in a Noose of Light. (I, 1859)

The photograph literalizes the 'Noose of Light' metaphor (Figure 2.14). In doing so, however, it adds orientalist meanings that FitzGerald had not intended. Light imagery begins and ends the *Rubáiyát*, and for Eardley-Wilmot this imagery attains importance in relation to the project of colonial photography. 'As a technology based on the power of light,' Ryan notes, 'photography assumed

particular symbolic significance as part of geographical discourse … [and] represented a transference of "light" into the "dark" recesses of the globe.'[79] While Eardley-Wilmot literalizes FitzGerald's 'Noose of light' into a sunrise, it also becomes a metaphor for such a colonial enterprise: an exploration of Indian forests becomes an exploration into the dark recesses of FitzGerald's poem and, beyond that, the original Persian text. In acknowledging that the medieval Persia about which Khayyám originally wrote no longer exists, Eardley-Wilmot attempts to replace it with a colonially controlled and constructed space, shedding photographic light on the purportedly dark, oriental nature of the *Rubáiyát*.

These issues come to a head in the publishers' note that begins the photobook. It notes that 'the illustrations in this edition are reproduced from photographs specially taken for it in the East'.[80] There is no evidence to suggest Eardley-Wilmot ever travelled to Persia, the supposed site of the poem; thus, the publishers' conflation of colonial India and medieval Persia into 'the East' undermines the supposed visual truth of photography. In her consideration of the 'Omar Craze', Michelle Kaiserlian suggests the responsibility for the substitution lies

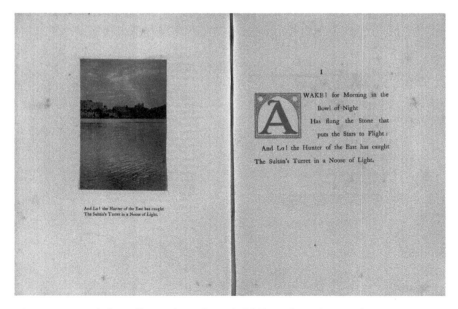

Figure 2.14 Mabel Eardley-Wilmot, 'Untitled (I)', in *The Rubáiyát of Omar Khayyám*, 1912. Reproduced with the permission of the Dummett family. Courtesy of the University of St Andrews Library, photo PK6513.A1F12.

with Eardley-Wilmot. 'Her visual substitution of India for Persia,' Kaiserlian writes, 'becomes a metaphorical conquering of land, culture, and poem and an exposition of imperialist rhetoric.'[81] While these effects hold true, there is no evidence to suggest intentionality on the part of Eardley-Wilmot. The reality is more nuanced. It seems unlikely that the photographs were originally taken with active orientalist intentions. Furthermore, I believe that book illustration was a result, not a cause, of her photography. There is a strong possibility that the *Rubáiyát* came later to Eardley-Wilmot's photographs – not, as the publishers' note suggests, as a direct influence upon them. Any apparently symbiotic moments between Eardley-Wilmot's photographs and the *Rubáiyát* do not survive closer inspection: all such moments have been manipulated after the taking of the photographs. In quatrain XLII, for example, the 'Angel Shape' has been superimposed over the captioned image; in quatrain LI, a clumsily etched silhouette of a hand has been added to the photograph to evoke the caption, 'The Moving Finger writes; and, having writ, / Moves on.' The recontexualization of her photographs in photobook form reveals not that they were taken as a contribution to a pervasive orientalist vision, but that they were the result of one – a product of the continuing popularity for consumable material that represented the Orient. By combining a poetic creation and visual representations of an actual place into an 'imaginative geography', Eardley-Wilmot blurred the lines between what is real and what is represented.

* * *

At a time when photography vied to become a 'true art form' and women 'had yet to be recognized as practitioners', notes Rachel Martin Cole, Adelaide Hanscom Leeson's work 'was a groundbreaking achievement for a female artist'.[82] Published in 1905, her edition of the *Rubáiyát* contains twenty-eight photographs portraying figures and symbols adapted from the poem, with Bay Area literati such as Charles Keeler, Joaquin Miller, and George Sterling acting as models. Her photographs combine the influences of the art nouveau movement, Pre-Raphaelitism, fellow photographer Anne Brigman (1869–1950), and cosmopolitan dance.[83] Judith Walkowitz suggests that two historic meanings of prewar cosmopolitanism shaped the kind of dance exemplified by Isadora Duncan and Maud Allan: 'First, a pleasurable, stylized form of imaginative expatriation, associated with privileged mobility; and second, a debased condition of deracination, hybridity, displacement, and racial degeneration – all the dangers of the unplaced.'[84] Applying these definitions to Hanscom Leeson's *Rubáiyát*, it is not difficult to see how her *tableaux vivants* dramatize her

fascination with orientalism in an act of 'imaginative expatriation', fabricating a 'free-floating' orientalized world within her studio.[85] Crafting an aesthetic around FitzGerald's symbolism, Hanscom Leeson created a semi-mythical space in which her photographs bore no indexical relationship to a geographically identifiable location. Photography's supposed quality of inherent truthfulness makes such a rejection of its indexicality a much more powerful statement than a similar strategy in the more purely creative undertakings of drawing and etching. From this perspective, Hanscom Leeson's photobook can be seen in the context of early twentieth-century American orientalism, in which 'oriental imagery appeared', Holly Edwards notes, 'as the backdrop for new and titillating personal experiences'.[86] In Hanscom Leeson's case, FitzGerald's Orient provided a photographic context in which to explore her own sexuality.

Hanscom Leeson was second only to Julia Margaret Cameron in her creative use of figure-centric photographs to enter into dialogue with poetry. Cameron's photographic edition of Tennyson's *Idylls of the King* (1875) was the first sequence to suggest photography could complement or even surpass poetry in aesthetic terms and move beyond the hierarchical illustrative relationship in which photography was *de rigueur* the junior partner. In adopting an explicitly pictorial approach, Hanscom Leeson used manipulated negatives and nude models, blended Persian and Christian symbols, and hybridized Pre-Raphaelite and orientalist traditions. Her work was not mere photographic illustration; instead, it marked the beginnings of a symbiotic relationship between poem and photograph. In a reflection of FitzGerald's own ethic of translation, Hanscom Leeson sought to capture the original's spirit rather than its literal content.

This approach allowed her to engage more closely with the play between literal and metaphorical truth that characterizes the *Rubáiyát*. The poem's metaphors and symbols are central not only to the photographs themselves but also to the structure of her photobook. The arrangement of quatrains and photographs does not encourage prescriptive, illustrative links between text and image. In most cases, three quatrains printed on the same page precede a photograph, but text and image are never seen together, as they are separated by blank pages. Thus, a literal connection to a specific image in a specific quatrain is often difficult to ascertain. Nor are the photographs captioned with specific excerpts, further undermining the possibility of direct connections. Since the quatrains and photographs are placed on subsequent rather than adjoining pages, with the space next to photograph or text remaining blank (forcing the reader to turn the page), each quatrain (or set of quatrains) is informed in equal

measure by the photograph on the previous and the subsequent set of pages. This structure allowed Hanscom Leeson to take greater freedom with the structure of FitzGerald's own poetic images and create her own network of photographic metaphors.

Hanscom Leeson's ability to create such networks bespeaks a highly original and uniquely personal response to the *Rubáiyát*. Like FitzGerald, she saw herself occupying an Omar-like role, but with her own understanding of what this entailed. 'Omar,' she thought, 'had a keen insight into the truth of things,' and she considered the poem to be 'an expression of the struggle of the human soul after the truth, and against the narrowing influence of the dogmatic religions of the time'.[87] FitzGerald published four editions of the *Rubáiyát* in his lifetime, and at the beginning of each was his prefatory essay on 'Omar Khayyám: The Astronomer-Poet of Persia'. This designation, Daniel Karlin remarks,

> is like a warning not to expect caliphs and harems, genii and giaours, magic carpets or Circassian beauties. It also connotes a respect for what is historically and culturally distinctive, as opposed to 'Oriental' in a vague, generalized sense.[88]

Like most illustrated editions of the poem, Hanscom Leeson's version drops FitzGerald's essay, and with it any sense of unified narratorial presence. For Hanscom Leeson, Omar was less an historical figure than a spirit that she and her work could embody. While this inevitably led to photographs that reduce the poem's historical and cultural distinctiveness, Hanscom Leeson's manipulations and embellishments encourage the reader/viewer to realize the artificiality inherent in any attempt to represent the Orient.

At the centre of Hanscom Leeson's *Rubáiyát* – and photopoetry more generally – is the question of how to handle poetic metaphor in photographs. Hanscom Leeson's looseness of approach meant that she developed FitzGerald's images beyond the scope of the poem itself, reinterpreting and extending them in her photographs. Drury has argued that the *Rubáiyát* is governed by an aesthetic of accident: 'Persistent images of flinging, scattering, and blowing' highlight the poem's denial of divine providence while simultaneously reflecting on FitzGerald's translation practice.[89] When Hanscom Leeson adopts this aesthetic, she does not photograph the flowers and sunrises that are flung and scattered in the poem: instead, her models *enact* the gestures of flinging and scattering. Motifs of flowers and sunrises lend themselves to traditional forms of photographic illustration: Hanscom Leeson's theatrical gestures, on the other hand, bespeak a greater symbiotic relationship between text and image.

Nowhere is this more evident than in quatrain I, when FitzGerald's imagery of scattering and striking clearly informs the theatrical nature of Hanscom Leeson's work:

Wake! For the Sun who scatter'd into flight
The Stars before him from the Field of Night,
 Drives Night along with them from Heav'n, and strikes
The Sultan's Turret with a Shaft of Light. (I, 1879)

Hanscom Leeson interprets rather than illustrates the metaphor, developing it beyond the space of the text. In fact, three photographs relate to this single quatrain. The photograph following the quatrain shows the gesture of a male model 'scatter[ing] into flight / The Stars', with swirls etched on to the negative with a palette knife. Immediately preceding the quatrain, however, is a photograph of a nude female model, arms outstretched, dressed in a thin, transparent veil: she appears to ascend from the dark space at the bottom of the photograph, like a 'Shaft of Light'. This conveys the idea of sunrise, although the model's gender contradicts FitzGerald's masculine gendering of the sun. The photobook's first photograph further complicates matters: a kneeling female model is used to evoke sunrise. The same model closes the photobook, again in a kneeling posture, but this time with her body lowered, evoking sunset. In providing three photographic exposures for a single quatrain, Hanscom Leeson mimics the multiplicity and factitiousness of the poem, and enables closer formal links to be developed between her images and the text. This excessive and contradictory photographic captioning not only suggests the inherent multiplicity of the poem, it also reveals an approach that parallels FitzGerald's attempt to capture spirit, rather than create a literal translation.

To suggest, however, that Hanscom Leeson merely modified FitzGerald's own metaphors would be to do her work a disservice. Her photographs construct networks of metaphors that, while derived from images and motifs in the text, create original layers of meaning. For example, the photograph of the male model 'scatter[ing] into flight / The Stars' depicts him with a sword though no sword is mentioned in the quatrain itself. The only textual appearance of a sword occurs in quatrain LX:

The mighty Mahmúd, Allah-breathing Lord,
That all the misbelieving and black Horde
 Of Fears and Sorrows that infest the Soul
Scatters before him with his whirlwind Sword. (LX, 1879)

This quatrain is followed by a photograph echoing the photograph that accompanied quatrain I (Figure 2.15). The presence of the sword and the comparable gestures of the model in both photographs link the two quatrains: connections between quatrains and photographs in Hanscom Leeson's photobook are not tied to specific pairings or governed by narrative sequence. Through the verb 'scatters', Hanscom Leeson plays upon FitzGerald's aesthetic of accident to suggest how her own images and metaphors are flung or scattered across the poem, both diverging from FitzGerald's quatrains and linking them in new and unexpected ways.

The aesthetic of accident also allowed Hanscom Leeson to exploit what William Cadbury terms the 'gross inconsistencies' of the poem's lyric voice, picturing a variety of models in the role of speaker.[90] In quatrain XXI, a female model represents the speaker, encouraging 'my Belovéd [to] fill the Cup that clears / To-day of past Regret and future Fears'. For a female photographer, casting the speaker as sexually ambiguous is both a subversive representational strategy and an echo of the poem's capricious images: the photographically represented speaker's shifting sexuality is in dialogue with the poem's instabilities of image and metaphor. As a result, Hanscom Leeson's photobook creates strong connections between the aesthetics of accident and transference. In fact, the aesthetic of transference governs Hanscom Leeson's photographs to the extent that it impinges on how we read the *Rubáiyát* alongside them. Cups, pots, jugs, and bowls occur frequently in the poem; for Hanscom Leeson they assume a central focus. Fourteen of her photographs feature such receptacles: the three photographs in which she includes text all mention a cup, pot, or jug explicitly or have a vessel incorporated into the scene. Hanscom Leeson's photograph for quatrain LV, for example, moves beyond illustration in its inclusion of a cup, alluding to several surrounding quatrains in which verses and wine are mentioned. Here, the 'Daughter of the Vine' gestures towards 'barren Reason', holding a cup towards her; Hanscom Leeson borrows one of FitzGerald's motifs and uses it to inform her theatrical interpretation of another quatrain.

Gesture is central to her entwinement of these two aesthetics. Where cups and other vessels are involved, a gesture is often central to the development of the image. In quatrain LVIII, Hanscom Leeson's photograph enacts the gesture of the 'Angel Shape / Bearing a Vessel on his Shoulder', a phrase that occurs in the unrhymed line of FitzGerald's un-English *aaba* form (Figure 2.16). The significance, as Drury has discussed, lies in the notion that the unpredictability of the line endings reinforces FitzGerald's aesthetic of accident.[91] That Hanscom

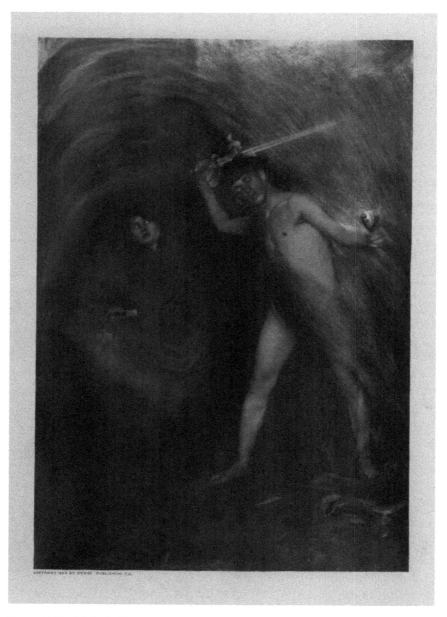

Figure 2.15 Adelaide Hanscom Leeson, 'Untitled (LX)', in *The Rubáiyát of Omar Khayyám*, 1905. Courtesy of the University of St Andrews Library, photo PK6513. A1F08.

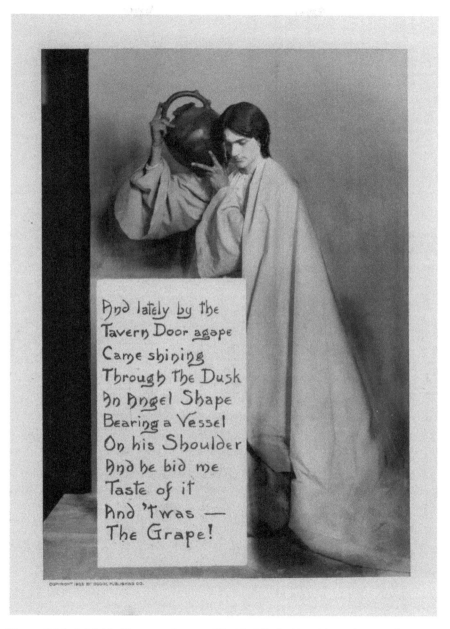

Figure 2.16 Adelaide Hanscom Leeson, 'Untitled (LVIII)', in *The Rubáiyát of Omar Khayyám*, 1905. Courtesy of the University of St Andrews Library, photo PK6513. A1F08.

Leeson should choose to photograph a gesture occurring in the unpredictable third line creates a formal link between the image patterns of accident and transference in both poem and photographs. Furthermore, it demonstrates looseness in translation comparable to that of FitzGerald. Through these formal resonances, Hanscom Leeson highlights how her interweaving of textual and visual metaphors creates a deeper structural engagement between poem and photograph.

We might question why Hanscom chose the 'bearing' gesture over that of the concluding line, the more active and engaging 'He bid me taste of it.' For one, this is undoubtedly a more subtle gesture, one less suited to Hanscom Leeson's style of photography. In addition, Hanscom Leeson also photographs moments of invocation alongside gestures: that is, when the speaker is invoking or gesturing to *the reader* to do something, not just when the speaker him/herself is being invoked, as in quatrain LVII. This practice links directly to Hanscom Leeson's aesthetic of transference. On both occasions when there is a direct invocation to the reader to 'fill the cup' – quatrains VII and XXI – Hanscom Leeson's photographs depict female characters holding out vessels. The act of gesturing here is twofold: the text gestures to the photographs and the photographs gesture beyond the space of the photobook. The 'bid me taste of it' of quatrain LVIII, however, looks inwards to the speaker, not outward to the reader, hence Hanscom Leeson's decision not to photograph the gesture. It is a sign of the symbiotic connection between poem and photographs that the focus turns to the reader and the space beyond the photopoem, not to the internal dynamics of text and image.

Adapting the *Rubáiyát* into an entirely imaginative construct – with photography more akin to painting or drawing than the visual truth of photography itself – Hanscom Leeson drew on the visual nature of the poem in order to develop new metaphorical resonances with her accompanying images. Eardley-Wilmot, on the other hand, provided a more literal interpretation in which the iconography of the poem was transported to colonial India. Neither photobook is a more real or true response to the poem than the other. There were different agendas and circumstances informing their unique responses. Each must be considered as part of its unique cultural, historical, and social context. A comparison of these two photobooks demonstrates how, in retrospective photopoetry, photographs could translate as well as illustrate a poem. What connects Hanscom Leeson and Eardley-Wilmot in their approaches to FitzGerald's *Rubáiyát* is that both photographers use the

act and object of photography as a means of cultural translation. Each offers a unique perspective in terms of how a poem can inform the taking, captioning, sequencing, and publishing of an accompanying photographic sequence. Each translates the *Rubáiyát* from what FitzGerald called its 'Persian garden' into a new and challenging space, taking the poem in new directions and making new claims for its status as part of the history of representing the Orient.[92] Eardley-Wilmot's photobook overlays her own set of experiences and photographs on the poem, and encourages the reader to consider FitzGerald's *Rubáiyát* in an orientalist context. While its literal approach does little to engage with the photographic subtext of FitzGerald's poem, Eardley-Wilmot's photobook enables us to understand how photography can use poetry as a means of cultural appropriation. Hanscom Leeson, on the other hand, integrates text and image, and as a result her photobook is closer in spirit to the *Rubáiyát*, though not to the reality of medieval Persia that underlies the poem. The manner in which Hanscom Leeson handled, evoked, and developed FitzGerald's images and metaphors conveys a deeper, personal engagement with the poem. It is for this reason that her photobook is one of the outstanding examples both of artistic responses to the *Rubáiyát* and of early works of photopoetry in general.

* * *

The photographic interpretations of the *Rubáiyát* heralded an important moment in photopoetic history. Where retrospective work, especially in Britain, had long relied on an illustrative framework, the translation approach adopted by American practitioners began to demonstrate how creative photographic responses to poetry were as valid as those that sought to provide literal equivalents to verse. Photography as a form of translation that sought the spirit rather than content of poetry would inform how photographers and poets began to collaborate in the early twentieth century. The American focus on people rather than place meant that translation projects were more politically nuanced than their illustrative, landscape-centric counterparts. Sophisticated engagements with identity-shaping ideologies – positive and negative – meant that photopoetry quickly became stylishly cosmopolitan. Hanscom Leeson's work demonstrates how the photographer was no longer content to support the voice of the poet, but strived to challenge and contradict it in pursuit of a conflicting, individual photographic interpretation. Such pursuits, as I have explored in the HICC's photographic work, were not always flights of the historical imagination, but served to reinforce destructive ideologies of gender and race. The HICC books demonstrate the manipulations possible through

retrospective photopoetry, with poems being used to support photographic narratives that they did not remotely endorse. The Eardley-Wilmot photobooks were more nuanced in their representation of identity politics: while the editorial decision to pair her photographs with poems set in the Orient demonstrates how picturesque photographs were used to appropriate the objectified other, the photographs themselves express how photography 'open[ed] up a new mode of expression, particularly for women to participate in the discourse of empire', and how commercial opportunities were opening up for women photographers.[93] These competing voices and ideologies attest to an especially turbulent moment in the history of photopoetry.

This chapter has attempted to suggest that early photopoetic practices are more complicated than the label 'photographic illustration' implies. The challenges and opportunities that photographers discovered in working with poetry led, in the early twentieth century, to collaborations with poets. These works would focus on relationships between poems and photographs that were mutually informing, rather than the single currents of interpretation and response that structured retrospective photopoetry.

Notes

1 Clara E. Laughlin, *Reminiscences of James Whitcomb Riley* (New York; Chicago: Fleming H. Revell, 1910), 63.

2 Laughlin, *Reminiscences*, 63–65.

3 See, for example, the two nudes published in Alfred Stieglitz's periodical *Camera Work* 18 (April 1907), 53–55.

4 Judith Fryer Davidov, *Women's Camera Work: Self/Body/Other in American Visual Culture* (Durham, NC; London: Duke University Press, 1998), 9.

5 Kathleen Pyne, *Modernism and the Feminine Voice: O'Keeffe and the Women of the Stieglitz Circle* (Berkeley; Los Angeles; London: University of California Press, 2007), xxix.

6 Linda Nochlin, foreword to *The New Woman International: Representations in Photography and Film from the 1870s through the 1960s*, ed. Elizabeth Otto and Vanessa Rocco (Ann Arbor: University of Michigan Press, 2011), ix.

7 Isobel Armstrong, *Victorian Poetry: Poetry, Poetics, and Politics* (London; New York: Routledge, 1993), 318.

8 Isadora Duncan, *The Art of the Dance*, ed. Sheldon Cheney (New York: Theatre Arts, 1928), 57.

9 Naomi Rosenblum, *A History of Women Photographers* (London; Paris; New York: Abbeville Press, 2000), 103.

10 Note a similar, more explicitly dance-related aesthetic in Edward R. Dickson, ed. *Poems of the Dance: An Anthology* (New York: Alfred Knopf, 1921).

11 Austin Dobson, *Collected Poems* (New York: E. P. Dutton, 1913; London: Kegan Paul, Trench, Trübner, 1913), 155–156.

12 'The Monochord', *The Works of Dante Gabriel Rossetti*, ed. William M. Rossetti (London: Ellis, 1911), 101.

13 Thomas Moore, *Odes of Anacreon: Translated into English Verse*, 4th ed. (London: Printed for J. Carpenter, 1804), 73–79.

14 Kendall Banning and Lejaren À Hiller, *Bypaths in Arcady: A Book of Love Songs* (Chicago: Brothers of the Book, 1915). All subsequent quotations from Banning's poetry derive from this edition.

15 John Berger, *Ways of Seeing* (London: Penguin, 1972), 54.

16 Agnes Richards, 'A Genius in Art Photography', *Fine Arts Journal* 32, no. 3 (March 1915), 107.

17 Ovid, *Metamorphoses*, trans. Frank Justus Miller, vol. 1 (London: William Heinemann, 1916; Cambridge, MA: Harvard University Press, 1916), 53.

18 *Ovid's Metamorphoses in Fifteen Books: Translated by the Most Eminent Hands. Adorn'd with Sculptures*, trans. Joseph Addison et al. (London: printed for Jacob Tonson, 1717), 32.

19 Ovid, *Metamorphoses*, trans. David Raeburn (London: Penguin, 2004), 40.

20 Ray Sapirstein, 'Picturing Dunbar's Lyrics', *African American Review* 41, no. 2 (Summer 2007), 327.

21 See James Guimond, *American Photography and the American Dream* (Chapel Hill; London: University of North Carolina Press, 1991), 21–54.

22 Michael North, *The Dialect of Modernism: Race, Language, and Twentieth-Century Literature* (New York; Oxford: Oxford University Press, 1994), 22.

23 Andrew Heisel, 'What to Do with "Southern Negro types" in Dunbar's Hampton Volumes', *Word & Image: A Journal of Verbal/Visual Enquiry* 28, no. 3 (July–September 2012), 244.

24 Duncan S. A. Bell, 'Mythscapes: Memory, Mythology, and National Identity', *British Journal of Sociology* 54, no. 1 (March 2003), 66.

25 Gavin Jones, *Strange Talk: The Politics of Dialect Literature in Gilded Age American* (Berkeley; Los Angeles: University of California Press, 1999), 203; Emily Oswald, 'Imagining Race: Illustrating the Poems of Paul Laurence Dunbar', *Book History* 9, no. 1 (2006), 214.

26 Heisel, 'Dunbar's Hampton Volumes', 243.

27 Oswald, 'Imagining Race', 222.

28 Oswald, 'Imagining Race', 219–220.

29 See Heisel, 'Dunbar's Hampton Volumes', 246.

30 Heisel, 'Dunbar's Hampton Volumes', 250.

31 See Ray Sapirstein, 'Out from behind the Mask; The Illustrated Poetry of Paul Laurence Dunbar and Photography at Hampton Institute' (PhD diss., University of Texas at Austin, 2005), 171–265.

32 Essie Collins Matthews, *Aunt Phoebe, Uncle Tom and Others: Character Studies Among the Old Slaves of the South, Fifty Years after* (Columbus, OH: Champlin Press, 1915), 16.

33 Sapirstein, 'Out from Behind the Mask', 253.

34 Deborah M. March, 'Reframing Blackness: The Photograph and African American Literary Modernism at the Turn of the Twentieth Century' (PhD diss., Yale University, 2012), 19.

35 Christopher Pinney, *Camera Indica: The Social Life of Indian Photographs* (London: Reaktion Books, 1997), 45, 46.

36 North, *Dialect of Modernism*, 22.

37 Kevin Kelly Gaines, *Uplifting the Race: Black Leadership, Politics, and Culture in the Twentieth Century* (Chapel Hill: University of North Carolina Press, 1996), 220.

38 Susan Prendergast Schoelwer, 'The Absent Other: Women in the Land and Art of Mountain Men', in *Discovered Lands, Invented Pasts: Transforming Visions of the American West*, ed. Jules David Prown et al. (New Haven, CT: Yale University Press, 1992), 143.

39 See Heisel, 'Dunbar's Hampton Volumes', 251. The other non-dialect poem is 'The Voice of the Banjo', in Paul Laurence Dunbar and Leigh Richmond Miner, *Joggin' Erlong* (New York: Dodd, Mead, 1906), 41–45.

40 See Judith Butler, *Gender Trouble: Feminism and the Subversion of Identity* (New York: Routledge, 1990), 136.

41 March, 'Reframing Blackness', 31–32.

42 March, 'Reframing Blackness', 32.

43 March, 'Reframing Blackness', 32–35.

44 Anindyo Roy, '"Gold and Bracelet, Water and Wave": Signature and Translation in the Indian Poetry of Adela Cory Nicolson', *Women: A Cultural Review* 13, no. 2 (2002), 141.

45 Roy, 'Signature and Translation', 142; Margaret MacMillan, *Women of the Raj* (New York: Thames & Hudson, 1988), 206–207.

46 Edward Marx, 'Decadent Exoticism and the Woman Poet', in *Women and British Aestheticism*, ed. Talia Schaffer and Kathy Alexis Psomiades (Charlottesville; London: University Press of Virginia, 1999), 139–157.

47 Marx, 'Decadent Exoticism', 148–149.

48 James Elroy Flecker, 'Laurence Hope', *Monthly Review* 81, no. 27 (June 1907), 164.

49 Roy, 'Signature and Translation', 143.

50 Roy, 'Signature and Translation', 143.

51 While no authoritative history of women photographers in British India has yet been written, several accounts exist concerning how photography was a popular pastime for the wives of colonial officials. On Charlotte Canning, wife of governor general of India Charles Canning, see Deepthi Sasidharan, 'A Different Stage of Existence: The Canning Album, 1855–65', in *Aperture and Identity: Early Photography in India*, ed. Rahaab Allana (Mumbai: Marg Publications, 2009), 44–61. On Hariot Lady Dufferin, former vicereine of India, see Eadaoin Agnew and Leon Litvack, 'The Subcontinent as Spectator Sport: The Photographs of Hariot Lady Dufferin, Vicereine of India', *History of Photography* 30, no. 4 (2006), 348–358.

52 See 'Simla Fine Arts Show: The Prize List', *Times of India*, 13 August 1906; 'The Simla Exhibition: Second Notices', *Times of India*, 19 August 1908; and 'Simla Art Exhibition: Prize Winners and Oils', *Times of India*, 14 August 1909.

53 John Falconer, '"A Pure Labor of Love": A Publishing History of *The People of India*', in *Colonialist Photography: Imag(in)ing Race and Place*, ed. Eleanor M. Hight and Gary D. Sampson (London; New York: Routledge, 2002), 57.

54 Gary D. Sampson, 'Unmasking the Colonial Picturesque: Samuel Bourne's Photographs of Barrackpore Park', in Hight and Sampson, *Colonialist Photography*, 84.

55 Christopher Pinney, 'Notes from the Surface of the Image: Photography, Postcolonialism, and Vernacular Modernism', in *Photography's Other Histories*, ed. Pinney and Nicolas Peterson (Durham, NC: Duke University Press, 2003), 204.

56 Pinney, 'Surface of the Image', 204.

57 For a full account of the photographic survey movement, see Elizabeth Edwards, *The Camera as Historian: Amateur Photographers and Historical Imagination, 1885–1918* (Durham, NC: Duke University Press, 2012).

58 Roy, 'Signature and Translation', 144.

59 Roy, 'Signature and Translation', 147.

60 Butler, *Gender Trouble*, 136.

61 Roy, 'Signature and Translation', 156.

62 Roland Barthes, *Camera Lucida: Reflections on Photography*, trans. Richard Howard (London: Vintage, 2000), 76.

63 Roland Barthes, *Image Music Text*, ed. and trans. Stephen Heath (London; Fontana Press, 1977; New York: Hill and Wang, 1977), 16.

64 Barthes, *Image Music Text*, 26.

65 Barthes, *Image Music Text*, 26.

66 Roy, 'Signature and Translation', 158.

67 William H. Martin and Sandra Mason, *The Art of Omar Khayyam: Illustrating FitzGerald's Rubaiyat* (London; New York: I. B. Tauris, 2007), 3.

68 For more detailed accounts of the Omar Craze, see Michelle Kaiserlian, 'Omar Sells: American Advertisements Based on *The Rubáiyát of Omar Khayyám*, c.1910–1920', *Early Popular Visual Culture* 6, no. 3 (November 2008), 257–269; and John Roger Paas, '"Under Omar's Subtle Spell": American Reprint Publishers and the Omar Craze', in *FitzGerald's Rubáiyát of Omar Khayyám: Popularity and Neglect*, ed. Adrian Poole et al. (New York: Anthem Press, 2011), 127–146.

69 Martin and Mason, *Illustrating FitzGerald's Rubáiyát*, 23.

70 See Annmarie Drury, 'Accident, Orientalism, and Edward FitzGerald as Translator', *Victorian Poetry* 46, no. 1 (2008), 37–53. Drury cites numerous examples of the orientalist argument, and the standard view can be found, as she suggests, in J. A. George, 'Poetry in Translation', in *A Companion to Victorian Poetry*, ed. Richard Cronin, Alison Chapman, and Antony Harrison (Malden, MA: Blackwell, 2002), 273–274.

71 Edward Said, *Orientalism* (London: Penguin, 1978), 53.

72 Ali Behdad and Luke Gartlan, introduction to *Photography's Orientalism: New Essays on Colonial Representation*, ed. Behdad and Gartlan (Los Angeles: Getty Research Institute, 2013), 1.

73 Edward FitzGerald to E. B. Cowell, 27 April 1859. *The Letters of Edward FitzGerald*, ed. Alfred McKinley Terhune and Annabelle Burdick Terhune, vol. 2 (Princeton: Princeton University Press, 1980), 335.

74 'The Scene of the Rubaiyat', *London Standard*, 28 May 1912.

75 James Ryan, *Picturing Empire: Photography and the Visualization of the British Empire* (London: Reaktion, 1997), 214.

76 Ali Behdad, 'The Oriental Photograph', in Behdad and Gartlan, *Photography's Orientalism*, 25.

77 Herbert Tucker, 'Metaphor, Translation, and Autoekphrasis in FitzGerald's *Rubáiyát*', *Victorian Poetry* 46, no. 1 (2008), 71.

78 Tucker, 'Autoekphrasis', 72.

79 Ryan, *Picturing Empire*, 26.

80 Mabel Eardley-Wilmot, *Rubáiyát of Omar Khayyám, by Edward FitzGerald* (London: Kegan Paul, Trench, Trübner, 1912), 'Publishers' Note'.

81 Michelle Kaiserlian, 'Infinite Transformation: The Modern Craze Over the *Rubáiyát of Omar Khayyám* in England and America, c.1900–1930' (PhD diss., Indiana University, 2009), 64.

82 Rachel Martin Cole, 'The Rubáiyát of Omar Khayyám', *Art Institute of Chicago Museum Studies* 34 no. 2 (2008), 41.

83 On Anne Brigman, see Pyne, *Feminine Voice*, 63–114; Susan Ehrens, *A Poetic Vision: The Photographs of Anne Brigman* (Santa Barbara, CA: Santa Barbara Museum of Art, 1995); and Heather Waldroup, 'Hard to Reach: Anne Brigman, Mountaineering, and Modernity in California', *Modernism/modernity* 21, no. 2 (April 2014), 447–466.

84 Judith Walkowitz, 'The "Vision of Salome": Cosmopolitanism and Erotic Dancing in Central London, 1908–1918', *American Historical Review* 108, no. 2 (2003), 340.

85 See also Christian A. Peterson, 'American Arts and Crafts: The Photograph Beautiful, 1895–1915', *History of Photography* 16, no. 3 (1992), 189–232.

86 Holly Edwards, 'A Million and One Nights: Orientalism in America: 1870–1930', in *Noble Dreams, Wicked Pleasures: Orientalism in America, 1870–1930*, ed. Holly Edwards (Princeton: Princeton University Press, 2000), 17.

87 'The Berkeley Girl Whose "Omar" Photos Startle the Literary Critics', *Berkeley Daily Gazette*, 19 March 1906.

88 Daniel Karlin, introduction to *The Rubáiyát of Omar Khayyám*, by Edward FitzGerald (Oxford: Oxford University Press, 2009), xxxii.

89 Drury, 'Accident', 41.

90 William Cadbury, 'FitzGerald's *Rubáiyát* as a Poem', *ELH* 34, no. 4 (December 1967), 541.

91 Drury, 'Accident', 40–41.

92 Edward FitzGerald to E. B. Cowell, 2 November 1858. *The Letters of Edward FitzGerald*, vol. 2, 323.

93 Agnew and Litvack, 'Spectator Sport', 358.

From Illustration to Collaboration

Picturing the City, 1913–1956

In March 1914 Ezra Pound (1885–1972) published the anthology *Des Imagistes*. In it he produced one of the defining works of the imagist canon. Often overlooked in favour of 'In a Station of the Metro', this poem is the culmination of what was, for Pound, a surreptitious concern with photography.

> The petals fall in the fountain,
> > the orange-coloured rose-leaves,
> Their ochre clings to the stone.[1]

In its visual immediacy, its dialectic of stillness and movement, and its delicate colour harmonies, 'Ts'ai Chi'h' encapsulates Pound's belief that the image 'instantaneously ... gives ... that sense of freedom from time limits and space limits'.[2] It presents a photographic image *sans* referent. Pound was one of the first to separate photography from reality and translate this lesson into a poetics that blended visual immediacy with a reciprocal concern for appearance and perception. Pound 'wish[ed] to give people new eyes, not to make them see some new particular thing'.[3]

Recording the moment of perception accentuates 'Ts'ai Chi'h' as an important bridge between photography and poetry in the modernist period. What the three-line poem actually records is multivalent. The overall impression is that of a visual snapshot, yet there is also movement in the falling petals and the clinging ochre: Pound's 'super-position'.[4] Thus we can interpret the poem as both image and event. Pound also redacts the comparative formula, and links the two images by implication only: after all, the photograph does not compare its constituent elements. The act of perception links the image and event of the poem: the rose leaves are not orange but 'orange-coloured', implying a photographic metaphor of development before the eyes of the perceiver. The perceiver, however, is absent: the poem's lack of pronouns creates an illusion of objectivity that

manifests Pound's thoughts of the image as when 'a thing outward and objective transforms itself, or darts into a thing inward and subjective'.[5] The structure of the poem, then, can be seen as a metaphor for the camera, the mediator between a seemingly objective reality and a subjective perceiver.

This apparent breakdown of perceptive consciousness is one example of what Jonathan Crary has identified as 'practices in which visual images no longer have any reference to the position of an observer in a "real", optically perceived world'.[6] Pound's poetry in the early twentieth century approached the condition of photography in that it denied the reader a surrogate reader/observer within the text: 'Ts'ai Chi'h' accounts for a moment of perception (event) and creates a photographic snapshot (image) absent both from an objective reality and, in one sense, a subjective perceiver. In Poundian terms, we may have stumbled across a compelling instance of a 'vortex'. The image, Pound writes, 'is a radiant node or cluster; it is what I can, and must perforce, call a VORTEX, from which, and through which, and into which, ideas are constantly rushing'.[7] It is this point of maximum energy that concludes 'Ts'ai Chi'h' with what seems like a camera shutter.

* * *

All photopoetic works hitherto discussed have been pictorial in nature, where we define pictorialism as being broadly concerned with photography as 'art' and the impulse, as Martin Parr and Gerry Badger summarize, 'to deny and obfuscate the mechanical and essentially documentary nature of photography'.[8] In classifying these works in photographic rather than poetic terms, I mean only to suggest that early photopoetic works were instigated almost always by photographers. The variety of poetry beneath this pictorial umbrella is vast, ranging from seventeenth-century pastoral to the Victorian epic, from African American dialect work to the long narrative poems of Walter Scott. Such diversity attests to the wide range of subjects that pictorial photographic practice was considered capable of illustrating.

Where pictorialism is a relatively well-defined movement in photography and held court over much of the nineteenth and early twentieth centuries, what we consider modernist photography is much trickier to identify, developing differently at different times in different countries. This tumult had a significant impact on photopoetry, and resulted in the explosion of symbolist and constructivist works in continental Europe; the isolationist tendencies of American work in comparison to the politically galvanized European avant-garde; and the relative stagnation of British work in keeping with its

photographic nadir in the early twentieth century. By opening this chapter with a discussion of Ezra Pound, I wish to suggest that in the early twentieth century, the most innovative photopoetic relationships in the anglophone world were taking place within the lines of imagist and Vorticist verse, not within the pages of photobooks.

Experiments in text and image were generally much more progressive in Europe, especially in France, Germany, and Russia, both in terms of collaborative practice and the typographical cohesion of poems and photographs. Glancing momentarily at a couple of examples will demonstrate the enormous divergence between anglophone and European photopoetry in this period, as well as the former's continued reliance on pictorialist themes and approaches. Paul Éluard and Man Ray's *Facile* (1935), for instance, is an iconic modernist work. It combines Éluard's love poems with nine black-and-white photographs of his wife, Nusch. Man Ray's photographs float around the text, with the curves and shapes of Nusch's body providing frames that challenge the outlines of the book. 'In most of the photographs,' Renée Riese Hubert remarks, 'the woman moves beyond the frame of the page. The viewer is urged to use his imagination to transgress the limits of the paper.'[9] The integration of poems and photographs into the photobook's design makes it one of European photopoetry's outstanding examples. Typographically distinct, and combining nude photographs and symbolist poems, it was unlike anything anglophone photopoetry had ever produced, and it bears witness to how the wealth of formal experimentation in the modernist-surrealist moment impinged directly on the relationship between poetry and photography.

Similarly innovative typographical arrangements can be seen in Russian constructivism's experiments with photomontage. Alexander Rodchenko and Vladimir Mayakovsky's *Pro Eto* (1923) is the standout example of Russian photopoetry, partnering Mayakovsky's long love poem with eight black-and-white photomontages designed by Rodchenko.[10] According to Parr and Badger, *Pro Eto* is 'one of the best examples in photobook history of a union that is … difficult to bring off successfully – that between photography and text'.[11] Its success, they claim, hinges both on Rodchenko's skill as a designer and Mayakovsky's 'conception of the poem's text as a visual as well as a literary experience' alongside photomontage's 'formal strategies of point and counterpoint … of finding visual equivalents to complement words'.[12] I cite Parr and Badger's claim here for their use of 'experience' and 'equivalents' in attempting to define the success or otherwise of a photobook. The word 'experience' recalls Nicole Boulestreau's

definition of the *photopoème* as something wherein 'reading becomes interwoven through alternating restitchings of the signifier into text and image', which suggests that the photopoem emerges in the act or experience of reading; is even a self-creation by the reader.[13] This experience is aided, it appears, when text and image feature 'equivalents' – whether thematic or formal – through which they are mutually enhanced. As I discuss below, Hart Crane seized on Alfred Stieglitz's idea of equivalents when writing his long poem *The Bridge* (1930), several editions of which featured photographs by Walker Evans. The likelihood of equivalents is increased when poets and photographers work together, as was the case with Éluard and Man Ray, Mayakovsky and Rodchenko. This chapter explores how modernist tendencies in poetry informed the segue from pictorialism to modernism in US photopoetry, which took the city as its focal point of representation, and collaboration as its principle working practice.[14]

Pound's photographic model

In the 1910s, American photography was gradually establishing itself as a legitimately artistic medium. Its successes included Alfred Stieglitz's (1864–1946) periodical *Camera Work* and his curatorial work on the International Exhibition of Pictorial Photography in Buffalo's Albright Gallery (1910). This proved Stieglitz's last association with the pictorial photography he had hitherto championed. Writing in 1919, almost a decade after his change of photographic direction, Stieglitz notes,

> It is high time that the stupidity and sham in Pictorial Photography be struck a solar plexus blow. The rot that is produced in the name of ART (and still more under the name of Photography) is appalling. ... I have been printing some more ... I try and try and try until I get what I want – no manipulation – *Straight*.[15]

The most emphatic demonstration of straight photography was Stieglitz's returning of *Camera Work* to its original photographic remit for its final issues in 1916 and 1917. Paul Strand (1890–1976), then an unknown photographer, best represented American photography's new direction, in which engagement with urban experience met experiments in abstraction and formalism common to the cubist work Stieglitz had published previously in *Camera Work*. In his accompanying essay, Strand wrote that pictorialist photography, with its 'hand work and manipulation' was 'the expression of an impotent desire to paint', a

failure to recognize that 'the full potential power of every medium is dependent upon the purity of its use'.[16] In March 1913, Stieglitz suggested that photography based on the principles of painting compromised photography's own artistic potential. 'Photographers must learn not to be ashamed to have their photographs look like photographs,' he noted. 'A photographer using photography to do a "stunt," or to imitate painting may amuse those who understand neither the fundamental idea of photography nor the fundamental idea of painting.'[17] Modernist American photography, unlike its European cousin, would be built on a pure, elitist concept of the medium, and would take, not the photobook but the gallery wall for its home.

In the same month, Harriet Monroe's *Poetry* published two essays on a new poetic movement: imagism. These constituted the movement's first manifesto-like expression following the publication of H. D.'s and Richard Aldington's poems in *Poetry* six months earlier, and outwardly eschewed both Georgian poetry and the schools of post-impressionism and futurism.[18] Two of the rules drawn up by the imagists refer specifically to the idea of purity in poetic language: 'Direct treatment of the "thing," whether subjective or objective,' and 'To use absolutely no word that did not contribute to the presentation.'[19] Stieglitz, rejecting the impurity of painterly analogues for photography and the resultant manipulative techniques of pictorialism, finds his poetic equivalent in Ezra Pound, whose rejection of the blotchily symbolist poetic culture of late-Victorian Britain derived from its lack of engagement with the 'direct treatment of the thing' – a synonym, one might argue, of Stieglitz's 'straight' photography.

Limited critical attention has been paid to the relationship between poetry and photography in the modernist period. Present studies either bury these nuances beneath the blanket of 'visual culture' or focus solely on the painterly or sculptural aspects of modernist prose. Michael North's *Camera Works* (2005) began to redress the balance, though attention to Pound is limited to the introduction. Emphasizing the change in attitudes to photography 'between two literary generations', from Pound in the 1920s to Isherwood in the 1930s, North writes:

> Pound was probably more vitally interested in photography itself than was Isherwood.... To disdain the conventionally photographic is not at all the same as disdaining photography. In fact, writers like Pound, who hoped to change the language of poetry, had far more to gain from the photographic model than the more conventional writers around them.[20]

Pound's writings on photography, however, are both scant and generally dismissive. In 1917 he wrote an anonymous preface on vortography that accompanied Alvin Langdon Coburn's exhibition of vortographs and paintings.[21] Coburn constructed the vortoscope from three of Pound's shaving mirrors, and when attached to a camera, it produced kaleidoscopic repetitions of forms: vortographs were the first completely abstract photographs. Pound's early poetry sought 'to transform vision or perception itself', writes Daniel Tiffany, and vortography appeared to offer an important visual model or analogue.[22] Pound's initial enthusiasm, however, is absent from the preface. 'Vorticism has reawakened our sense of form,' Pound remarks, but vortography itself 'stands below the other vorticist arts in that it is an art of the eye, not of the eye and hand together'.[23] The *volte-face* led to the breakdown of his relationship with Coburn, and Pound's comments have shaped the standard critical account of his attitudes towards photography.

So what did Pound want from photography if, as North suggests, he had most to gain from a photographic model of poetry? And why did he maintain such a negative attitude towards photography and the photographic? As is not uncommon, Pound's criticisms can often be reflected back to illuminate his own working practices. Writing under the pseudonym B. H. Dias for the *New Age* in 1918, Pound remarked,

> Photography is a poor art because it has to put in everything, or nearly everything. If it omits, it has to omit impartially. It omits by a general blur. It cannot pick out the permanently interesting parts of a prospect. It is only by selection and emphasis that any work of art becomes sufficiently interesting to bear long scrutiny.[24]

Pound's 'work of art', here, is clearly an imagist poem, with its governing principles of 'selection and emphasis', both linguistically and formally. But what is a photograph if it is not 'the permanently interesting parts of a prospect', if it is not the photographer who also engages in the arts of 'selection and emphasis'? This reveals Pound's central anxiety: that the imagist project does not differ significantly from the visual images that 'any imbecile can shoot off [with] a Kodak'.[25] After all, what initially pleased Pound about the invention of the vortoscope was that the 'simple device ... frees the camera from reality and lets one take Picassos direct from nature'.[26] By 'reality' Pound means 'photographic reality', as he seems unable to perceive how one person's photograph of a particular landscape or building will differ from somebody else's. The vortoscope, on the

other hand, stands above photography in that 'the vortographer combines his forms *at will*. He selects just what he actually wishes and excludes the rest'.[27] Photographic reality is finite; vortographic – and therefore imagist – reality is infinite.

Pound's problem, as far as a photographic model for poetry was concerned, was combining movement and stasis: the idea that an imagist poem should be an event and an image. 'What distinguishes the Imagist poem', writes Christopher Bush, 'from the static images that presumably any imbecile or even a machine can produce is described [by Pound] as a kind of *movement*, but this movement is difficult to define in that it does not seem to be a matter of bodies moving in space. On the contrary, it almost seems to be a quality only of certain *images*'.[28] Pound's approach to poetic language and form led him towards a surprising discovery. He argued that poetic language 'must be a fine language, departing in no way from speech save by a heightened intensity (i.e. simplicity)'.[29] He found that this 'simplicity' could be best harnessed through the Japanese *hokku*, or haiku, a poetic form that intensifies ordinary language by creating what Yoshinobu Hakutani calls an 'instantaneous perception of the relatedness between the two entirely different objects'.[30] 'In a Station of the Metro' is a '*hokku*-like sentence', Pound writes, its form akin to the ' "one image poem" ... a form of super-position, that is to say, it is one idea set on top of another'.[31] While he does not explicitly connect the haiku with photography, Pound's ideas of what constitutes an 'image' seem to anticipate Roland Barthes's more overt connection between poem and photograph. It is worth repeating here what Barthes notes in *Camera Lucida*:

> A trick of vocabulary: we say 'to develop a photograph'; but what the chemical action develops is undevelopable, an essence (of a wound), what cannot be transformed but only repeated under the instances of insistence (of the insistent gaze). This brings the Photograph (certain photographs) close to the Haiku. For the notation of a haiku, too, is undevelopable: everything is given, without provoking the desire for or even the possibility of a rhetorical expansion. In both cases we might (we must) speak of an *intense immobility*: ... neither the Haiku nor the Photograph makes us 'dream'.[32]

'*Intense immobility*' offers a succinct definition of imagist poetics, recalling Pound's continual if fluctuating reiterations of what actually constituted an 'image', the problem of 'movement' that Bush suggests is central to the imagist project. Hakutani has interpreted Pound's image as 'an action', but it would

perhaps be better to consider it a suspended action, a moment of concentrated energy, most analogous to the fraction of reality, or moment of tension, captured in the photograph.[33]

'The Imagist project,' Bush argues, 'is characterised by a tension between the liberation of the eye from convention *and* an overcoming of the merely, mechanistically, optical and immediate.'[34] Where does this tension leave the poetic speaker of imagist verse, the subjective perceiver who gives voice to Pound's images? Pronouns are a good marker of quite how Pound sought 'to give people new eyes' while simultaneously avoiding the mechanistic, objective eye of the camera. 'Ts'ai Chi'h' mentions no personage at all. 'Doria' mentions 'me' and 'us', tying the speaker to the character of Doria to whom he refers. 'The Return' focuses solely on 'they'; the haiku-like 'Fan-Piece for Her Imperial Lord' on 'Her' and 'you'; and 'Liu Ch'e' on 'she'. Of all Pound's poems in *Des Imagistes*, only one, 'After Ch'u Yuan', uses the pronoun 'I'. As a translation from the titular Chinese poet, the 'I' conflates the original speaker with the voice of Pound's translation. A photographic analogy informed Pound's approach to translation. 'The translation of a poem having any depth,' he writes, 'ends by being one of two things: Either it is the expression of the translator, virtually a new poem, or it is as it were a photograph, as exact as possible, of one side of the statue.'[35] Like 'Doria' and 'The Return', 'After Ch'u Yuan' was written before imagism was announced, and as such it only hints towards aspects of the 'image' Pound would later refine in 'Ts'ai Chi'h' and 'In a Station of the Metro'. The haiku-like indentation of lines is evident, as is a form of super-position in which non-static images such as 'the gods walk garlanded with wistaria' and 'leopards drawing the cars' begin to accumulate. The poem, however, retains an overwhelmingly subjective position: the anaphoric 'I will' begins lines one, seven, and eight. There is little scope here for 'a thing outward and objective' to become 'a thing inward and subjective' because we are starting from the reverse position. In his most successful imagist work, Pound would reject this kind of speaker, seeking not to place the reader within the poem through the pronoun 'I', but present an image objectively, without reference to an 'I' figure, in a movement away from 'the expression of the translator' towards the 'photograph'. Pound would rely on a kind of poetic *punctum* to enable the reader to partake in the transformation of the image from objective to subjective: the subjectivity, then, was the reader's response to the poem, not the expression of the image by the speaker of the poem.

One result of this can be seen in Pound's annotations to *The Waste Land* (1922). North claims that 'photography' was Pound's 'quick shorthand term to

disparage some lines in the drafts of *The Waste Land*', and links Pound's apparent opprobrium to modernism's supposed 'disdain of the mimetic'.[36] Looking at the two occasions where Pound uses 'photography' and 'photo' as annotations, however, one might argue that Pound is not disparaging the verse at all; rather, he sees a kind of poetic *punctum* lacking in his own work:

> 'My nerves are bad tonight. Yes, bad. Stay with me.
> 'Speak to me. Why do you never speak. Speak.
> 'What are you thinking of? What thinking? ~~Think.~~ What?
> 'I never know what you are thinking. Think.'
> ...
> 'Are you alive, or not? Is there nothing in your head?'[37]

Both passages occur within sections Pound labels 'wonderful': 'photography' was far from a disparaging remark. Moreover, both passages were included in the final poem. Both passages are instances of dialogue. With an awareness of the photographic subtext of image and vortex, it is possible to suggest that dialogue provides a compelling outlet for Pound's ideas of movement within poetry. In these passages, vision is entirely implied: that is, in the implied set-up of speaker and interlocutor. This kind of disembodiment, in relation to the imagist poem as a movement from 'outward and objective' to 'inward and subjective', is reflected in Eliot's use of abstract vocabulary. 'Speak[ing]' and 'thinking' are not concrete, visual actions; concrete nouns such as 'nerves' and 'head' are used figuratively. Pound insisted on a more elliptical style for *The Waste Land* to enhance the visual snapshots that made up the imagist project. Turning these snapshots into dialogue fashioned an illusion of instantaneousness, creating both the image and event that Pound struggled to incorporate into his imagist verse.

The negotiation between movement and stillness in static images finds its logical extreme in Coburn's vortographs. These, Melissa Schaum writes, 'amplify the sense of motion and still-point so central to the Vorticist endeavor and unable to be fully realized by the more static media of paint and woodcut', a reference to Pound's original search, among the Vorticist arts, for a poetic equivalent.[38] 'The camera's ability to convey movement and stillness,' Schaum continues, 'relies not only on the relation of forms, masses, and angles, but on the contrast between the blurred, multiple exposures of line which replicate the optical perception of motion through space, versus the sharpened still point of the singly-exposed center.'[39] This is what Pound sought in his imagist poetry: two ideas, joined in a 'one image poem', jostling syntactically to portray movement and stillness. The

techniques of imagism were built towards this aim. By redacting the comparative term 'as' or 'like', the verb governing both ideas replaces the hinge between them. 'In a Station of the Metro', Bush notes, centres on the ambiguity of 'apparition' as noun and verb. 'The ambivalence of this one word', he writes,

> signals, and allows, the poem to be at once photographic and antiphotographic, to embody in a figure of optical arrest a suspension of verbal convention *and* also to transcend this immediacy by becoming language.... . Pound's poetic project would retain the liberating moment of photography while overcoming the more radical implications of photography's decontextualizing, depersonalizing force.[40]

The poem pivots on a sole verb that might not be a verb at all, complementing the excision of the static 'as' or 'like' as the hinge between the two images. Where we might expect the final line to read 'like petals on a wet, black bough', removing the comparative term means that, as much as written and spoken language allows us to, we see the two images at once, as one image, not as two separate images that are in some way alike. Mike Weaver has traced the origins of Poundian super-position through Coburn's engagement with Arthur Wesley Dow's importation of nuanced Eastern tonality and perspective into the Western study of photographic composition and representation. 'The Japanese written character for "perspective", Weaver writes,

> is a combination of 'near' and 'far' and, unlike the Western idea of one thing being seen *through* another, implies an overlay of one thing *on* another in the same plane.... . The effect is less of superimposition in the Western sense than of superposition, so that elements are read upward or downward over the two-dimensional surface of the picture.[41]

This is reflected in Coburn's vortographic portrait of Pound (Figure 3.1), where the prismatic layers emanate from what Pound called Vorticism's 'point of maximum energy'. 'From this compelling still point', Schaum writes,

> the figure appears to come at the viewer in a remarkable rush of exposures, a type of ex-pressing or unfolding ... With a trick of tonality, however, Pound's visage can suddenly also be seen to be receding *into* itself; the lightened foreground exposures creating the optical illusion of the faces *retreating* from the viewer, like an infinite reflection of mirrors.[42]

Pound creates, through the redaction of comparative terms and the ambiguity of verbs, a poetic equivalent to the 'super-position' of Coburn's vortographs. In 'Ts'ai

Figure 3.1 Alvin Langdon Coburn, 'Ezra Pound (Cubist Manner)', c.1916. Reproduced with the permission of The Universal Order. Courtesy of George Eastman Museum.

Chi'h', Pound uses the haiku form to centre verbal and visual attention onto the verbless central line 'the orange-coloured rose-leaves'. Two images of movement, centring on the verbs 'fall' and 'clings', surround the verbless, static centre. This 'vortex' combines the two images to create a 'one image poem'. The verbal super-position acts in the same way as one of Coburn's vortographs, the poem both retreating into itself and unfolding from a central, verbless stasis. Moreover, the lack of pronouns in 'Ts'ai Chi'h' leaves the poem curiously suspended between an objective statement and a highly subjective impression: a state that recalls, one might argue, a photograph.

'The photographic gaze,' writes Bush, 'embodies neither objectivity in any conventional sense nor an absence of subjectivity, but rather a specific and very peculiar kind of subjectivity, one tied to and indeed synonymous with a specific

location and moment.'[43] Across Pound's imagist haiku, various constructions of 'super-position' allow his images to inhabit a space similar to the peculiar subjectivity that characterizes photographs. Where the comparative term is present, Pound experiments with its precise location. 'Alba' (41), for example, layers an image from nature on top of the desire for a subjective persona (hence 'me') in a haiku-like poem:

As cool as the pale wet leaves
of lily-of-the-valley
She lay beside me in the dawn. (*SPT*, 41)

The use of 'as' to begin the poem superposes the two images without drawing attention to the comparative: that is, a similar construction, 'She lay beside me in the dawn as cool as the pale wet leaves', hinges on the comparative 'as cool as', emphasizing how the two clauses, while connected, are not the same. Instead, Pound treats the two ideas as a single image: they are not hinged or joined but flow into one another. Like a photograph, a haiku can create instantaneous connections between images and objects that, at first glance, seem unrelated.

'Alba' and 'Fan-Piece' – which I believe are companion poems – represent Pound's first foray into the long imagist or Vorticist poem: to craft instantaneous connections between images on a larger scale. 'I am often asked,' Pound writes in a footnote to his 'Vorticism' essay,

whether there can be a long imagiste or vorticist poem. The Japanese, who evolved the hokku, evolved also the Noh plays. In the best 'Noh' the whole play may consist of one image. I mean it is gathered about one image. Its unity consists in one image, enforced by movement and music. I see nothing against a long vorticist poem.[44]

This began in 'Alba' with Pound's use of the word 'cool' as his comparative descriptor, a word whose definition must change from 'leaves' to 'She', or else Pound's 'super-position' would simply involve listing like terms and images. The comparative coolness, though, is linked by 'lily-of-the-valley', sweet scented but highly poisonous. The word 'cool' is an ambiguous comparative term that enables Pound to superimpose lily-of-the-valley onto the figure represented by 'She' without offering a direct comparison, much in the same way that the 'selection and emphasis' in framing a photograph often compares constituent elements of that photograph without explicitly foregrounding the nature or purpose of such a comparison. This construction is modified in 'Fan-Piece' (43)

(included in *Selected Poems and Translations*), when 'as' is used in the second of three lines to balance the superimposed images:

O fan of white silk,
clear as frost on the grass-blade,

You also are laid aside. (*SPT*, 43)

The comparative hinge creates a linear rather than instantaneous relationship between images. 'Fan-Piece' would border on this construction were it not for 'also' in the concluding line. This gestures outside the poem towards an additional persona or thing, while 'You' refers to the 'fan of white silk'. Comparing 'Fan-Piece' with 'Alba', we notice similarities in haiku-like structure and the superposition of images through 'as'. If the two are partner poems, the 'She' in 'Alba' would complete the empty comparison of 'Fan-Piece': the fan is also 'laid' aside, just as 'She lay' in 'Alba'. This would represent an instance of Vorticist principles on a larger scale, because each uses 'to lay' as its central verb – 'lay' in 'Alba' and 'laid' in 'Fan-Piece' – thus connecting the two haiku through super-position. Both poems experiment with how a sequence of poems can, to quote Pound, '[gather] about one image' and create instantaneous impressions that seem to evoke the original image while, at the same time, being it. The original image remains static while appearing to conjure a series of like images, in which stillness and movement coexist through an aesthetic of simultaneous retreat and expansion: verbally through the haiku-like forms, and visually through the superposition of similar yet distinct images. Moreover, Pound creates a subjective space that is, in essence, photographic: dependent on a unique perspective, but open to the perspectives of all.

America and the city

While Pound's work enacted fascinating dialogues between photography and poetry, photopoetry itself remained relatively unchanged in the United Kingdom and United States at the beginning of the twentieth century. In the 1910s and 1920s, no distinctly modernist photopoetry book emerged from the pictorial orthodoxy. Isolationist tendencies in American art informed patriotic photopoetry, such as William Herschell and Paul Shideler's *The Kid Has Gone to the Colors* (1917) (Figure 3.2) and pictorial representations of landscapes and

nature more common to British photopoetry, including Effie Waller's *Rhymes from the Cumberland* (1909) and Henry van Dyke's anthology *The Poetry of Nature* (1914). Likewise, British photopoetry began to look inwards: photopoetry entered a twenty-year lull between Mabel Eardley-Wilmot's edition of *The Rubáiyát of Omar Khayyám* (1912) and Kathleen Conyngham Greene's edited collection *The English Landscape: In Picture, Prose, and Poetry* (1932). This inward turn seems even more remarkable when we remember that, in the same period, photopoetic practitioners in continental Europe had produced, among other works, *Pro Eto* (1923) and *Facile* (1935), both of which are defining works of modernist visual art.

It was not until the 1930s that the modernist photobook in America began to emerge. This did not, however, represent an immediate shift in photopoetic practice and theme. 'For more than a decade,' Parr and Badger remark, 'American art turned inwards, searching for historically defined American qualities and largely ignoring the ferment of ideas galvanizing European art. The search of the "American-ness" of American art uncovered many fine things ... but the corollary of this cultural navel-gazing was an inevitable provincialism.'[45] The standard American photopoetry book in this vein is Archibald MacLeish's *Land of the Free* (1938). It is 'the opposite of a book of poems illustrated by photographs', writes MacLeish:

> It is a book of photographs illustrated by a poem. The photographs, most of which were taken for the Resettlement Administration, existed before the poem was written. The book is the result of an attempt to give these photographs an accompaniment of words. In so far as the form of the book is unusual, it is a form imposed by the difficulties of that attempt. The original purpose had been to write some sort of text to which these photographs might serve as commentary. But so great was the power and the stubborn inward livingness of these vivid American documents that the result was a reversal of that plan.[46]

On the right of each double-page spread is a photograph (Figure 3.3); on the left, MacLeish's free verse, which he calls the 'Sound Track'. The poem, MacLeish claims, adopts the illustrative function usually associated with photographs, reversing the privileged position of word over image in the construction of meaning. 'Of all the hybrid projects that combined Resettlement Administration (RA) and Farm Security Administration (FSA) photographs of the Great Depression in the United States with a sustained literary component and complement,' writes Louis Kaplan, '*Land of the Free* remains the most unusual

Figure 3.2 Paul Shideler, 'Untitled', in *The Kid Has Gone to the Colors*, 1917. Courtesy of the University of St Andrews Library, photo PS3515.E765K5F17.

and enigmatic of these "word and image" collaborations'.[47] MacLeish's insistence on the 'livingness' of the photographs, however, 'downplays their status as representations and their artificial and constructed nature. This includes,' Kaplan summarizes, 'the theatrical possibilities of staging, the tendentious possibilities

of propaganda, and even the effects of reframing and sequencing to which he has subjected them.'[48]

If the major problem with photographic illustration had been the demotion of photography to the role of visual curio, the major problem with poetic illustration was that photographs were now being co-opted to support narratives that were at best disingenuous and at worst outright fabrications. In one contemporary review, John Holmes objected to MacLeish's use of the FSA images. 'He gets himself all worked up over some photographs,' Holmes writes,

> and thousands of eye-minded people know that they can't always believe what they see in photographs, for the camera does lie, or it can be made to tell things that aren't truth. By this I don't mean any of the photographs are faked, but that MacLeish's method in using them to make a book is unfair, and that the result cannot be defended.[49]

Holmes's ire derives from MacLeish's decision not to include descriptive captions but instead to write a poem whose voice assumes collective responsibility for

Figure 3.3 Dorothea Lange, 'Waiting for the Semi-Monthly Relief Checks at Calipatria, California' (1937), in *Land of the Free*, 1938. Courtesy of the Farm Security Administration, Library of Congress, Washington, DC.

the people pictured in the FSA photographs. Sequencing the photographs alongside his 'Sound Track', MacLeish reframes and recontextualizes the images, reinscribing them with meaning only in relation to his poem. The poem itself is hesitant and stammering: often, a photograph is accompanied by no more than three or four words, such as the opening line, "We don't know …". Speaking in the first-person plural throughout the poem, the narrator lends his voice to an apparent crisis of community that arose as a direct result of the Great Depression. MacLeish was one of the first poets to write specifically for a photographic sequence. Acting also as photographic editor, MacLeish was able to order and reorder the sequence, mimicking the compilers of early photopoetic anthologies such as Philip Henry Delamotte and William Morris Grundy. With complete control over the poem and the photographs (bar actually taking them), MacLeish's *Land of the Free* is perhaps more like a self-collaborative book of photopoetry than a retrospective one, and occupies an important place in photopoetic history for two reasons: first, its suggestion that the current of illustration did not have to run from poem to photograph; and second, for its use of documentary images. When we consider that *Land of the Free* was published in the same year as Walker Evans's era-defining *American Photographs* (1938) – a modernist photobook that combined literary, documentary, and artistic modes – it becomes apparent that wider trends in American photography were only beginning to inform photopoetic work.

One of the most enthusiastic admirers of *Land of the Free* was the American poet Carl Sandburg (1878–1967), who praised the poem as 'profound and musical, even without the amazing pictorial equivalents'.[50] Sandburg himself published a book of photopoetry, *Poems of the Midwest* (1946), which contains two complete collections of his verse: *Chicago Poems* (1916) and *Cornhuskers* (1918). It appears, however, that Sandburg had little to do with the accompanying photographs. The World Publishing Company commissioned well-known art critic and writer Elizabeth McCausland (1899–1965) to act as photographic consultant for the project. Sole responsibility for choosing the photographs rested with McCausland, and she sourced the images from various collections including the FSA, the Office of War Information, and other war agencies. 'In selecting photographs for *Poems of the Midwest*,' she remarks in her note on the photograph credits,

> we sought not literal picturings of Sandburg's subject matter but visual equivalents of his mood and feeling. Mechanical fidelity to fact of time and

place did not seem as important as truth to the meaning of the poems. Since the poet's vision is dual, directed inward and outward, and the camera's vision is single, focused on visible reality, such equivalents are not always easy to find. We hope that the look on a face, the gesture of a hand, the sweep of wide lands, will intensify the emotions evoked by the poems.[51]

Most photographs complement the poems in a way that is not merely illustrative, even though, compared with *Land of the Free, Poems of the Midwest* is a more traditional photopoetry book in the sense that photographs were paired with pre-written poems. To create 'mood and feeling' instead of 'literal picturings', McCausland rejected poetic captions. Having finalized the photographic selection, McCausland sent extracts from Sandburg's poems to World Publishing's designer, Abe Lerner, albeit with anxieties:

> I feel that if captions are used, the ellipsis should be part of them to show how the line, or lines, have been taken out of the context of the poem. My own feeling is still against captions, as the line of type does pull the eye away from the picture or distract somewhat. However if the captions tie the pictures and poems together, then that is probably a more important factor to consider.[52]

The captions were not included in the final version. The photographs faced Sandburg's short poems on adjacent pages, with the reader left to intuit the mood and atmosphere represented by the pairing. Both photobooks feature FSA photographs, yet they are used in each for subtly different purposes. A key difference emerges here between two types of photopoetry. FSA images are used in *Land of the Free* for a sociopolitical purpose, directing the message of MacLeish's poem. In *Poems of the Midwest*, however, there is no cogent photographic narrative: photographs were chosen in isolation, as 'visual equivalents' to particular poems. MacLeish's photobook drew on the wider connotations of the FSA photographs, whereas McCausland, lacking the narrative provided by a long poem, included the images to highlight visual set-pieces of Sandburg's work. This is an important distinction in terms of how the relationship between poetry and photography was becoming more outward facing, gesturing towards the cultural, political, and social contexts in which works of photopoetry were conceived.

Four years after MacLeish's 'Sound Track', the Limited Editions Club published a two-volume edition of Walt Whitman's *Leaves of Grass* with photographic illustrations by Edward Weston (1886–1958). Founded by George Macy in 1929, the Limited Editions Club specialized in expensively produced, lavishly illustrated books – mostly classics – for member-subscribers. Under Macy's

guidance, the Limited Editions Club attracted leading figures in the graphic arts to design and illustrate the books, from Henri Matisse and Picasso to Norman Rockwell and Edward Steichen. Like *Land of the Free*, Weston's *Leaves of Grass* (1942) occupies an uncertain place in the history of American photobooks. One might assume that a photobook combining Weston's photographs and Whitman's poems would be a gold standard for early twentieth-century photobooks. It is fair to suggest, however, that Macy and Weston had different – not to say entirely conflicting – visions for the project. 'My reaction to W. W. [Walt Whitman] Book is quite definite,' Weston wrote when the book was published: 'it stinks.'[53]

In photopoetic terms, the *Leaves of Grass* project is rooted in the retrospective tradition. Producing photographs to accompany a poem that already exists – let alone one as ingrained in American consciousness as *Leaves of Grass* – lends itself to illustrative relationships between image and text. When Macy approached Weston with the commission in 1941, illustration was at the forefront of his idea:

> Whitman's own symbolism could be sharpened by the inclusion of real American places which are part of Whitman's vision of America. If I could take photographs, I believe that I could think of a fine composition to illustrate every other line in Whitman's poetry.[54]

This was not quite what Weston had in mind. 'This I should tell you,' he wrote to Nancy and Beaumont Newhall two months later, 'there will be no attempt to "illustrate", no symbolism except perhaps in a very broad sense, no effort to recapture Whitman's day.'[55] Weston saw his photographs in dialogue with Whitman's poems, not subservient to them. As he saw it, his was 'the task of rendering visual the underlying themes, the objective realities, that make up Whitman's vision of America.'[56] The closest Weston came to defining these 'underlying themes' was in another robust letter to Macy in August 1941:

> The fact is illustrating specific lines in the poems would – to my mind – be too easy and get you nowhere.... It is my feeling that the only photographs worthy to go into an edition of *Leaves* are those that will present the same kind of broad, inclusive summation of contemporary America that Whitman himself gave.... There is one clear limitation on the photographer – one field that belongs to him – his job is to photograph the world around him today; and wherever he crosses that boundary he gets into trouble.[57]

Until Macy fired Weston's friend Merle Armitage as designer, Weston had refused point blank to provide specific extracts from *Leaves* to caption his photographs. Forced to meet Macy's request, Weston had his wife, Charis Wilson, select lines

and sections from *Leaves* that reflected his work on the project. 'It is unclear,' writes Francine Weiss, 'whether or not [they] knew these lines of verse would be used as captions in the final publication.'[58]

Macy's 'assignment of captions produced static and flat image-text combinations,' Weiss remarks: in certain pairings, 'independently, both the image and the text have more power than they do combined.... The image and text do not function together to create a new synthetic meaning or message.'[59] It was not until the 1976 Paddington Press reprint that the image-text-caption model was exploded and Weston's wish for captionless photographs was posthumously fulfilled. While the removal of captions might seem a minor difference, when aligned with several other alterations, the 1976 edition emerges closer to Weston's design for the project. 'Because there are no captions in this later edition,' remarks Susan Danly,

> Weston's images become typologies of people and places. They stand for contrasting types of American experience: rural and urban, young and old, detail and distance, natural and man-made. So even without the help of words, these photographs can tell a story.[60]

The photographs retain their photographic integrity, creating their own narrative that intersperses with Whitman's poems. This structure highlights the fact that Weston was temporally unable to photograph the America that Whitman captured in his verse: once this is realized, the photographs become a separate project tied to *Leaves of Grass* through a common theme: a series of 'equivalents' that are not direct illustrations. Partnered in the book, their interactions will cause as many harmonies as frictions, as many conflicts as exchanges.

That being said, another important difference in the 1976 edition that was not part of Weston's vision for the project is that, while the photographs generally follow the same order as the 1942 edition, they occur in back-to-back pairs. 'This pairing creates different kind of visual narrative,' Danly suggests, 'absent in the earlier work and certainly unforeseen by Weston. It is a narrative marked by sharp visual contrasts.'[61] Although Weston may not have foreseen such a narrative, this kind of distinct relationship between his photographs and the poems seems to chime more easily with his own vision of the project for picturing the 'underlying themes' of Whitman's America and, by extension, his own vision. *Leaves of Grass* is a retrospective work of photopoetry, but one that demonstrated how the photographer was becoming more involved in the processes of combining their work with the poem(s). It also demonstrates the

centrality of editors to retrospective photopoetry. Editorial interference, as Weston saw it, diluted the purpose of including photographs in the first place, and inclusions such as captions further weakened how the images interacted with the verse. Once poets and photographers themselves became responsible for editing their work, collaboration emerged as the dominant photopoetic practice.

While *Land of the Free* and *Leaves of Grass* were the most high-profile photopoetic works of the 1930s and 1940s, they were not the only important volumes published in this period. The anthology *Photopoems: A Group of Interpretations through Photographs* (1936) by photographer Constance Phillips combines images of the modern city with works of nineteenth- and early twentieth-century poets. The volume demonstrates how, when the photographer acts also as editor, more complex relationships can be formed between poems and photographs. Prior to *Photopoems*, photopoetic anthologies had centred primarily on picturesque landscapes, such as William Morris Grundy's *Sunshine in the Country* (1861) and A. W. Bennett's Wordsworth edition *Our English Lakes, Mountains and Waterfalls* (1864). Phillips's volume does include a number of picturesque photographs, yet it is most remarkable in its use of urban scenes to reinterpret the work of poets such as Wordsworth and Walter Scott, whose ideas of the metropolis were obviously much different to Phillips's scenes of New York in the 1930s. 'It is my purpose,' Phillips writes, 'to show that many of these famous lines, some written centuries ago, can today be given a new and original interpretation through the dramatic medium of modern photography. In other words, I am attempting to "re-sight" poetry through the lens.'[62] If we judge Phillips's photobook on her own terms, she achieves some degree of success: she does create some genuinely original 're-sightings' of 'famous lines', playing with the juxtaposition of poetic and photographic perspectives. On the other hand, while she asks the reader 'not to look for too literal illustration, for I have tried more to convey the mood of the poem than to reproduce the actual imagery of the poet', some pairings are entirely literal in nature. These tend to be picturesque or limply natural images: accompanying Joyce Kilmer's poem 'Trees' is a photograph with trees in the foreground; for Edward FitzGerald's chess metaphor in the *Rubáiyát of Omar Kháyyam,* Phillips uses a photograph of men playing chess.

Little is known about Phillips herself. Two years after *Photopoems*, she published *So You Want to See New York?* (1938), a photoguide to the titular city with her own photographs and text. She contributed to the magazine *Popular*

Photography as late as 1943, publishing an image of New York's Chinatown that is arguably the outstanding photograph in the magazine's 'Women with Cameras' feature.[63] Part of its power derives from its narrative capacity: Phillips isolates a local story within the bustle of the city, placing the viewer in an unfamiliar yet communal situation. The best photographs of *Photopoems* share a similar capacity for storytelling. Phillips represents the city from a variety of perspectives: street-level pedestrians, up towards skyscrapers, and out across the city from a mid-storey window. Russell Sedgefield photographically illustrated Scott's *The Lay of the Last Minstrel* in 1872 using topographical images that situate the reader/viewer in the Scottish Borders, the scene of the long poem. Phillips, however, chose a silhouetted man looking out over Manhattan (Figure 3.4) to reflect the mood of the extract beginning,

> Breathes there a man with soul so dead,
> Who never to himself hath said,
> This is my own, my native land!
> Whose heart hath ne'er within him burned,
> As home his footsteps he hath turned
> From wandering on a foreign strand?[64]

The extract asks whether such a man exists, 'concentred all in self', and what would become of him should he value 'titles, power, and pelf' over feelings of home and belonging. Though Scott did not imagine the skyscrapers of New York for his 'native land', Phillips's photograph suggests the kernel of Scott's thought is applicable as much to modern life as to mid-sixteenth-century Borders feuds. Scott's extract alters how the photograph would be viewed in isolation. The use of the window frame within the photographic frame hints at a liminal position: the silhouetted figure could be leaving home, returning home, or entirely stationary, overlooking the city in which he has accrued 'titles, power, and pelf'. The poetic narrative posits several potential narratives for the photograph, none of which map precisely on to Phillips's image. Here the reader/viewer is wrenched from the comfort of the spectatorial position common to picturesque photopoetry; they are challenged, instead, to discover the connection between poem and photograph. The reader/viewer is made to question how the photograph appropriates, supports, and/or undermines the poem, and how the two narratives combine or resist each other. It is no coincidence that this uncertainty occurs in an urban setting. Although *Photopoems* is not a consistently sophisticated collection, the effect of urban photography on comparatively antiquated

Figure 3.4 Constance Phillips, 'The Lay of the Last Minstrel', in *Photopoems: A Group of Interpretations through Photographs*, 1936. Courtesy of the University of St Andrews Library, photo TR650.P45.

verse both legitimizes modern photographic topics as artistic subjects and reimagines an outdated mode of photographic illustration. By demonstrating that the perspectives of poet and photographer are not always shared, Phillips's best pairings experiment with the nature of photo-illustration and posit a more outward-facing relationship between poetry and photography built on dislocation and the imaginative reconciliation of text and image.

* * *

During the segue of pictorialism into modernism, the city emerged as a common site of alienation and disorientation in the literature and photography of the early twentieth century. Photopoetic practitioners took the peculiarly subjective space Pound created in his poems as one that disembodied the reader, and the city was a productive location in which to explore this idea in relation to a reading experience that shuttles back and forth between poems and photographs. The transformation of the natural landscape into urban environments created a period in which 'the public attempted to explain the feelings induced by seeing a vast panorama of man-made objects': people found urban landscapes overwhelming, and bridges and skyscrapers represented 'the

conquest of natural obstacles and forces'.[65] 'The impression upon the visitor,' remarked Brooklyn Mayor Seth Low on the completion of the Brooklyn Bridge in 1883, 'is one of astonishment that grows with every visit.'[66] In an attempt to combat, or in some cases exploit, this disorientation, poets and photographers fashioned several variations of an 'urban sublime', an extension of what David E. Nye has identified as the geometrical and technological sublimes of American cultural history.[67]

One of the earliest works of urban photopoetry is *The Evanescent City* (1915) by poet George Sterling (1869–1926) and photographer Francis Bruguière (1879–1945). Written to commemorate the Panama-Pacific International Exposition (1915), the poem is important for its legitimization of the city as a site for photo-illustration, achieved in similar terms to which photography was first used for artistic illustration: topographical verse helped to legitimize photography as an artistic medium. Now, to legitimize the city, the language and imagery of topographical poetry were fashioned into an urban sublime. Faced with the sublime power and terror of the city, human perceptive powers invariably failed, just as they failed when such attributes formed part of the natural world. Sterling's poem celebrates not the city itself but its decline, at the hands of the natural world, into a series of picturesque ruins. The second stanza reads:

Awhile I stand, a dreamer by the deep,
 And watch the winds of evening sap her walls,
Till ashen armies to the ramparts sweep
 And seas of shadow storm the gleaming halls.[68]

Sterling describes a sunset but does so in terms of 'ashen armies', 'winds of evening', and 'seas of shadows' sacking the city. The sunset serves as an extended metaphor for a natural disaster: it razes the city to the ground and undermines the supposed celebration of human achievement that the poem was written to commemorate. The exposition itself was held in part to memorialize the recovery of San Francisco from the 1906 earthquake. Grand buildings were erected, such as the Tower of Jewels, Palace of Horticulture (Figure 3.5), and Court of the Universe, and their names caption Bruguière's photographs. However, these buildings were built with a temporary compound on skeleton structures, and were intended to crumble into disrepair after the exposition and create a series of picturesque ruins. This lends an illusory quality to Bruguière's images, as these buildings, save the Palace of Fine Arts, endure only in photographs.

Sterling's language of ruin emphasizes the disjuncture between the events of his poem and the imposing structures seen in Bruguière's photographs. The third stanza alone contains 'dies', 'crumbling', 'fall', and 'ruined', while Bruguière's accompanying photograph represents a statue by Leo Lentelli in the foreground and a grand domed building in the background. All Bruguière's photographs show similar grandeur, and captions such as 'Palace', 'Court', and 'Universe' imply splendour and longevity, stirring astonishment within the reader/viewer. 'From the perspective of the human-made environment,'

Figure 3.5 Francis Bruguière, 'Palace of Horticulture', in *The Evanescent City*, 1915. Courtesy of the University of St Andrews Library, photo TC781.B1S74 1916.

writes Christophe Den Tandt, 'it is indeed easier to discern that the moment of sublime terror is always to some extent a social construct, that it is a spectacle liable to be harnessed to an ideological agenda.'[69] This 'sublime terror' is partially constructed in *The Evanescent City* through the absence of people in Bruguière's photographs. As an artificially constructed metropolitan landscape, the sole perspective in Bruguière's 'city' is the photographer, the conduit through whom the reader/viewer approaches the urban environment. The overwhelming presence of the city diminishes the presence of the poetic 'I', a technique reminiscent of the perceptive failures common to romantic poets when confronted by the sublimity of the natural world. Photographing the buildings after rather than during the Exposition allows the reader/viewer to witness the 'city', in effect, alone, as a site intended to induce sublime terror or wonder. This visual construction creates an urban equivalent to what Den Tandt recognizes in romanticism as a 'political appropriation of the sublime [that] leads to the elaboration of rituals of spectatorship that construct nature as an object of desire and conquest'.[70] The 'city' acquires the attributes of the sublime scene: the centrality of the single spectator recalls nineteenth-century photographically illustrated editions of Wordsworth and Scott and demonstrates the longevity of this spectatorial approach to photopoetry. *The Evanescent City* extends the photopoetic links between spectatorship and staging into the urban landscape, the site in which this model eventually collapses into the multiple perspectives and abstract patterns (represented by crowds and the use of tall buildings for vantage points) redolent of an increasing concern with the metropolitan landscape as distinct from the traditions and tropes of representing nature.

Consequently, *The Evanescent City* did not explore the contemporary metropolitan landscape: rather, it sought to monumentalize the man-made by invoking sublime tropes more common to romantic poetry. When poets and photographers did turn their attention to the modern American city – specifically, New York – their work built on the isolation and remoteness of the individual that *The Evanescent City* had introduced to photopoetry. The city functioned as an appropriate location through which to explore the peculiar kind of subjectivity embodied by the photograph. The city presented poets and photographers with a kind of initiation ritual, 'in the position of having to investigate a new world, or to reassess a supposedly familiar one'.[71] Such investigations fostered connections between the aesthetic and critical vocabularies of poetry and photography that expanded on the ideas

Pound had first enumerated in his writings on the image. One of the most renowned interactions occurred between Stieglitz and Hart Crane (1899–1932), whose long poem *The Bridge* (1930) owed a significant debt to Stieglitz's photographic vocabulary. Having met in April 1923, Crane later wrote to Stieglitz, spilling over with enthusiasm for the work of the photographer who, he considered, had 'captured life'. At the centre of Stieglitz's work, Crane notes, was 'Speed ... – the hundredth of a second caught so precisely that the motion is continued from the picture infinitely: the moment made eternal'.[72] Crane evokes the image/event paradox central to Pound's imagist and Vorticist work, and he sought to explore a similar dialectic of stillness and movement in his poetry. But while Pound was never completely convinced by the aesthetic merits of photography, Jane Rabb argues that Stieglitz's influence enabled Crane 'to perceive the ability of an image to immortalize a moment, realize the aesthetic and spiritual possibilities of the new technology, and, above all, use natural objects ... as "equivalents" of subjective emotional states in his writing'.[73] Crane's use of the man-made Brooklyn Bridge (rather than a natural object such as an apple or cloud) as a Stieglitzian 'equivalent' for his vision of a poem that would be the 'mystical synthesis of "America"' aimed to evoke the 'ultimate harmonies' of Stieglitz's 'stationary, yet strangely moving pictures'.[74] The competing metaphorical and visual qualities of Crane's bridge thus proved problematic. Crane could use metaphors of bridging to span present-day Brooklyn and his vision of a mythical American past, yet when the project became specifically oriented around the Brooklyn Bridge from approximately 1924, the visual appearance of the bridge proved difficult for Crane to incorporate into his poem without compromising the metaphorical qualities of the verse. As a poetic 'equivalent', the Brooklyn Bridge provided Crane with a vision of his metaphor: such was its significance, Crane realized, that to evoke the idea of 'equivalence' he incorporated three photographs by Walker Evans (1903–1975) into the Black Sun Press edition of the poem in March 1930, plus an original frontispiece photograph by Evans in each of the Liveright editions, published in April and July 1930.

For a frontispiece Crane had originally wanted a painting by the modernist artist Joseph Stella.[75] When the idea for a deluxe edition of *The Bridge* was first discussed in 1929 with Harry and Caresse Crosby's Paris-based Black Sun Press, Crane immediately thought of Stella, whose work he had come to know in 1928. Crane's letters to the Crosbys document the eventual abandonment of the Stella frontispiece, primarily due to the proposed costs, and the eventual use of Evans's

photographs. Engraving companies would charge $200 for colour reproduction plates of Stella's painting. Crane then proposed, writing to the Crosbys,

> to send a good photographer over to the [Brooklyn Museum] to get a good, clear picture.... . The plate for this can be made in Paris cheaper and possibly better than here [New York]. It may look better, even, without color – if we get a good photo and a sharp, clear half-tone.[76]

When this, too, proved unviable, Crane arranged to use photographs by friend and neighbour Evans, whom he rated 'the most living, vital photographer of any whose work I know. More and more I rejoice that we decided on his pictures rather than Stella's.'[77] 'When they were set as small plates on the oversized pages of the Black Sun edition of *The Bridge*,' notes Langdon Hammer, 'Evans's photos of the Brooklyn Bridge ... did not compete with the poem's images, as Stella's heroic paintings would have done. Instead, in their surprising smallness, they emphasized the intimacy and inwardness of Crane's vision.'[78] The deluxe nature of the Black Sun edition sets *The Bridge* apart from the uniformity of earlier photopoetry books. The pages measured 8½ by 10½ inches, a generous size that emphasized the small photographs; smaller, indeed, than their original negatives. The first and third photographs bracket the text, while the second is placed in the middle of the poem, surrounded by blank pages. The position of this photograph was crucial. Crane insisted

> that the middle photograph ... goes between the 'Cutty Sark' Section and the 'Hatteras' Section. That is the 'center' of the book, both physically and symbolically.... . Evans is very anxious, as am I, that no ruling or printing appear on the pages devoted to the reproductions.[79]

Rather than illustrating specific instances of the poem, Evans's photographs represent both the subjective qualities Crane drew from Stieglitz's idea of 'equivalents' and the bridge as the material form of the poem. As support towers anchoring the bridge to land, the photographs bookending the poem act in the same way as Crane's opening and closing invocations, 'To the Brooklyn Bridge' and 'Atlantis' respectively. The photographs themselves are radically different to anything hitherto seen in photopoetry. They modify the urban sublime of Bruguière's *Evanescent City*, presenting the Brooklyn Bridge not in the visual language of the natural world but in abstract patterns of lines and hard edges, emphasizing the angularities of a structure that, come 1930, would have seemed a familiar urban construction. Evans was not simply celebrating

the bridge, Nye argues, but also 'the camera as an instrument of knowledge capable of expressing the multiplicity of a monumental technological form'.[80] Evans's photographs capture the abstract qualities of the bridge from numerous perspectives, yet its sublime quality emerges more from what Evans leaves out of his frames: not one of his photographs captures the entire span of the bridge. Such an absence reflects Edmund Burke's observation that 'hardly any thing can strike the mind with its greatness, which does not make some sort of approach towards infinity', just as Crane's concept for *The Bridge* stretched back towards a mythical American past and forwards to a vision of modern America.[81]

The sublime rhetoric in 'To the Brooklyn Bridge' and 'Atlantis' accentuates how Evans's photographs disorient the reader/viewer. This is one area where photography intensifies the urban sublime, as it can defamiliarize feats of engineering and create varied and unusual perspectives. The first photograph emphasizes a typical pedestrian view from beneath the bridge, its dark underside stretching across the East River towards the city skyline. The second photograph represents a view from the bridge, looking down on a tug boat, the dark, frothing water, and a barge loaded with containers: a stark contrast to the phantom ships and 'apparitional sails' glimpsed by the poet in the preceding section. These realities of modern life, writes Gordon K. Grigsby, provide 'an ironic comment on the reality-vision conflict of "Cutty Sark" and "Cape Hatteras" and, by extension, of the whole poem'.[82] Here, Evans places the reader/viewer on the bridge but the bridge itself cannot be seen. Only in the third photograph does the reader/viewer stand on and see the bridge, yet it is presented more in terms of a modernist sculpture than a utilitarian carriageway (Figure 3.6). Each image offers a degree of obscurity, and the bridge remains predominantly abstract even after its towers and cables are revealed in the third photograph. The strong, dominating diagonal lines visually link all three photographs, even though the bridge, as an architectural object, emerges only gradually. Evans's photographs evoke rather than directly depict the bridge, and as such offer an alternative relationship for photographs that accompany poems. Linking the abstractions of the photographs to the disorientation of the poetic speaker and, by extension, the reader/viewer, Evans derived a photopoetic strategy from Stieglitz's idea of the photographic 'equivalent', the natural object standing in for a subjective, emotional state. Crane's use of the man-made bridge challenged what might constitute an 'equivalent', and he referred to his writing method as 'architectural'.[83] Evans,

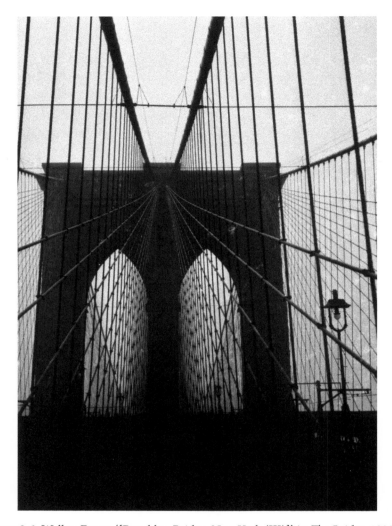

Figure 3.6 Walker Evans, '[Brooklyn Bridge, New York (III)]', in *The Bridge*, 1930.
The Metropolitan Museum of Art, Gift of Arnold H. Crane, 1972. © Walker Evans
Archive, The Metropolitan Museum of Art. Image copyright The Metropolitan
Museum of Art/Art Resource/Scala, Florence.

too, refused to illustrate the bridge: his evocations present the bridge, through
a series of abstractions and misdirections, as a spectacle to be approached with
trepidation.

Echoing the awe of romantic poets before natural phenomena, Crane
described the elation of crossing the bridge on foot as 'being carried forward

and upward simultaneously', the bridge acting as a conduit to higher feeling.[84] Evans's two frontispieces for the Liveright editions reinforce the development of a distinctly urban sublime. As frontispieces, these photographs possess a traditional function in familiarizing the reader/viewer with the bridge, yet Evans manipulates perspective to create wonder and terror through disorientation, a visual equivalent to Crane's verbal exhilaration. In the April frontispiece, Evans shot the bridge at a dramatic diagonal angle from below, framing the bridge without any reference to what it bridges; for the July frontispiece, 'the Bridge's multiple cables [are] an analogue to Crane's multiple meanings ... a visual counterpart to those chaotic ironies which punningly infiltrate Crane's poem'.[85] Focusing again on the sharp diagonal lines characterizing the Black Sun images, the photographs accentuate the awe Crane represents cinematically in 'To Brooklyn Bridge' as 'some flashing scene / Never disclosed', an extension, it would seem, of his desire to echo Stieglitz's 'stationary, yet strangely moving pictures'.[86] Crane creates tension between stillness and movement to disorient the reader. He uses architectural nouns such as 'girder' and 'cables' sparingly, evoking rather than describing the bridge. He focuses instead on the grandeur of the bridge as a site capable of provoking ecstatic responses:

> Down Wall, from girder into street noon leaks,
> A rip-tooth of the sky's acetylene;
> All afternoon the cloud-flown derricks turn ...
> Thy cables breathe the North Atlantic still.
> ...
> Again the traffic lights that skim thy swift
> Unfractioned idiom, immaculate sigh of stars,
> Beading thy path – condense eternity:
> And we have seen night lifted in thine arms. (63–64)

This situates the bridge as a kind of Atlas figure supporting the world, suggesting how man-made structures and nature combine to form sublime spectacles in urban environments. Here, the bridge symbolizes Crane's attempt to achieve wholeness through the reconciliation of opposites, an attempt also manifested in the photobook form of *The Bridge*, reconciling the arts of poetry and photography in an 'unfractioned idiom'. But Crane also allows for their differences, and in doing so *The Bridge* demonstrates that poetic and photographic 'equivalents' can be metaphorical rather than literal, antagonistic rather than complementary.

Queer cities: 'What Rudy's camera takes'

The cinematic quality of *The Bridge* derives in part from a general concern with urban life in 1920s cinema, of which Paul Strand and Charles Sheeler's *Manhatta* (1921) is a seminal work. Although a detailed discussion of 'photopoetry on film' is beyond the scope of this book, it is worth noting how Strand and Sheeler's inclusion of extracts from several poems by Walt Whitman blends the poet's romanticism with their own high modernism. This accentuates the city as a new aesthetic category, one whose bustle and movement, while suited especially to the visual arts, was legitimized in part by Whitman's romantic engagement with 'million-footed Manhattan'. The inclusion of Whitman's verse in Strand and Sheeler's film is one example of how the 1890s' generation responded 'to the creation of an artificial horizon, a completely man-made substitute for the geology of mountains, cliffs, and canyons'.[87]

The absence of people in Evans's *The Bridge* photographs reflects Crane's greater concern with the sublimity of the Brooklyn Bridge, not its functionality. The sole perspective of the poet/photographer was sufficient to place the reader/viewer in a sublime encounter. Come 1930, almost a hundred years into photopoetic history, people were the focus in only a handful of photobooks. Works such as Julia Margaret Cameron's *Idylls of the King* (1875), Adelaide Hanscom Leeson's *Rubáiyát of Omar Khayyám* (1905), and the six photo-illustrated editions of Paul Laurence Dunbar's poetry (1899–1906) represent people, yet each, to a greater or lesser extent, belong to the 'theatrical' subgenre of pictorial photography. With the advent of documentary and street-level photography in the early twentieth century, the human figure became a much more common subject, as the works of MacLeish and Weston demonstrate. Their photobooks, however, are still retrospective in composition, with MacLeish drawing on FSA photographs and Weston tasked with accompanying Whitman's *Leaves of Grass*. In collaborative photopoetry, the human figure as a central subject emerged in the work of Swiss-born photographer Rudy Burckhardt (1915–1999) and American poet and dance critic Edwin Denby (1903–1983), arguably the first canonical partnership in photopoetic history. Combining an awareness of sublime architecture and an engagement with street-level city fabric, their work on New York and the Mediterranean reinterpreted the human figure in photopoetry, once 'antlike' in *Manhatta* and absent in *The Bridge*.[88] Alongside Denby's poetry of urban patois, Burckhardt's photographs alternate between rooftop vantage points and the sidewalk, communicating a greater interest in what Whitman termed the

'ceaseless crowd' of the city. Their nuanced interpretation of the urban sublime re-embodies the reader/viewer in the hitherto alien space of the photopoetic city, albeit within a space of confusion and disorientation. The material of their work – issues of home, exile, and dwelling – informs subsequent photopoetry in the United Kingdom and United States, and it is difficult to overstate the importance of their partnership to collaborative photopoetic practice.

Burckhardt met Denby in Switzerland in 1934 and together they travelled to New York the following year. Burckhardt began photographing the city in 1937. At first he had felt 'overwhelmed with its grandeur and ceaseless energy.... . The tremendous difference in scale between the soaring buildings and people in the street astonished me.'[89] This contrast informed the pair's initial collaboration, the private photograph album *New York, N. Why?* (1939), which contains six poems and sixty-seven photographs, arranged in three sections.[90] The first two sections examine street furniture and shopfronts: these are inhabited spaces but people are absent from the photographs. Only in the third section do they emerge, crowding the streets and the photobook itself, often three or four photographs per page (Figure 3.7). Denby's poem 'Mid-day Crowd' responds to this sudden influx:

> Isolated, active, attractive, separated,
> Momentary, complete, neat, fragmentary,
> Ordinary, extraordinary, related,
> Steady, ready, harried, married, cute, astute, hairy. (75)

The rush of Denby's internally rhymed adjectives seeks to mimic Burckhardt's visual preoccupation with people: the focus is not on their faces, however, but the way they move. In Burckhardt's photographs, faces are for the most part omitted, obscured, or only partially caught. They do not tell stories of individual subjecthood but about the small parts that people play in the symphony of urban life. Focusing alternately on arms, torsos, legs, and feet, Burckhardt studies pedestrian motion, identifying people through their manner of walking: not who they are, what they do, or where they are from. This focus on motion makes the static photographer figure and poetic speaker outsiders or outcasts in the general flow of the city. They observe, record, and remain still. These privileged perspectives combine to conjure, visually and verbally, the busyness of the city. This is paradigmatic of Burckhardt and Denby's partnership, and demonstrates how connections between poem and photograph can develop beyond illustration to become allusive, evocative, and metaphorical when there is a collaborative relationship in place, with text and image conceived in tandem.

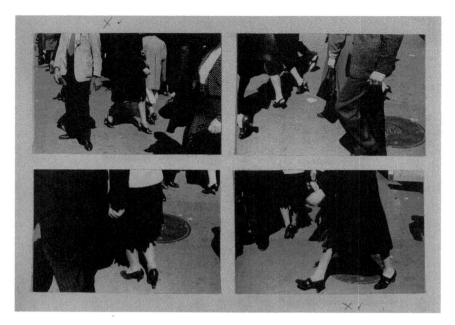

Figure 3.7 Rudy Burckhardt, 'Untitled', in *New York, N. Why?* 1938. © Estate of Rudy Burckhardt, ARS New York/IVARO Dublin, 2017. Courtesy of the University of St Andrews Library, photo TR647.B8493.

Situating photopoetry at street level, Burckhardt and Denby do not privilege the individual within the crowd. In 'Adjoining Entrances to Office Buildings in Renaissance Styles', Denby writes,

Post factum our fate is casually blue-printed
To palliate its ridiculous immensity,
Our architecture also instead of demented
Is viewed as a function of our own density. (73)

The 'ridiculous immensity' of the city aligns the 'fate' of its people with architectural blueprints, suggesting that their lives can be mapped as easily as buildings. Such is the role of architecture in the lives of citizens that, through 'density', it seems to metaphorically embody them. Denby compares a banker's smile to the 'sweet stone pastry' of a 'building's orifice', assimilating flesh and stone. In response to Burckhardt's photographs, which introduce New York as a seemingly uninhabited place, Denby's poems use architectural language to ascribe human characteristics to the city's buildings. A central concern emerges with the phrase 'get the building faced' (81). Faces – their absence and

presence – shape *New York*. The entirety of Part 1 comprises faces of buildings and their details. The first human faces we witness, in the second section, are photographs or illustrations: faces that appear on advertisements in newsstands and shop fronts. When Burckhardt focuses on actual people in the last section, his main preoccupation with movement eschews the individual and the human face, thus complicating the idea of photography as a 'face-to-face' encounter.[91] Burckhardt's predominantly faceless bodies privilege the corporeality of the photographer – a body with a face, capable of recognizing other humans – above those whom he photographs. From a Levinian perspective, Burckhardt rejects the immediate other. 'The way in which the other presents himself, exceeding *the idea of the other in me*, we here name face,' Levinas writes. 'The face is a living presence,' he continues, 'it is expression.... The face speaks. The manifestation of the face is already discourse.'[92] Burckhardt's representation of people, on the one hand, demonstrates how the city can dehumanize its inhabitants; on the other, it accentuates other attributes of identity, such as motion, that help shape and structure the connections between his photographs and Denby's poems.

Burckhardt and Denby were ideally suited to pioneer a more intricate and symbiotic photopoetry because they were drawn to subject matter that was itself inherently liminal: 'The world of curbside and sidewalk'. This world, notes Doug Eklund,

> constitutes the overarching *mise-en-scène* of the entire album, not only as the liminal zone that separates public and private, interior and exterior, but also as the ineffable space between people, energies, or entities (a leitmotif of Denby's accompanying poems) and perhaps even the space of the photographic image itself, which is indelibly touched by and inexorably removed from the real.[93]

Denby declared that Burckhardt's photographs were responsible for how he saw the everyday quality of public space. In his essay 'Dancers, Buildings and People in the Street', Denby rhapsodizes on people's movements, street facades, standpipes, window framings, the accumulation of office buildings and factories, the brilliantly coloured trucks with fancy lettering. 'As for myself,' he writes, 'I wouldn't have seen such things if I hadn't seen them first in the photographs of Rudolph Burckhardt.'[94] In Poundian terms, it was Burckhardt's 'selection and emphasis' that enabled Denby to see the city anew. Denby's work explores the connections and tensions between public and private spaces, and it is important to read Burckhardt's photographs alongside the poems, as they situate Denby's private individuals within the city's public spaces.

Burckhardt and Denby's first published book of photopoetry was *In Public, in Private* (1948), which doubled as Denby's debut poetry collection. Featuring nine photographs by Burckhardt and a frontispiece by Willem de Kooning, the major formal change between *New York* and *In Public* is one of reversal: here there is a predominance of poems interspersed with photographs, not photographs interspersed with poems. Burckhardt's images include street-level scenes and shots of skyscrapers, arranged to capture the city's different scales. Denby's poems offer snapshot narratives of the city life depicted in Burckhardt's photographs. Denby described Burckhardt's gaze as an 'instantaneous eye. He doesn't ... exploit the city for places where the situation will be right. If something should happen, that's right by chance.'[95] We might consider Denby's verse, marked by a quality of indifference, in a similar light. The title of the collection, Tyler Schmidt remarks, foregrounds Denby's 'central obsession with the social and spatial contradictions of the American city', and his poems model a 'queer attentiveness'.[96] In mapping new understandings of public space and private desire, Denby's urban imagination articulates an acute sense of alienation and dislocation. 'Can these wide spaces suit a particular man?' (9) Denby asks in one poem; in another he reflects that 'Time in every sky I look at next to people / Is more private than thought is' (6). Upsetting the public/private dualism, Denby infuses city streets, luncheonettes, and apartment houses with private feelings of erotic attraction, buried rage, and sexual abjection.

One major aspect of Denby's 'queer attentiveness' is his manipulation of the Shakespearean sonnet. Almost all of Denby's poems adopt this form, and his writing of them went against more or less every current of advanced American poetry imaginable. In 1952, William Carlos Williams rallied against the sonnet as a perverse form for American poets – 'Forcing twentieth-century America into a sonnet – gosh, how I hate sonnets – is like putting a crab into a square box' – yet Denby's sonnets wear this rebuke as a badge of honour.[97] They are syntactically difficult, thrumming with syncopated rhythms and subtle tonal shifts. One of his most famous, 'The Climate of New York', begins *In Public*:

> I myself like the climate of New York
> I see it in the air up between the street
> You use a worn-down cafeteria fork
> But the climate you don't use stays fresh and neat. (3)

As Jeff Hilson remarks, the lines of this sonnet move about in ways that, as line seven suggests, 'refuse to fit'.[98] The final couplet is both flat and discursive: it

neither resolves the themes of the poem nor provides a satisfactory conclusion. The final line – 'We can take it for granted that here we're home' – refers both to New York and the couplet itself: we take it for granted that the sonnet will be a sonnet, and that it will end this way. To develop this idea of home, Burckhardt's photographs and Denby's poems redefine the reader/viewer as a photopoetic pedestrian, experiencing the city at street level. Redefining the spatial relationship between an individual and their environment, notes George Pattison,

> had to do with the simultaneous expansion and intensification of the individual's visual interaction with the urban environment, reflected in such diverse phenomena as the innovative art of window-dressing (together with the beginnings of modern advertising) and the multiplication of new visual and spatial experiences (magic lanterns, dioramas, stereoscopy, photography, etc.).[99]

Denby evokes the city through his queer sonnets, providing 'new visual and spatial experiences' through his formal and tonal manipulations, just as Burckhardt's photographs visually represent the 'diverse phenomena' of New York. One component of Denby's attempt to demarginalize the queer speaker is to queer the space of the sonnet. Through tonal and syntactic awkwardness, he achieves this feat while remaining true to the metrics and structure of the Shakespearean sonnet.

With Burckhardt's photographs alongside them, Denby's poems intensify the reader's experience of the city. The reader can see and hear New York, from its architecture, public transport, and street furniture to snippets of conversation and the evocation of street sounds such as roaring traffic and construction sites. Poems and photographs work together to create a surrogate body for the reader who, in looking at the photographs and reading the poems, is tangibly affected by these sights and sounds. In the poem 'A New York Face', the appearance of the city is compared to a restless human face, always moving, blinking, smiling, yawning, and showing emotions. The faces of its inhabitants come to reflect the 'face' of New York itself, and Denby's evocation of such faces makes up for their lack in Burckhardt's photographs. 'The great New York bridges reflect its face,' Denby writes, 'Personality scoots across one like tiny / Traffic intent from Brooklyn' (7). For balance, however, 'City Without Smoke' (8) shows the speaker watching each inhabitant of the city look at 'the sky's grace / ... with his mortal face'. 'Mortal' might seem like an unusual, seemingly obvious description for a human face, but when we consider the poem alongside Burckhardt's photographs – in which faces are, at best, half seen – Denby is suggesting that

people are not simply cogs in the city machine. The key structure in Burckhardt and Denby's city photopoetry is the tension between the stark anonymity of Burckhardt's photographs and how Denby's poems articulate the unseen, private aspects of individuals.

This tension informs the 'queer attentiveness' of Denby's speaker. 'So a million people are a public secret,' he remarks, '(As night is a quieter portion of the day)' (38). In many poems, the reader follows Denby's eye. In 'Summer' the speaker remarks how 'the grass sleepers sprawl without attraction': they attract the speaker, though, and he observes

> Some large men who turned sideways, old ones on papers,
> A soldier, face handkerchiefed, an erection
> In his pants – only men, the women don't nap here. (9)

The obscured face reminds us of Burckhardt's photographs. Pitted against this, however, is the speaker's subjective perception. His eye movement from face to crotch is a subtle indication of desire, and is one of many examples in *In Public* where the speaker articulates a private feeling in response to a seemingly impersonal or public image. The phrase 'the women don't nap here' suggests this is a recurring scene or experience. The speaker is familiar with this locale, and knows only men sleep here. There is no photograph in the book that explicitly matches or corresponds with this poem, yet this in turn is a key characteristic of Burckhardt and Denby's photopoetry: neither the poems nor photographs illustrate each other. Rather, they work together to create atmosphere and mood. Burckhardt's photographs demonstrate the inclusivity of the street and city, and support Denby's attempt to demarginalize the queer speaker.

* * *

While *New York* and *In Public* take the metropolis for their subject, Denby and Burckhardt's second published collaboration, *Mediterranean Cities* (1956), focuses on cities of European antiquity. Burckhardt travelled to Italy in the early 1950s, photographing in Florence, Rome, Sicily, Tuscany, Umbria, and later in Greece. Denby joined the trip, and together they stayed in Naples to collaborate on the book that combines twenty-nine sonnets and twenty-eight photographs.[100] The change in scale from single city to continental journey led to a change in the arrangement of poems and photographs. Rather than face Denby's poems on adjacent pages, Burckhardt's photographs form their own sequence at the centre of the book, dividing the sonnets into two shorter sequences. This creates the impression of two distinct, separate journeys that

continually intersect. The place names from Greece and Italy that title the poems and photographs occasionally overlap, but most are unique to one or the other. Unlike the majority of earlier photopoetry, the photographer does not merely follow in the poet's footsteps, and the reader is not halted at photographically designated points of the poems. The photographic inset narrative challenges the reader/viewer to make their own connections between the sequences. This structure affirms the three-dimensionality of the collection, with the distinct, unique perspectives of poet and photographer overlaid in such a manner that neither dominates nor obscures the other.

Despite the stark contrast between American modernity and European antiquity, Denby and Burckhardt portray these divergent spaces in a manner ostensibly similar to their New York work. Burckhardt's photographs are still concerned with motion, capturing the abstract patterns of people walking through piazzas rather than along 52nd Street (Figure 3.8). These photographs, Phillip Lopate suggests, recall 'the narrative-vignette style of the great Parisian humanist photographers, Cartier-Bresson, Doisneau, Brassai, and Boubat'.[101] Burckhardt demonstrates an awareness of the history of European photography while retaining his typical 'snapshot informality'. Mirroring the photographs, the dually 'pedestrian and … conversational' dynamics of Denby's poems evoke a city life not dissimilar to that of *New York* and *In Public*.[102] The queer attentiveness of Denby's speaker persists into *Mediterranean Cities*, albeit with one major difference: transplanted to Burckhardt's home continent, as Mary Maxwell identities, the roles 'are reversed: it's the "Yank" poet now "to whom darling Europe is foreign"'.[103] The attentiveness is heightened through a sense of national foreignness which, rather than having a debilitating effect on the speaker, seems to allow him to express desire more openly. 'Homosexuality,' Maxwell notes, 'subtly hinted at in the New York poems, here finds powerful expression.'[104] This is most apparent in the indistinct and imprecise imagery of *Mediterranean Cities*. In 'Paestum', the condensed syntax of the opening lines creates a bewildering network of visual images:

> Buffalo among fields, an old bus, the sea
> Rock hills grow small beyond a somnolent plain
> Jacket folded placed near the bole of a tree
> Between a jug stood a wrapped package lain. (101)

The city ruins and the narratorial 'I' share their first appearance in the eighth line: 'Poseidon's hall looms columned; I watch dozing'. 'Dozing' implies a state

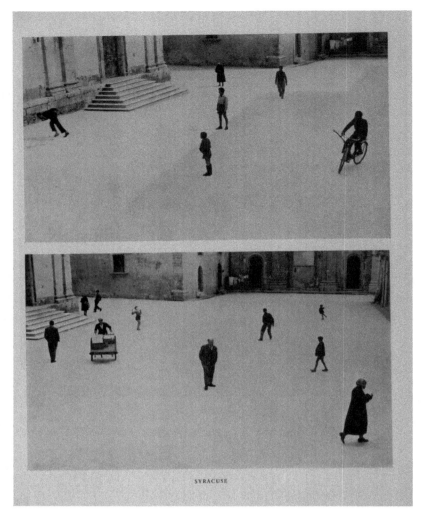

Figure 3.8 Rudy Burckhardt, 'Syracuse (II)', in *Mediterranean Cities*, 1956. © Estate of Rudy Burckhardt, ARS New York/IVARO Dublin, 2017. Courtesy of the University of St Andrews Library, photo PS3507.E54M4.

of semiconsciousness, and other verbs in the poem contribute to the scene of nascence, such as 'dawning', 'heaved', and 'trembles'. Most evocative is the image 'Merged like opposed wrestlers', which lends a physical sense to how the speaker perceives the city. It is a bodily experience for the speaker, one that he struggles to perceive and subsequently represent in his poems. The words 'shape' and 'shapes' occur seven times in the sequence; a simplification, writes Vincent

Katz, 'against which the narrator struggles'.[105] This, however, is one of the erotic charges of the book: the sweltering atmosphere of the poems dissolves people, art, landscape, nature, and architecture into indistinct 'shapes'. Metamorphic verbs abound, such as 'melting' and 'burning'. This atmosphere precludes the creation of a surrogate body for the reader: unlike in the New York work, the face no longer functions as a metaphor for the urban environment. Instead, the atmosphere breaks bodies down into constituent parts, which in turn are used to evoke the city. Oval windows, for example, are like 'eyes'; barges 'blond savory arm[s] / Fleshed'. The river Arno is a 'delicious tongue that poisons as it kisses'. The presence of others is also suggested in bodily terms, with noses, waists, legs, fingers, hands, calves, bellies, and shoulders all part of Denby's erotic representation of the city. Denby's breaking down of the Mediterranean limb by limb carries an erotic charge. Eyes frequently recur in ways that are at once voyeuristic, threatening, and titillating: 'The phosphor-drift leaps in these Naples/ Eyes, thousands of eyes, thousand and one night eyes' (97).

Photographically, however, *Mediterranean Cities* is light and cool. Its landscapes are bathed in a predominantly soft light. Burckhardt's explorations of the temporal and spatial identities of Mediterranean alleys and squares, notes Maxwell, are tonally closer to Denby's prose writings than to his poems. The only moment of 'heated decadence' in Burckhardt's photographs, Maxwell argues, is the 'unnamed image of the overgrown steps' that begins the photographic sequence.[106] The stilled pace of life in Taormina and Ischia does not bristle with the same concentrated energy as the New York intersection. Although Burckhardt's photographs bear little tonal relation to Denby's poems, this contrast is not a collaborative flaw. It accentuates the idea that photopoetry relies as much on contrast and rupture as it does on exchange and equivalence. *Mediterranean Cities* is a sonnet sequence, one that retains the formal innovations – or perversions – Denby introduced in *New York*. While these innovations highlighted the experiences of a gay man in a predominantly heteronormative public space in the New York work, such experiences are more thematically apparent in *Mediterranean Cities*. The articulation of desire informs the representation of landscape, and this is related to the presence of a more open and outward-facing poetic speaker. The poetic 'I' in *Mediterranean Cities* occurs far less frequently than in *In Public*. To Ron Padgett, this 'infrequency … did not squelch the poet's presence, but made it more pervasive, as his sensibility is discovered not in the largeness of the self but in the largeness of the world'.[107] This echoes Frank O'Hara, who notes that *Mediterranean Cities* ends with 'the

emergence of the poet's being from his feeling in "the place". The poet himself eventually is the place.'[108] That this is not, for the most part, a place immediately identifiable with Burckhardt's photographs is not a problem. A certain degree of ambivalence between poem and photograph was part of the project's conception. As Denby wrote in one of his earliest sonnets:

> Rudy like Sherlock with a microscope
> Finds this field under our nose outside the heart,
> But says he wasn't thinking of farms, the dope,
> Nor the charm of the inscription part.
>
> (In the mind, though, this enormous intersection
> Moves about like in water a reflection.) (82)

This 'enormous intersection' of poetry and photography comprises two distinct visions that stand alone and, when read together, combine and question each other. Through exchange, rupture, and dissonance, their photopoetry questions the necessity of obvious connections between text and image.

<p style="text-align:center">* * *</p>

Although a sense of photopoetry remains somewhat moot in the discussion of Pound's imagism, it is important to recognize how the two competing languages of poetry and photography were integrated into the culture of experimentation between, and especially within, the arts in the early twentieth century. Pound's experiments with poetic form and structure as surrogates for the visuality and instantaneity of the photographic image comprise an important nodal point in photopoetic history: imagism was the first poetic moment to recognize the aesthetic and structural analogies between poetry and photography. Imagism as a photographic language provided a foundational scheme for the furtherance of the relationship between poem and photograph, as Crane's development of Stieglitz's idea of 'equivalents' demonstrates. Its photographic model of poetry reimagined the relationship between text and image. We are able to see, especially in the collaborative work of Burckhardt and Denby, how the bonds between poem and photograph relied less on descriptive and illustrative practices and more on evocation and metaphor: their combination, but also their separateness. This had significant repercussions for the reader/viewer: photopoetic books developed from linear journeys through narrative poems and anthologies of pastoral verse into immersive experiences, forsaking the prescriptive mapping of photograph onto poem, and poem onto photograph, in favour of subtle modulations in collaborative practice that placed the reader/viewer in the middle of things.

The importance of the city, here, should not be overlooked. Emerging out of a concern to capture, in Weston's phrase, a 'kind of broad, inclusive summation of contemporary America', the city became a site in which poetry and photography could work together to evoke everyday experiences, encouraging the reader/viewer to make their own connections between text and image. Burckhardt and Denby relocated the sublime aspects of the city, first seen in the work of Sterling and Crane, to street level, allowing the reader to picture and hear themselves within these disorienting environments while maintaining a similar sense of wonder. Heightening this effect was the closer relationship between poet and photographer. Poems and photographs began to be written and taken in relation, not simply in response, to each other, creating what John Fuller has described as 'a third creative personality'.[109] This kind of visual and verbal synthesis was, in one sense, a central tenet of imagism, and it is through analysis of these principles that collaboration, the central photopoetic practice of the twentieth century, can be most fruitfully examined.

Notes

1 Ezra Pound, *Selected Poems and Translations*, ed. Richard Sieburth (London: Faber, 2010), 43. All subsequent quotations from Pound's poetry derive from this edition.

2 Ezra Pound, 'A Few Don'ts by an Imagiste', *Poetry* 1, no. 6 (March 1913), 200.

3 Ezra Pound, 'Vorticism', in *Gaudier-Brzeska: A Memoir* (Hessle, UK: Marvell, 1960), 85.

4 Pound, 'Vorticism', 89.

5 Pound, 'Vorticism', 89.

6 Jonathan Crary, *Techniques of the Observer: On Vision and Modernity in the Nineteenth Century* (Cambridge, MA: MIT Press, 1990), 2.

7 Pound, 'Vorticism', 92.

8 Martin Parr and Gerry Badger, *The Photobook: A History*, vol. 1 (London: Phaidon, 2004), 61. All further quotations refer to vol. 1.

9 Renée Riese Hubert, *Surrealism and the Book* (Berkeley: University of California Press, 1988), 80.

10 For a fuller discussion of *Pro Eto*, see Aleksandar Bošković, 'Photopoetry and the Bioscopic Book: Russian and Czech Avant-Garde Experiments of the 1920s' (PhD diss., University of Michigan, 2013).

11 Parr and Badger, *Photobook*, 91.

12 Parr and Badger, *Photobook*, 91.

13 Nicole Boulestreau, 'Le Photopoème *Facile*: Un Nouveau Livre dans les années 30', *Le Livre surréaliste: Mélusine IV*, ed. Henri Béhar (Lausanne: L'Age d'Homme, 1982), 164.

14 A third important, and slightly later, example of European photopoetry is Jindrich Heisler and Jindrich Štyrsky's *Na Jehlách* těchto dní (Prague: Fr Borový, 1945). Published in English as *On the Needles of These Days* (Berlin: Edition Sirene, 1984). For a full discussion, see Ian Walker, 'Between Photograph and Poem: Štyrsky and Heisler's *On the Needles of These Days*', in *Surrealism and Photography in Czechoslovakia: On the Needles of These Days*, by Krzysztof Fijalkowski, Michael Richardson, and Ian Walker (Farnham, UK: Ashgate, 2013), 67–84.

15 Alfred Stieglitz to R. Child Bayley, 9 October 1919, in *Alfred Stieglitz, Photographs and Writings*, ed. Sarah Greenough and Juan Hamilton (Washington, DC: National Gallery of Art, 1983), 203–204.

16 Paul Strand, 'Introduction', *Camera Work*, 49–50 (June 1917), np.

17 Quoted in Greenough and Hamilton, *Alfred Stieglitz*, 196.

18 See F. S. Flint, 'Imagisme', *Poetry* 1, no. 6 (March 1913), 198–200; and Pound, 'A Few Don'ts', 200–206.

19 Flint, 'Imagisme', 199.

20 Michael North, *Camera Works: Photography and the Twentieth-Century Word* (Oxford: Oxford University Press, 2005), 24.

21 See Ezra Pound, 'The Vortographs', in *Ezra Pound and the Visual Arts*, ed. Harriet Zinnes (New York: New Directions, 1980), 154–157.

22 Daniel Tiffany, *Radio Corpse: Imagism and the Cryptaesthetic of Ezra Pound* (London; Cambridge, MA: Harvard University Press, 1995), 30.

23 Pound, 'Vortographs', 155, 156.

24 B. H. Dias [Ezra Pound], 'Art Notes: Kinema, Kinesis, Hepworth, Etc.', *New Age* 23, no. 22 (September 1918), 352.

25 Pound, 'Vortographs', 156.

26 Ezra Pound to John Quinn, 13 October 1916, in *Ezra Pound and the Visual Art*, ed. Zinnes, 241–242.

27 Pound, 'Vortographs', 155, 156.

28 Christopher Bush, *Ideographic Modernism: China, Writing, Media* (Oxford: Oxford University Press, 2010), 64.

29 Ezra Pound to Harriet Monroe, 15 January 1915, in *The Letters of Ezra Pound, 1907–1941*, ed. D. D. Paige (London: Faber, 1951), 91.

30 Yoshinobu Hakutani, *Haiku and Modernist Poetics* (New York: Palgrave Macmillan, 2009), 71. Accounts of Pound's engagement with haiku, or *hokku*, routinely assign a variety of parties responsible for his introduction to the

Japanese form, including his fellow imagists T. E. Hulme, F. S. Flint, and Aldington; Pound's own acquaintance with the writings of Ernest Fenollosa; and Yone Noguchi, a bilingual Japanese and American poet whose numerous volumes of criticism and poetry introduced Japanese verse to Britain in the early twentieth century. For a summary, see Hakutani, *Haiku and Modernist Poetics*, 69–88.

31 Pound, 'Vorticism', 89.

32 Roland Barthes, *Camera Lucida: Reflections on Photography*, trans. Richard Howard (London: Vintage, 2000), 49.

33 Hakutani, *Haiku and Modernist Poetics*, 71.

34 Bush, *Ideographic Modernism*, 64.

35 Quoted in David Anderson, *Pound's Cavalcanti* (Princeton, NJ: Princeton University Press, 1983), 5.

36 North, *Camera Works*, 24.

37 T. S. Eliot, *The Waste Land: A Facsimile and Transcript of the Original Drafts Including the Annotations of Ezra Pound*, ed. Valerie Eliot (London: Faber, 1971), 10–13.

38 Melita Schaum, 'The Grammar of the Visual: Alvin L. Coburn, Ezra Pound, and the Eastern Aesthetic in Modernist Photography and Poetry', *Paideuma* 24, no. 2–3 (Fall–Winter 1995), 97.

39 Schaum, 'Grammar of the Visual', 97–102.

40 Bush, *Ideographic Modernism*, 65.

41 Mike Weaver, *Alvin Langdon Coburn: Symbolist Photographer* (New York: Aperture Foundation, 1986), 16.

42 Schaum, 'Grammar of the Visual', 105.

43 Bush, *Ideographic Modernism*, 60.

44 Pound, 'Vorticism', 94n.

45 Parr and Badger, *Photobook*, 88.

46 Archibald MacLeish, *Land of the Free* (New York: Harcourt, Brace, 1938), 89.

47 Louis Kaplan, *American Exposures: Photography and Community in the Twentieth Century* (Minneapolis: University of Minnesota Press, 2005), 27. For a more detailed discussion of *Land of the Free*, see Kaplan, *American Exposures*, 27–54.

48 Kaplan, *American Exposures*, 29.

49 John Holmes, 'Poetry Now', *Boston Transcript*, 16 April 1938, 2.

50 Carl Sandburg to Archibald MacLeish, 17 March 1938. Box 20, Archibald MacLeish Papers, Manuscript Division, Library of Congress, Washington, DC. Permission granted by Paula Steichen Polega and John Steichen and the Barbara Hogenson Agency, Inc.

51 Carl Sandburg, *Poems of the Midwest* (Cleveland: World Publishing, 1946), np.

52 Elizabeth McCausland to Abe Lerner, 13 July 1946. Box 3, folder 29, item 68, Elizabeth McCausland Papers, 1838–1995, bulk 1920–1960. Archives of American Art, Smithsonian Institution.

53 Edward Weston to Merle Armitage, 29 December 1942. Harry Ransom Center, University of Texas, Austin.

54 George Macy to Edward Weston, 7 February 1941. Harry Ransom Center, University of Texas, Austin.

55 Weston to Nancy and Beaumont Newhall, 28 April 1941. Harry Ransom Center, University of Texas, Austin.

56 Weston to Macy, 13 February 1941. Harry Ransom Center, University of Texas, Austin.

57 Weston to Macy, 15 August 1941. Harry Ransom Center, University of Texas, Austin.

58 Francine Weiss, 'The Limited Editions Club's *Leaves of Grass* (1942) and the American Imagetext', *European Journal of American Culture* 32, no. 2 (2013), 143.

59 Weiss, 'American Imagetext', 144, 145.

60 Susan Danly, '"Literally Photographed": Edward Weston and Walt Whitman's *Leaves of Grass*', in *Edward Weston: A Legacy*, ed. Jennifer A. Watts (London: Merrell, 2003), 77.

61 Danly, 'Literally Photographed', 77.

62 Constance Phillips, foreword to *Photopoems: A Group of Interpretations through Photographs* (New York: Covici Friede Publishers, 1936), np.

63 See 'Women with Cameras', *Popular Photography* 13, no. 3 (September 1943), 45.

64 Phillips, *Photopoems*, np.

65 David E. Nye, *American Technological Sublime* (Cambridge, MA: MIT Press, 1994), 77.

66 Quoted in David G. McCullough, *The Great Bridge: The Epic Story of the Building of the Brooklyn Bridge* (New York: Simon & Schuster, 2001), 493.

67 See Nye, *American Technological Sublime*, 45–142.

68 George Sterling and Francis Bruguière, *The Evanescent City* (San Francisco: A. M. Robertson, 1915), 4.

69 Christophe Den Tandt, *The Urban Sublime in American Literary Naturalism* (Urbana: University of Illinois Press, 1998), 6.

70 Den Tandt, *Urban Sublime*, 6.

71 Den Tandt, *Urban Sublime*, xi.

72 Hart Crane to Alfred Stieglitz, 15 April 1923, in *O My Land, My Friends: The Selected Letters of Hart Crane*, ed. Langdon Hammer and Brom Weber (New York: Four Walls Eight Windows, 1997), 149.

73 Jane M. Rabb, ed., *Literature and Photography: Interactions 1840–1990, a Critical Anthology* (Albuquerque: University of New Mexico Press, 1995), 223.

74 Crane to Gorham Munson, 18 February 1923, in *O My Land*, 131; Crane to Stieglitz, 15 April 1923, in *O My Land*, 149. For an example of a natural 'equivalent' in photopoetry, see Alvin Langdon Coburn's *The Cloud* (Los Angeles: C. C. Parker, 1912), which pairs six of Coburn's photogravures with the titular poem (1820) by Percy Bysshe Shelley.

75 Stella's own thoughts on the Brooklyn Bridge are worth noting: 'Many nights I stood on the bridge ... I felt deeply moved, as if on the threshold of a new religion or in the presence of a new DIVINITY.' See Joseph Stella, 'The Brooklyn Bridge (A Page of My Life)', *transition*, no. 16–17 (June 1929), 88.

76 Crane to Harry and Caresse Crosby, 30 August 1929, in *O My Land*, 415.

77 Crane to Caresse Crosby, 2 January 1930, in *O My Land*, 422.

78 Hammer, ed., *O My Land*, 390.

79 Crane to Caresse Crosby, 26 December 1929, in *O My Land*, 421.

80 Nye, *American Technological Sublime*, 87.

81 Edmund Burke, *A Philosophical Enquiry into the Sublime and Beautiful*, ed. James T. Boulton (London; New York: Routledge, 2008), 63.

82 Gordon K. Grigsby, 'The Photographs in the First Edition of *The Bridge*', *Texas Studies in Literature and Language* 4, no. 1 (Spring 1962), 9.

83 Crane to Otto H. Kahn, 12 September 1927, in *O My Land*, 346.

84 Crane to Waldo Frank, 18 January 1926, in *O My Land*, 227.

85 Paul Giles, *Hart Crane: The Contexts of* The Bridge (Cambridge: Cambridge University Press, 1986), 104.

86 Hart Crane, *Complete Poems*, ed. Brom Weber (Newcastle upon Tyne: Bloodaxe, 1984), 63. All subsequent quotations from *The Bridge* derive from this edition.

87 Nye, *American Technological Sublime*, 91.

88 Jan-Christopher Horak, 'Paul Strand and Charles Sheeler's *Manhatta*', in *Lovers of Cinema: The First American Film Avant-Garde, 1919–1945*, ed. Horak (Madison: University of Wisconsin Press, 1995), 279.

89 Quoted in Phillip Lopate, *Rudy Burckhardt* (New York: Harry N. Abrams, 2004), 11–12.

90 The album was published in 2008 by the Metropolitan Museum of Art as the catalogue to an exhibition of the same name. The six Denby poems were published under the heading 'Poems Written to Accompany Photographs by Rudy Burckhardt', in *Edwin Denby: The Complete Poems* (New York: Random House, 1986), 71–84. All further quotations from Denby's poems refer to this edition.

91 Walking is equally important in Burckhardt's later collaborations with poet Vincent Katz (1960–): see *New York, Hello!* (1990) and *Boulevard Transportation* (1997).

92 Emmanuel Levinas, *Totality and Infinity: An Essay on Exteriority*, trans. Alphonso Lingis (Pittsburgh, PA: Duquesne University Press, 1969), 50, 66.

93 Douglas Eklund, 'The Pursuit of Happiness: Rudy Burckhardt's New York, 1935–1940', in *New York, N. Why?* by Edwin Denby and Rudy Burckhardt (New York: Nazraeli Press, 2008), np.

94 Edwin Denby, *Dance Writings & Poetry*, ed. Robert Cornfield (New York: Knopf, 1986), 259.

95 'The Cinema of Looking: Rudy Burckhardt and Edwin Denby in Conversation with Joe Giordano', by Joe Giordano, *Jacket* 21 (February 2003), accessed 10 May 2017, http://jacketmagazine.com/21/denb-giord.html.

96 Tyler T. Schmidt, *Desegregating Desire: Race and Sexuality in Cold War American Literature* (Jackson: University Press of Mississippi, 2013), 103.

97 William Carlos Williams, *Interviews with William Carlos Williams*, ed. Linda Wagner-Martin (New York: New Directions, 1976), 30.

98 Jeff Hilson, Paul Muldoon, and Meg Tyler, 'Contemporary Poets and the Sonnet: A Trialogue', in *The Cambridge Companion to the Sonnet*, ed. A. D. Cousins and Peter Howarth (Cambridge: Cambridge University Press, 2011), 21.

99 George Pattison, *Kierkegaard, Religion, and the Nineteenth-Century Crisis of Culture* (Cambridge: Cambridge University Press, 2002), 1.

100 While its influence on Burckhardt and Denby, if any, was negligible, William Leighton's self-collaborative volume *Roman Sonnets* (1908) paired sonnets with commercial photographs of Roman monuments such as the Coliseum. See William Leighton, *Roman Sonnets* (Florence: G. Giannini & Son, 1908).

101 Lopate, *Rudy Burckhardt*, 23; Jed Perl, *New Art City: Manhattan at Mid-Century* (New York: Knopf, 2005), 261–262.

102 Mary Maxwell, 'Edwin Denby's New York School', *Yale Review* 95, no. 4 (October 2007), 71.

103 Maxwell, 'Denby's New York School', 76.

104 Maxwell, 'Denby's New York School', 78.

105 Vincent Katz, 'Visiting Edwin Denby's Mediterranean Cities', in *Hidden Agendas: Unreported Poetics*, ed. Louis Armand (Prague: Univerzita Karlova v Praze, 2010), 79n7.

106 Maxwell, 'Denby's New York School', 77.

107 Ron Padgett, introduction to *Denby: Complete Poems*, xxiii.

108 Frank O'Hara, 'Rare Modern', review of *Mediterranean Cities*, by Edwin Denby and Rudy Burckhardt, *Poetry* 89, no. 5 (February 1957), 313.

109 John Fuller and David Hurn, introduction to *Writing the Picture* (Bridgend, UK: Seren, 2011), 11.

4

Shaping Photopoetic Space
1957–1994

'There is a theory,' writes the poet John Fuller, who collaborated with photographer David Hurn on the photopoetic book *Writing the Picture* (2010),

> that a successful collaboration essentially creates a third creative personality. In some ways a poem is a fulfilment of one aspect of the photograph that the poet has chosen to explore. It becomes a completion of one of the functions of that photograph. But of course there could be an infinity of those functions, and an infinity of poems. The one that gets written is the poet's chosen feelings about the picture.[1]

Fuller raises an important point about what happens when poems and photographs interact on the page – that in a successful photopoem, poem and photograph become, on the one hand, inseparable, and on the other there remains the knowledge that this is simply one such possible pairing insofar as the conduit of response that prompts either poem or photograph is, in a sense, infinite. It is a 'third creative personality' that recognizes and maintains the personalities of poet and photographer through which it was created. As Robert Crawford and Norman McBeath state in their photopoetry manifesto, 'Collaborations which work are like close human relationships: in a successful pairing of poem and photograph each will be independent yet interdependent.'[2]

For Fuller and Hurn, it seems that the conduit of response runs incontrovertibly from poet to photographs. In their 'Conversation by Way of Introduction' to *Writing the Picture*, Hurn states: 'Poetry is far more flexible than photography. The writing must be about the pictures. The pictures must come first. Trying to pretend you are taking a photograph that represents an already written poem is absurd.'[3] As we have seen in the previous three chapters, photographers had been taking pictures to represent already written poems for the best part of a century. Much of their work was challenging and innovative, prompting new ideas and fresh approaches to how we consider the connections between text and image. What is perhaps Hurn and Fuller's most useful suggestion is the gradual

concentration of scope, with poets tending to hone in on one 'aspect' of the photograph. Equally, when photographers respond to poems, it is less 'absurd' should they hone in on one image or aspect of the poem to create a photographic 'equivalent' through metaphor or evocation. 'Within a set of pairings,' write McBeath and Crawford, 'there should be a range of connective strands: again like a relationship, where there are lots of different facets of attraction and at the same time a deep consistency.'[4]

As the previous chapter explores, there are photopoetic books in which text and image are paired deliberately – for example, Archibald MacLeish's *Land of the Free* (1938) – and there are photopoetic books which seek to evoke a particular atmosphere, such as Rudy Burckhardt and Edwin Denby's *New York, N. Why?* (1938). These latter photobooks are not structured around pairings of poems and photographs, but rely instead upon the reader/viewer making their own connections across the breadth of the whole book. Such arrangements are dependent on the nature of the collaborative relationship: whether, for example, poet responds to photographer, photographer responds to poet, poet and photographer respond to each other, or poet and photographer create separate works based on a shared theme or idea, and pair up or arrange their work later. This chapter examines a range of collaborative relationships and explores how closer ties between poet and photographer result in work that is, in effect, co-authored. Photopoetry books in the nineteenth and early twentieth centuries often take the poet as sole author, relegating the photographer to an adjunct position, often mentioned in subtitles such as 'with photographs by', or 'with photographic illustrations by'. Indeed, now that photopoetry has moved from a retrospective to collaborative stage, new questions emerge. How does each art differ, for example, when it is made or written with an awareness that it will be viewed or read alongside the other? What working practices inform, not only how photographs are taken and poems written, but also how they are sequenced, rejected, reinstated, and adapted?

With collaboration in mind, this chapter also examines the changing nature of British photopoetry in the mid-to-late twentieth century. It considers the introduction of city spaces to British photopoetry, and discusses how photopoetic collaboration re-evaluated pictorial landscapes – the visual locus of many photographically illustrated poetry books – turning them into more immersive spaces through ideas of dwelling and travel, and the relationship between nature and culture. This was achieved through an alignment between documentary and topographical traditions in photography, complementing the

imagist inheritance of mid-twentieth-century British poetry: the move, Simon Armitage notes, 'away from linear and chronological treatments of its subjects, towards more instantaneous executions of subject and form'.[5]

Documentary, surrealism, and post-war Britain

British collaborative photopoetry was slower to emerge than its American counterpart. The doldrums of British art photography in the 1930s meant that British photopoetry had no answer to continental experiments such as Paul Éluard and Man Ray's *Facile* (1935), or to the search for 'American-ness' in the metropolis, from Paul Strand and Alfred Stieglitz to Walker Evans and Rudy Burckhardt. To suggest that any coherent school of photopoetry existed during this period would be to overstate any developments in British photopoetry since the photographically illustrated 'collected works' trend of the late nineteenth century. Works of this nature continued to be published into the 1930s, Kathleen Conyngham Greene's *The English Landscape* (1932) being a standard example.

Among the first collaborations to emerge were those by W. H. Auden (1907–1973): *Letters from Iceland* (1937) with Louis MacNeice (1907–1963), and *Journey to a War* (1939) with Christopher Isherwood (1904–1986).[6] These combine prose, poems, photographs, captions, and other visual images such as tables and charts in what Marsha Bryant calls a collage 'that appropriates the discourses of poetry, rhetorical documentary, travelogue, and high modernism'.[7] In *Letters to Iceland*, Auden frequently positions the poetic speaker as a tourist in an 'elsewhere' place. 'The children stare and follow,' Auden writes, 'think of questions / To prove the stranger real' (91). Auden's photographs are playful snapshots, 'out of focus, some with wrong exposures' (21), and he describes the mental and physical 'holiday' of being in Iceland, which situates the country in contrast to the finely wrought 'literary' product that he and MacNeice actually produce. Considering the poet/photographer in the role of 'tourist' is productive. Photographs, Susan Sontag notes, 'help people to take possession of a space in which they are insecure. Thus, photography develops in tandem with one of the most characteristic of modern activities: tourism'.[8] Auden's figure of the tourist 'stranger' invests the landscape with agency through its inherent oppositions: a contrasting subjectivity to that of the 'local', and the camera as 'impersonal'. Yet, as Sontag argues, 'Gazing at other people's reality with curiosity, with detachment, with professionalism, the ubiquitous photographer operates as if that activity

transcends class interests, as if its perspective is universal.'[9] Such impersonality is impossible; an objective, documentary 'eye' is ultimately unachievable.

Auden's subversion of documentary through his tourist persona and 'out of focus' snapshots recalls Roland Penrose's (1900–1984) photopoetic project *The Road Is Wider than Long* (1939), which recounts Penrose's journey through Greece and the Balkans with American photographer Lee Miller (1907–1977). As Ian Walker remarks, the ambiguous subtitle 'An Image Diary from the Balkans' makes it unclear whether the book 'is a diary accompanied by images or, more intriguingly, a diary made up of images'.[10] The poetic fragments, each in a variety of fonts and colours and bearing only slight visual concord with the photographs, create a kind of dream space, a journey as much through physical as mental terrain. Peter Osborne's discussion of the 'Surrealist tour guide', Walker notes, is an appropriate model for *The Road*. 'For the Surrealists,' writes Osborne, 'travel was a method, a means of smoking out the unconscious ... The surrealist journey conveyed them towards an encounter with some kind of otherness which might also destabilise and transform them.'[11] Penrose's encounters with gypsies and wanderers, 'the journeys alone that fill / the world', heighten the reciprocity of movement in *The Road*, contrasting with the stasis of the locals in *Letters* compared with Auden's 'stranger'.[12] 'The photographer,' writes Sontag, 'is always trying to colonize new experiences or find new ways to look at familiar subjects.'[13] Her idea of photography as a 'supertourist' encourages the reader to see Penrose's selection and ordering of images as a 'possession of a space'. As Anthony Carrigan suggests, 'tourist photography ... involves the isolation and eventual development of discrete images which are powerfully constitutive of landscape perceptions'.[14] Long poems provided narrative in nineteenth-century photopoetry: photograph followed photograph, mirroring the linear text. Auden and Penrose began to exploit this structure, collaging non-referential poems and photographs to create highly subjective impressions of place that did not support illustrative relationships between text and image.

The 'tourist' model for photopoetry was not applied again until the 1960s. This time it was used not for 'alien' lands but places closer to home: namely, post-war urban environments. Douglas Dunn's Hull and Thom Gunn's London explore how poetry, when paired with documentary photography, can heighten the latter's potential for the surreal and uncanny. Dunn (1942–) composed *Terry Street* (1969) while studying for an English degree at the University of Hull. Living in a house he bought for £250 – 26 Flixboro Terrace, perpendicular to Terry Street, one of the 'rat-coloured igloos of the northern working-class' – Dunn felt

himself a strange kind of exile, a cultural hermit isolated from his neighbours in streets that were, in Dunn's words, 'already "condemned" as Unfit for Human Habitation ... Actually, those who lived in these streets hadn't long been promoted to the status of "human".[15]

Dunn sent a selection of poems from *Terry Street* to the *London Magazine* in 1968, whose editor, Alan Ross, commissioned a suite of accompanying photographs. Ross chose the renowned London-based photographer Robert Whitaker (1939–2011) whose work includes the controversial 'butcher' album-sleeve for The Beatles' US album *Yesterday and Today* (1966) and, later, photojournalism assignments in Bangladesh and Vietnam. Whitaker arrived in Terry Street on a warm Saturday morning in June 1968 and Dunn immediately had reservations: 'I worried about how he'd get on with the locals from the moment I saw him, his girlfriend, and his sportscar. Very snobbish of me, I'm sure.'[16] Whitaker produced nearly sixty photographs, eight of which followed Dunn's verse in the August 1968 edition of *London Magazine*.[17] The entire suite was not published until 1994, when they accompanied the opening sequence of *Terry Street* in a special edition of the journal *Bête Noire*. Editor John Osborne, not Dunn and Whitaker, arranged the poems and photographs, noting in his accompanying essay that

> where Dunn's verbal photographs carry a deal of editorial comment, Robert Whitaker's visual ones are direct, unencumbered. Where Dunn offers depth in a manner that may seem too judgemental, Whitaker offers a more transient, glancing vision but one superbly attuned to the dynamics of everyday life.[18]

The environs of Terry Street lent a collective identity to Dunn and Whitaker's subjects. Whitaker responded to the place itself as much as to Dunn's poems, though he remarked, 'I kept in mind the poetry... . I remember making a comment ... "What a pleasure to illustrate these simple concise words." '[19] The resulting sequence of photographs, however, surpasses Whitaker's supposedly illustrative intentions.

This 'attuned' exploration of locale through photographs and poems was not the first project of its kind. Anglo-American poet Thom Gunn (1929–2004) collaborated with his photographer brother Ander Gunn (1932–) on *Positives* (1966), an exploration of London and its inhabitants from various social classes and stages of life. It contains thirty-nine black-and-white photographs and thirty-seven poems, the longest of which stretches to twenty-one lines. Thom had lived on Talbot Road, W11, from 1964–1965 while staying in Britain for

twelve months on a fellowship from the National Institute of Arts and Letters. He worked on the poems from February through May 1965, immediately after completing two major long poems: 'Misanthropos', about the lone survivor of a nuclear war, and 'Confessions of the Life Artist', a sequence about the nature and process of artistic composition.[20] The unrhymed syllabic poems of *Positives* were a return to shorter verse forms that Gunn had struggled to write since the completion of *My Sad Captains* (1961), and were 'probably' Gunn's first poems in free verse, as he remarked in a 1995 interview.[21]

Unlike Dunn and Whitaker's *Terry Street*, in which poems preceded photographs, *Positives* was constructed around Thom's responses to Ander's photographs. As Thom notes, 'my brother's pictures were almost always the starting point for my comments. Often, though, I was present when he took the pictures – it was a real collaboration.'[22] So inseparable did Gunn consider his poems from Ander's photographs that he included only two of the poems in his *Collected Poems* (1994). As poems, however, Gunn remained uncertain as to precisely what he had written. 'I was never very sure whether what I was writing opposite the photographs were poems or captions,' Gunn wrote in an essay first published in 1979.[23] Later, in 1995, he clarified that they 'are just captions; [they] were easy.'[24] Gunn's intention, he remarks in the same interview, was 'to adapt William Carlos Williams for the English', and with Williams's help Gunn 'found a way … of incorporating the more casual aspects of life, the non-heroic things in life, that are of course a part of daily experience and infinitely valuable.'[25] It was 'daily experience' that informed *Positives*, and both Gunn brothers were, in a sense, acting on the opening lines of 'Confessions': 'Whatever is here, it is / material for my art.'[26]

Despite their differing compositional methods, *Positives* and *Terry Street* share a number of connections with the Mass Observation movement, founded in 1937 by Tom Harrisson (1911–1976), Humphrey Jennings (1907–1950) and Charles Madge (1912–1996). With influences in surrealism and documentary, Nick Hubble notes, Mass Observation remains somewhat enigmatic. Hubble points, as I do now, to a summary of Mass Observation,

> characterised variously as a documentary or photographic project (Laing, 1980), as a deeply flawed social survey (Abrams, 1951), as a middle-class adventure at the expense of the working class (Gurney, 1997), as salvationist (Hynes, 1976), as a people's history (Calder, 1985), and as a life history project which was a precursor to, for example, present-day oral history (Sheridan, 1996).[27]

The style of photographs produced by figures such as Bill Brandt, Humphrey Spender, and Julian Trevelyan in the north of England is of photopoetic interest. In the 1930s, the north was represented more as a trope than an actual place, especially in the decade's 'travel books'. 'It seems that to travel north,' notes Walker, 'was to travel somewhere that was not really England at all.'[28] In the first Mass Observation book, *First Year's Work* (1938), Bolton is rechristened 'Northtown'.[29] This creation of an imagined geography is intriguing: Harrisson invited Spender to photograph Bolton as part of the former's obsession with facts. Spender later recalled, 'It was factual data, of every kind, that he wanted from photos.'[30] This kind of 'data' can be seen in Whitaker's photographs, as with Mass Observation it is given a strangeness, a surreal quality juxtaposing banal reality in which, as Walker argues of Spender, 'The "sur" of Surrealism does not indicate that it is *beyond* reality, but rather that it is a heightened and deepened understanding of it.'[31] Whitaker's surreal quality in *Terry Street* does not feel contrived: the dog peering above a garden fence, the pile of overturned prams, and the image of two near identically dressed women taking a small child for a walk.

Whitaker's photographs heighten reality, creating an imagined, alien place at the heart of Terry Street that is rooted in a sense of temporal dislocation. Dunn remarks how 'Bob's photographs underline for me that although he took them in 1968 the place in them was dated at least ten years before. Different time zone. Different country, even.'[32] The subjectivity of the observer compromises the authenticity of 'factual data'. Walker mentions 'Spender's later confessions about how much of a voyeur and intruder he felt in Bolton, spotted as a foreigner as soon as he opened his mouth: "I was somebody from another planet." '[33] Dunn's own detachment tempers the supposed objectivity of his poems. 'I found it hard to get to know any of my neighbours,' Dunn notes. 'To them, it seemed important, and negative, that I wasn't local and was at "the College".... Some of them seemed to spend a lot of time looking at me. I spent a lot of time looking back.'[34] Dunn was an intellectual, a Scot, and a fervent advocate of left-wing politics: an alien to northern England, in his view, with its 'houses that are monuments to entertainment'.[35] Women see Dunn,

> at my window, among books
> a specimen under glass, being protected,
> And laugh at me watching them.
> They minuet to Mozart playing loudly

On the afternoon Third. They mock me thus,
They mime my culture. (*Terry Street* (hereinafter *TS* in citations) 67)

This aesthetics of looking, of recording and preserving salient details, corresponds with Jane Stabler's identification in Dunn's work of a 'wary fascination with the way in which photography exactly holds the past'.[36] Dunn uses his living room window as a metaphor for the frame of the photograph, though he is often the one framed 'under glass'. There is a ghostly, photographic afterlife to these women as 'The movements they imagine go with minuet / Stay patterned on the air'. This conjures the ghostly quality Roland Barthes would later ascribe to photography. Barthes calls the photograph 'a certificate of presence', 'literally an emanation of the referent. From a real body, which was there'.[37] These afterlives – 'a superimposition … of reality and of the past' – become a photographic model for Dunn, echoed in Whitaker's portfolio.[38] One photograph of a man asleep in a car – in which Whitaker is reflected in the window – is a spectral kind of self-portrait, challenging photographic objectivity through its self-referential nature and its compositional flaw, blighted by the reflection (Figure 4.1). Whitaker becomes a character of Terry Street while retaining his outsider status, writing himself into its representational history, just as Dunn's consciousness inevitably pervades the poems.

While Whitaker's photographs picture the Terry Street neighbourhood, Dunn's poems most often contain speakers situated indoors and alone. This is perhaps an inheritance from Philip Larkin's poetry, in which the speakers, argues Edward Picot, are 'aware of the natural world outside, but isolated from it just as they are isolated from other human beings'.[39] These speakers are the subjective centres of the poems, as we have seen in 'Young Women in Rollers', even though Dunn aimed for a documentary-like poetic persona. 'As an outsider,' Dunn notes, 'observation … was as much as I could expect of myself in depicting the other people who lived there; and … my poems of that time [took] the form of testimony and, where I could manage it, of objective realism'.[40] Here emerges the central difference between *Terry Street* and *Positives*: Whitaker's photographs were responses to Dunn's poems, whereas Gunn's poems were responses to his brother's photographs. Gunn was conscious that he was working from representations rather than straight from life, and this necessitated a subtly different act of writing. To examine how Gunn responded to Ander's photographs, it is instructive to look at one of his subsequent poems, 'Song of a Camera', written to the photographer Robert Mapplethorpe. 'I suppose it is

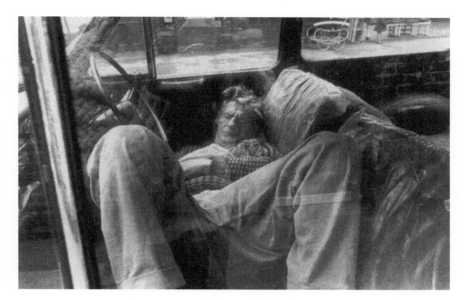

Figure 4.1 Robert Whitaker, 'Untitled (1968)', in *Terry Street: A Bête Noire Special Edition: Poems by Douglas Dunn, Photographs by Robert Whitaker*, 1994. Image © Robert Whitaker. Courtesy of the University of St Andrews Library, photo PR6054. U54T4F94.

meant to be sung in a rather neutral, cold voice,' Gunn remarked of the poem, 'which is what I imagine the voice of a camera would be.'[41] Gunn writes:

> I am the eye
> that cut the life
> you stand you lie
> I am the knife.[42] (*CP* 348)

It is not this 'neutral, cold voice' on which Gunn based the speaker of *Positives*, but the technique of excision: this enabled Gunn to focus on the strangeness of seeing 'a piece of life frozen in all its ambiguity', as he called the photograph.[43] Often the speaker(s) of the *Positives* poems ranges beyond the accompanying images, usually by speculating on the mental lives of the people pictured in the photographs. For example, 'Syon House' interprets the photograph by imagining the consciousness of the pictured figure, lending a narrative to the scene (Figure 4.2).[44] 'Oppressed by a sense of columns', the speaker pushes back,

> but their pressure
> is continual because

they have no mind or feeling
to vacillate ... (*Positives* (hereinafter *P* in citations) 44)

But Gunn's ruminations are not solely given to abstractions. Having accompanied his brother when taking the photographs, Gunn used memories from these excursions to thaw the ambiguity of Ander's images:

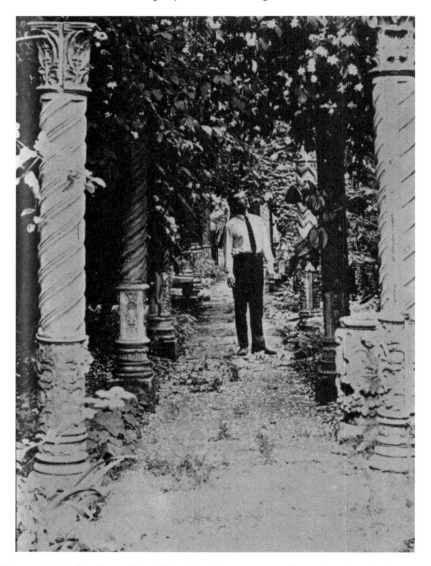

Figure 4.2 Ander Gunn, 'Syon House', in *Positives*, 1966. Reproduced with the permission of Ander Gunn. Courtesy of the University of St Andrews Library, photo PR6013.U65P6.

a distant sound of water,
dew on blackberry bushes
globing the thorns, glossing
the mauve, slightly whiskered
segments of unripe berries ... (*P* 44)

This is a complete departure from the photograph, a description that imbues the black-and-white image with colour, sound, movement, and texture. It also complicates our appreciation of how the poetic speaker engages with figures in the photographs. Rarely is there an exclusive correlation. Gunn maintains an omniscient relationship to the photographs, and in that sense his 'captions' do not attempt to recreate the photographs verbally; rather, they extend and modify. Hence we are allowed an insight into an individual's consciousness alongside the supposed detachment of description.

The issue of dependence is central to how we see *Positives* in the context of photopoetic history. As Gunn seemed to suggest by including only two of the poems in his *Collected*, his verses need Ander's photographs in order to make sense. In 'He Rides Up and Down, and Around' (16) for example, the poem contrasts two boys pictured in Ander's photograph (Figure 4.3). A young boy seems thrilled at riding a bicycle, while an older boy 'dreams of cars'. The older boy is in the background, seemingly peripheral to the focus of the image, yet the poem leads inexorably to his thoughts. This is so much the case that the opening lines read as a recollection of his childhood, and we see the younger boy in the photograph as a ghostly emanation of the older:

He rides up and down, and around:
all things are means to wheely ends.
All things radiate from the spokes under
that hard structure of bars crossing
precisely and usefully. But another
leans against an iron fence, grown
older, and dreams of cars. (*P* 16)

Even though 'another' makes clear the distinction between the two boys, the way Gunn's poem leads the reader's eye across the photograph allows us to perceive how the older boy sees himself and his own childhood in the bicycle-riding younger boy. The photograph, in a sense, is the speaker's mental image. The way Gunn constructs the mental lives of his speakers often posits the photograph as something imagined, rather than as 'a piece of life frozen'. In another photograph, an image of a little girl in a wooden highchair, her feet dangling beneath her, is

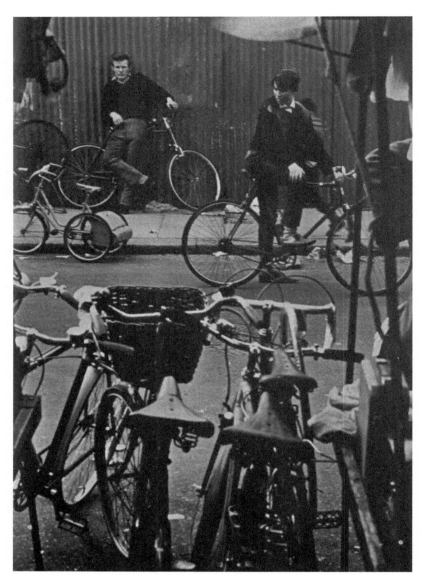

Figure 4.3 Ander Gunn, 'He Rides Up and Down, and Around', in *Positives*, 1966. Reproduced with the permission of Ander Gunn. Courtesy of the University of St Andrews Library, photo PR6013.U65P6.

accompanied by the lines 'In a bus it is nice to ride on top because / it looks like running people over' (*P* 12). The jaunty syntax and language evoke the speech of an infant, and this time the poem is the speaker's mental image as she pretends she is riding a bus. These kinds of reciprocities between poem and photograph highlight how 'response' structured the book. Gunn was dismissive of these poems because they could not stand alone in the way that Ander's photographs make up a self-contained suite. Taken as an entire photopoem, however, *Positives* demonstrates what poem and photograph can bring to one another on the page. 'In a very real sense,' Andrew Miller notes, '*Positives* could be described as one long associative poem,' which, in its imagistic tendencies, would make it a candidate for what Ezra Pound conceived as the long imagist poem.[45] Compared to the interdependence of *Positives*, the *Terry Street* poems and photographs make separate, independent portfolios that can stand alone in their own right. Distinct poetic and photographic voices are audible and visible in *Terry Street*, whereas the collage of *Positives* blends and blurs the distinctions between the two art forms. Despite these differences, both photopoetic sequences are important examples of the different working relationships between poets and photographers, as well as examples of new trends in British photopoetry: first, the setting of post-war urban landscapes, and second, the relationships between people and their environments.

Spatial poetics in Allen Ginsberg's *Ankor Wat*

The photopoetic landscape transforms again when the 'tourist' ventures further afield, as is the case in Allen Ginsberg's 'long collage-voice poem' *Ankor Wat* (1968).[46] Published by Fulcrum Press, one of the most renowned small presses of the period, the poem recounts Ginsberg's (1926–1997) pilgrimage to the twelfth-century Hindu temple in Siemreap, Cambodia, alongside photographs by Alexandra Lawrence.[47] *Ankor Wat* can be traced back to modernist collage through Ginsberg's inclusion of explanatory notes, which follow the poem. This assumes, as Davidson suggests of Eliot and Pound,

> a lost and discoverable historical unity existing beyond the poem. Pound's 'I cannot make it cohere' at the end of *The Cantos* … and Eliot's use of footnotes at the end of 'The Waste Land' both indicate the desire for the existence of an external totality of which their fragmentary poems are a representation.[48]

Ginsberg combines fragments of historical information with numerous voices and tones to occupy the space of the silent temple. Considering this space, and how the photographs contribute to an atmosphere of silent antiquity, Ginsberg's polyvocal collage achieves Henri Lefebvre's idea that 'space can no longer be conceived of as passive or empty'.[49] The poem indicates an increased spatial awareness in the relationship of the body both to physical space and the space of the text. Ginsberg, the nomadic poet, blurs these spaces: the temple itself fits Doreen Massey's idea that a 'notion of place (usually evoked as "local place") has come to have totemic resonance', and the movement of the poet through this space leads him to build the poem as a similar kind of structure through collage.[50]

This aesthetic affects how we read a photopoem. As Davidson notes in his discussion of postmodern spatial poetics, Deleuze and Guattari's idea of the 'rhizome' is a productive way of examining how poems produce their own space.[51] *Ankor Wat* represents an important mutation of collage into rhizome, emphasizing the contiguity of poem and photograph more so than the illustrative works of the nineteenth and early twentieth centuries. Deleuze and Guattari's interest in the rhizome, Davidson argues, was 'in exposing inequalities and concealed or naturalized power structures ... those of the relationship between structures of language and the social world'.[52] 'A rhizome,' note Deleuze and Guattari, 'ceaselessly establishes connections between semiotic chains, organizations of power, and circumstances relevant to the arts, sciences, and social structures.'[53] The rhizome possesses 'principles of connection and heterogeneity: any point of a rhizome can be connected to anything other, and must be', in addition to a deconstructive tendency, revealing 'semantic and pragmatic contents of statements, to collective assemblages of enunciation, to a whole micropolitics of the social field'.[54] Our understanding of *Ankor Wat* as a rhizomatic photopoem is enhanced when we consider Deleuze's articulation of the rhizome in distinction to what he calls an arborescent conception of knowledge. These are tree-like structures, 'hierarchical systems with centers of significance and subjectification', lacking the ability of the rhizome to interrelate with other models or concepts.[55] Ginsberg's poem depends largely on metaphors of roots and branches, and Lawrence's photographs depict how such arboreal elements are growing among the temple ruins: in a sense, the natural world reclaims the man-made structure (Figure 4.4). Lawrence's photographs are visually repetitive, and seem to encroach on the poem just as they depict the jungle clutching

at the temple. The interspersion of poem and photographs encourages the reader to make connections between them. Their branches and roots become intertwined. 'There exist tree and root structures in rhizomes,' write Deleuze and Guattari,

> conversely, a tree branch or root division may begin to burgeon into a rhizome.... A new rhizome may form in the heart of a tree, the hollow of a root, the crook of a branch. Or else it is a microscopic element of the root-tree, a radicle, that gets rhizome production going.[56]

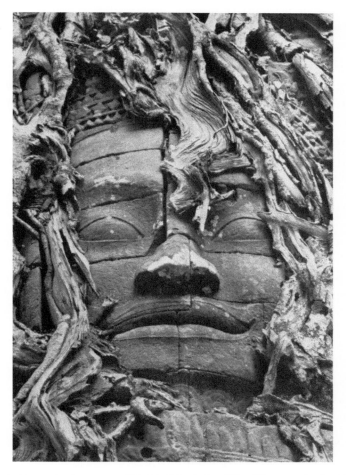

Figure 4.4 Alexandra Lawrence, 'Untitled', in *Ankor Wat: Photographs by Alexandra Lawrence*, 1968. Courtesy of the University of St Andrews Library, photo PS3513. I74A8G69.

It is important to realize how retrospective photopoetry tended to be more arboreal in nature: that is, the poem was given prominence at the top of the tree-like structure, and the photographs were the subordinate elements, arranged at specific points of the poem. The whole structure was a closed, complete system with fixed relations between text and image. While it is unclear precisely how *Ankor Wat* was arranged (and by whom), it was most likely the work of an additional editor. Should this be the case, *Ankor Wat* is an unusual example of retrospective photopoetry in which editorial practice actually produced something rather arresting in its creation of a single structure that enhances the connections between poem and photographs, establishing new thematic and structural links between them, and encouraging new ways of reading the photopoem.

Ankor Wat centres on movement, physically among the concrete space of the temple and mentally across the cultures, countries, and histories to which Ginsberg alludes. This psychonomadism contrasts with early photographically illustrated poetry, which was more attuned to what Davidson, in relation to spaces easily state-monitored, calls 'the coordinates of the Euclidean space and the functional grid'.[57] Our experience of reading a photopoem is spatial and temporal: the connections we draw between text and image; the interruptions between reading and looking; moving from one word to another, one image to another. This furthers Davidson's conception of body and text. 'A poem is not a body and a body is not a text,' Davidson writes,

> yet both exist in a relationship between their materialism (the text as material and the body as material); their conceptualization through processes of representation; and their performance in specific times and places. It is in this complex of relationships that a focus on the body can support various readings of poetry.[58]

The photopoem creates a body comparable to the nomadic, rhizomatic figure of the speaker(s). The rhizomatic quality of this interaction obscures the fact that the poem and photographs were composed over a gap of five years. Ginsberg's spatial metaphors reflect the combination, in Lawrence's photographs, of natural wood and stone with the temple's representations of spiritual bodies. The poem begins with an invocation, of sorts, to the temple:

> Ankor – on top of the terrace
> in a stone nook in the rain
> Avelokitesvera faces everywhere
> high in their stoniness.[59]

At first this might seem like an arboreal structure: the temple is immediately presented as the uppermost visual point of reference, 'high' and 'on top'. It is given a bodily, facial presence, with the eyes of Avelokitesvera, a personification of the 'Lord who looks down', one of the four sublime states of Buddhism. This spatial ordering occurs at the beginning of our reading experience, and three photographs showing the tree-adorned temple and Avelokitesvera precede the verse itself. The creation of the body in photopoetic space relies on the rhizomatic manner in which meaning is simultaneously constructed and dismantled across the poems and photographs of an entire text. This is achieved through spatial metaphors. 'The entire text of this composition', Ginsberg writes in his notes to the poem, 'was written in one night half sleeping and waking, as transcription of passages of consciousness in the author's mind made somnolent by an injection of morphine-atrophine in a hotel room in the town of Siemreip adjacent to the ruins of Ankor Wat.'[60] Another section was written while 'high on ganja (pot) on the roof of the temple of Ankor Thom'.[61] Early in the poem Ginsberg asks, 'What happens to me when I get high', relying on the same spatial metaphor as his initial description of the temple and the common term for a drug-induced state.

Ginsberg's poetics of height resemble his own altered consciousness and blur the boundaries between the poem's mental and physical spaces. His free verse adheres to no particular structure of indentation, emphasizing the speaker's feeling of disembodiment. The typography highlights similar concerns:

U

n

d

e

r a fan and canopied mosquito net. (308)

Though sporadic, these visual puns reflect Ginsberg's methods of representing the body in space. Early in the poem the speaker notes, 'I am afraid where I am / "I am inert"' (309), suggesting both mental and physical uncertainty and locating the tension within the speaker's body. The speaker's drug use produces an intriguing slant on how to theorize the body: body theory exists in two principal strands, Davidson notes, 'that of the body *in* space, and the way the body "produces" space through perspective, scale and travel, and that of the space *of* the body itself, both its internal space and the surface of the skin'.[62] Although the speaker is insistently contextualized within physical space, there is a sense his body is divorced from the physical world and 'produces' only mental

space, a paradox encapsulated in the line 'I going to take *both* sides' (310). The excision of 'am' heightens the disembodiment, the speaker's impossible desire to be in two places at once or to take both sides of a story or argument, which would return him to a figurative middle ground. Lawrence's photographs can be read as an attempt to visualize the speaker's drug-induced perceptions of the temple. The reader/viewer journeys with the speaker,

> Slithering hitherward paranoia
> > Banyans trailing
> > > high muscled trees crawled
> > over the roof its big
> > long snakey toes … (306)

The transformation of the banyan trees into snakes is the poem's central metaphor. A result of the speaker's drug use, this metamorphosis mentally situates the rhizomatic poem as 'always in the process of construction'.[63] This disconcerting sense of continual expansion is evoked in the lines 'Avelokitesvera's huge / many faces in opposite directions / in high space' (308). Ginsberg creates an opposition between the stone statues and the trees:

> The huge snake roots, the vaster
> > serpent arms fallen
> > octopus over the roof
> > in a square courtyard – curved
> > roofcombs looked Dragon-back-stone-scaled.
>
> > > > > > (308–309)

The metaphorical leap from roots to snakes is a simple one, as the photographs visually affirm, yet the inclusion of 'octopus' and 'Dragon' complicates this relationship. These creatures highlight the rhizomatic structure of the poem, and the metamorphic quality of its images, which overlap, further, negate, combine with, destabilize, and affirm each other.

The rhizome renders arbitrary the linear structure of the poem, as do the photographs, which neither refer to specific lines nor form an overarching narrative. Massey has posited a 'relational politics of place', a model devoid of the security of the 'local', a model which is 'the sum of all our connections, and in that sense utterly grounded, and those connections may go round the world'.[64] Ginsberg, however, is not 'grounded': he is an example of disrupted space, one half of Davidson's idea of space as 'both lived and conceptualized. . . . We have an embodied experience of space [as] well as a mental concept of

space.'[65] Late in the poem, the speaker's lack of physical rootedness becomes explicit:

> I can can't go on forever. I'm in the
> Jet Set, according to my memory,
> dissociated in Space
>
>
>
> It
>
> winds in and out of space and time the
> physical traveller –
> Returning home at last, years later as
> prophesied, 'Is this the way that
> I'm supposed to feel?' (322)

The depersonalized 'physical traveller' is 'it', one thing among many in the poem's matrix of material things, associated with the liminal spaces of train station and airport. The disconcerting temporal/spatial shifts of air travel are indicative of displacement, the nomadism of the poet, and the 'privileging of movement through space over residence within a "place"'.[66] Although Ginsberg's speaker dwelt, briefly, within the temple, the space of his own mind predominated. The images of the poem are more figurative reflections on the temple, relying on the photographs for a sense of physical place. The return 'home' is equally estranging, the physical return unable to conclude the psychonomadism of the traveller, who remains 'dissociated in Space'. This bodily dislocation is affirmed in the jarringly metrical quotation, 'Is this the way that / I'm supposed to feel?' The photopoem as rhizome dislocated the body from the text and developed a poetics of liminality through which the nomadic poet and photographer could inhabit a territory forever shifting.

Dwelling in Orkney and the Calder Valley

If Ginsberg and Lawrence are photopoetic nomads whose work explores ideas of space in greater depth than the places they represent, British photopoetry in the mid-to-late twentieth century lends more attention to specific, local environments. Jonathan Bate, in his discussion of the word 'environment', remarks that 'prior to the nineteenth century there was no need for a word to describe the influence of physical conditions on persons and communities

because it was self-evident that personal and communal identity were intimately related to physical setting'.[67] The two collaborations between Orcadian poet George Mackay Brown (1921–1996) and Swedish photographer Gunnie Moberg (1941–2007), a resident of Orkney, explore the relationship between physical settings and personal and communal identities. Their two collaborations could hardly be more opposed in terms of style, production, and conception: the first, *Stone* (1987), is a limited edition of 125 copies, hand press printed at the Officina Bodoni, Verona, by Gabriella and Martino Mardersteig, and published by Colin Hamilton and Kulgin Duval.[68] The second, *Orkney Pictures & Poems* (1996), is a retrospective of Moberg's photographic work, mostly in colour, published by the commercial publisher Colin Baxter some two months after Brown's death.[69] As Hamilton recalls, *Stone* emerged from Brown and Moberg's realization that they both had produced work on the subject of stone, 'although the poems were not written in response to the photographs any more than the photographs illustrated the poems'.[70] Conversely, *Orkney Pictures & Poems* derived from Moberg's interest in the American photopoetry book *Not Man Apart* (1965), an edited collection of Robinson Jeffers's verse interwoven with landscape photographs by, among others, Ansel Adams and Edward Weston.[71] The juxtaposition of colour and monochrome photographs, the combination of landscapes with abstract compositions of stone and kelp, and William Garnett's aerial photographs all appealed to Moberg. She lent her copy to Brown, who responded gnomically, 'Thanks for the Big Sur book ... a hard model to follow'.[72] Working from photographs was not Brown's usual practice, but he found the change 'quite stimulating'.[73] Writing to Moberg, Colin Baxter asked for captions rather than poems, which could be 'any length you like really and as poetic as George wishes'. *Orkney* was also meant to include 'a sensible sized introduction/ essay by George ... perhaps 3–4000 words'.[74] This was shelved when, to Moberg's surprise, Brown responded to her photographs with actual poems.[75]

Moberg moved to Orkney in 1976 where, despite a background in photography, she worked at first in batik. A chance meeting with Orkney's chief pilot, Andy Alsop, whom she accompanied with her camera on inter-island flights for two years, led her back to photography.[76] These images, encompassing coastlines, fields, geological formations and archaeological remains first appeared in her photobook *Stone Built* (1979). The crisp, formal arrangements of her aerial photographs proved central to her work on both *Stone* and *Orkney Pictures & Poems*. 'I always tried to take pictures that were simple and clean,' Moberg remarks. 'From the air you lose one dimension, but in the landscape

you always have three and that clutters up my pictures sometimes – it's very hard to get a clean line.'[77] Her concern with line and texture lends an aerial quality to her *Stone* photographs, uniting in abstraction the 'hieroglyph[s]' of the stones with the patterns of the Orkney landscape (Figure 4.5).[78] Comparing Moberg's work in *Stone* and *Orkney*, there is a striking resemblance between her aerial photographs and her images of stones, rock formations and pools: the eye fails, for a moment, to recognize whether it sees from hundreds of feet or a matter of inches. Photographs accompanying 'Tide', 'Skara Brae', and 'Knap of Howar: Papay' in *Orkney* recall patterns and shapes from *Stone*; the *Stone* portfolio's abstractions enact the Orcadian landscape in microcosm. The overhead angle of *Stone* complicates the scope of the photographs, and their blend of the macro- and microscopic acts as an equivalent to the personal and historical lenses of Brown's poems, which deal simultaneously with the intimate peculiarities of life and landscapes, and a broader sense of Orcadian history and mythology.

Brown's poems often personify stones, lending them voices and using their constancy amid human flux to conjure historical Orkney. 'Song of the Stone' compares stone's longevity to buttercup, seagull, man, star, raindrop and hourglass. This 'song' is one of the numerous vocal forms of *Stone*: others include the dialogues of 'Mile Stone' and 'Time a Stone', the repetitions of 'Flower of the Stone', and the imagined interview of 'Foreign Skipper: 17th Century'. Brown draws attention to nature as a kind of language, and uses the forms of his poems to mimic the natural world. The form of 'Seascape: The Camera at the Shore', for example, enacts the ebb and flow of the tide, recalling how some of Moberg's photographs in *Stone* appear to evoke the shore as if from an aerial perspective. Brown's rhymes offer both closure and renewal:

The Atlantic beats twice a day
In cold gray throes.
...

Among that hoard and squander, with her lens
Gunnie goes. (*CPGMB* [*The Collected Poems of George Mackay Brown*] 261)

The poem is unusual in its reference to the photographer figure. Brown positions Moberg as recording the language of nature, sifting through the 'hoard and squander' to capture revealing glimpses of the environment. Brown's reference is illuminating because we do not see the photographer taking pictures, but wandering through the landscape. Moberg herself remarked that she had 'worn

Figure 4.5 Gunnie Moberg, 'Seascape: The Camera at the Shore', in *Stone*, 1987.
Reproduced with the permission of the Gunnie Moberg Estate. Courtesy of the
Orkney Library & Archive.

out every stone' in her exploration of Orkney, and Brown's poem asks the reader/
viewer to perceive the intimate bond between the photographer and her physical
setting.[79] By equating picture-taking and physical movement, Brown allows the
questions in 'Foreign Skipper' to prompt a series of photograph-like images:

> *Cities?*
> The smallest City, a stone cluster,
> at the heart of the city a stone
> Kirk. The Kirk seemed a Ship.

Earth-rooted, it sought (red) the
Gold of sunrise. (*CPGMB* 262)

Brown's manipulation of scale recalls how Moberg's photographs in *Stone* evoke aerial perspectives. Brown zooms in, from city to its material form (stone), then to the city centre, the 'Kirk', before blurring this hitherto finely wrought reduction in scope with this strange image of a church that looks like a ship, one that is both 'earth-rooted' and seeking the sunrise, as a ship might sail towards the horizon. Brown creates a puzzling mirage through repetition within an already limited linguistic vein, echoing how the visual language of Moberg's photographs blur our apprehension of sea and land, water and stone, in their abstract yet seemingly familiar patterns.

The most important connection between *Stone* and *Orkney* is the idea that poetry and photography can – or, indeed, cannot – evoke the language of the natural world. As in *Stone*, Brown lends a voice to the stones in *Orkney*, but this time they are in the form of a man-made structure. In the final stanza of 'Martello Tower', Brown voices the titular structure: 'Here I stand still, one useless giant, / A Samson blinded' (*Orkney Pictures & Poems* (hereinafter *OPP* in citations) 15). The rending of its stones is comparable to the blinding of Samson, and the tower seems to speak on behalf of the injured quarry. Moberg's aerial photograph of the lone tower is a study of pattern and form that combines the tactility of the terrain with a vertical gaze (Figure 4.6). Her Orkney images represent the first sustained inclusion of aerial photographs in photopoetry, taking their lead from Garnett's images in *Not Man Apart*. Moberg's manner of masking topography and disguising the centrality of the photographic eye distances her work from previous landscape photographs used in photopoetry, which were not abstract enough to challenge and appropriate the accompanying poems. 'Such aerial mobility,' Marina Warner writes,

> providing a common ideal vantage point to pursue a narrative and communicate its free play with time and place, functions analogously to the omniscient third-person point of view, above the action and detached from it. But at the same time, with startling flexibility, it can also imply a single observer, a first-person perceiver who is uniquely, almost prophetically, equipped to see all.[80]

'This heroic and often vast vision,' she continues, 'can also give access to small, personal glimpses of private scenes,' and Moberg's aerial photographs feel like the equivalent of eavesdropping on the secrets of the Orcadian landscape.[81]

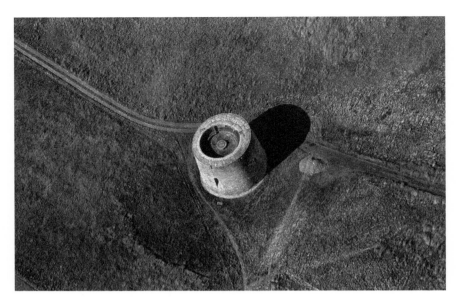

Figure 4.6 Gunnie Moberg, 'Martello Tower', in *Orkney Pictures & Poems*, 1996. Reproduced with the permission of the Gunnie Moberg Estate. Courtesy of the Orkney Library & Archive.

Commenting on aerial photography in the 'Introductory Poem' to *Orkney*, Brown writes:

> The eye of the camera seeks patterns
> On shore, on hill, in fields and lochs,
> And at all seasons.
> ……………………..
> The patterns were there, for withering eyes
> To stook and store
> In granaries of story and legend. (*OPP* 9)

These 'patterns' are synonymous with the poet's 'story and legend', and recall the 'hoard and squander' in *Stone* through which the photographer sifts in order to record the stories and histories of the natural world. Many of Brown's poems in *Orkney* function both as stories in themselves and recordings of other stories: they are often self-reflexive in that Brown attempts to return them to the earth, metaphorically, through images of decay. Brown draws attention to photography as a form of technological apparatus, similar to language both in its ability to record and its potential to distort. In 'Knap of Howar: Papay' Brown

writes, 'A million bungalows will rot like mushrooms / And this house be rooted still' (*OPP* 24). The natural simile evokes cultural decay and human ecological irresponsibility, yet this is delicately balanced: that the ancient house will 'be rooted still' suggests a potentially positive relationship between culture and nature. In 'Horse Mill', a more negative relationship is expressed as 'broken earth', and the poem concludes with the line 'technology has no tongue for praise' (*OPP* 29). 'No tongue' is important because it suggests muteness; 'praise' because of its religious and musical connotations, and with it the suggestion that technology, such as photography, has little power other than to record. The opening stanza of 'Horse Mill' attributes this break to language:

> The work horses are gone from 'the island of horses'
>> (They are banished
>> With the language and songs of the people.) (29)

'Language,' Bate writes, 'is itself a symptom of humankind's apartness from other species and our subsequent power to destabilize ecosystems.'[82] In 'Fishing Boats', Brown demonstrates a nuanced attention to language, necessary for songs and stories, but potentially destabilizing to man's relation to the earth, by speculating on the 'secret words' and 'spells and supplications' of fishermen (*OPP* 99). Moberg's photograph of the irreparably damaged fishing boats seems to emphasize man's folly in thinking 'secret words' and 'boat talk' can influence or control nature. References to language – 'that tongue', both as a synonym for language and in a collective sense – posit speech as potentially destabilizing: its unnatural 'spells and supplications' highlight man's folly in presuming language can influence or control the natural world. Similarly, Brown inverts the Mother Nature trope, demonstrating how such clichés alienate man from the natural world: for Brown, it is the 'old mother' who 'bruises [a boat] with denial and rage'. Terry Gifford suggests that, where pastoral still exists in Brown's work, 'his idealization is for the whole cycle', including the hardships of life.[83] This is the main thematic innovation of Brown and Moberg's photopoetry: they were aware that landscape can be inscribed by the languages of poem and photograph, hence they portrayed the natural environment as much more complex and multifaceted than had typically been documented in earlier photopoetry. This led to a structural innovation: Moberg destabilizes the privileged position of the reader/viewer, and in response Brown provides a rebuke to pictorial landscape photopoetry by lending his voice to a fuller, more critical account of the natural world, and the impacts of human culture in and upon it.

* * *

In 1981 Weidenfeld and Nicolson published two anthologies in their 'Landscape Poets' series: selections of Robert Burns and Thomas Hardy, introduced and edited by Karl Miller and Peter Porter respectively. The hallmark of the series was the inclusion of John Hedgecoe's black-and-white photographs, which served as evocative visual reminders of the landscapes represented in the verse. Reviewing the two books in the *Times Literary Supplement*, Scottish poet Edwin Morgan took aim:

> Hardy must have seemed a natural choice for a series of 'Landscape Poets', even though his most powerful, extended and photographable landscape effects come in his novels and not in his poems.... Burns is more concerned with men and women than with places.... If there is one thing which distinguishes Burns when he uses landscape, it is his references to winter, to storms, snowdrifts and cold, as can be seen in many of the poems here; that the photographs reflect nothing of this is an indication of how little this volume has been thought out.[84]

The practice of using landscape photographs to set scenes is, of course, a foundation of photographically illustrated poetry, though one wonders with 'landscape poets' as poorly chosen as Burns and Hardy whether the whole project was either lazy and misguided or ironic and subversive. Assuming the former, the 'Landscape Poets' series – abandoned after these two volumes – provides a belated climax to the retrospective work that had long since peaked in the late nineteenth and early twentieth centuries. It was work like this to which Brown and Moberg responded in their collaborations, retaining landscape as the central focus of their photobooks but treating it with more cultural, ecological, and social awareness.

In his review, Morgan also took aim at Fay Godwin and Ted Hughes's *Remains of Elmet* (1979), remarking on its 'strange disjunction between the dark, empty, brooding melancholy of the photographs ... and the jagged, tormented, hammering short lines of the poems'.[85] Godwin and Hughes, too, dispensed with pictorial landscape photographs as mere visual accessories to poems. Instead, they foregrounded the often difficult, antagonistic relationships between poem and photograph as a structural metaphor for the relationship between nature and culture. While Godwin's body of work includes literary portraits, urban scenes, and the colour photographs of her 'Glassworks' series, she is best known for her explorations of the landscapes in which people live and work. Her focus on human involvement in the natural world situates her work in a more

documentary tradition than the pictorial landscape photography that we have seen elsewhere in photopoetry. As Liz Wells remarks, 'At one level [Godwin's] work was conservative; it argued for a pastoral heritage that she feared was now disregarded. But she was aware that, historically, this pastoral was a selective and idealised view of the rural, certainly from the point of view of small farmers, rural workers, and innkeepers and others subsisting within the limitations of the rural economy.'[86] According to Roger Taylor, 'In her early interviews Godwin mystified her public by stating categorically that she was a documentary photographer.... What Godwin wanted to suggest was her need to report back on the state of the landscape.'[87] Her approach to the natural world resonated with Hughes's, which Terry Gifford has described as 'post-pastoral', a response to the perception of pastoral as 'a false construction of reality, usually idealised, often nostalgic, and distorting the historical, economic and organic tensions at work in human relationships with Nature.'[88] As we have seen in Brown and Moberg's collaborations, a more critical engagement with landscapes, places, and spaces is indicative of a richer and more complex reading experience in which the reader/viewer becomes more imaginatively invested in the relationship between text and image. This is even more apparent in Godwin's work with Hughes, and can be examined most pertinently in the changes made between *Remains* and its significantly revised reissue *Elmet* (1994).

Both books explore the landscapes of the historic kingdom of Elmet, the last Celtic kingdom to fall to the Angles in the seventh century. 'For centuries,' Hughes writes in the introduction to *Remains*, 'it was considered a more or less uninhabitable wilderness, a notorious refuge for criminals.'[89] In the early nineteenth century, the Upper Calder Valley, once part of Elmet, was transformed by the industrial revolution into 'the hardest worked river in England'. The subsequent decline of the textile industry in the early twentieth century led to the upheaval Hughes documents in *Remains*. Hughes was born in Mytholmroyd, a small town on the banks of the river Calder, and 'throughout my lifetime', he writes, 'I have watched the mills of the region and their attendant chapels die'.[90] Evident even from this brief summary are the mythological and personal lenses central to Hughes's portrayal of Elmet. While ideas of regeneration, myth, and nostalgia have informed the critical reception of *Remains*, few attempts have been made to consider the poems in relation to Godwin's photographs.[91] Hughes's poems were, in a sense, filtered through Godwin's representation of landscape. Photographs in *Remains* appear to illustrate the poems, and the connections, at first glance, seem literal. For instance, the poem 'Rhododendrons' (*Remains*

of Elmet (hereinafter *RE* in citations) 87) faces a photograph of rhododendron leaves; 'Mill Ruins' (*RE* 38) faces a ruined mill. On other occasions, the photographs illustrate particular images within the poems, such as the gulleys in 'It Is All' (*RE* 23), and the 'spent cartridge-cases' of 'Grouse-Butts' (*RE* 60). However, this would assume that Godwin took her photographs with particular poems in mind, whereas Hughes wrote most of his poems in response to Godwin's photographs. In a letter to Godwin he notes that 'the few poems – ½ dozen or so – I wrote before your pictures seem to me the least interesting – more or less a continuation of my other writing – but what I did from the pictures seems to me new, and there's no other way I could have got them'.[92] The photographs, then, do not illustrate the poems at all: the collaboration upends the typical premise of photographic illustration. Instead, Hughes's poems illustrate Godwin's photographs: that is, they engage with the images and imbue them with sensory, historical, and personal contexts. In 'Mill Ruins' (*RE* 38), Godwin's photograph of a crumbling mill prompts Hughes to reflect how, with the decline of the textile industry in the valley, 'its great humming abbeys became tombs'. In Godwin's photograph, nature is slowly reclaiming the old mill: foliage encroaches on the skeleton structure, and her perspective – beneath the mill, looking up at it – situates the reader/viewer within the landscape, similarly encroached upon by the surrounding foliage. Hughes uses the mill as a conduit to explore the valley at various historical moments. From those who left the valley as a result of declining industry, Hughes turns his attention to its contemporary inhabitants, the children who come 'Roaming for leftovers'. 'What would not burn,' he writes, 'they levered loose and toppled down hillsides,' and in the foreground of Godwin's photograph lays a kind of headstone, on which the inscription '1812' and the initials 'I. H.' are legible. Here Hughes adds a narrative to Godwin's photograph, as well as an historical underpinning: the children pick over the carcass of a former time.

Hughes's poem is an interpretation rather than an illustration. His focus on movement brings the static photograph to life. Hughes writes about the valley's history through images of movement: at the end of the poem, the children 'trailed away homeward aimlessly / Like the earliest / Homeless Norsemen'. This is the language of exile, displacement, and nomadism, and while Hughes's comparison between young vandals and the Norseman is perhaps slightly forced, the photograph offers a different comparison: it compares the vandals to the mill owners and workers, whose own violence was against the landscape. In the most successful pairings of poem and photograph, the narratives of

each blend and clash. The *Elmet* reissue highlights the idea that, in *Remains*, poems and photographs existed in interpretative relationships. 'Mill Ruins' itself was dropped, though its photograph was retained: it was paired with another photograph rather than a different poem. These occasional photographic spreads occur in both *Remains* and *Elmet*, and function to highlight the fact that connections between poems and photographs occur across the entire book, not only in discrete pairings. Likewise, some poems, most notably the ekphrastic 'Six Young Men' (*Elmet* (hereinafter *E* in citations) 112–113), are not paired with photographs, allowing the reader to make their connections with photographs across the book. On other occasions, poems are retained but their paired photograph is replaced: for instance, 'Rhododendrons' (*E* 45) is paired with a much more evocative photograph in *Elmet* than in *Remains*, with the evasive 'chill virulence' of the titular plant echoing the imagery of Hughes's poem. Godwin's photograph represents a dense and intricate patterning of branches and leaves: this encompasses almost the entire frame, but in the upmost third, a row of chimneys peers above the tangle of what Hughes calls 'evergloom'. Godwin's choice to change to this photograph from the original close-up image of leaves demonstrates a greater metaphorical attention to Hughes's imagery of invasion, which informs the implicit colonial criticism of the concluding line, 'Ugly as a brass-band in India'.

Similarly, Hughes revised some poems to enrich their connections with Godwin's photographs. Hughes made significant revisions to 'Hardcastle Crags' (*RE* 13) and it was republished as 'Leaf Mould' (*E* 28) alongside its original photograph: a wooded area of the valley, with a large tree in the left foreground and the play of light on the woodland floor. First published in *Wolfwatching* (1989), 'Leaf Mould' is one of a number of poems Hughes wrote 'partly as a correction of the over-determined plan' of *Remains*.[93] Both versions of the poem begin with the pastoral injunction 'Think often of the silent valley, for the god lives there', a line clearly derived from the stillness of Godwin's photograph. In 'Hardcastle', Hughes contrasts this illustrative opening with the following poem, in which a Hughes-like speaker, immured in the history of the valley, reveals the 'old siftings of sewing machines and shuttles' beneath the religious silence: the valley is 'a grave of echoes', where the wind 'releases / The love-murmurs of a generation of slaves'. Hughes perhaps thought 'Hardcastle' was too self-contained: that is, the opening injunction contrasted well enough with the ensuing repudiation, and the photograph merely set the scene. 'Leaf Mould', then, is one example of Hughes's attempt to strike a more personal note, a note

that recalls Hughes's initial conception of *Remains* as the 'chance to write the autobiography of my childhood, in easy descriptive little verses'.[94] While Hughes abandoned the 'embarrassing egotism' of that plan – having realized that it was 'about a region that belong to everybody who lives or has lived in it, not only me' – *Elmet* contains a greater sense of Hughes's autobiography, and the new and revised poems were an attempt, he notes, to '[populate] the photographs without challenging their images'.[95] 'Leaf Mould' is a model poem in this regard. Hughes takes the 'generation of slaves' from the original poem and attributes his sensitivity to the valley's history to his mother, whom Hughes shows in the poem walking through 'Hardcastle Crags, that echoey museum'. Most importantly, the agency of the 'air-stir' in 'Hardcastle' is attributed, in 'Leaf Mould', to Hughes's mother walking through the woods: the subsequent 'love whispers' are the result not simply of a natural rustle of wind, but of his mother's footsteps. The lines in 'Leaf Mould' read,

> The lightest air-stir
> Released their love whispers where she walked
> The needles weeping, singing … (*E* 28)

The insistence on pairing the revised poem with the same Godwin photograph also serves an important function, as 'Leaf Mould' develops its relationship with the image from illustrative background to immersive environment. The above lines deepen this immersion, picturing a figure walking through the woodland scene that Godwin's image depicts. Here, the woodland floor of the photograph develops an aural as well as visual quality, so the reader/viewer imagines the sound of the leaves beneath their own feet. Hughes refers to himself in the second person, and the frequent invocation to 'you' enriches the idea that the reader/viewer has entered this environment: the low angle of the photograph enhances the reader/viewer's sense of being within the landscape rather than looking down on it from a privileged position. In this instance, the new poetic context of the photograph enables it to develop a different layer of meaning. The pastoral use of the photograph in *Remains* is overlaid with a personal moment from Hughes's prelife: it is a memory, after all, that Hughes does not actually have (in the poem he is 'still in [his mother's] womb'), deriving, presumably, from his mother's stories. Even so, it is a memory that he can stage, via his poem, in Godwin's photograph, which becomes an environment where Hughes imagines his mother digging handfuls of leaf mould, the result of a similar process of accumulation and binding. Hughes's mother removes the mould to crumble it

over 'her handfuls of garden': 'Leaf mould. Blood-warm. Fibres crumbled alive / Between finger and thumb.' These images of accumulation and dispersal serve as a formal metaphor for Hughes's collaboration with Godwin, and *Elmet* in particular: meaning accumulates within pairings of poem and photograph in *Remains*, and they inform the pairings of *Elmet*.

When Faber published *Remains* in 1979, the book received mixed reviews. 'The pictures are superb,' wrote Glyn Hughes in the *Guardian*, 'nonetheless I feel that it would have been better to have issued them as a separate volume: they are a romantic tour, while the poems offer so much more, partly because of the myth that holds the book together.'[96] Although there are historical reasons for the comparison, given the origins of photographically illustrated poetry in the commercial tour photography of the nineteenth century, the phrase irked Godwin because of the implied passivity of her images. As Tom Normand reminds us, contemporary photographers 'recognise that the photograph is an intervention that demands negotiation.'[97] Peter Porter, in the *Observer*, while still critical of the book, at least considered the poems and photographs mutually informing, claiming that the reader/viewer 'is so consistently battered by language that he has to turn to the heavily inert photographs to look for some clue to Hughes's intentions.'[98] The poor quality of the printing served as an unwitting metaphor for the tone of *Remains*. One fundamental difference between *Remains* and *Elmet*, notes Gifford, is 'the difference in emphasis between "empty sockets" and "survivors" '.[99] Gifford derives these terms from the title poem of *Remains*, which Godwin and Hughes omitted from *Elmet*. The omission is important in that the removal of particular verbal image sets affects the reader/viewer's approach to the photographs. 'Remains of Elmet' refers to 'the long gullet of Calder / Down which its corpse vanished'; 'the sunk mill towns' which admit tourists 'to pick among the crumbling, loose molars / And empty sockets' (*RE* 53). By omitting this poem, Hughes removed images of corpses and decay that informed the tone of *Remains*. Importantly, the photograph that accompanied the poem in *Remains* is included in *Elmet*, though it is paired with another photograph rather than a different poem. This inclusion reflects a wider change in focus in terms of Hughes's relationship with a place he considered home. Godwin's photographs allowed Hughes to rediscover his connection to place: as quoted above, the poems Hughes wrote as responses to Godwin's photographs 'seemed ... new', not a continuation of his older work. Omitting the 'Remains' poem but retaining its paired photograph demonstrates Hughes's gradual re-acclimatization to a home from which he clearly felt estranged: the tourists of 'Remains' are replaced by

Hughes's family reminiscences in poems such as 'Familiar', 'Two Photographs of Top Withens', and 'Walt'.

It is clear from the introductory poem to *Remains* (retitled 'The Dark River' in *Elmet*) that people had always been important to Hughes's conception of the project. The poem meditates on time, memory, and place, uniting them through an emphasis on language as the crucial link between culture and nature. Given 'the spirit of survivors behind *Elmet*', as Gifford notes, language assumes an important role in perpetuating and preserving memories.[100] Hughes's phrase 'archaeology of the mouth' (*E* 13) conjures the roots of memory in language, though he also considered Godwin's photographs a kind of visual language. 'Without your pictures', Hughes wrote to Godwin, 'most readers of the poems would be completely lost for a concrete setting. The poems relate to your pictures as commentaries to an original, great difficult text, and there is no question of them having any existence apart.'[101] Hughes's use of 'text' functions as a metaphor that ascribes authority to Godwin's photographs. His poems sought something 'simple and atmospheric': 'My guiding metaphor', Hughes writes, 'was film music: non-visual, non-specific, self-effacing.'[102] The desire for a 'concrete' or authoritative setting is seen in the retitling of many poems. Most poems in *Remains* take titles from their opening lines, whereas they are retitled, in *Elmet*, to evoke actual, identifiable places: 'Auction' (*RE* 107) becomes 'Auction at Stanbury' (*E* 46), 'Where the Mothers' (*RE* 10) becomes 'Abel Cross, Crimsworth Dean' (*E* 15), and 'Dead Farms, Dead Leaves' (*RE* 54) becomes 'Shackleton Hill' (*E* 40). Written language glosses the visual language, framing the photographs from a particular perspective. By positioning his poems as responses to Godwin's photographs, Hughes is able to have, in a sense, the final word. Regardless of whether or not his imagery 'dissolve[s] into soft focus', we begin to see Godwin's landscapes through Hughes's eyes.

In 'Walt' (*E* 98–99), a new addition to *Elmet*, Hughes merges these physical and mental geographies. The eponymous Walt lies wounded in a shell hole, pinned down by sniper fire:

> [He] went walks
> Along the Heights Road, from Peckett to Midgley,
> Down to Mytholmroyd . . .
>
> .
> All day
> He walked about that valley, as he lay
> Under High Wood in the shell-hole. (*E* 98)

The places Hughes mentions in Walt's psychogeographical walks is an impressive list of locales, in stark contrast to the singular 'High Wood', the place of Walt's entrapment during the Battle of the Somme. As Gifford notes, 'Memory is overlaid on memory in a multi-layered construction of nature ("the skyline tree-fringe") that is itself a celebration of "kinship," the name we give to one experience of culture as nature ("as through binoculars").'[103] The hazy quality of the image visualizes the 'multi-layered' memories of the poem. Godwin evokes the 'skyline tree-fringe' in the background, and the strong diagonals in her study of fields, stone walls and a hazy railway viaduct represent the mobility evident in the verse in the repetition of 'up', 'along', 'down', and 'about' (Figure 4.7). As so often in the *Elmet* poems, there is a present-day return to a recollected place. Here the speaker accompanies Walt back to the now 'perfect field' where the sniper had pinned him:

'Here,' he hazarded. 'Somewhere just about here.
This is where he stopped me. I got this far.' (*E* 99)

Figure 4.7 Fay Godwin, 'Walt', in *Elmet*, 1994. Image © The British Library Board, Godwin photo 19/2 (2).

On this journey Walt 'frowned uphill towards the skyline tree-fringe', thus locating the image at High Wood: Godwin's photograph, however, situates it in the Calder Valley, further collapsing the poem's distinctions, between poem and photograph, of time and place. It is a picture from Walt's imagination, so entwined in his memory had High Wood and the Calder Valley become. Walt's deep dwelling in the Calder Valley meant he could walk it imaginatively and, years later, superimpose the various places listed in the poem over the battlefield from which he conjured them. Looking again at Walt's wanderings, the spaces of Hughes's poem echo the byways and paths in Godwin's photograph. Directions such as 'along the', 'down to', 'up', 'then up', 'and up over', and 'back past' allow the reader/viewer to pause in each village, crossroads, or valley before continuing, as Walt did, 'down to' or 'along' to the next place. As our eyes flicker across a photograph, we too pause before tracing new paths between its visual details. It is typical of Hughes's engagement with the relationship between poetry and photography that connections between the two media form the subtext of many of the *Elmet* photopoems. Underlying Walt's mental walks is death: in his imaginative roaming, Walt was readily anticipating death. Photographs are both aides-memoire and constant reminders of death, and Hughes's poems are elegiac in nature. *Elmet* works not as a series of discrete pairings of poems and photographs but as a sequence whose traces and reports can be seen and heard across the entire photobook. Hughes confided to Stephen Spender that the style of *Remains* 'was an adjustment to the photographs' and that he 'tried to hit a dimension outside the visual finality of the picture'.[104] Writing to Godwin, on the other hand, Hughes remarks that *Remains* 'is one circulation, one organism ... In a system like the one we've constructed there, they can only read the poems to find their way deeper into the pictures'.[105] This uncertainty, that the poems are at once routes deeper into, and further out of the photographs, is resolved in *Elmet* when Hughes and Godwin abandoned prescriptive pairings of text and image in favour of the 'one organism' Hughes initially proposed, one in which connections between poems and photographs span the whole photobook. *Elmet* is a network of visual and verbal images, within and across photopoems. It is precisely because of the clash between the single image of the photograph and the imagery of the poem that together they are capable of producing nuanced, sophisticated, and symbiotic combinations of text and image.

Among poets who have collaborated with photographers, Hughes is unusual for the relative thoroughness of his conceptual engagement with photography. He emerges as a key theorist of photopoetry. The central tenet of his approach

concerns the 'collision' of visual and verbal image. In a letter to graduate student Anne-Lorraine Bujon, he remarks that 'the verbal image … always loses' in the collision, and that only through 'a blurred focus, generalised mood-evocation' could his poems 'harmonise' rather than clash with or obstruct Godwin's photographs.[106] Although Hughes emphasizes the clash between visual and verbal imagery, a justifiable position given the potential contrasts and ruptures that this structure affords, it is noticeable that his idea of photopoetic harmony relies on the subjugation of one form to the other. Poems, in Hughes's conception, function like captions. Hughes developed these ideas further in an unpublished fragment that, while difficult to date precisely, is most likely a draft introduction for *Elmet* focusing more on the photopoetic relationship than the history of the Calder Valley. While these reflections were omitted from the final introduction, they remain important both for the insight they offer into Hughes's theorization of poetry and photography, and the contrast between his theory and its realizations in *Remains* and *Elmet*. For example, Hughes expands on his concept of 'collision' by suggesting that

> when a scenic poem and a scenic photograph are forcibly married, the inexorably fixed and single image of the photography simply short-circuits and empties the multiple, simultaneous, shifting possibilities of any visually distinct (and yet verbal) imagery in the poem. The effect … is for the poem to be trapped in the focus of the photograph.[107]

As I quoted above, Hughes considered his own part in *Remains* 'as the musical accompaniment of a film, subordinate', in relation to Godwin's photographs.[108] By placing photography at the centre of the collaboration, Hughes had come a considerable way from his ungenerous suggestion, in 1971, that 'photography is a method of making a dead accurate image of the world without any act of imagination'.[109] Hughes raises some valid concerns about the balance between the two arts in photobook form, but it is insightful also to reflect on how photography, at first considered a mere novelty when placed alongside poetry in illustrated volumes, had become, in the eyes of one major twentieth-century practitioner, the aesthetic *raison d'être* of the entire photopoetic endeavour. As I hope has become obvious in my discussion of photopoetry almost from the beginning, theories that allow the primacy of one art over the other tend not to allow for more sophisticated relationships between poem and photograph. Indeed, *Remains* and *Elmet* are more complex and sophisticated books than Hughes's theorization allows. Only when we

consider the mutual bonds between text and image, and their connections as creative rather than antagonistic, can we begin to appreciate how they work together in photopoetry.

In *Elmet*, Top Withens became an important site for the emergence of this more symbiotic relationship between poems and photographs. Two photopoems are especially significant: first, 'Open to Huge Light' (*RE* 16), retitled as 'Two Trees at Top Withens' (*E* 21), both accompanied by the same photograph. Second, and exclusive to *Elmet*, is 'Two Photographs of Top Withens' (*E* 19), which adopts the photograph paired with 'Top Withens' (*RE* 102) in *Remains*. Both poems, especially 'Huge Light'/'Two Trees', evidence some degree of desolation and evoke Hughes's post-pastoral quality. Godwin's photographs act in a similar manner, accentuating the development of photopoetry from nineteenth-century village pastoral to the 'intervention' of the ecologically aware documentary photographer. The desolation of 'Huge Light'/'Two Trees' reflects an unflinching engagement with the land (Figure 4.8). Gifford notes how Godwin's photographs confirm Hughes's identification of the 'wind-shepherds' with trees and the 'sheep' with human figures: this engagement maintains the project's metamorphic quality.[110] The crouched human figure is possibly taking a photograph, 'visions / From emptiness to brighter emptiness' of the denuded landscape. Hughes describes the light as 'huge', connoting the vastness of the light bathing the trees and the physical capturing of this in the photograph, the action of light and the formation of the image. The phenomenological relationship between landscape and the body is important to how Godwin and Hughes conceived the connections between poems and photographs. The body becomes a central reference point in how we read their poems and photographs in dialogue. The photopoem becomes an embodied experience through the aural nature of the poems and the visual nature of the photographs.

In 'Two Photographs' (*E* 19), the speaker refers to his 'snapshot', taken on a climb to the two trees, from Stanbury, with his uncle Walt and a woman identifiable as Sylvia Plath. 'It was a blue day, with larks, when I aimed my camera. // We had all the time in the world,' he reflects, conjuring the still moment captured in the photograph. The gradual decline of the stone hut into 'roofless / Pissoir' is compared to the endurance of the trees:

> But the tree –
> That's still there, unchanged beside its partner,
> Where my camera held (for a moment) a ghost.

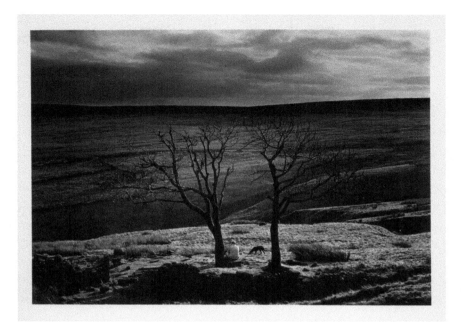

Figure 4.8 Fay Godwin, 'Two Trees at Top Withens', in *Elmet*, 1994. Image © The British Library Board, Godwin photo 19/1 (40) Top Withens. File C13527-42.

The ghost is Plath, 'still in [her] twenties', who 'sit[s] holding [her] smile, in one of the sycamores', the missing presence from the second photograph in an otherwise unchanged landscape. In their discussion of photography and Hughes's poetry, Sally Minogue and Andrew Palmer remark that 'a poem about a photograph re-presents the photograph whilst taking a position in relation to it'.[111] While 'Two Photographs' represents the 'snapshot', it is partnered with Godwin's photograph of the scene mentioned in the poem (Figure 4.9). This photograph acts as the poem's second photograph, taken on a climb to Top Withens almost forty years later, and visualizes the position the poem takes in relation to the first photograph, the recollected 'snapshot'. Of the original walk, the speaker says 'We'd climbed from Stanbury. / And through all the leaves of the fierce book / To touch Wuthering Heights,' equating physical climbing with the spatial and temporal aspects of reading.[112] The combination of poem and photograph creates a temporal and spatial map: the poem maps the temporal moment of the 'snapshot' on to the spatial, visual representation of the second photograph that Godwin's image mirrors in *Elmet*. The perspective of Godwin's

photograph situates the viewer within the windswept tall grass, in the act of walking to the top of the hill, and mirrors the movement of Hughes's speaker on the second climb. Taken at such a distance from the trees, Godwin's photograph evokes the 'ghost' captured in the speaker's second photograph, and acts as a 'concrete setting' for the speaker's memory.

The inclusion of 'Two Photographs' in *Elmet* creates additional visual and verbal networks between its setting and that of 'Two Trees', as well as between the pairings of poem and photograph. While the 'Huge Light' pairing stood in relative isolation in *Remains*, it becomes part of a two-pairing sequence in *Elmet*, given that the 'Two Photographs' pairing precedes it. Beyond the titles of the poems, their settings are linked through the location of Godwin's photographs: in 'Two Photographs', the viewer is climbing towards the hilltop, with the 'ruinous' house a dark shape on the horizon. In 'Two Trees', the viewer has reached the summit, looks out over the dark and silent fields and, crouching next to one of the trees, takes a photograph. While Godwin's perspective here excludes the structure of the house, it is alluded to in the pile of rubble in the

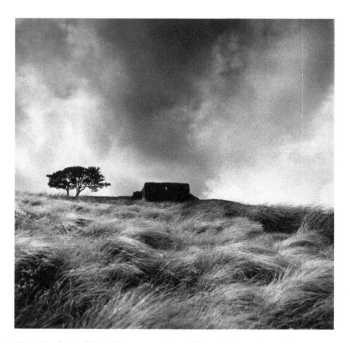

Figure 4.9 Fay Godwin, 'Two Photographs of Top Withens', in *Elmet*, 1994. Image © The British Library Board, Godwin photo 35/9 (53).

left foreground. While the house is not mentioned in 'Two Trees', it provides the immediate visual focus of 'Two Photographs' – 'The house is ruinous enough, in my snapshot' – and is the visual centre of the accompanying photograph. Godwin's 'Two Trees' photograph frames the picture-taking activity of 'Two Photographs' and, when her two photographs are taken in sequence, they accentuate the passing of time between the two moments evoked in 'Two Photographs' through their capturing of the changing seasons. In Godwin's 'Two Photographs' image, the trees are in leaf, and in 'Two Trees' they are bare – in the latter poem they are described as 'Wind-shepherds / Play[ing] the reeds of desolation', a phrase that evokes their denuded state. Godwin's attention to seasonal changes heightens the manner in which the reader/viewer takes the Calder Valley not as a series of timeless remains preserved in a museum exhibit – like the tourists, 'pick[ing] among crumbling, loose molars' in *Remains* (*RE* 53) – but a land that persists, that is immersive, and that is subject to renewal rather than decay. As Gifford notes, the new title *Elmet* was chosen to imply 'the continuity of place', a region that persists not only through the changing seasons but also through the memories of its inhabits, passed from one generation to the next.[113]

Poem and photograph present complementary narratives that together form a deeper verbal and visual network of images and memories surrounding Elmet. Neither poem nor photograph loses anything when considered in isolation but, when taken as a photopoem, they are mutually informing, familiar in such a way as to encourage the overlaps between them without one dominating the other. While I have not intended to make Hughes's own perspective the uncritical centre of my own analysis, I have drawn on his conception of poetry and photography because of his unusual position, among photopoetic practitioners, as a theorist of this relationship. As a basis from which to critique how the photopoems of *Remains* and *Elmet* operate – and, more broadly, photopoems discussed in this chapter and beyond – Hughes's comments form one of the first detailed accounts of the photopoetic relationship, one that does not allow for a productive collision between poem and photograph; rather, one in which the poem has to subjugate its verbal energies to the visual supremacy of the photograph. What I hope this chapter has shown, conversely, is that productive collisions are possible in photopoetry, especially when poet and photographer work in collaboration, and when the collaboration situates the reader/viewer as an active participant in whichever landscape, cityscape, or environment is at the centre of the photopoems.

In the years following the Second World War, photopoetry revealed a deeper connection between person and place. Poets and photographers traversed the globe and came to live in, and engage with, specific locales, combining and juxtaposing their experiences in collaborative photobooks. Landscapes and urban environments were no longer sites of passive aesthetic spectatorhood but immersive spaces in which the 'third creative personality' could flourish. Closer working relationships between poets and photographers meant that, for the first time in photopoetic history, both art forms existed on an equal footing, with Hughes even suggesting that Godwin's photographs were the premier component of their collaboration. Written and taken in conjunction with one another, poems and photographs in collaborative photopoetry became self-reflexive, and works such as *Positives* and *Elmet* were as much about the photopoetic relationship as they were about the people of London and the history of the Calder Valley. As we see the photographic focus become more concentrated, the poetic focus weaves narratives and histories beyond the photographic frame, reversing the structure of illustrative photopoetry in which the photographs were insular representations of specific scenes or landscapes in the poem. These changes would shape photopoetry into the twenty-first century.

Notes

1 John Fuller and David Hurn, introduction to *Writing the Picture* (Bridgend, UK: Seren, 2010), 11.

2 Robert Crawford and Norman McBeath, 'Photopoetry: A Manifesto', in *Chinese Makars*, by Crawford and McBeath (Edinburgh: Easel Press, 2016), 68.

3 Fuller and Hurn, introduction, 10.

4 Crawford and McBeath, 'Photopoetry: A Manifesto', 69.

5 Simon Armitage, introduction to *Landmarks: A Survey*, by Fay Godwin (Stockport: Dewi Lewis Publishing, 2001), 10.

6 W. H. Auden and Louis MacNeice, *Letters from Iceland* (London: Faber, 1937); W. H. Auden and Christopher Isherwood, *Journey to a War* (London: Faber, 1939). All quotations from Auden and MacNeice refer to *Letters*.

7 Marsha Bryant, *Auden and Documentary in the 1930s* (Charlottesville; London: University of Virginia Press, 1997), 62. Given that poetry and photography are not the sole components of this photobook, I am limiting my analysis of Auden's collaborative work to a point with wider photopoetic significance.

8 Susan Sontag, *On Photography* (London: Penguin, 1979), 9.

9 Sontag, *On Photography*, 55.

10 Ian Walker, *So Exotic, So Homemade: Surrealism, Englishness and Documentary Photography* (Manchester: Manchester University Press, 2007), 80.

11 Peter D. Osborne, *Travelling Light: Photography, Travel and Culture* (Manchester: Manchester University Press, 2000), 166.

12 Roland Penrose, *The Road is Wider than Long* (London: London Gallery Editions, 1939). Reprint (Los Angeles: J. Paul Getty Museum, 2003), np.

13 Sontag, *On Photography*, 42.

14 Anthony Carrigan, *Postcolonial Tourism: Literature, Culture, and Environment* (New York: Routledge, 2012), 47.

15 Douglas Dunn, introduction to *Terry Street: A Bête Noire Special Edition*, ed. John Osborne (Hull: Bête Noire, 1994), 7.

16 Dunn, introduction to *Terry Street*, 12.

17 Douglas Dunn, 'Terry Street', in *London Magazine* 8, no. 5 (August 1968), 62–66. Whitaker's photographs follow the sequence and are non-paginated.

18 John Osborne, 'Terry Street', in Dunn, *Terry Street*, 97.

19 Robert Whitaker, preface to *Terry Street: Photographs by Robert Whitaker, Poems by Douglas Dunn* (Hull: Kingston-upon-Hull City Museums, Art Galleries & Archives, 1996), 3.

20 'Misanthropos' was first published in *Encounter* (August 1965), 19–25; 'Confessions of the Life Artist' in *New Statesman* 69, no. 1783 (14 May 1965), 768–769.

21 Thom Gunn, 'The Art of Poetry, No. 72', interview by Clive Wilmer, *Paris Review* 135 (Summer 1995), 169.

22 Quoted in Stefania Michelucci, *The Poetry of Thom Gunn: A Critical Study*, trans. Jill Franks (Jefferson, NC; London: McFarland, 2009), 111. Gunn first mentions Ander's photographs for a potential book project in a diary entry dated 11 November 1964. See 'Diary 1962–1966', carton 2, folder 34, Thom Gunn Papers, BANC MSS 2006/235, The Bancroft Library, University of California, Berkeley.

23 Thom Gunn, *The Occasions of Poetry: Essays in Criticism and Autobiography*, ed. Clive Wilmer (London: Faber, 1982), 181. Gunn's essay 'My Life Up to Now' was originally published as the biographical introduction to *Thom Gunn: A Bibliography, 1940–1978*, ed. Jack W. C. Hagstrom and George Bixby (London: Bertram Rota, 1979).

24 Gunn, 'The Art of Poetry', 169.

25 Gunn, 'The Art of Poetry', 151.

26 Thom Gunn, *Collected Poems* (London: Faber, 1994), 159. Hereafter *CP*.

27 Dorothy Sheridan, Brian Street and David Bloome, *Writing Ourselves: Mass-Observation and Literary Practices* (Cresskill, NJ: Hampton Press, 2000), 27.

28 Walker, *So Exotic*, 116.

29 Tom Harrisson and Charles Madge, eds., *First Year's Work* (London: Lindsay Drummond, 1938), 7.

30 Humphrey Spender, *Worktown People* (Bristol: Falling Wall Press, 1982), 20.

31 Walker, *So Exotic*, 118.

32 Dunn, introduction to *Terry Street*, 14.

33 Walker, *So Exotic*, 117; Spender, *Worktown People*, 16.

34 Dunn, introduction to *Terry Street*, 8.

35 Dunn, 'Young Women in Rollers', in Dunn, *Terry Street*, 67. All further quotations from Dunn's poetry derive from this edition.

36 Jane Stabler, 'Biography', *Reading Douglas Dunn*, ed. Robert Crawford and David Kinloch (Edinburgh: Edinburgh University Press, 1992), 7.

37 Roland Barthes, *Camera Lucida: Reflections on Photography*, trans. Richard Howard (London: Vintage, 2000), 87, 80.

38 Barthes, *Camera Lucida*, 76.

39 Edward Picot, *Outcasts in Eden: Ideas of Landscape in British Poetry since 1945* (Liverpool: Liverpool University Press, 1997), 43; see also Janice Rossen, *Philip Larkin: His Life's Work* (New York; London: Harvester Wheatsheaf, 1989), 25–48.

40 Douglas Dunn, *Under the Influence: Douglas Dunn on Philip Larkin* (Edinburgh: Edinburgh University Library, 1987), 10.

41 Thom Gunn, 'First Elliston Presentation Poetry Reading'. Poetry Reading, The Elliston Project from University of Cincinnati, Cincinnati, OH, 15 October 1981, https://drc.libraries.uc.edu/handle/2374.UC/697029?submit=Go&query=thom%20gunn&focusscope=&mode=search. Accessed 23 May 2017.

42 Thom Gunn, *Collected Poems* (London: Faber, 1994).

43 Thom Gunn, 'First Elliston Presentation Poetry Reading'.

44 Thom Gunn and Ander Gunn, *Positives* (London: Faber, 1966), 44. Unless otherwise stated, all further quotations from Gunn's poetry refer to this edition.

45 Andrew Miller, *Poetry, Photography, Ekphrasis* (Liverpool: Liverpool University Press, 2015), 177.

46 Tony Trigilio, *Allen Ginsberg's Buddhist Poetics* (Carbondale: Southern Illinois University Press, 2007), 30.

47 Allen Ginsberg and Alexandra Lawrence, *Ankor Wat* (London: Fulcrum Press, 1968). All quotations from Ginsberg's poetry derive from this edition. A scarcity of information about Lawrence has prevented me from studying her working practice. Ginsberg wrote *Ankor Wat* in 1963, and it is unclear whether or not Lawrence took the photographs specifically for the Fulcrum Press edition.

48 Ian Davidson, *Ideas of Space in Contemporary Poetry* (Basingstoke; New York: Palgrave Macmillan, 2007), 14.

49 Henri Lefebvre, *Key Writings*, ed. Stuart Elden, Elizabeth Lebas and Eleonore Kofman (New York; London: Continuum, 2003), 208.

50 Doreen Massey, *For Space* (London: Sage, 2005), 5.

51 See Davidson, *Ideas of Space*, 39–47.

52 Davidson, *Ideas of Space*, 41.

53 Gilles Deleuze and Felix Guattari, *A Thousand Plateaus: Capitalism and Schizophrenia*, trans. Brian Massumi (London; New York: Continuum, 2004), 8.

54 Deleuze and Guattari, *Thousand Plateaus*, 7, 8.

55 Deleuze and Guattari, *Thousand Plateaus*, 18.

56 Deleuze and Guattari, *Thousand Plateaus*, 16.

57 Davidson, *Ideas of Space*, 41.

58 Davidson, *Ideas of Space*, 57.

59 The Fulcrum Press edition is non-paginated. For ease, all quotations refer to the 'Angkor Wat' text in Allen Ginsberg, *Collected Poems 1948–1980* (London: Viking, 1985), 306–323: here 306.

60 Ginsberg and Lawrence, *Ankor Wat*, 'Notes', 23.

61 Ginsberg and Lawrence, *Ankor Wat*, 'Notes', 23.

62 Davidson, *Ideas of Space*, 48.

63 Davidson, *Ideas of Space*, 41.

64 Massey, *For Space*, 181, 185.

65 Davidson, *Ideas of Space*, 33.

66 Davidson, *Ideas of Space*, 42

67 Jonathan Bate, *The Song of the Earth* (London: Picador, 2000), 13.

68 George Mackay Brown and Gunnie Moberg, *Stone* (Foss, UK: Kulgin D. Duval and Colin H. Hamilton, 1987). *Stone* is non-paginated, and all quotations from it refer to *The Collected Poems of George Mackay Brown*, ed. Archie Bevan and Brian Murray (London: John Murray, 2005).

69 George Mackay Brown and Gunnie Moberg, *Orkney Pictures & Poems* (Grantown-on-Spey, UK: Colin Baxter, 1996).

70 Colin Hamilton, *Stone: Ten Bindings*, exhibition catalogue (Edinburgh: National Galleries of Scotland, 2006), np.

71 Robinson Jeffers, *Not Man Apart: Photographs of the Big Sur Coast*, ed. David Brewer (San Francisco: Sierra Club, 1965).

72 George Mackay Brown to Gunnie Moberg, 27 February 1994, Gunnie Moberg Papers, Orkney Library and Archive. Hereafter cited as Moberg MSS.

73 George Mackay Brown, interview by Colin McPhail, Kirkwall, nd., audio recording, Moberg MSS.

74 Colin Baxter to Gunnie Moberg, 30 January 1994, Moberg MSS.

75 Given that Moberg and Brown were effectively neighbours, little correspondence exists relating to their collaborative style. In one letter to Moberg about publishing details, Brown remarks, 'Fancy, having to write to each other when we live so close!' Brown to Moberg, 12 February 1994, Moberg MSS.

76 Alistair Peebles, 'From the Air to the Shore to the Garden: The Photographs of Gunnie Moberg', *Oar Nine* (June 1996), 10.

77 'Pamela Beasant meets Gunnie Moberg', *Northwords* 34 (Spring 2004), 20.

78 Brown to Moberg, 8 May 1987, Moberg MSS.

79 Peebles, 'From the Air', 11.

80 Marina Warner, 'Intimate Communiqués: Melchior Lorck's Flying Tortoise', in *Seeing from Above: The Aerial View in Visual Culture*, ed. Mark Dorrian and Frédéric Pousin (London; New York: I. B. Tauris, 2013), 12.

81 Warner, 'Intimate Communiqués', 11.

82 Bate, *Song of the Earth*, 149.

83 Terry Gifford, 'Towards a Post-Pastoral View of British Poetry', in *The Environmental Tradition in English Literature*, ed. John Parham (Aldershot; Burlington, VT: Ashgate, 2002), 52.

84 Edwin Morgan, 'Images in Illustration', review of *Landscape Poets: Thomas Hardy*, ed. Peter Porter, and *Landscape Poets: Robert Burns*, ed. Karl Miller, *Times Literary Supplement* (25 September 1981), 1095.

85 Morgan, 'Images in Illustration', 1096.

86 Liz Wells, *Land Matters: Landscape Photography, Culture and Identity* (London: I. B. Tauris, 2011), 189.

87 Roger Taylor, 'Topographer with Attitude', in *Landmarks: A Survey*, by Fay Godwin (Stockport: Dewi Lewis Publishing, 2001), 17.

88 Terry Gifford, 'Gods of Mud: Hughes and Post-Pastoral', in *The Challenge of Ted Hughes*, ed. Keith Sagar (London: Macmillan, 1994; New York: St Martin's Press, 1994), 130.

89 Ted Hughes, introduction to *Remains of Elmet*, by Hughes and Fay Godwin (London: Faber, 1979), 8.

90 Hughes, introduction to *Remains*, 8.

91 For example, see Ann Skea, 'Regeneration in *Remains of Elmet*', in *The Challenge of Ted Hughes*, ed. Keith Sagar (London: Macmillan, 1994; New York: St Martin's Press, 1994), 116–128.

92 Ted Hughes to Fay Godwin, 4 July 1976, in *Letters of Ted Hughes*, ed. Christopher Reid (London: Faber, 2007), 420.

93 Ted Hughes, 'Ted Hughes on Wolfwatching', *Poetry Book Society Bulletin* 142 (Autumn 1989), 1.

94 Hughes to Anne-Lorraine Bujon, 16 December 1992, in *Letters*, 633.

95 Hughes to Bujon, in *Letters*, 633.

96 Glyn Hughes, 'Myth in a Landscape', review of *Remains of Elmet*, by Fay Godwin and Ted Hughes, *Guardian*, 24 May 1979, 16.

97 Tom Normand, 'Reconfiguring Documentary Photography in a Globalised World: Some Contemporary Photographers from Scotland', *Studies in Photography* (2012), 49.

98 Peter Porter, 'Landscape with Poems', review of *Remains of Elmet*, by Fay Godwin and Ted Hughes, *Observer*, 15 July 1979, 37.

99 Terry Gifford, ' "Dead Farms, Dead Leaves:" Culture as Nature in *Remains of Elmet* & *Elmet*', in *Ted Hughes: Alternative Horizons*, ed. Joanny Moulin (London: Routledge, 2004), 42.

100 Gifford, 'Culture as Nature', 44.

101 Hughes to Godwin, 31 May 1979, in *Letters*, 420.

102 Hughes, 'Ted Hughes on *Wolfwatching*', 3.

103 Gifford, 'Culture as Nature', 46.

104 Hughes to Stephen Spender, 9 September 1979, in *Letters*, 427.

105 Hughes to Godwin, 4 July 1976, in *Letters*, 420.

106 Hughes to Bujon, 633.

107 Ted Hughes, 'Note on History of Calder Valley'. Ted Hughes Papers, MSS 644, Box 72, ff. 11, Stuart A. Rose Manuscript, Archives, and Rare Book Library, Emory University (hereafter cited as Hughes MSS). This fragment expands significantly on Hughes's other reflection on poetry and photography: see 'Ted Hughes on Wolfwatching', 1–3.

108 Hughes, 'History of Calder Valley', Hughes MSS.

109 Ted Hughes, 'Myth and Education', *Children's Literature in Education* 1 (March 1971), 56.

110 Gifford, 'Culture as Nature', 40.

111 Sally Minogue and Andrew Palmer, '"Horrors Here Smile": The Poem, the Photograph and the *Punctum*', *Word & Image: A Journal of Verbal/Visual Enquiry* 29, no. 2 (2013), 204.

112 The Top Withens farmhouse is reputed to have inspired the setting for the Earnshaws's house in Emily Brontë's novel *Wuthering Heights* (1847).

113 Gifford, 'Culture as Nature', 43.

Site Rhyme, 1992–2015

Photopoetry and the Architectures of Memory

When the roof collapsed on the banqueting hall in Thessaly that the Greek poet Simonides (c.556–c.468 BCE) had left moments earlier, his visual memory of where each guest was sitting allowed him to identify the misshapen corpses, themselves beyond recognition and, in a sense, recover the dead. This technique of memory allows a speaker to construct his/her oration as an imagined architectural space. Each idea or paragraph corresponds to a room or passageway, and the speaker travels on a predetermined route through the imagined space. Through landscape, photopoetry possesses a similar mnemonic mapping: both poetry and photography are vehicles for memory and monument. Although we understand photopoetry through the formal and thematic architectures that define it, this is not without complications. What is the relationship, for example, between an actual topographical site, its representation in poetry and photography, and our own mental imaginative or recollected version of it? As Seamus Heaney (1939–2013) remarked of his poem *Sweeney Astray* (1983), it is as much the 'local power' of the landscape that 'affect[s]' the reader as the mythological resonance of the Sweeney story.[1] Photopoetry constructs an architectural space in our minds: the imaginative, immersive photopoem, the visual and verbal composite of poem and photograph. The definition of architecture, notes Shelley Hornstein, can be expanded to encompass:

> a constructed environment – whether in natural, manufactured, or imagined materials – that demarcates space. In this way, architecture is the mapping of space – physical, mental or emotional.
>
> It follows then that architecture is the act of delineating and shaping space to carve a place.[2]

This chapter explores photopoems as architectural spaces, and examines how symbiotic relationships between poem and photograph prompt affective responses in the reader/viewer through the creation of a Roland Barthes-like photopoetic 'punctum'.[3] In a structural sense, these architectural spaces return early twenty-first-century photopoetry to its nineteenth-century theatrical roots: the combination of sound and vision creates an immersive environment aimed at prompting the reader/viewer's affective responses. Conversely, these spaces no longer represent the linear journeys of nineteenth-century photopoetry: the poet and photographer no longer lead the reader along a predetermined course. Instead, in collections with long poems or that revolve around a central place, poetic speakers are figures that share, and prompt, the reader's own bewilderment, in the case of Heaney's *Sweeney's Flight* (1992) and Kathleen Jamie's *The Autonomous Region* (1993). When photopoetry books contain predominantly short poems, it is more difficult to determine a central poetic voice or photographic eye. As a result, objects take on a central resonance: as the visual scope of photopoetry narrows from picturesque vistas to tree stumps and discarded beer bottles, a sense of place is created through the traces of people, cultures, and stories present both in the photographs and the narratives contained in the poems. Placed at the centre of the photopoetry book for the first time, the reader/viewer is left, instead, to muddle through unaided and find their own paths.

Come the late twentieth century, collaboration had definitively replaced retrospection as the dominant photopoetic practice. As suggested in the previous chapter, however, the breadth of collaborative practice is vast, and connections between poem and photograph – poet and photographer, even – were still subject, in Paul Muldoon's phrase, to 'the grins and grimaces of recognition'.[4] With this in mind, this final chapter seeks to address a diverse range of collaborative practices in contemporary photopoetry rather than plot a selective course that suggests photopoetry is evolving towards some kind of formal, thematic, or collaborative apotheosis. I have selected these works from the large range of contemporary photopoetry in order to indicate that, as with any other art form, its history contains nodal points that influenced and shaped subsequent work.[5] This final chapter can be appreciated most fully in conjunction with the conclusion as an extended discussion of the state of contemporary photopoetry: how and why it has reached its current form, and what the future may hold for collaborations between poets and photographers.

The place of photopoetry

Written in three weeks upon her return to Scotland, Kathleen Jamie's *The Autonomous Region: Poems and Photographs from Tibet* (1993), pairs Jamie's lyric poems with the photographs of Sean Mayne Smith. Jamie and Smith spent months together travelling with pilgrims, monks, and nomads on the roads towards Tibet, where their journey was halted at the border because of a military clampdown, general strikes, and the Tiananmen Square massacre. Rumours of the massacre seep through the poems: 'She telt me / they've killed 5000 people in Beijing'; 'And the rumours say yes, the rumours say no' (*The Autonomous Region* (hereinafter *AR* in citations) 70). Reviewing *The Autonomous Region*, Caroline Blyth notes, 'This is about as un-autonomous a region of language as you can get.'[6] Such prevarication recalls Allen Ginsberg and Alexandra Lawrence's *Ankor Wat* (1968), where Lawrence's photographs balance Ginsberg's capricious images. While Ginsberg and Jamie are by no means comparable poets, their photopoetic collaborations throw up some remarkable structural and thematic similarities when we consider the politics of travel and the nature of home, exile, and dwelling. Common to both is the collapse of temporal and spatial structures common to earlier photopoetry: while this is explored through the drug-induced musings of the poetic speaker in *Ankor Wat*, Jamie borrows two historical figures who, alongside the speaker, journey through the cultures, histories, and geographies of the region. 'On the journey across China,' Jamie writes,

> I "met" two historical characters. One was Fa-hsien, a Chinese Buddhist monk of the 4th century A.D.... . I recognised him in the Buddhist and Taoist wandering monks I saw at truck-stops, fortune-telling to raise a bit of cash, or hitch-hiking, or resting at the door of yurts.... . The other character was equally real. In 640 A.D. the Princess Wen Cheng ... travelled from Beijing to Lhasa as the bride of the king of Tibet. Far from seeking knowledge, she was bringing it with her.[7]

This creates a collage of languages, voices, and perspectives that use Tibet as a conduit through which to explore ideas of home and exile. Unlike Ginsberg's sense of home, which manifests itself as a physical location, Jamie's takes root in language, which becomes an affirmation of identity (in her usage of Scots) and a form of connection and displacement across the various real and imaginary places in the poems. As Dorothy McMillan remarks, *The Autonomous Region*

'indicate[s] the need to travel to understand "home" but also the need to come home in order to establish valid senses of both here and there'.[8] The use of Fa-hsien and Princess Wen Cheng as fellow travellers dissolves the temporal distance between past and present. They are stowaways in a different time: Wen Cheng is 'acting up' in the 'dining-car' of a modern train (34), while Fa-hsien '[rides] hobo on the box-car' and 'doesn't half / admire how the nomads ride' (39).

The connections Jamie draws between ancient and modern nomads are augmented in Smith's accompanying photographs (Figure 5.1). In his preface Smith refers to 'the simple dignity of the work of … Paul Strand and Walker Evans. I wanted to bring something of these qualities into my pictures of Tibet'.[9] Smith does not work to expose social conditions; rather he and Jamie share an interest both for erasure and for marking the courage of the Tibetans under difficult political circumstances. His photographs are soft in focus and sympathetic: his sequence of monks at various ages evokes the continuity of past, present, and future, the resistance of a way of life. For Smith, looking assumes a role comparable to speech in Jamie's poems, and he draws on the power of the gaze to denote ownership or, indeed, belonging. The steady gaze of 'Nomad with skull necklace, Heimahe' is tied to Jamie's adjacent poem:

Devotions over, the ice mountains'
jagged edges met his gaze. He smiles, 'Life!
wo! *That* straggling caravan.' Then: 'But what to you
are the ramblings of Fa-hsien?' Begins to walk. (19)

The note of defiance here is echoed in Smith's image, as is the connection between 'home' and walking: the background to the image suggests transit, a kind of accidental setting in which the nomad has paused for a spontaneous photograph. This too is evoked in 'ramblings', which refers simultaneously to Fa-hsien's wanderings and the stories born of his nomadic life. The subjects of Smith's photographs become the metaphorical, contemporary equivalents of the historical figures 'met' by Jamie in her verse. His captions are poised not to identify individuals, but to evoke a way of life that stretches back thousands of years.

That there are captions at all suggests Smith had a more documentary project in mind: Blyth suggests that Smith's thirty-seven photographs 'are an essay in their own right'.[10] The captions regularly refer to pilgrims, nomads, and monks, as well as scenes of movement or potentially traversed space, such as 'Leaving

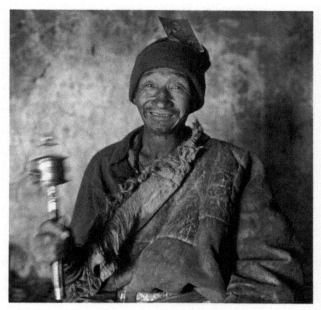

PILGRIM AT TARCHEN, MOUNT KAILASH, WEST TIBET

Figure 5.1 Sean Mayne Smith, 'Pilgrim at Tarchen, Mount Kailash, West Tibet', in *The Autonomous Region*, 1993. Image © Sean Mayne Smith. Courtesy of the University of St Andrews Library, photo PR6060.A477A8.

Xiahe on the road to the plains' (53) and 'The path around Mount Kailash, West Tibet' (21). These mirror the 'here and there' of Jamie's poems, structured in such a way as to suggest various journeys: the poems in the first suite are without titles and appear to comprise the first of three intertextual sequences, the others being 'The princess breaks the Sun-Moon Mirror' (26–41) and 'The travels of Fa-hsien' (42–61). The collaboration ends with a series of shorter, titled poems, most of which are written in Scots and represent what McMillan calls 'an imaginative act' reaffirming the vernacular tongue, under threat from erasure. This forms part of Jamie's tribute to Tibetan courage, which she marks 'with the old tongue of her own people'.[11] Jamie's use of Scots simultaneously affirms her own identity and, 'looking for adventure and searching for a myth', highlights her distance from home.[12]

Ideas of nomadism further enhance the connection between sight and speech in Smith's photographs and Jamie's poems. Smith's image 'Wandering monk at the Kumbum Monastery, Taersi' (56) shows a monk in the foreground looking

back towards something out of shot, his body moving in one direction, his eyes looking in the other, reflecting Jamie's adjacent verse:

Set a stout hert tae stey brae
 he winked (a wink that showed
he wasn't so old he couldn't
follow home a twisting road
with a click of his heels,
wouldn't resist
 a backward glance
to see who followed this ridiculous dance
through many people's many tongues.) (57)

Stories are a kind of dance (and going 'home' a 'ridiculous' one) enacted by the body: everyone in the poems and photographs are en route, 'journey[men], a-journeying' (22). The proximity of 'a backward glance' to 'many tongues' demonstrates the connection between looking and speaking in nomadic terms, and how both sound and vision are capable of evoking and re-telling these journeys. The word 'home' features only three more times in the entire book, and each time in a different form. There is the speculative 'O monk, whither do you wander? / to garner wisdom and bring scripture home' (45); the 'home-turned figure' (59); and Jamie's own sudden apprehension that she is 'far fae hame' (78). Home is a distant, hazy, almost liminal place given how *The Autonomous Region* is rooted in nomadic spaces. Focusing on one of the numerous pilgrims, Jamie writes:

We saw him once more: in the dusty dawn
a distant home-turned figure
jaunty as a fiddler
down the loch-side dirt track.

As we saddled up, ready for the last push,
wondering again what kind of place it was
we rode toward
 with a new resolve. (59)

The journeys Jamie invokes are open-ended, 'home-turned' but not at home, an echo of Deleuze and Guattari, who remark, 'The life of the nomad is the intermezzo. Even the elements of his dwelling are conceived in terms of the trajectory that is forever mobilizing them.'[13] With the reference to the 'loch-side', Jamie foreshadows the Scots poems, which might be read as a more personal

response to her Tibetan journey than the interwoven voices of Fa-hsien and Wen Cheng. Only in Scots is Jamie able to suggest a completed journey, in the final poem 'Xiahe', although the idea of actually returning home remains moot:

the herd cries a wheen wirds
o Tibetan sang,

an A'm waukenet, on a suddenty mindit:
A'm far fae hame,
I hae crossed China. (78)

Both familiar and less familiar sounds awaken the speaker to the fact that she is 'far fae hame'. Jamie's poems create liminal spaces that, while containing echoes of home, remain far from offering permanence. They add an additional dimension to the physical journeys that preoccupy Smith: photographs capture surfaces, and as a result Jamie's poems infuse Smith's images with the cultural and historical geographies of Tibet. Like Jamie and Smith, the reader is twixed in between different times, cultures, languages, and voices, left to plot a course along with the other nomads, past and present, who are the central focus of the photobook. The connections forged between poems and photographs in *The Autonomous Region* demonstrate a shift in photopoetic focus from topography and landscape to the cultures, histories, and stories that underlie those places: places that are remembered, recreated, and reimagined through different eyes and voices.

Perhaps the most famous exile in photopoetic history is Mad Sweeney, the subject of Seamus Heaney's collaboration with photographer Rachel Giese (1936–). Prior to *Sweeney's Flight* (1992), Heaney had been reluctant to enter a project in which his poems would act as supplement to, or stimulus for, photographs. This reluctance arose, Heaney noted, from 'an unease about ... the combination of speechless photograph and wordlogged verse: ... I tended to foresee misalliance of some sort between the impersonal, instantaneous thereness of the picture on one side of the page, and the personal, time-stretching pleas of the verse on the other.'[14] What enabled Heaney to pursue *Flight* – aside from Giese's substantial knowledge of 'parts of Ulster lying within and beyond the boundaries of Sweeney's original kingdom of Dal-Arie' – was his decision to turn the narrative of *Sweeney Astray* into a lyric sequence.[15] 'My original desire,' he writes,

had been to snatch certain moments of definition and intensity out of their place in the story and to present them as lyric poems in their own right, but in the end I felt this would have been too high-handed a treatment. Nevertheless, the

hankering to skim off certain favourite lines persisted, and when I saw Rachel's pictures, I realized that the right person had arrived at the right time. I was immediately emboldened to snip lyric leaves off the old narrative boughs.[16]

The movement from narrative to lyric sequence retains a narrative impulse through 'moments of definition and intensity': a photographic analogy. The inclusion of photographs within the lyric/narrative hybrid stages a radically different story to that of the J. G. O'Keeffe bilingual edition from which Heaney derived his version of *Astray*.[17] *Flight* focuses on the events after Ronan curses Sweeney to 'roam Ireland, mad and bare', afflicted by 'mad spasms', and to live 'bird-brain among branches', and the majority of Heaney's 'lyric leaves' are in Sweeney's voice.[18] Eventually Sweeney arrives at Glen Bolcain, a haven for the mad, and reflects on his flight from human society. It is here that Heaney's decision to rename the sequence becomes clearer. The original title, *Sweeney Astray*, suggests aimlessness, a rambling without beginning or end, whereas *Sweeney's Flight*, naming Sweeney's endeavour rather than describing his state, suggests a fleeing from danger, a departure or retreat, and implies a sense of purpose.[19] In addition, the retitling recalls Sweeney's bird-like state throughout the poem, as well as more modern kinds of flights that jar with the timelessness of the photographs. As Nora Chadwick has argued, Sweeney's flight was 'not the result of true madness, but of a deliberate way of life', and Heaney's retitling acknowledges, if not a specific destination to Sweeney's roaming, a different experiential relationship with the natural world.[20]

'The King of the Ditchbacks' precedes the lyric sequence. This poem explores Heaney's own relationship with the Sweeney myth, and connects the activities of writing and wandering; or, as Heaney remarks, his own procession 'into the paths of absorption and "migrant solitude"'.[21] I will return to the idea of absorption: first, however, several images from 'Ditchbacks' recur in *Flight*, including the opening lines 'As if a trespasser / unbolted a forgotten gate' (*Sweeney's Flight* (hereinafter *SF* in citations) 4) and the description of Sweeney as 'a denless mover' (4). This is a crucial image to the sequence's photopoetic structure, as is the idea of 'hiatus' in the second section of 'Ditchbacks'. Excluding a topographical photograph that precedes the whole collection, the sequence is bookended by two photographs of a doorway in an abandoned orchard, the first a detail of the second (Figure 5.2). 'Hiatus', from the Latin, meaning a physical opening or aperture (but now more widely used to reflect a break in chronological time) reflects the liminal space Sweeney, the 'denless mover', comes to inhabit between human and natural

worlds, and his overlapping descriptions of both as homes, shelters, or nests.[22] Come the conclusion, the photograph retreats in focus, showing the doorway in its surroundings of bare trees and overgrown briars: Sweeney, come his death, had flown to the natural world. Here Giese's photographs demonstrate a metaphorical relationship with Heaney's text, and evoke the idea that Sweeney's flight was purposeful: his dwelling in the earth, and the return of his body to its 'clay nest'.

Sweeney's forsaking of his kingdom and human company, and his ensuing isolation, are expressed in architectural metaphors: 'The roof above my head has gone' (58), he cries, and he later describes himself as 'a derelict doomed to loneliness' (65). Sweeney's architectural metaphors demonstrate the significance of the proposed building of a church on his land that caused the rupture with Ronan. The land slowly reclaims the cast-adrift Sweeney. 'Look at me now,' he laments,

> wind-scourged, stripped
> like a winter tree

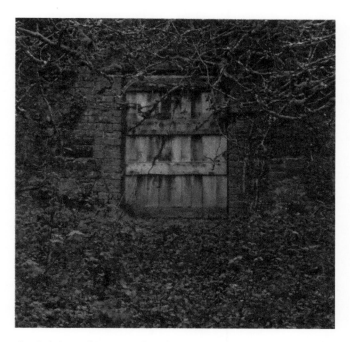

Figure 5.2 Rachel Giese, 'Door in Abandoned Orchard', in *Sweeney's Flight*, 1992. Image © Rachel Giese Brown. Courtesy of the University of St Andrews Library, photo PR6058.E2S8G5.

clad in black frost
and frozen snow. (14)

Giese's subsequent photograph – a winter tree – acts as a portrait of Sweeney, echoing his metamorphosis. The bird's nest in Giese's photograph, an important image of Sweeney's, acts as consolation for his lament that he is 'without bed or board' (42) but is absent from his self-description (Figure 5.3). Only in the concluding section does the omniscient speaker, denoted throughout by italics, refer to Sweeney as having 'nested' in Glen Bolcain: the 'clay nest' of his grave (78). Although this is literally realized in his death, Sweeney's sole reference to nests allows us to read his *Flight* as a desire for a dwelling in the natural world:

In November, wild ducks fly.
From those dark evenings until May
let us forage, nest and hide
in ivy in the brown-floored wood. (60)

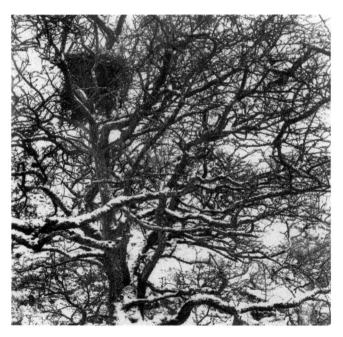

Figure 5.3 Rachel Giese, 'Nest in Snowy Thorn', in *Sweeney's Flight*, 1992. Image © Rachel Giese Brown. Courtesy of the University of St Andrews Library, photo PR6058.E2S8G5.

That the nest appears much earlier in the photographs than the poems is an example of photopoetic foreshadowing. Through the tension between poem and photograph the reader/viewer is made aware of Sweeney's desire before it is explicitly mentioned. Sweeney's first idea of nesting is a kind of solipsistic enclosure:

> I would live happy
> in an ivy bush
> high in some twisted tree
> and never come out. (38)

Used to banqueting halls and nature as a backdrop for the 'hullaballoo / of the morning hunt' (38), Sweeney is circumlocutious in his nesting imagery, and his references to other animal dwellings, such as badger setts, highlights his initial isolation from the natural world. Later he refers to himself as 'a sheep / without a fold' (68): an ethereal photograph of sheep in the mist occurs several pages after this quatrain, formally evoking the lostness of the sheep from their fold in the separation of poem from directly referential photograph. Of all the animal dwellings mentioned, only nests are photographed, creating a narrative foreshadowing Sweeney's own desire to nest. The vulnerability of the nest is the locus of what Heaney calls the 'local power' of the Sweeney story, and his consideration of Sweeney as an everyman figure has phenomenological undercurrents. 'Even though [the poem] dramatizes the predicament of an individual character,' Heaney notes, 'the character himself is often less an individual than a mouthpiece for the common, primary sensations and emotions which everybody experiences in the presence of the natural world.'[23] The encouragement to sense what Sweeney senses in the natural world echoes Gaston Bachelard, who encourages us

> to recapture the naïve wonder we used to feel when we found a nest. This wonder is lasting, and today when we discover a nest it takes us back to our childhood or, rather, to a childhood; to the childhoods we should have had. For not many of us have been endowed by life with the full measure of its cosmic implications.[24]

Heaney's *Flight* recalls Jonathan Bate's thoughts on John Clare (1793–1864), who wanted to 'build an analogue of a bird's nest in a poem', and Heaney's 'snip[ping] of lyric leaves from narrative boughs' becomes a nest-building metaphor.[25] *Flight* can also be read as a reinterpretation of early photopoetry books, notably 'the illuminating fragment' Helen Groth identified as central to William Morris

Grundy's *Sunshine in the Country* (1861), which 'constructed a sequence of moments of identification'.[26] Heaney's snipping enacts Sweeney's vulnerable search for a surrogate natural home, mirrored in the memorial function of the photographs whose accumulation serves to represent Sweeney's kingdom, Dal-Arie. The aperture between poem and photograph creates representational space between Sweeney's lament (purportedly from the seventh century) and the inescapably modern photography, the technology of which draws attention to itself, as does the deliberate timelessness of Giese's images, all of which exclude signs of modernity. The photographs, in square format on one half of an otherwise blank double-page spread, are explicitly framed, and the surrounding white space seems pressing and enclosing, recalling Sweeney's earlier image of nesting as a kind of entrapment.

Giese's arrangement of photographs controls how the reader/viewer identifies with the landscape: she juxtaposes topographical views with close-ups of trees and foliage. We implicitly accept the photographs' indexicality, though these details are impossible to locate definitively within Sweeney's landscape, just as the landscapes themselves are indeterminable to anyone other than those who can identify local topographical formations. That we cannot definitively locate these details encourages the reader to add to the photographs, to reimagine them. Heaney suggests the material of the 'Sweeney stanzas … belongs to everyone' and 'has the given, anonymous in-placeness of hillsides and shorelines'.[27] Photopoetically, the reader/viewer is presented with 'common, primary sensations' and invited to create a specific phenomenological experience out of the combination of poem and photograph.

Bate describes Clare's poetry as 'the record of his search for a home in the world', and it is worthwhile reading the Sweeney story in a similar manner.[28] Sweeney's horizon is comprised of natural things – watercresses, birch trees, ivies – and the sequence is a phenomenological exploration of Sweeney's dawning 'at-homeness' in the world and the changes he undergoes between what we might term the 'human' and 'natural' realms. As Chadwick suggests, 'It is clear that Suibhne is a recluse, and his oratory is the woodland'.[29] Sweeney's hymn to the trees, the height of his rapture, suggests a kind of absorption in his wandering, an absorption reflected in Heaney's structural nest-building metaphor. Absorption might be considered primordial insofar as it represents an essential practical engagement as a means of existence, prior to building other relationships to and within the world. Sweeney, however, does not build: he does not, in Hilde Heynan's phrase, 'make a place out of undifferentiated space'.[30] The desire to

nest, in which Sweeney achieves death as death, is occasioned by the unearthly sweetness of a voice that encourages Sweeney to dwell within the natural world, and to reject once and for all his desire for the kingdom he abandoned:

> *Near a quick mill-pond, your perch*
> *on a dark green holly branch*
> *means far more now than any feast*
> *among the brightest and the best.* (25)

Sweeney's metamorphosis into a bird (literal or figurative) posits a form of dwelling more attuned to his situation: only absorption in the natural world can assuage his unease. Nest-building as an absorptive, practical activity structures the reader/viewer's experience of Sweeney's flight, an activity reflected in the composition of the photopoetry book. 'Painting in oils,' writes Michael Fried, 'has had the capability of thematizing the fact that a finished picture is inevitably the product, and in certain respects the record, of the painter's sustained absorption over time in the act of painting.'[31] Photography, contrarily, 'finds it vastly more difficult ... to produce images that "read" unequivocally in those terms.'[32] The 'sustained absorption' of photopoetry, however, occurs in the reader/viewer through their affective responses, as well as the collaborative absorption of poet and photographer from which the photobook emerges as 'product' or 'record'. Heaney's sequence of 'lyric leaves' positions the photopoem as both absorptive and durational. *Camera Lucida*, Marie Shurkus notes,

> attempted to describe another layer of representation in which images convey information to viewers but information that cannot be captured mimetically or symbolically because this information is durational – it can only develop through time as a virtual form that differentiates itself by entering the actual through a material expression, such as a living body.[33]

The 'living body' of the reader acts as the surrogate for the lyric voice of Sweeney and the photographic eye, which together enable *punctual* responses; or, in Shurkus's phrase, 'how repeated associations with expressive beings or situations ... begin to register forms of affective knowledge that through time become linked to particular identities or situations.'[34] *Flight* is photopoetry of the bird nest as a means of engaging the reader in the kind of immersive present that one might call a 'lived intensity'.[35] Concluding the poem, the omniscient speaker '*stand[s] beside Sweeney's grave / remembering him*' (78). The photograph shows a crescent moon, with mist swirling around a mountaintop behind a black foreground (Figure 5.4). The connection Heaney draws between a specific

site (the grave) and the act of remembering affirms the photopoetic project of *Flight*: it encourages the reader to recall similar instances through their physical, *punctual* responses to poem and photograph. In the final stanza, the speaker becomes a physical surrogate for the reader. Giese's photograph does not show the grave – instead, it situates the reader in the land: *'[Sweeney's] memory rises in my breast'* (78), the speaker notes, returning the photopoem to the reader's living body.

Heaney's choice of italics to denote an omniscient speaker (or 'witness') highlights a problem of lyric poetry in terms of affect. The relationship between photography and witness does not possess an intermediary in the way that lyric poetry places a speaker between poet and reader. The only intermediary, so to speak, is the camera itself, framing a moment's ambiguity. Paul Muldoon's matrices of voice and allusion draw attention to this affective problem, and his collaborations with photographers Bill Doyle (1926–2010) and Norman McBeath (1952–) demonstrate architectural underpinnings. Muldoon (1951–) has produced two volumes of photopoetry since the mid-1990s: *Kerry Slides* (1996)

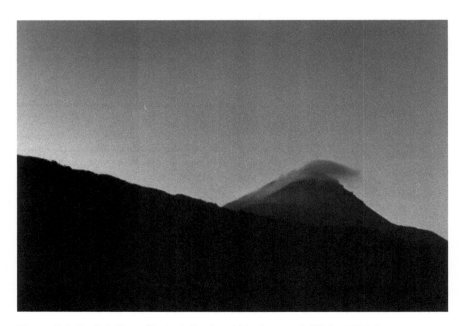

Figure 5.4 Rachel Giese, 'Errigal, Daybreak', in *Sweeney's Flight*, 1992. Image © Rachel Giese Brown. Courtesy of the University of St Andrews Library, photo PR6058.E2S8G5.

with Irish photographer Doyle, and *Plan B* (2009) with Scottish photographer McBeath. The untitled poems of *Kerry Slides* act as a sequence of 'slides', both in the sense of musical embellishments and photographic transparencies. *Plan B*, contrarily, is one of three preludes to Muldoon's collection *Maggot* (2010), the others being *When the Pie Was Opened* (2008) with drawings and engravings by Lanfranco Quadrio, and *Wayside Shrines* (2009) with paintings and drawings by Keith Wilson. Compared to the mass-produced *Maggot*, notes Jeffrey Bilbro, these books 'embody Muldoon's search for a different kind of order in their unusual format', a search especially important to his photopoetry.[36]

Kerry Slides opens with a dangerous embarkation, the 'wreckers of Inch Strand' tricking unwitting ships into 'Dingle Bay's insidious shallows and shoals' to set about them with 'pikes and pitchforks' (*Kerry Slides* (hereinafter *KS* in citations) 7). Slippages in perception inform the collection: the wreckers, here,

> tied a lantern or hurricane-light
> to some wild-eyed pony's mane or tail
> that it might flash and flare and flick and flail
>
> like a lantern tied to a storm-tossed mast. (7)

This unpredictable encounter in which pony blurs into ship, ship into pony, mimics the perceptive problems in reading/viewing photopoetry in which illustration is no longer a central organizing principle. The ship's captain's 'floundering' is doubled in the reader through the ambivalent 'mane or tail': the pony is all front and all back at the same time, in two places at once, an echo of '"Lefty" Clery' in Muldoon's 'Twice',

> grinning from both ends of the school photograph,
> having jooked behind the three-deep rest of us to meet the Kodak's
> leisurely pan; 'Two places at once, was it, or one place twice?'[37]

This optical sleight of hand explains why the opening poem is photographically unaccompanied: Muldoon portrays Kerry as threatening and hostile, an impression Doyle's photographs undercut. Muldoon invites the reader to look beneath the surfaces of the photographs, skewing and destabilizing expectations of Kerry – in photopoetic tradition – as a kind of home. Home in Muldoon's poetry, Clair Wills suggests, 'is a site of trauma and violence ... connected with Muldoon's sense of the disturbing, even shocking histories which lie concealed just below the surface of everyday life'.[38] This threatening landscape is distant from the picturesque aesthetics of nineteenth-century photopoetry,

and even the post-pastoral elements of George Mackay Brown's Orkney and Ted Hughes's Calder Valley. Doyle's photographs of architecture, then, act as the 'surface of everyday life', sites to be ransacked for their concealed histories, and our passage through these structures acts as a central metaphor for how we read and view *Kerry Slides*. This emphasizes the titular pun: as well as evoking musical embellishments and photographic transparencies, 'slides' acts as a verb, describing how the reader moves between poem and photograph, from one pairing to the next.

Sleights of hand also occur in Doyle's photographs. Accompanying the collection's second sonnet, Doyle's image shows a cat clambering over a reclining Muldoon, who looks through a window onto hazy grassland (Figure 5.5). Muldoon's lounging figure mirrors the undulations of the landscape and, although it becomes apparent that a window separates him from the outside world, the intimation of how poet becomes part of his chosen landscape is unavoidable. The window focuses attention on both the photographic frame and the liminal space between poet and subject. Two kinds of ambiguous absorption occur in this photograph: Muldoon's with the outside world, and the cat's attention to Muldoon's hands. 'In absorptive pictures,' writes Jeff Wall, 'we are looking at figures who appear not to be "acting out" their world, only "being in" it.'[39] Landscape absorbs Muldoon and, as a result, Muldoon is absorbed into it in Doyle's photograph. Muldoon, oblivious to his surroundings, becomes them. Doyle's photograph posits Muldoon, comically, as part of the landscape: the cat explores the contoured space of the poet. Muldoon's absorption is clearly a state of 'implied temporal protractedness', in Fried's term, mirroring another requirement of absorption: 'The spectatorial project of close and detailed looking.'[40] This is not absorption in practical activity, in the manner of Wall's photographs (for example *Untangling* (1994), or *Morning Cleaning* (1999)) but in looking. Muldoon spectates, just as the photographer and the reader/viewer spectate. The poem's transportations of time, animal ('Sika deer', 'Natterjack toad', 'the gadwall, the Greater Spotted slug'), and place (from 'Japanese secateur' to 'Minard Castle' on the Dingle Peninsula) contrast with the sedate photographic scene. Poetry, photography, and nature are connected in the idea of using 'a Japanese secateur / to nibble one wallflower' (15), recalling Heaney's 'snip[ping]' of lyric leaves from narrative boughs'. Muldoon's image, though, differs from nesting: the suggestion, instead, that the poet simply 'nibble[s]' from the profusion of the natural world parallels the idea that photographs are fragments of a wider reality. In both cases, it is the reader whose affective

Figure 5.5 Bill Doyle, 'Surely That Can't Be a High-Pitched Whistle', in *Kerry Slides*, 1996. Reproduced with the permission of The Gallery Press. Courtesy of the University of St Andrews Library, photo 6063.U367K4.

response, their own absorption, makes sense of the oblique dialogues between poem and photograph.

Muldoon's poems engage with the tension between the self-consciousness of their formal constructions and the destructions and desecrations of their subject matter. The recurrent use of buildings in Doyle's photographs presents the reader with a visual site around which the spaces of the poem are delineated: a site, that is, for memory. Muldoon's sonnet 'An ogham stone' (later republished as 'The Fridge' in *Hay*) unites past and present through an architectural simile, beginning,

> An ogham stone stands four-square as the fridge
> I open yet again to forage
> for a bottle of Smithwick's or Bass. (51)

Through ogham, an alphabet used for Primitive Irish and often inscribed vertically on stone monuments, Muldoon satirizes modernity's magnetic fridges as inscriptive sites for shopping lists, photographs, and other miscellanea. The opening of the fridge door is metaphorically echoed in Doyle's photograph

with the open doorway of the Gallarus Oratory, an early Christian church on the Dingle Peninsula, which recalls the shape of an upturned boat and, in this context, the shipwreck of the opening poem (Figure 5.6). In Irish, the name of the oratory is Séipélín Ghallarais, which Peter Harbison glosses as meaning 'something like "The House or Shelter for Foreigner(s)"', potentially defined as 'those pilgrims who had come from outside the Peninsula'.[41] Although Doyle's photographs are often stock, romanticized images, the choice of the oratory may highlight Muldoon's 'foreign' status as a northerner writing about the south. Therefore, we might consider *Kerry Slides* a place of exile rather than home. Such a construction foreshadows Muldoon's argument in his Clarendon Lectures that, in John Kerrigan's summary, 'the Irish are in exile in Ireland itself ... because of a history of expropriation and insecurity'.[42] Ideas of liminal and undelineated spaces are central to Muldoon's poetry, and the idea of routes opposed to roots is an important tension in *Kerry Slides*.

Figure 5.6 Bill Doyle, 'An Ogham Stone Stands Four-Square as the Fridge', in *Kerry Slides*, 1996. Reproduced with the permission of The Gallery Press. Courtesy of the University of St Andrews Library, photo 6063.U367K4.

The ogham stone is not visible in Doyle's photograph but exists to the left of the oratory as one faces its doorway: its 'four-square' shape, however, is alluded to in the shape of the oratory's doorway and in the sonnet's rhyme scheme: AABCDEF BCDEFGG consists of two shorter edges (the half-rhymed opening, and regular concluding, couplets) and two longer (the BCDEF scheme, which repeats across the sonnet's two halves). Ogham's verticality prompts the reader to consider the right-hand margin of the poem, the vertical structure of rhyme mirroring the stone's 'notches and nicks'. The majority of the rhymes occur through the substitution or addition of a single letter, and rhyme is seen as a kind of liminal space, reflecting the slippage in meaning between 'Beárrthóir' and 'bearradóir', just as minor alterations in 'notches and nicks' create different letters. The inscriptions consist of personal names, 'Sean O'Boyle; John McCarter; Jerry Hicks', Muldoon's teachers of English and Irish at St Patrick's College, Armagh: ogham stones typically memorialize people through naming them. The photopoem blends and blurs three distinct spaces – oratory, ogham stone, fridge – while drawing a connection between poem and photograph as sites for memorialization. That these memories are inscribed in stone is as significant as the fact that all three aforementioned spaces are objects opposed to geographical locations. *Kerry Slides* begins to enact the movement of photopoetry from landscape to object as the central site for affective responses.

The object of photopoetry

McBeath and Muldoon had been exploring collaborative possibilities as early as 2002. Writing to Muldoon after a meeting during that year's Edinburgh International Book Festival, McBeath refers to a ' "tangential" link' between poem and photograph that had characterized their conversation.[43] In attempting to identify this connection, McBeath notes four potential categories of photograph for the collaboration – landscape, reportage, portrait, artefact – before settling on reportage, which, he writes, 'encompasses behaviour, attitude, wit, comment, insight and even text'.[44] Muldoon, though not especially keen on 'Tangents' as a title, was enthusiastic about the project and thought the book should be led by the photographs.[45] By the following April, McBeath had drawn up a proposal for 'Tangents' and submitted it, along with a cache of forty photographs, to Aperture for consideration.

When *Tangents* was rejected in October 2003, the project was shelved until a serendipitous encounter four years later. Meeting again at the Edinburgh International Book Festival, McBeath and Muldoon realized that reportage, far from 'provid[ing] a link between us whilst preserving this need for the oblique', actually left no room for poetic evocation.[46] As they parted, McBeath gave Muldoon a photogravure: a statue of Apollo wrapped in polythene, an image that would become central to their subsequent collaboration, and a style of photograph that left enough space for Muldoon to provide poetic evocation and story. Under the working title 'Schottische', McBeath sent Muldoon three caches of photographs between August 2007 and February 2008, with a final cache sent shortly afterwards. It was this final cache that contained the photographs that would make it into the book, retitled *Plan B* in May 2008. That none of the 'Schottische' photographs were included in *Plan B*, let alone any of those from the original 'Tangents' set in 2003, demonstrates the extent to which the project had developed from its reportage origins.

The most notable aspect in the development of the project is that, while one subject or theme might work for one collaboration, it will not necessarily work for another. Reportage, while unsuitable for Muldoon and McBeath, was the focus of John Fuller and David Hurn's *Writing the Picture* (2010) in which the 'third creative personality', in a manner of speaking, fashions the connective strands between poem and photograph. The majority of Hurn's reportage photographs focus on rural Wales, and Fuller wrote poems in response to the images. While this echoes how Muldoon responded to McBeath's images, it is not uncommon for a photographer to respond to a poem, despite Hurn and Fuller's protestations that such an undertaking is 'absurd'.[47] In 1990 McBeath received his first photopoetry commission from the university magazine *Oxford Today* to respond to the new Seamus Heaney poem 'Markings'.[48] It proved an important moment, clarifying for McBeath the idea of 'response' and the need for evocation over illustration. 'It took me ages!' McBeath remarks, 'And in the end I came up with something really tangential, really off, just some light coming through a door.... It wouldn't be close, it wouldn't be a direct meaning at all, it would be a response.'[49] McBeath's photograph does not illustrate a particular image in the poem; rather, it plays with the title, depicting the ephemeral mark of light on the wooden floor which in turn responds to the multiple meanings of 'marking' in Heaney's poem, from the lines of a football pitch or garden to how we record, or mark, the past. The idea of 'response' also structured McBeath's interpretation of 'The Beach' by Kathleen Jamie, produced as a limited-edition

portfolio for an exhibition called 'The Written Image' by Edinburgh Printmakers and the Scottish Poetry Library.[50] McBeath honed in on the line 'hoping for the marvellous', suggesting that that was what both poet and photographer do.[51] On why he wanted to work with poets, McBeath explains, 'I thought there was a real and … quite interesting and comforting fact that the poets were looking at things I was looking at with my camera, often quite insignificant things.'[52] This almost conspiratorial sense of detail, of noticing the insignificant, again reinforces McBeath's idea that the photopoetic collaboration 'has to be tangential, evocative, different'. The key to this, McBeath notes, is 'engaging the viewer's imagination, and for that you need a bit of difficulty or mystery', the result of paying extraordinary attention to seemingly ordinary things.[53]

Like *Kerry Slides, Plan B* is not a sequence, though it contains several small lyric sequences that draw greater attention to the tactile quality, the 'thingness', of both poems and photographs. McBeath, Muldoon writes, 'has that rare ability to allow nothing, least of all himself, to come between the subject of a photograph and the perceiver…. There is, rather, an invitation to *meditate*. The very idea of a "subject" soon begins to seem crudely inappropriate.'[54] The idea of a unified lyric speaker in a Muldoon poem, too, seems crudely inappropriate. The lyric sequence since the early twentieth century has tended towards 'a new formal and ideological disposition … artifactuality', notes Roland Greene, 'an acknowledgement that the work does not tell of experience lived or seen, but is a thing made', and is composed of 'several independently realized voices'.[55] In Muldoon's photopoetry (or 'photoetry', as he terms it), there is an additional layer of construction on top of the poems' own self-consciousness: how to reconcile the indirect and evocative connections between poem and photograph.[56] Used on the book's dustcover, the term 'collaboration', Andrea Tauvry notes, is equivocal, meaning both 'united labour, co-operation; *esp.* in literary, artistic, or scientific work', as well as 'traitorous cooperation with the enemy'.[57] Tauvry argues that a photopoetics of resistance structures *Plan B*, alongside the 'nature of … exchange' belonging to any photo-textual work.[58] Such 'exchange' is typically found in early illustrative photopoetry, and the nature of exchange between poem and photograph recalls the materiality of each, how poems (commonly sonnets) were exchanged, just as photographs are exchanged as postcards, snapshots, and, today, as immaterial, digital images.

It is therefore important to explore the development, in *Plan B*, of the contradictions and suspensions in Muldoon's lyric voice in relation to the 'trauma and violence' first witnessed in *Kerry Slides*. *Plan B* centres on what

Adam Newey calls 'the theme of life's cock-ups, contingencies and conspiracies', and the relationship between poem and photograph develops what Wills calls Muldoon's interest 'in how poetic language can articulate the imagination's capacity to encompass contradiction, to hold alternative possibilities in suspension'.[59] In 'Plan B', the collection's opening sequence, various narratives proceed through obliquity and misdirection in Muldoon's colloquial off-rhymed couplets and their seemingly tangential connections to McBeath's photographs. 'Plan B' combines five photographs with seven verse sections: the photopoem is not a sequence of pairings in the traditional sense, and is spread across pages so that each photograph faces lines from two verse sections at once (aside from the final photograph, of the old piano, paired solely with the seventh section). This arrangement alludes to the traditional practice of photographic illustration, in which discrete pairings of poem and photograph bore direct descriptive relation to one another. 'Plan B', however, calls repeated attention to the metaphorical imputation of the photographs across the entire poetic sequence, causing the reader to flick back and forth across the photopoem. This framework, McBeath notes, 'makes you work a little harder to think how they are and why they are paired like that.... . It's not that easy, and you're suddenly thinking, "Oh, is that right? What does that go with? Why have they done that?" and it's not a neat link.'[60] In adopting an approach to photopoetry in which fluid pairings discourage the reader from complacently reading the poem and viewing the photograph as 'neat', discrete entities, McBeath and Muldoon create a non-linear architectural space in which the reader lingers and circles. This represents an important break in photopoetic history. The structure of discrete pairings characterizes the majority of photopoetry from its mid-nineteenth-century origins to contemporary collaborations. As we have seen, however, some collaborations have rejected this structure, seeking instead a tone or atmosphere across the entire photobook: Rudy Burckhardt and Edwin Denby's *New York, N. Why?* (1938), for example, or Fay Godwin and Ted Hughes's *Elmet* (1994). It is possible to connect this structural innovation with the sense that the photopoem alludes to architecture in a manner similar to Susan Sontag's link between architecture and photography. 'Photographs', Sontag writes,

> when they get scrofulous, tarnished, stained, cracked, faded still look good; do often look better.... . The art that photography does resemble is architecture, whose works are subject to the same inexorable promotion through the passage of time; many buildings, and not only the Parthenon, probably look better as ruins.[61]

The poem, as an entity discrete from the photograph, crumbles and, in doing so, scatters its remnants further from its centre, and the 'ruins' encompass more photographs. Imagining the poem as a material object is a useful analogy when we think both of the photobook as an object and the tactile origins of photopoetry in scrapbooking and commonplacing. The significance is pertinent in relation to the materiality of the photographic image (and Sontag's architectural analogue) to which McBeath alludes through the inclusion of several dilapidated architectural structures in *Plan B*. The collection begins with an image of a threshold overrun by the natural world, a possible allusion to the orchard doorway beginning *Sweeney's Flight*. Similarly, McBeath reverses and reinterprets Giese's change in focus: he includes an image of an old piano abandoned in a field as the final photograph of 'Plan B', and a detail of the same piano from a different perspective as the penultimate photograph of the collection. Paired with the different perspectives in *Plan B*, McBeath's focusing, opposed to Giese's panning – moving from threshold to object – highlights the overall *punctual* direction of early twenty-first-century photopoetry.

The speaker's supposed complicity in the violent histories of 'Plan B' is apparent in the manner in which slippages in language evoke rather than describe theme. For example,

> On my head be it if, after the years of elocution and pianoforte,
> the idea that I may have veered
>
> away from the straight
> and narrow of Brooklyn or Baltimore for a Baltic State
>
> is one at which, all things being equal, I would demur.
>
> (*Plan B* (hereinafter *PB* in citations) 9)

But all things are not equal. The accumulation of clauses diverts the reader from the insinuation that only the speaker himself has raised 'the idea', the sentence beginning with the implications of his own suggestion and ending with his demurral. 'Elocution' echoes through the poem as electrocution: though the word itself is not used – the closest we manage is the euphemistic 'zapped' (15) – the image recurs through the electrocution of Topsy the elephant and the anonymous 'bloody prisoner' (15). The slippage links the speaker's narrative with the silenced voices of the other tales, which are refashioned into this composite, 'artifactual' form. Likewise, the archaic 'pianoforte' alludes to the abandoned piano in the final photograph: in using the word, Muldoon

renews it, just as McBeath remakes that particular piano as a photographic object, with a new material existence. Similarly, Muldoon's image of 'the KGB garrotte' as a 'refinement of the Scythian torc' (13) is placed next to the McBeath photograph titled *Rope* (Figure 5.7). As Tauvry notes, 'the end-rhyme "ope" in section four visually echoes the unnamed "rope" and, finally, one of the meanings of the last verb in section five "to belay" is "to coil a running rope" '.[62] 'Plan B' is problematically ekphrastic: poem links thematically to photograph but, as Tauvry continues, the 'interaction is more oblique as the poet develops a whole narrative based on the theme of the rope without ever mentioning the term directly'.[63] The oblique photopoetic attention to objects throughout the sequence highlights McBeath's idea of photographs as 'traces', with objects possessing meanings and histories outwith the image. Photopoems create material histories and Muldoon emphasizes this in his patterns of repetition: both object and colloquialisms link the sections of 'Plan B'. The phrase ending one section begins the next: 'To have fetched up here' closes one and begins two; 'A pitchfork' closes two and opens three; the verb 'gather' closes three and begins four, a verb which conjures the curatorial processes of both poet and photographer as well as reader/viewer, whose affective response gathers poem and photograph into photopoem.

An important feature of McBeath's photopoetry is the focus on objects rather than places. McBeath notes that his *Plan B* photographs present 'found objects in found places' and, with the exception of the nautilus shell, 'there has been absolutely no intervention at all; they've all relied on happenstance'.[64] McBeath collaborated with Scottish poet Robert Crawford on *Simonides* (2011), a collection of the titular Greek poet's fragments translated into Scots and accompanied by English glosses and photographic prints. Both McBeath and Crawford attach importance to the 'oblique' relationship between poem and photograph, Crawford highlighting the potentially 'alienating' quality of the Scots, 'both … foreign and familiar', which requires the 'listener or reader … to *reach* a bit'.[65] In McBeath's photographs, this reach is achieved through a sense of human presence, even though his photographs do not contain people. 'I've always been interested in human behaviour, in people,' McBeath remarks,

> but particularly in the *traces* of what they've done – the evidence that's been left afterwards. It seems to me far more mysterious, and again there are so many more possibilities that surround that. You have to speculate. You have to make some suppositions and judgments, and work out rather more.[66]

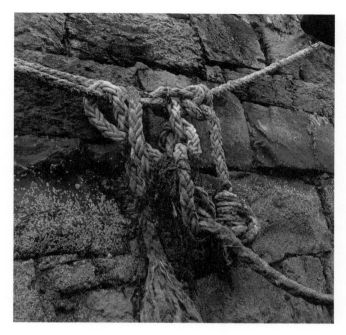

Figure 5.7 Norman McBeath, 'Rope', in *Plan B*, 2009. Reproduced with the permission of Enitharmon Press. Courtesy of Norman McBeath.

By focusing more on human traces rather than human figures, McBeath moves photopoetry in a different direction from Ted Hughes's desire to evoke the theatrical quality of people in Fay Godwin's photographs, discussed in the previous chapter. For McBeath, the photopoetic stage is devoid of human figures, and contains, in the case of *Simonides*, broken and discarded objects. These are, in a sense, 'theatrical' scenes, suggestive of something having happened, or about to happen: a kind of mystery that taxes the viewer's imagination.[67]

In Crawford and McBeath's collaboration *Light Box* (2015), the idea of photopoetic staging takes on a new formal dimension. The form of the project – an artist's box – means the poems and photographs can effectively be reordered, allowing the reader to create their own serendipitous links between new pairings. 'It's a secret little thing that you can share,' McBeath notes, 'that you can look at: a bit more than a book really, the size is larger, so there's more of a presence to both the poems and the photographs. They are more things in their own right.'[68] Here the role of the reader/viewer in staging the photopoetic relationship is much more pronounced than it is in the photobook, as the tactile

element of reading is often forgotten. With poems and photographs printed on separate leaves (39.2 x 38 cm), the reader must physically hold each one, exploring the box in either a linear fashion or spreading out the leaves to make new combinations. That McBeath describes both poems and photographs as 'things' is highly significant to the increasing thematic concern with objects in contemporary photopoetry, and this formal conception of photopoetry as itself an object or thing reinforces the formal as well as thematic symbiosis in the photopoetic relationship. Similarly, the touch of the reader on each leaf returns photopoetry to its haptic origins in scrapbooking and commonplacing. As McBeath notes, 'When you move them across the box you get this shift in juxtaposition which I think is quite a nice dynamic to have in there. It's a set but there's some movement.'[69]

This haptic 'movement' is translated into a structural equivalent when the formal overlaps between poem and photograph are considered. Crawford notes in the introduction to *Light Box* that 'the Japanese haiku form ... has a shaped brevity that comes closest to the shutter's click'.[70] McBeath, familiar also with the variety of poetic forms Muldoon employs in photopoetry (including the sonnet and couplet), considers the 'short form, and ... the tight rhythm' of haiku a good metaphor for the instantaneity of the photographic process. 'In a lot of other poems,' McBeath notes, 'there's a sculptural form to it, which maybe matches the pictures in some senses ... the bulk of it, the size of it, there's more of a balance.'[71] These two ideas of movement combine when we consider some of the project's haikus and photographs in relation to one another. The box-set format of *Light Box* allows the reader/viewer to create different permutations of poem and photograph, which emphasizes the non-linear aspect of *Light Box* as a tactile object. Images such as the circle engage the reader's imagination and encourage the development of connective strands between both discrete and non-discrete pairings. The first pairing, 'Aton', connects a photograph of the circular lens of a Zeiss-Ikon Compur camera (Figure 5.8) with a haiku celebrating the Egyptian sun God, Aton:

> Eternal start-up,
> Organic light-emitter,
> Hallowed be thy name.[72]

Sun and lens share visual circularity and the importance of a name, with Crawford's 'hallowed' suggesting an oral dedication or sanctification intoned through repetition of 'Aton'. McBeath's inclusion of the camera's name within

Figure 5.8 Norman McBeath, 'Aton', in *Light Box*, 2015. © Norman McBeath.

his image demonstrates a modern kind of worship, especially in marketing, of brands and labels. Then, re-pairing the poems and photographs, the 'Eternal start-up' of the circle – no beginning, no end – also provides the project, in linear form, with consistency: *Light Box* begins with the sun and ends with the 'clear, round clockface' of the moon that 'will last forever' ('Lux Aeterna'). The photograph paired with this poem, however, does not show a full moon; rather, the moon is partially obscured behind the silhouette of a tree. The hazy quality of the sky in this image returns the reader to a similar haziness captured in the photograph of McBeath's Zeiss-Ikon lens, where photographic apparatus becomes photographic subject.

Beyond the thematic and metaphorical links within *Light Box*, however, the circle seems an appropriate image given Crawford's suggestion of the haiku's 'shaped brevity'. The circle, perhaps, achieves what Barthes called the '*intense immobility*' of the haiku, just as the photograph is, in a sense, the capturing or embalming of the past: it is without beginning and without end.[73] But what, in particular, makes the haiku the most appropriate poetic form to reflect the instantaneous quality of photography? Comparing the *Light Box* poems to those

in *Simonides* elucidates Crawford's mention of the haiku's 'shaped brevity'. 'A key point about the haiku,' Crawford notes,

> is that it's a recognisably short form. But it's also very accurately shaped, and most readers are aware of that fact: this precise shaping makes it analogous to the framing of the photograph, particularly in a work where all the photographs are exactly the same size. In this way the 'rhyme' between poem and photograph is enhanced. In *Simonides* several (though not all) of the texts are fragments – torn off – and so they play off against the wholeness of the photographs, even when the photographs themselves depict broken or abandoned objects. In *Light Box* each haiku is a tiny but complete shape, so the relationship between poem and photograph is subtly different.[74]

Crawford is careful to relate the link between photography and the haiku to photopoetry in an exhibition context. Echoing Hughes's thoughts on how the fixed photographic image often overrides the multitudinous, simultaneous visual images embedded in the poem, Crawford suggests that often in exhibitions 'people register the photograph immediately but don't bother reading all of the poem beside it (the impulse to progress through the exhibition is too strong)'.[75] There is too vast a history of photopoetry exhibitions to be explored within this book, though it should be noted that an exhibition format embodies many of the issues of framing, staging, and movement I have discussed, providing a physical space through which the reader/viewer can explore the poems and photographs.[76] Crawford's discussion of the haiku is an important moment in the theorizing of the photopoetic relationship, though it should be stressed that the formal analogy relates only to the instantaneity of photography, not its essential condition: that is, a combination of its formal, tonal, thematic, cultural, material facets that have led to innumerable histories of photography that support, contradict, appropriate, and develop each other.

With this in mind, Crawford and McBeath are not alone in pairing short poems with images. W. G. Sebald (1944–2001) and Jan Peter Tripp (1945–) collaborated on *Unrecounted* (2004), with Sebald's haiku-like poems juxtaposed with Tripp's photo-realistic engravings of pairs of eyes. While *Unrecounted* is not, in the strictest sense, photopoetry, it provides a useful counterpoint to the limits of the photopoetic relationship.[77] Tripp's etchings are based on photographs, and their value, as Sebald writes, are in Tripp's careful modifications, such as the suspension of photography's 'mechanical sharpness/vagueness relationship'. At times, Sebald writes, 'those happy errors occur from which unexpectedly

the system of a representation opposed to reality can result'.[78] The traces of Tripp's hand prevent the lithographs from adopting the death-like quality of the photographic reproduction. Sebald's approach to photography derives, in many ways, from Barthes's *Camera Lucida*, and he sees, as Barthes saw, 'an agent of death' in the camera and, in the photograph, 'something like the residue of a life perpetually perishing'.[79] To Sebald, 'the photographic image turns reality into a tautology', and Tripp's moments of slippage distance his art from such a formulation.[80] Sebald's short texts, then, act in a way that opposes Crawford's formulation: they draw attention to the laboriousness of Tripp's etchings, rather than the instantaneity of photography as evoked in the haiku.

* * *

For Muldoon, however, the most important aspect of photopoetry is not the formal link to instantaneity that the haiku provides, but the closeness of the tonal nuances of the sonnet to the photographic *punctum*. In *Plan B*, 'Francois Boucher: *Arion on the Dolphin*' (*PB* 25–35), a sequence of six sonnets, each paired with a photograph, explores the sea-voyage of the lyrist Arion who, by jumping into the sea, thwarts his greedy fellow voyagers' plot to kill him. He is subsequently rescued by a dolphin while the plotters are shipwrecked. Behind the complicatedly ekphrastic poem is the titular painting (1848) (Figure 5.9) and Théodore Géricault's *The Raft of the Medusa* (1819), as well as historical analogues including the sinking of submarine PT-109, commanded by John F. Kennedy, in 1943. Muldoon also incorporates the historical circumstances of Boucher's *Arion*: French king Louis XV commissioned the painting in the mid-eighteenth century as one of four panels, representing the elements, to crown the doors of his hunting lodge, Château de La Muette. The contemporary French audience would have understood Arion to symbolize Louis, who, aged five, became heir apparent to the French throne, or 'dauphin', which also means dolphin.

Plan B represents a difficult ekphrastic relationship between poem and photograph. Andrew Miller explains that, while photographic ekphrasis typically 'involves itself in a narrative', anti-ekphrasis unravels the text-image bond between poem and photograph, with the poem denying a relationship with its ekphrastic source.[81] Tauvry highlights one instance of this resistance in *Plan B*, centring on the Apollo photograph that kindled the entire collaboration. The moment becomes even more significant when we recognize the importance of this photograph:

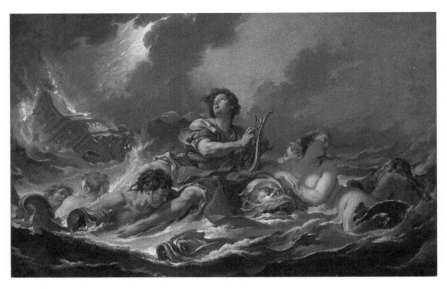

Figure 5.9 François Boucher, 'Arion on the Dolphin', 1748. Princeton University Art Museum. Public domain image.

had I not suddenly been forced to brake
for Apollo wrapped in polythene,
I might have been emboldened

and gone with the flow. (37, 39)

It is the sole time that Muldoon directly acknowledges one of the photographs, Tauvry notes, and she is right to suggest how 'the fact that the photograph of Apollo only appears on the following double page emphasises the fact that *Plan B* is not a traditional textual-visual diptych and that links between poems and photographs should not be taken for granted'.[82] Even more significant, perhaps, is the manner in which the photograph breaks the lines across the pages: the line 'I might have been emboldened' enjambs across the photograph and into the next double-page spread, to find its semi-resolution in 'and gone with the flow'. Tauvry appears to attribute more decisiveness to these lines than Muldoon necessarily implies. The passage is mired in the conditional tense, with the speaker beginning sentences and clauses with 'Had I' and 'had I not', before the 'I might have' that Tauvry seems to take for Muldoon's definite rejection of ekphrastic poetry. In this light, the following lines – 'Even a road resists being led to water / like a lamb to the slaughter' (38) – seem like a wry reflection than a declaration of intent.

As it is, Muldoon and McBeath engage with ekphrastic poetry in order to suggest a more symbiotic possibility for the relationship between poems and photographs. As Tauvry has shown, exchange and resistance are vital to this project, and Miller explains how, in the rivalry between text and image, 'just as these poems strive to bond with the photographs they describe, they also express a resistance to these images'.[83] Discussing Thom and Ander Gunn's *Positives* (1966), Miller posits this relationship as an 'unraveling' despite the fact, he writes, that 'were the text and image separated, one would sense a disintegration of their greater combined significance'.[84] This apparent contradiction becomes clearer in the work of McBeath and Muldoon. The ekphrastic focus of the poem 'Arion' is Boucher's painting 'Arion on the Dolphin' (1848), though it would be a great stretch to suggest that Muldoon's poems – or McBeath's photographs – have a typically ekphrastic relationship with the painting. Muldoon's poems do not, as James Heffernan writes of ekphrastic poems, 'typically deliver[] from the pregnant moment of visual art its embryonically narrative impulse', nor 'make[] explicit the story that visual art tells only by implication'.[85] Instead, the encounter between Muldoon's poems and McBeath's photographs creates oblique, metaphorical composites that the reader has to negotiate, combine, unpick, and recalibrate. The reader is drawn into this encounter because the painting itself is not reproduced alongside the poems and photographs: its name is used as the title of the photopoem to anticipate the reader's affective response. Miller suggests that 'photographs seem to inspire encounters between their viewers and their subjects', differing from Heffernan's idea of narrative because 'the sort of pregnant moment one finds in a photograph … seems to inspire a different sort of imitation'.[86] Miller's idea of 'encounter' presumably follows that of David Kennedy, who argues for ekphrastic encounters within British poetry. Kennedy's argument derives from the proposition that 'the idea of representation as a choice that produces a relationship between two things that, in effect, changes both', and Miller extends this to involve the reader in this encounter.[87] When we consider *Plan B* in the currents of photopoetic history, we can see that McBeath and Muldoon turn the early photopoetic paradigm of poet-as-guide upside down: Muldoon guides the reader around a painting they cannot see, accompanied only by McBeath's elliptical, oblique photographs. A mythological painting has replaced the Lake District, Highlands, and villages of mid-nineteenth-century Britain: a painting whose mythological subject has no indexical reality beyond the object of the painting. It is a story, a myth. It is almost as if the links between poem and photograph are not meant to be teased

out, are meant to remain oblique, to encourage endless circlings and recirclings and the ultimate realization that, unlike the journeys of early photopoetry, we are not actually being taken anywhere at all. Twenty-first-century photopoetry, then, is concerned with the *punctual* moment: the encounter, not the journey.

In 'Plan B', the mishearing of 'Cork' for 'New York' anticipates Muldoon's pun on misspelling in 'Arion', on which the poem hinges:

> this sudden displacement of teak
> suggesting the outlook's bleak
> for both dolphin and *Dauphin*, spelling trouble
> for another figurehead . . . (29)

The comical image of the sinking ship as 'this sudden displacement of teak' indicates Muldoon's colloquial method and glances towards the arrangement of poems and photographs: image displacing image, allusion displacing allusion. Muldoon's sonnets accentuate their 'made' quality as architectural objects. Similarly, as Wills writes of Gallogly, hero of Muldoon's 'The More a Man Has the More a Man Wants', 'His ability to mutate parallels the poem's own creative impulse – the aesthetic transformations enacted by poetic language, or the metamorphosis of the traditional meditative sonnet form into a supple tool of narrative verse.'[88] It would be generous to call 'Arion' a narrative poem yet its narrative fragments (none of which are satisfactorily concluded) act as vehicles for Muldoon's flitting across the visual space of Boucher's painting. Muldoon's run-on lines enact the movement of the eye across the painting; his shorter lines the sharper focus on particulars, such as 'a bloodied Triton still grasping his horn' (25). Jarringly, Muldoon's images bear little visual relation to the facing photograph. Such discursive, tangential relationships are achieved partially through recourse to other art forms as performative models, and Muldoon's poem hinges somewhere between eighteenth-century theatre and a glam-rock concert. The nonchalance of 'this eye-linered and lip-glossed Arion fouters / with his lyre's five strings' (25) reflects Muldoon's melding of seemingly remote forms of theatrical performance, the happenstance of McBeath's found objects, and their self-consciously artful pairings: the elaborations of eye-liner and lip-gloss that constitute the collection's collaborative element, the preparation before the performance. Artifice and the multisensory aspect of both theatre and concert are reflected in the poem's synaesthetic flourishes, such as the 'sky's pinks and pewters / resound' (25). The line break acts as the moment of sensory disjuncture, constituting, in microcosm, the poem's inherent performative absorption.

'Arion' repeats the sequencing principle of 'Plan B', beginning each sonnet with the image immediately closing the last and alluding to the photographs in poems not immediately facing them, thus creating a similar, circular structure. The 'distant grassy knoll' (29) concluding the third sonnet circles back to the photograph accompanying the first: it might, in this sense, be considered 'distant'. These images, like the recurrent motifs in a play, highlight Muldoon's incorporation of performative, theatrical models to replace the earlier photopoetic structure of the journey. McBeath's photographs act as a series of Chekhov's guns within this performative space: to call them objects suggests a stasis belying their active roles. Through the absorption of the photopoem in its own theatricality, the reader is drawn to interpret its features in theatrical terms, and McBeath's images are crucial to either the content or creation of the photopoem. The performative space of the theatre encourages us to look at the photopoem as architectural: such a construction echoes the Simonidean mind palace – not only its *performance*, but also its spatial structure. Yet, while oratory elements are recalled, recited, and traversed in a linear fashion, Muldoon's photopoetry is more interactive, positing plentiful combinations and permutations. Performing the photopoem, objects become more than theatrical props: rather, they become its structural fabric.

This is very much the case in *Simonides*, where photopoetic symbiosis is inextricable from ideas of materiality. McBeath insisted that the 'thin strand of metaphorical connection ... be as thin as possible, to give the viewer a chance to get their imagination going'.[89] McBeath connects this 'meditative' aspect of *Simonides* to the formal balance of white space and the sparseness of the texts. 'There is a calmness', McBeath notes, 'there's a generosity of space – there's not a lot happening. It's designed to promote an ability to contemplate, to reflect, and that too has a resonance of the whole idea behind it.'[90] The emphasis on materiality adds a further dimension both to objects within the poems and photographs, and to the poems and photographs themselves: that is, their materiality. This recalls Sontag on the resemblance of photography to architecture, how the materiality of each is emphasized over time. Of the frames around his photographs McBeath notes:

In a way they testify that this is a full-frame print.... And when you print it, as the light is shone through the negative ... if you're not going to crop it you get these marks, which are little bits of light shining through. So each one has a unique thumbprint, as it were – these marks around the edges will be different,

because when they are put into the carrier it's a slightly different position each time. And so it's a mark of authenticity, and it makes them also rather different from just square, cropped, neat pictures that are far more familiar.[91]

McBeath adopted the same strategy for *Plan B*, accentuating the materiality of the photograph. Such emphasis returns photopoetry to its roots in scrapbooking, commonplacing, and the tipped-in photographs of early anthologies. In the theatrical context of McBeath's photopoetry, objects within the photographs are made active and 'resound in the brain-pan' (25), as Muldoon writes in 'Arion'. Objects populate this created, performative space in the absence of human figures. Their meaning resides in their *use in* the photopoem. *Simonides* concludes with as sparse a photopoem as is possible, pairing the Scots 'dunter' (dolphin) with an image of an inflatable shark (Figure 5.10).[92] 'Dunter' was quickly established as the sequence-ending photopoem, a moment of levity following fragments on death and the fallen. 'In a sense it ends,' Crawford notes, 'by being eroded away to almost nothing, but significantly *not* nothing – something with life in it.'[93] The sparseness of the poem highlights the materiality of the inflatable, plastic beach toy. Simonides's poems, Crawford suggests, are 'often no longer than captions [and] these fragments' very brevity gives them an eerie contemporaneity in our era saturated with its own shortened text messages.'[94] But the poem, for all its brevity, is not illustrative. The 'dunter' is neither an actual, flesh-and-blood dolphin, nor a toy dolphin: its visual, shark-like qualities undercut the illustrative, indexical relationships between poem and photograph from which photopoetry originated.

The dolphin is important to Muldoon and McBeath's 'Arion', and 'Dunter' further illumes the importance of objects and their uses in photopoetry, the borderlines of absorption and theatricality. 'Arion' is a highly theatrical photopoem, yet the centrality of objects to its overarching structure highlights its absorptive qualities. McBeath's framing techniques allude, in 'Arion', to the materiality of painting: viewing the actual painting in a gallery or museum space rather than immaterially, reproduced on the internet or in a book. This locates absorption in a physical, architectural space, in a way that the reproduced image in a book or on the internet cannot. McBeath attempts to alter that, seeking to overcome the reproductive obstacle both through the uniqueness of framing for each image and, most importantly, through his concern with the materiality of *making* art. The fourth photograph of 'Arion' depicts paint tubes piled haphazardly on a paint-splattered bench (Figure 5.11). Visual attention is drawn

Figure 5.10 Norman McBeath, 'Dunter (XXV)', in *Simonides*, 2011. © Norman McBeath.

to the one smooth tube among the crinkly, used heap, accentuating the tactility of the photograph: or, as Fried describes Wall's photograph *Staining Bench, Furniture Manufacturer's, Vancouver* (2003), 'densely layered with material traces of practical activity'.[95] These traces amount to the practical activity of photopoetic collaboration, encountered through the materials and tactility of painting as a manner of evoking Boucher's canvas in its visual absence. Although McBeath's photograph is tactile, its monochromatic character detracts from its immediacy (the paint tubes are ready-to-hand but also distant): captured, Tauvry mentions, in the verb 'infiltrate' in the second section, 'the possibility of . . . colour' both in the photograph and, ultimately, in the painting to which the (richly colourful) poems refer.[96] McBeath's adoption of a viewpoint that accentuates his photographic activity emphasizes this distance, and confirms, as Fried writes of Wall's *Diagonal Composition no. 3* (2000), 'a certain phenomenological (and ontological?) distance from the ordinary use of the objects depicted'.[97] Objects in these photopoems are not used ordinarily: they are staged, visually relocated to provoke affective responses from reader. The subject of 'Arion' is not the

painting itself but its composition, and the composition of the collaborative photopoem: it is in the absorptive mode, self-referentially enacting absorption rather than illustrating it.

Such objects – 'Dunter' in *Simonides*, 'Arion' in *Plan B* – emphasize the photopoem as monument, referring back to ideas of memorialization in Simonides's architectural model of address. The final photograph of 'Arion' locates the reader in an overgrown graveyard, looking askew at an elaborate tombstone modelled, it seems, on an anchor, thus ironically uniting the various shipwrecks and capsizals to which the poem alludes. The photopoem concludes with a physical structure: the stone memorial reflects how the poem and photograph monumentalize the past while simultaneously becoming 'scrofulous, tarnished, stained, cracked, faded'. Absorbed in the creation of the photopoetic theatre, Crawford, McBeath, and Muldoon nod beyond its confines to narratives outwith the photopoems, to moments refusing total comprehension that exist only within the submerged memories of the reader/viewer.

Figure 5.11 Norman McBeath, 'Paint', in *Plan B*, 2009. Reproduced with the permission of Enitharmon Press. Courtesy of Norman McBeath.

Notes

1 Seamus Heaney, introduction to 'Sweeney Astray', in *Sweeney's Flight,* by Heaney and Rachel Giese (London: Faber, 1992), 87. All quotations from Heaney's poetry refer to this edition.

2 Shelley Hornstein, *Losing Site: Architecture, Memory and Place* (Farnham, UK; Burlington, VT: Ashgate, 2011), 4.

3 For a recent study of Barthes and affect, see Marie Shurkus, 'Camera Lucida and Affect, Beyond representation', *Photographies* 7, no. 1 (2014), 67–83.

4 Paul Muldoon, introduction to *Plan B,* by Muldoon and Norman McBeath (London: Enitharmon, 2009), 7. Unless otherwise noted, quotations from Muldoon's poetry refer to this edition.

5 In an encyclopedic history of photopoetry, the following collaborations warrant extended discussion: Jorie Graham and Jeannette Montgomery Barron, *Photographs and Poems* (Zurich: Scalo, 1998); Valerie Gillies and Rebecca Marr, *Men and Beasts* (Edinburgh: Luath Press, 2000); Janet Sternburg, *Optic Nerve* (Los Angeles: Red Hen Press, 2005); Tamar Yoseloff and Vici MacDonald, *Formerly* (London: Hercules Editions, 2012); Eliza Griswold and Seamus Murphy, *I Am the Beggar of the World* (New York: Farrar, Straus and Giroux, 2014); and Polly Jean Harvey and Seamus Murphy, *The Hollow of the Hand* (London: Bloomsbury Circus, 2015).

6 Caroline Blyth, 'Rumours of a Massacre', *Times Literary Supplement,* 10 December 1993, 22.

7 Kathleen Jamie, preface to *The Autonomous Region: Poems & Photographs from Tibet,* by Jamie and Sean Mayne Smith (Newcastle upon Tyne: Bloodaxe, 1993), 6.

8 Dorothy McMillan, 'Here and There: The Poetry of Kathleen Jamie', *Études Écossaises* 4 (1997), 126.

9 Sean Mayne Smith, introduction to *The Autonomous Region,* 7.

10 Blyth, 'Rumours of a Massacre', 22.

11 McMillan, 'Here and There', 128, 127.

12 Smith, introduction to *The Autonomous Region,* 7.

13 Gilles Deleuze and Felix Guattari, *A Thousand Plateaus: Capitalism and Schizophrenia,* trans. Brian Massumi (London; New York: Continuum, 2004), 380.

14 Seamus Heaney, preface to *Sweeney's Flight,* by Heaney and Giese, vii.

15 Heaney, preface to *Sweeney's Flight,* viii.

16 Heaney, preface to *Sweeney's Flight,* vii.

17 J. G. O'Keeffe, *Buile Suibhne (The Frenzy of Suibhne): Being the Adventures of Suibhne Geilt, a Middle Irish Romance* (London; Dublin: Irish Texts Society, 1913).

18 For a full summary of the Sweeney story, see Philip Edwards, *Pilgrimage and Literary Tradition* (Cambridge: Cambridge University Press, 2005), 166–168.

19 Thanks to Hannah Britton for bringing this to my attention.

20 Nora Kershaw Chadwick, *The Age of the Saints in the Early Celtic Church* (London; New York; Toronto: Oxford University Press, 1961), 105.

21 Heaney, preface to *Sweeney's Flight*, viii.

22 *Oxford English Dictionary*, s. v. 'hiatus, n', accessed 17 September 2014, http://www.oed.com/view/Entry/86656?redirectedFrom=hiatus.

23 Heaney, preface to *Sweeney's Flight*, vii.

24 Gaston Bachelard, *The Poetics of Space*, trans. Maria Jolas (Boston: Beacon Press, 1994), 93.

25 Jonathan Bate, *The Song of the Earth* (London: Picador, 2000), 160.

26 Helen Groth, *Victorian Photography and Literary Nostalgia* (Oxford; New York: Oxford University Press, 2003), 43.

27 Heaney, preface to *Sweeney's Flight*, vii.

28 Bate, *Song of the Earth*, 153.

29 Chadwick, *Age of Saints*, 108.

30 Hilde Heynen, *Architecture and Modernity: A Critique* (London; Cambridge, MA: MIT Press, 1999), 17.

31 Michael Fried, *Why Photography Matters as Art as Never Before* (New Haven, CT: Yale University Press, 2008), 50.

32 Fried, *Why Photography Matters*, 50.

33 Shurkus, 'Camera Lucida and Affect', 78.

34 Shurkus, 'Camera Lucida and Affect', 79.

35 Gregory J. Seigworth, 'From Affection to Soul', in *Gilles Deleuze: Key Concepts*, ed. Charles J. Stivale (Montreal: McGill-Queens University Press, 2005), 162.

36 Jeffrey Bilbro, 'Reflective Order: Paul Muldoon's Whimsical Forms', *ANQ* 25, no. 1 (Winter 2012), 69.

37 Paul Muldoon, *Poems 1968–1998* (London: Faber, 2001), 331.

38 Clair Wills, *Reading Paul Muldoon* (Newcastle upon Tyne: Bloodaxe, 1998), 25.

39 Fried, *Why Photography Matters*, 38.

40 Fried, *Why Photography Matters*, 47.

41 Peter Harbison, *Pilgrimage in Ireland: The Monuments and the People* (Syracuse, NY: Syracuse University Press, 1995), 77.

42 John Kerrigan, 'Paul Muldoon's Transits: Muddling through after *Madoc*', in *Paul Muldoon: Critical Essays*, ed. Tim Kendall and Peter McDonald (Liverpool: Liverpool University Press, 2004), 128.

43 Norman McBeath to Paul Muldoon, 2 September 2002, Paul Muldoon papers, Stuart A. Rose Manuscript, Archives, and Rare Book Library, Emory University. Hereafter cited as Muldoon MSS.

44 McBeath to Muldoon, 2 September 2002, Muldoon MSS.

45 See Paul Muldoon to Norman McBeath, 10 April 2003, and Muldoon to McBeath, 6 December 2002, Muldoon MSS.

46 McBeath to Muldoon, 2 September 2002, Muldoon MSS.

47 John Fuller and David Hurn, introduction to *Writing the Picture* (Bridgend, UK: Seren, 2010), 10.

48 Seamus Heaney and Norman McBeath, 'A New Poem by Seamus Heaney', *Oxford Today* 3, no. 3 (1990), 21.

49 Norman McBeath, interview by the author, Edinburgh, 13 February 2015.

50 Kathleen Jamie and Norman McBeath, *The Beach* (Edinburgh: Easel Press, 2013). 'The Written Image' was held at Edinburgh Printmakers from 16 November to 21 December 2013.

51 McBeath, interview by the author.

52 McBeath, interview by the author.

53 McBeath, interview by the author.

54 Muldoon, introduction, *Plan B*, 7.

55 Roland Arthur Greene, *Post-Petrarchism: Origins and Innovations of the Western Lyric Sequence* (Princeton, NJ: Princeton University Press, 1991), 14.

56 Muldoon, introduction to *Plan B*, 7.

57 Andrea Tauvry, '"Little Grunts, the Grins and Grimaces of Recognition": Resistance and Exchange in Paul Muldoon and Norman McBeath's *Plan B*', *Revue LISA/ LISA e-journal* 12, no. 3 (2014), par. 3, http://lisa.revues.org/6026; *Oxford English Dictionary*, s. v. 'collaboration, n', accessed 14 March 2015, http://www.oed.com/view/Entry/36197?redirectedFrom=collaboration%23eid.

58 Tauvry, 'Resistance and Exchange', par. 2.

59 Adam Newey, 'Connections at the Keyboard', *Guardian*, 16 May 2009; Wills, *Reading Paul Muldoon*, 136.

60 McBeath, interview by the author.

61 Susan Sontag, *On Photography* (London: Penguin, 1979), 79.

62 Tauvry, 'Resistance and Exchange', par. 15.

63 Tauvry, 'Resistance and Exchange', par. 15.

64 Norman McBeath, interview by Ryan Van Winkle, *Scottish Poetry Library*, podcast audio, 21 December 2010, http://scottishpoetrylibrary.podomatic.com/entry/2010-12-21T04_51_40-08_00.

65 Norman McBeath and Robert Crawford, interview with Jessica Hughes, *Practitioners' Voices in Classical Reception Studies* 3 (2012), http://www.open.ac.uk/arts/research/pvcrs/2012/mcbeath-crawford.

66 McBeath and Crawford, interview with Jessica Hughes.

67 McBeath, interview by the author.

68 McBeath, interview by the author.

69 McBeath, interview by the author.

70 Robert Crawford, introduction to *Light Box*, by Crawford and Norman McBeath (Edinburgh: Easel Press, 2015); Roland Barthes, *Camera Lucida: Reflections on Photography*, trans. Richard Howard (London: Vintage, 2000), 49.

71 McBeath, interview by the author.

72 Crawford and McBeath, *Light Box*, 'Aton'.

73 Barthes, *Camera Lucida*, 49.

74 Robert Crawford, e-mail message to author, 9 March 2015.

75 Crawford, email message.

76 Some of the most important photopoetry exhibitions include Rudy Burckhardt and Edwin Denby's *New York, N Why?* (Metropolitan Museum of Art, New York, 2008–2009); Robert Crawford and Norman McBeath's *Simonides* (Edinburgh College of Art, 2011; Whitney Humanities Center, Yale University, 2012); and Paul Muldoon and Norman McBeath's *Plan B* (Scottish Poetry Library, Edinburgh, 2010; ESB Substation, Cork, 2011).

77 Notably, photographs from Thomas Becker's series *Urnatur* straddled the first printing of Sebald's poem *Nach der Natur: Ein Elementargedicht* (1988), published in English as *After Nature* (2003). It was apparently the idea of the publisher (Grone) to bring together Sebald's work with Becker's photographs, and such an arrangement was not repeated in subsequent printings or translations. See Lise Patt, introduction to *Searching for Sebald: Photography after W. G. Sebald*, ed. Lise Patt with the assistance of Christel Dillbohner (Los Angeles: Institute of Cultural Inquiry, 2007), 22.

78 W. G. Sebald, 'As Day and Night, Chalk and Cheese: On the Pictures of Jan Peter Tripp', in *Unrecounted*, by Sebald and Jan Peter Tripp (London: Penguin, 2004), 84–85.

79 Sebald, 'As Day and Night', 84.

80 Sebald, 'As Day and Night', 84.

81 Andrew Miller, *Poetry, Photography, Ekphrasis* (Liverpool: Liverpool University Press, 2015), 3.

82 Tauvry, 'Resistance and Exchange', par. 4.

83 Miller, *Poetry, Photography, Ekphrasis*, 173.

84 Miller, *Poetry, Photography, Ekphrasis*, 174.

85 James Heffernan, *Museum of Words: The Poetics of Ekphrasis from Homer to Ashbery* (Chicago: University of Chicago Press, 1993), 5.

86 Miller, *Poetry, Photography, Ekphrasis*, 175–176.

87 David Kennedy, *The Ekphrastic Encounter in Contemporary British Poetry and Elsewhere* (Farnham, UK: Ashgate, 2012), 2.

88 Wills, *Reading Paul Muldoon*, 90; Muldoon, *Poems 1968–1998*, 127–147.

89 McBeath and Crawford, interview with Jessica Hughes.

90 McBeath and Crawford, interview with Jessica Hughes.

91 McBeath and Crawford, interview with Jessica Hughes.

92 Robert Crawford and Norman McBeath, *Simonides* (Edinburgh: Easel Press, 2011),
 poem XXV.

93 McBeath and Crawford, interview with Jessica Hughes.

94 Robert Crawford, 'Simonides and the War on Terror', in *Simonides*, by Crawford
 and McBeath, 5.

95 Fried, *Why Photography Matters*, 55.

96 Tauvry, 'Resistance and Exchange', par. 28.

97 Fried, *Why Photography Matters*, 54.

Conclusion
Photopoetry and the Future

In *Chinese Makars* (2016), his most recent photopoetic collaboration with Norman McBeath, Robert Crawford makes Scots versions of poetry from the Tang Dynasty poets (608–907): Li Bai, Wang Wei, Du Fu, and Xue Tao. The book also includes photographs by John Thomson (1837–1921), whose work in China and South East Asia made him the pre-eminent nineteenth-century Scottish photographer of those regions. 'In its inclusion of early and recent photographs,' Crawford remarks,

> as in its inclusion of ancient poems and modern Scots versions of them, this volume seeks to cross temporal as well as linguistic and cultural boundaries; it aims to provide readers with a vantage point from which to look around in time and place, seeing Scotland and China reflected in one another through acts of translation that are both verbal and visual.[1]

As such, *Chinese Makars* embodies four key features of contemporary photopoetry: the importance of small presses, the resurgence of formal experimentation, photopoetry as an act of translation, and the centrality of collaborative practice to connections between poem and photograph.

What I have tried to plot in this book is a critical history of the relationship between poetry and photography, primarily in photobook form, and as the result of collaborative practice, widely defined, between poets and photographers. I have used the term 'photopoetry' to collect disparate photo/poem relationships, from nineteenth-century scrapbooks and stereographs to contemporary photobook collaborations. In doing so, I have taken for granted that the relationship between poem and photograph has always been one of disruption and serendipity, evocation and metaphor, wonder and symbiosis. I have sought, where possible and appropriate, to locate the collaborations within contexts such as economic and social history, and photographic and book history, though I make no claim to be exhaustive in this endeavour. There is plenty of work still to do to situate

photopoetry in these contexts, and draw greater connections between the results of photopoetic collaboration and the circumstances in which they are produced. Likewise, I have not disguised the fact that my interest lies primarily in the poetic half of photopoetic collaborations: I leave it to photographic historians to approach photopoetry with a keener eye for photographic meaning and the abundance of theories that surround photography as both art and science. By way of conclusion, I would like to focus on the four key features of contemporary photopoetry as outlined above, in relation to *Chinese Makars*, and relate them to photopoetic history more generally.

As I hope has become clear, one of the main trends highlighted in this study is the passage, broadly speaking, from retrospective to collaborative practice in the creation of photopoetry. I have shown throughout this book how the relationship between poem and photograph has always been one of evocation and metaphor, and I have explored the nuances of this relationship through the differences between retrospective and collaborative practice. Were poems written as responses to photographs, or vice versa, for example, or were they written and taken simultaneously with a common idea in mind? How were they arranged in the photobook and in other formats? I have sought to demonstrate how the relationship between poem and photograph changes when, for example, they form discrete pairings, form separate sequences, are arranged more with a tone or atmosphere in mind, or form connections with each other across the whole photobook, not just to the poem or photograph on the facing page.

One consistent idea present in each chapter is that of translation. Many photopoetic practitioners have conceived the act of responding to poems or photographs as one of translation. From Adelaide Hanscom Leeson's approach to Edward FitzGerald's *Rubáiyát of Omar Khayyám* to Crawford's Scots versions of ancient Greek and Chinese; from the photographic model underlying Ezra Pound's imagist translations of Chinese poets in *Cathay* (1915) to Eliza Griswold's translations of landays from Afghanistan in *I Am the Beggar of the World* (2014), translation has featured both as a structural principle of the photopoetic relationship and as a literary model that, in Crawford's terms, requires 'the reader of translated verse to be conscious of having to "reach" a little'.[2] It is worth noting, at this point, how anglophone photopoetry has become more outward-facing in recent years, moving away from the locales of Britain and America towards other places, times, and cultures. This involves physical journeys – as in Ginsberg and Lawrence's *Ankor Wat* (1968), Jamie and Smith's *The Autonomous Region* (1993), and PJ Harvey and Seamus Murphy's *The*

Hollow of the Hand (2015) – as well as literary translations that seek to explore cultures, histories, and stories now temporally remote. Indeed, Crawford and McBeath's current photopoetry project is an artist's box combining McBeath's photographs with a new version of Crawford's translation of 'The Dream of the Rood', one of the oldest known works of English literature. Reaching from one language to another echoes the reach required to connect poem to photograph, photograph to poem, in that connections are not necessarily obvious. Translation is a more generous model than illustration, allowing for relationships that are not perceived as definitively literal or descriptive. Oftentimes, a particular tone or spirit is sought, and the egotism of the translator can emerge in the avoidance of obvious literal equivalents. The Scots poems of *Chinese Makars* are printed not with the original Chinese poems but alongside English glosses which, for the reader unfamiliar with Scots, serve further to complicate the relationship between poem and photograph. The poem 'Deer Pairk' reads:

Tuim bens. Naebdy kythin.
Jist vices echoin –
An licht hame-comin tae ilka daurk fir,
The strath's tap bricht aince again.

> (*Chinese Makars* (hereinafter *CM* in citations), 52)

Where we might expect a woodland scene, McBeath provides a photograph of human footprints in sand (Figure 6.1). Eerily, the shadows make it seem as if they are not imprints at all, but lend them physical presence, and it is the idea of presence that structures the pairing. Crawford glosses 'Naebdy kythin' as 'Nobody in evidence', but clearly McBeath's photograph evidences some kind of presence, a trace, just as the Chinese poem is present only in its translated and glossed forms. The footprints serve as the 'voices echoing' throughout the photobook, and their various sizes and directions attest to multivalence and discursion. The footprints make no definite path, just as there are no definite, incontrovertible connections between poem and photograph, nor between the original poems and their translations. Similarly, the inclusion of Thomson's photographs translates them to a new context, and recalls the editorial practices of early photopoetry books. Collaboration allows for a variety of structures between poems and photographs, all of which reveal different aspects of, and connective strands between text and image.

A vital component of collaborative photopoetry has been small presses, which have been at the centre of photopoetry publishing since the earliest

Figure 6.1 Norman McBeath, 'Deer Pairk', in *Chinese Makars*, 2016. © Norman McBeath.

photographically illustrated poetry anthologies of the mid-nineteenth century. Many nineteenth-century works, in both Britain and America, were published by presses that folded quickly, merged with other small presses, or were amalgamated into larger conglomerates that would become the major publishing houses we know today. That said, small presses rose to real prominence in the twentieth century, when photopoetry emerged into the luxury book market. Hart Crane, for example, promised *The Bridge* to Harry and Caresse Crosby's Paris-based Black Sun Press, to be printed on high-quality paper and meticulously produced in a luxurious limited edition. Crane's contract with the Crosbys stipulated that Liveright could not publish their American trade edition until April 1930, several months after the Black Sun edition went on sale. This, according to Crane, made Liveright 'furious, but – it can't be helped'.[3] Other examples include the Edward Weston/Walt Whitman *Leaves of Grass* (Limited Editions Club, 1942), and George Mackay Brown and Gunnie Moberg's *Stone* (Kulgin Duval and Colin Hamilton, 1987). Not all small-press photopoetry takes the form of such limited editions, however, but it is important to recognize

one trend in photopoetic history towards the idea of the photopoetic reader/ viewer as connoisseur. Equally, the reliance on small presses makes photopoetry seem somehow conspiratorial, a secret shared between enthusiasts, something to be hunted and unearthed. It is with some regret that I have assumed the role of bibliographer, who comes along and spoils all the fun. That said, there are undoubtedly works I have missed, ones that should be discussed or at least mentioned in this study, which I leave for others to trace.

If small presses have permitted and encouraged innovation and experiment throughout photopoetic history, what then of larger presses? Aside from the popular photographically illustrated poetry anthologies of the nineteenth century, photopoetry has afforded precious little commercial opportunity, and for this reason it has been rare for larger presses to produce more than one or two photopoetry books at most. Faber's cluster of photopoetry – *Positives* (1966), *Remains of Elmet* (1979), *River* (1983), *Sweeney's Flight* (1992), and *Elmet* (1994) – seems to be the exception, even if these books are often compromised by the poor quality of the reproduced photographs. Faber has not published a photopoetry book since Fay Godwin and Ted Hughes's *Elmet* in 1994, for reasons that relate, one expects, to the high costs of reproducing photographs in poetry books that are aimed at already small audiences. Farrar, Straus and Giroux recently published Eliza Griswold and Seamus Murphy's *I Am the Beggar of the World* (2014), which pairs Murphy's photographs with Griswold's translations of landays from contemporary Afghanistan. Murphy was also involved in *The Hollow of the Hand* (Bloomsbury Circus, 2015), which pairs his photographs with poems by Polly Jean (PJ) Harvey. Between 2011 and 2014, Harvey and Murphy made a series of journeys together to Afghanistan, Kosovo, and Washington, DC, compiling photographs and poems for what Murphy calls 'our look at home and the world'.[4] These books represent a more political turn in photopoetry, which began, on a global scale, with Kathleen Jamie and Sean Mayne Smith's *The Autonomous Region* (1993), published by Bloodaxe Books, one of Britain's leading poetry presses. Interestingly enough, Bloomsbury Circus published *Hollow* in four different editions: limited edition box set (250 copies), hardback, eBook, and what they term 'a reader's paperback version'.[5] I have only been able to afford limited space to issues of marketing and reception in this study, yet it seems suggestive, in this instance, that the perceived audiences for *Hollow* are distinctly photographic and poetic, and that it is marketed almost as two separate books, not as a work of photopoetry.

Modern small presses have published most contemporary photopoetry, from Norman McBeath's Easel Press to renowned publisher of Irish poetry and drama, the Gallery Press; from the non-profit Red Hen Press based in Los Angeles to Hercules Editions, a new press based in Lambeth, London, specializing in collaborations between contemporary artists and writers. In 2012, Hercules Editions published *Formerly*, a collaboration between poet Tamar Yoseloff and photographer Vici MacDonald. The chapbook, which renowned British poet Ian Duhig considers 'the best collaboration between these arts that I have seen since Fay Godwin and Ted Hughes' *Remains of Elmet*', features fourteen 'loose sonnets' by Yoseloff that were written in response to MacDonald's photographs.[6] *Formerly* commemorates a disappearing London, one of seedy bars, industrial sites, and council estates. While such commemorative projects are common to photopoetry, of greater interest is the nature of the book's publication. Its first edition, limited to three hundred copies, contained a free location guide called 'Off the Map', which includes factual information about the sites featured in the chapbook, and provides then-and-now photographs of each site in addition to commentaries from poet and photographer. *Formerly* also toured London as an exhibition, and spawned the reader-participation project 'You Are Here', which invited readers/viewers to walk around the South Bank area of London and write their own response, 'generated by the process of walking and observing', in a specially produced booklet.[7] Such formal innovations evoke the physical space of photopoetry as described in the previous chapter, and demonstrate how the reader/viewer is challenged and encouraged to make their own connections between poem and photograph. With small presses, more resources are afforded to the creation, in a sense, of the world surrounding the photobook, extending the relationship between poem and photograph beyond its pages. Small-press photopoetry books often form parts of larger projects. Crawford and McBeath's *Chinese Makars*, for example, is one product of a larger project at the University of St Andrews. Crawford set up workshops pairing creative writing students with Chinese speakers from across the university in order to make Scots versions of classical Chinese poems. At the time of writing, they are due to be published as a pamphlet titled *Loch Diànnǎo*.

While exhibitions and walking tours seek to increase engagement with photopoetry, its primary form has long been the photobook, the adoption of which leant itself to a linear relationship between photograph and poem. The earliest photopoetry books functioned almost like walking tours or guidebooks, with the photographer steering the reader/viewer through the place of the

poem(s), with some strategically positioned illustrations to evoke, for example, the Lake District or the Scottish Highlands. This primarily retrospective practice declined once poets and photographers began to collaborate, and the focus on a unified place also receded given the growing preference for shorter, lyric poems which shuttle between times, places, cultures, and voices. The return of sequences in McBeath and Paul Muldoon's photopoetry offers a modern interpretation of the photopoetic journey, immersing the reader/viewer in a mental labyrinth in which there is no predetermined route or destination. With collaborative practice, the idea that the reader/viewer would be led by poet and/or photographer receded in favour of a scenario in which the poet and photographer created a theatrical space that engaged the reader/viewer's affective responses to poem and photograph.

The linearity of the photopoetic book, however, is difficult to overcome. While McBeath and Paul Muldoon have attempted to create a matrix of links between their poems and photographs – and Crawford and McBeath use the artist's box format to encourage a more immersive engagement – the structure of the photobook still dictates the linear manner in which one reads. McBeath and Muldoon have reshaped photopoetic space to its logical extreme – short of the collage and photomontage forms common to European photopoetry – by moving away from a linearly traversable space to one self-consciously theatrical in which the reader/viewer is left to figure out the connections between poem and photograph. Ginsberg's *Ankor Wat* is similar, in that the poem seems to abandon the reader/viewer in the maze-line space of the jungle temple, yet Lawrence's photographs act, to some extent, as an anchor. Ted Hughes was the first poet to suggest, explicitly, the idea of the photopoetic book – or part of it – as a theatrical stage, with his poems equivalent to a musical score. Yet such an approach might not be progressive at all, simply a return to the earliest photopoetic scrapbooks and albums, with reader/viewers assuming a similar role to that of compilers. This is not to suggest, however, that scrapbooks are uncomplicated artefacts. 'A scrapbook,' notes Patricia Buckler, 'is quite literally an *intertext*, an item whose plurality of texts points to a culture's prior texts while creating a dialogue of its own with its contemporary cultural context and the cultures of future readers.'[8] There are obvious physical limits, however, to how the photopoetic book can function as an immersive reality. These limits are most evident when we consider the role of the reader/viewer in photopoetry, and how projects such as the *Formerly* walking tour seek to immerse the reader/ viewer in the actual environment of the collaboration. In transcending the

physical object of photopoetry, however, such projects prompt the question of how the reader/viewer can be placed at the centre of photopoetry, insofar as their affective responses create connections between poem and photograph. Would such a model be possible through computer programmes, in which reader/viewers make their own pairings of text and image? Would this practice go beyond collaboration to something more immersive or networked? After all, the intertextual scrapbook has become an online phenomenon through social media sites and apps such as Facebook, Twitter, and Instagram, in which viewers dictate, or click, their own progress through the virtual landscape.

I have confined my discussion of photopoetry to its physical, tactile forms, yet a brief analysis of digital photography may prove useful to a consideration of future forms of photopoetry. With the rise of digital photography, will photographs still become, in Susan Sontag's words, 'scrofulous, tarnished, stained, cracked, faded'?[9] 'The logic of the digital photograph,' writes Lev Manovich,

> is one of historical continuity and discontinuity. The digital image tears apart the net of semiotic codes, modes of display, and patterns of spectatorship in modern visual culture – and, at the same time, weaves this net even stronger. The digital image annihilates photography while solidifying, glorifying and immortalizing the photographic.[10]

Photography is undergoing the kind of etymological shift poetry underwent in the last century, where poetry, to use Manovich's terms, was annihilated at the expense of the solidification, glorification, and immortalization of the 'poetic'. The *idea* of poetry has almost become a cliché; 'poetic' has become a byword for beautiful, profound, something 'having the style or character proper to poetry as a fine art; elevated or sublime in expression'.[11] This definition elucidates the title of the Manuel Alvarez Bravo retrospective *Photopoetry* (2008), in which no poetry is present: the photographs pertain to a certain 'poetic' quality, style, or character.[12] In a culture saturated with the visual image, it is unsurprising that the 'character' and rhetoric of poetry has been co-opted to act as a barometer of aesthetic merit: this only furthers the photographic lens through which we are beginning to perceive the world.[13] Where Fred Ritchin asks, 'Does the photograph still require a photographer, or even a camera?' we might well ask whether the poem still requires a poet.[14]

The photopoetic book, then, is of crucial importance in maintaining the integrity of poetry and photography as art forms that exist both together and apart. It is worth repeating Martin Parr and Gerry Badger's remark, quoted

in my introduction, that the photobook has an 'important role within the history of photography. It resides at a vital interstice between the art and the mass medium, between the journeyman and the artist, between the aesthetic and the contextual.'[15] Within the history of poetry, too, it might be argued that photopoetry has a similarly important place in terms of how we perceive, construct, and interpret the poetic image. If anything, the connections between poetry and photograph strengthen each as an individual medium, as photopoetry is as much about resistance as it is about reciprocity. In its myriad forms and practices, photopoetry has a rich and complicated history, reliant as much on the similarities between poetry and photography as on their differences. My selection of works has been determined not by the individual merit of the poems and photographs themselves but by their combined merit as photopoems, the work they do in dialogue, on the page. In selecting works and examining their forms as well as the procedures of their composition, I hope to suggest important links between poetry and photography while maintaining the integrity of each. As discourses pertaining to the 'photographic' and 'poetic' continue to erode the nuances of what it means to perceive, look, and create photographs and poems, through photopoetry we are able to preserve the distinct meaning of each – distinctions emboldened through collocation.

This concern, while likely to shape the future of photopoetry, is not the crux of the present study. In arguing for a new form of art, I have attempted, in the first book-length history of photopoetry, to delineate an engaging, conflicting, diverse body of work that has undergone, over the last 170 years, ceaseless change: structurally, stylistically, and theoretically. I have sought to reveal the neglect of an area of text/image studies that affects not only the manner in which we approach photopoetry, but poetry and photography themselves. Most importantly, however, this book has attempted to move beyond the moment of discovery to offer a sustained analysis of photopoetry, an exploration of its multiple forms and potentials, a critique of its paradigm, and an argument for its contribution to text/image relations, inviting a new and innovative approach to how we read poems, photographs, and the space between them.

Notes

1 Robert Crawford, introduction to *Chinese Makars*, by Crawford and Norman
 McBeath (Edinburgh: Easel Press, 2016), 9.

2 Crawford, introduction to *Chinese Makars*, 8.

3 Hart Crane to Allen Tate, 14 December 1929, in *O My Land, My Friends: The Selected Letters of Hart Crane*, ed. Langdon Hammer and Brom Weber (New York: Four Walls Eight Windows, 1997), 420.

4 'The Hollow of the Hand', Bloomsbury Publishing, accessed 10 May 2017, http://www.bloomsbury.com/uk/the-hollow-of-the-hand-9781408865286/.

5 'The Hollow of the Hand', http://www.bloomsbury.com/uk/the-hollow-of-the-hand-9781408865286/.

6 'About the Formerly Chapbook', Hercules Editions, accessed 10 May 2017, https://herculeseditions.wordpress.com/portfolio/formerly/.

7 'About the Self-Guided Project', Hercules Editions, accessed 10 May 2017, https://formerlysonnets.wordpress.com/2012/12/11/about-self-guided/.

8 Patricia P. Buckler, 'Letters, Scrapbooks, and History Books: A Personalized Version of the Mexican War, 1846–1848', in *The Scrapbook in American Life*, ed. Susan Tucker, Katherine Ott, and Buckler (Philadelphia, PA: Temple University Press, 2006), 65.

9 Susan Sontag, *On Photography* (London: Penguin, 1979), 79.

10 Lev Manovich, 'The Paradoxes of Digital Photography', in *The Photography Reader*, ed. Liz Wells (London; New York: Routledge, 2003), 241.

11 *Oxford English Dictionary*, s. v. 'poetic, adj. and n', accessed 5 December 2014, http://www.oed.com/view/Entry/146532?rskey=jr4Cy7&result=1&isAdvanced=false.

12 Manuel Alvarez Bravo, *Photopoetry* (London: Thames & Hudson, 2008).

13 Likewise, exploring photographic tropes in poetry, and poetic tropes in photography, are two entirely different books, both of which are beyond the scope of my own consideration of photopoetic history. Nor do I intend to write them.

14 Fred Ritchin, *After Photography* (New York: W. W. Norton, 2009), 30.

15 Martin Parr and Gerry Badger, *The Photobook: A History*, vol. 1 (London: Phaidon, 2004), 11.

Bibliography

Primary Sources

Aitken, Cora Kennedy. *Legends and Memories of Scotland*. London: Hodder and Stoughton, 1874.

Alexander, Christine. *Airdrie, Scotland*. Philadelphia, 1875.

Arnold, Edwin, and Mabel Eardley-Wilmot. *The Light of Asia*. London: Kegan Paul, Trench, Trübner, 1908.

Auden, W. H., and Christopher Isherwood. *Journey to a War*. London: Faber, 1939.

Auden, W. H., and Louis MacNeice. *Letters from Iceland*. London: Faber, 1937.

Banning, Kendall, and Lejaren À Hiller. *Bypaths in Arcady: A Book of Love Songs*. Chicago: Brothers of the Book, 1915.

Biddle, Clement. *Airdrie and Fugitive Pieces*. Philadelphia: George Gebbie, 1872.

Biddle, Clement. *Poems*. Philadelphia: Lindsay & Baker, 1876

Billman, Ira, and Clarence H. White. *Songs of All Seasons*. Indianapolis: Hollenbeck Press, 1904.

Brecht, Bertolt. *Kriegsfibel*. Berlin: Eulenspiegel Verlag, 1955. Published in English as *War Primer*. Translated by John Willett. London: Libris, 1998.

Brigman, Anne. *Songs of a Pagan*. Caldwell, ID: Caxton Printers, 1949.

Brown, George Mackay, and Gunnie Moberg. *Orkney Pictures & Poems*. Grantown-on-Spey, UK: Colin Baxter, 1996.

Brown, George Mackay, and Gunnie Moberg. *Stone*. Foss, UK: Kulgin D. Duval and Colin H. Hamilton, 1987.

Browning, Elizabeth Barrett. *A Selection from the Poetry of Elizabeth Barrett Browning: With Photographic Illustrations by Payne Jennings*. London: Suttaby, 1884.

Browning, Elizabeth Barrett, and Adelaide Hanscom Leeson. *Sonnets from the Portuguese*. New York: Dodge Publishing, 1916.

Browning, Elizabeth, and Robert Browning. *Florence in the Poetry of the Brownings: Being a Selection of the Poems of Robert and Elizabeth Barrett Browning which Have to Do with the History the Scenery and the Art of Florence*. Edited by Anna Benneson McMahan. Chicago: A. C. McClurg, 1904.

Burckhardt, Rudy, and Edwin Denby. *In Public, In Private*. Prairie City, IL: Press of J. A. Decker, 1948.

Burckhardt, Rudy, and Edwin Denby. *Mediterranean Cities*. New York: G. Wittenborn, 1956.

266 *Bibliography*

Burckhardt, Rudy, and Edwin Denby. *New York, N. Why?* 1938. Reprinted. New York: Nazraeli Press, 2008.

Burckhardt, Rudy, and Vincent Katz. *Boulevard Transportation*. New York: Tibor de Nagy Editions, 1997.

Burckhardt, Rudy, and Vincent Katz. *New York, Hello!* Chicago: Ommation Press, 1990.

Byron, George Gordon. *The Poetical Works of Lord Byron: With Photographic Illustrations by Payne Jennings*. London: Suttaby, c.1889.

Cameron, Julia Margaret. *Illustrations to Alfred Tennyson's Idylls of the King and Other Poems*. London: Henry S. King, 1875. Facsimile of the first edition. New York: Janet Lehr, 1986.

Conyngham Greene, Kathleen, ed. *The English Landscape: In Picture, Prose, and Poetry*. London: Ivor Nicholson & Watson, 1932.

Crane, Hart, and Walker Evans. *The Bridge*. Paris: Black Sun Press, 1930.

Crane, Hart, and Walker Evans. *The Bridge*. New York: Liveright, 1930. First Liveright edition April 1930, second edition July 1930. Each edition features a different frontispiece photograph by Evans.

Crawford, Robert, and Norman McBeath. *Chinese Makars*. Edinburgh: Easel Press, 2016.

Crawford, Robert, and Norman McBeath. *Light Box*. Edinburgh: Easel Press, 2015.

Crawford, Robert, and Norman McBeath. *Simonides*. Edinburgh: Easel Press, 2011.

Curtis, Tony, Grahame Davies, Mari Owen, and Carl Ryan. *Alchemy of Water/Alcemi Dŵr*. Llandysul, UK: Gomer Press, 2013.

DeCarava, Roy, and Langston Hughes. *The Sweet Flypaper of Life*. New York: Simon & Schuster, 1955.

Delamotte, Philip Henry, ed. *The Sunbeam: A Book of Photographs from Nature*. London: Chapman and Hall, 1859.

Dickson, Edward R., ed. *Poems of the Dance: An Anthology*. New York: Alfred Knopf, 1921.

Dunbar, Paul Laurence, and the Hampton Institute Camera Club. *Poems of Cabin and Field*. New York: Dodd, Mead, 1899.

Dunbar, Paul Laurence, and the Hampton Institute Camera Club. *Candle-lightin' Time*. New York: Dodd, Mead, 1901.

Dunbar, Paul Laurence, and the Hampton Institute Camera Club. *When Malindy Sings*. New York: Dodd, Mead, 1903.

Dunbar, Paul Laurence, and Leigh Richmond Miner. *L'il Gal*. New York: Dodd, Mead, 1904.

Dunbar, Paul Laurence, and Leigh Richmond Miner. *Howdy, Honey, Howdy*. New York: Dodd, Mead, 1905.

Dunbar, Paul Laurence, and Leigh Richmond Miner. *Joggin' Erlong*. New York: Dodd, Mead, 1906.

Dunn, Douglas. 'Terry Street'. *London Magazine* 8, no. 5 (August, 1968), 62–66.

Dunn, Douglas, and Robert Whitaker. *Terry Street: A Bête Noire Special Edition.* Edited by John Osborne. Hull: Bête Noire, 1994.

Eardley-Wilmot, Mabel. *The Rubáiyát of Omar Khayyám by Edward FitzGerald.* London: Kegan Paul, Trench, Trübner, 1912.

Éluard, Paul, and Man Ray. *Facile: poems de Paul Éluard; photographies de Man Ray.* Paris: Éditions G. L. M., 1935.

Fairylife and Fairyland. A Lyric Poem Communicated by Titania through her Secretary, Thomas of Ercildoune. London: L. Booth, 1870.

Farnsworth, Emma Justine. *In Arcadia.* New York: G. M. Allen, 1892.

FitzGerald, Edward, and Adelaide Hanscom Leeson. *The Rubáiyát of Omar Khayyám.* New York: Dodge Publishing, 1905.

FitzGerald, Edward, Adelaide Hanscom Leeson, and Blanche Cumming. *The Rubáiyát of Omar Khayyám.* London: George G. Harrap, 1912; New York: Dodge Publishing, 1912.

Fuller, John, and David Hurn. *Writing the Picture.* Bridgend, UK: Seren, 2010.

Gillies, Valerie, and Rebecca Marr. *Men and Beasts.* Edinburgh: Luath Press, 2000.

Ginsberg, Allen. *Ankor Wat: Photographs by Alexandra Lawrence.* London: Fulcrum Press, 1968.

Godwin, Fay, and Ted Hughes. *Elmet.* London: Faber, 1994.

Godwin, Fay, and Ted Hughes. *Remains of Elmet.* London: Faber, 1979.

Graham, Jorie, and Jeannette Montgomery Barron. *Photographs and Poems.* Zurich: Scalo, 1998.

Gray, Thomas. *Poems and Letters.* London: Chiswick Press, 1863.

Griswold, Eliza, and Seamus Murphy. *I Am the Beggar of the World.* New York: Farrar, Straus and Giroux, 2014.

Grundy, William Morris, ed. *Sunshine in the Country: A Book of Rural Poetry Embellished with Photographs from Nature.* London: Richard Griffin, 1861.

Gunn, Thom, and Ander Gunn. *Positives.* London: Faber, 1966.

Harvey, Polly Jean, and Seamus Murphy. *The Hollow of the Hand.* London: Bloomsbury Circus, 2015.

Heaney, Seamus, and Rachel Giese. *Sweeney's Flight.* London: Faber, 1992.

Heaney, Seamus, and Norman McBeath. 'A New Poem by Seamus Heaney'. *Oxford Today* 3, no. 3 (1990), 21.

Heisler, Jindřich, and Jindřich Štyrský. *Na Jehlách těchto dní.* Prague: Fr. Borový, 1945. Published in English as *On the Needles of These Days.* Berlin: Edition Sirene, 1984.

Herschell, William. *The Kid Has Gone to the Colors: And Other Verse, Illustrated with Photographs by Paul Shideler.* Indianapolis: Bobbs-Merrill, 1917.

Hope, Laurence [Adela Nicolson], and Mabel Eardley-Wilmot. *Songs from the Garden of Kama.* New York: John Lane, 1908; London: Heinemann, 1908.

Hughes, Ted, and Peter Keen. *River.* London: Faber, 1983.

Jame, Kathleen, and Norman McBeath. *The Beach.* Edinburgh: Easel Press, 2013.

Jamie, Kathleen, and Sean Mayne Smith. *The Autonomous Region: Poems & Photographs from Tibet*. Newcastle upon Tyne: Bloodaxe, 1993.

Jeffers, Robinson. *Not Man Apart: Photographs of the Big Sur Coast*. Edited by David Brower. San Francisco: Sierra Club, 1965.

King, Ben, Essie Collins Matthews, and Leigh Richmond Miner. *Ben King's Southland Melodies*. Chicago: Forbes, 1911.

Leighton, William. *Roman Sonnets*. Florence: G. Giannini & Son, 1908.

A Little Story for Grown Young Ladies, Illustrated Photographically. Album 37, General Album Collection, University of St Andrews Special Collections Library.

Longfellow, Henry Wadsworth. *The Poetical Works of Henry W. Longfellow: With Photographic Illustrations by Payne Jennings*. London: Suttaby, c.1882.

Longfellow, Henry Wadsworth, and Francis Frith. *Hyperion: A Romance*. London: A. W. Bennett, 1865.

Maclagan, Alexander. *Balmoral: Lays of the Highlands and Other Poems*. London; Glasgow; Edinburgh: Blackie & Son, 1871.

MacLeish, Archibald. *Land of the Free*. New York: Harcourt, Brace, 1938.

Macnab, John Alleyne. *Song of the Passaic*. New York: Walbridge, 1890.

Milton, John. *The Poetical Works of John Milton: With Photographic Illustrations*. London: Suttaby, c.1879.

Moore, Thomas. *The Poetical Works of Thomas Moore: With Photographic Illustrations by Payne Jennings*. London: Suttaby, c.1890.

Muldoon, Paul, and Bill Doyle. *Kerry Slides*. Oldcastle: Gallery Press, 1996.

Muldoon, Paul, and Norman McBeath. *Plan B*. London: Enitharmon Press, 2009.

Murray, Les. *The Australian Year: The Chronicle of Our Seasons and Celebrations*. North Ryde, NSW: Angus & Robertson, 1985.

Penrose, Roland. *The Road Is Wider than Long*. London: London Gallery Editions, 1939. Reprinted. Los Angeles: J. Paul Getty Museum, 2003.

Phillips, Constance. *Photopoems: A Group of Interpretations through Photographs*. New York: Covici Friede Publishers, 1936.

Riley, James Whitcomb. *Riley Love-Lyrics: With Life Pictures by William B. Dyer*. Indianapolis: Bobbs-Merrill, 1899.

Riley, James Whitcomb. *Riley Love-Lyrics: With Life Pictures by William B. Dyer*. Rev. edn. Indianapolis: Bobbs-Merrill, 1905.

Rodchenko, Alexander, and Vladimir Mayakovsky. *Pro Eto*. Moscow: Gosundarstvennoe, 1923. Reprinted *Pro Eto = That's What*. Translated by Larisa Gureyeva and George Hyde. Todmorden, UK: Arc Publications, 2009.

Sandburg, Carl. *Poems of the Midwest*. Cleveland: World Publishing, 1946.

Scotland: Her Songs and Scenery, as Sung by Her Bards, and Seen in the Camera. London: A. W. Bennett, 1868.

Scott, Walter. *The Poetical Works of Sir Walter Scott: With Photographic Illustrations by G. W. Wilson*. London: R. & A. Suttaby, c.1880.

Scott, Walter, and George Washington Wilson. *The Poetical Works of Sir Walter Scott.* Edinburgh: Adam and Charles Black, 1872.

Scott, Walter, George Washington Wilson, and Thomas Ogle. *The Lady of the Lake.* London: A. W. Bennett, 1863.

Scott, Walter, and Russell Sedgefield. *The Lay of the Last Minstrel.* London: Provost, 1872.

Scott, Walter, Russell Sedgefield, and Stephen Thompson. *The Lord of the Isles.* London: Provost, 1871.

Scott, Walter, and Thomas Annan. *Marmion: A Tale of Flodden Field.* London: A. W. Bennett, 1866.

Sebald, W. G., and Thomas Becker. *Nach der Natur: ein Elementargedicht.* Nördlingen, Germany: F. Greno, 1988.

Sebald, W. G., and Jan-Peter Tripp. *Unrecounted.* London, Penguin, 2004.

Shakespeare, William. *The Works of William Shakespeare: Life, Glossary, &c. With Photographic Illustrations.* London: R. & A. Suttaby, c.1890.

Sheeler, Charles, and Paul Strand, dirs. *Manhatta.* US, 1921.

Shelley, Percy, and Alvin Langdon Coburn. *The Cloud.* Los Angeles, C. C. Parker, 1912.

Siskind, Aaron, and John Logan. *Photographs and Poems.* Rochester, NY: Visual Studies Workshop, 1976.

Spooner, Zilpha, ed. *Poems of the Pilgrims.* Boston: A. Williams, 1882.

Sterling, George, and Francis Bruguière. *The Evanescent City.* San Francisco: A. M. Robertson, 1915.

Sternburg, Janet. *Optic Nerve.* Los Angeles: Red Hen Press, 2005.

Van Dyke, Henry, ed. *The Poetry of Nature.* New York: Doubleday, Page, 1914.

Waller, Effie. *Rhymes from the Cumberland.* New York: Broadway Publishing, 1909.

Weston, Edward, and Walt Whitman. *Leaves of Grass.* 2 vols. New York: Limited Editions Club, 1942. Reprinted. New York: Paddington Press, 1976.

Williams, T. R. *Scenes in Our Village.* London: London Stereoscopic Company, 1857.

Wordsworth, William. *The Poetical Works of Wordsworth: With Photographic Illustrations by Payne Jennings.* London: Suttaby, c.1880.

Wordsworth, William, and Thomas Ogle. *Our English Lakes, Mountains, and Waterfalls, as Seen by William Wordsworth.* 4th ed. London: A. W. Bennett, 1862.

Yevtushenko, Yevgeny. *Invisible Threads.* New York: Macmillan, 1981.

Yoseloff, Tamar, and Vici MacDonald. *Formerly.* London: Hercules Editions, 2012.

Archival Material

Archibald MacLeish Papers. Manuscript Division, Library of Congress, Washington, DC.

Elizabeth McCausland Papers. Archives of American Art, Smithsonian Institution, Washington, DC.

General Album Collection. Special Collections Library, University of St Andrews.

Gunnie Moberg Papers. Orkney Library and Archive, Kirkwall.

Paul Muldoon Papers. Stuart A. Rose Manuscript, Archives, and Rare Book Library, Emory University.

Ted Hughes Papers. Stuart A. Rose Manuscript, Archives, and Rare Book Library, Emory University.

Thom Gunn Papers. Bancroft Library, University of California, Berkeley.

Secondary Sources

Agnew, Eadaoin, and Leon Litvack, 'The Subcontinent as Spectator Sport: The Photographs of Hariot Lady Dufferin, Vicereine of India'. *History of Photography* 30, no. 4 (2006), 348–358.

Allan, David. *Commonplace Books and Reading in Georgian England.* Cambridge: Cambridge University Press, 2010.

Alvarez Bravo, Manuel. *Photopoetry.* London: Thames & Hudson, 2008.

Anderson, David. *Pound's Cavalcanti.* Princeton, NJ: Princeton University Press, 1983.

Armitage, Simon. Introduction to *Landmarks: A Survey*, by Fay Godwin, 10–11. Stockport: Dewi Lewis Publishing, 2001.

Armstrong, Carol. *Scenes in a Library: Reading the Photograph in the Book, 1843–1875.* Cambridge, MA; London: MIT Press, 1998.

Armstrong, Isobel. '"The Lady of Shalott": Optical Elegy'. In *Multimedia Histories: From the Magic Lantern to the Internet*, edited by James Lyons and John Plunkett, 179–193. Exeter: University of Exeter Press, 2007.

Armstrong, Isobel. *Victorian Poetry: Poetry, Poetics, and Politics.* London; New York: Routledge, 1993.

Armstrong, Nancy. *Fiction in the Age of Photography: The Legacy of British Realism.* Cambridge, MA: Harvard University Press, 1999.

Arnold, Matthew. *Poems.* London: Macmillan, 1885.

The Art Journal. Unsigned review of *Sunshine in the Country*, edited by William Morris Grundy. 1 February 1861.

Bachelard, Gaston. *The Poetics of Space.* Translated by Maria Jolas. Boston: Beacon Press, 1994.

Barrett Browning, Elizabeth. *Elizabeth Barrett to Miss Mitford: The Unpublished Letters of Elizabeth Barrett Browning to Mary Russell Mitford.* Edited by Betty Miller. London: Murray, 1954.

Barthes, Roland. *Camera Lucida: Reflections on Photography.* Originally published 1980. Translated by Richard Howard. London: Vintage, 2000.

Barthes, Roland. *Image Music Text*. Edited and translated by Stephen Heath. London: Fontana Press, 1977; New York: Hill and Wang, 1977.

Barthes, Roland. *The Pleasure of the Text*. Translated by Richard Miller. New York: Hill and Wang, 1975.

Batchen, Geoffrey. 'Vernacular Photographies'. *History of Photography* 24, no. 3 (Autumn 2000), 262–271.

Bate, Jonathan. *The Song of the Earth*. London: Picador, 2000.

Beckman, Karen, and Liliane Weissberg, eds. *On Writing with Photography*. Minneapolis: University of Minnesota Press, 2013.

Behdad, Ali. 'The Oriental Photograph'. In *Photography's Orientalism: New Essays on Colonial Representation*, edited by Behdad and Luke Gartlan, 12–32. Los Angeles: Getty Research Institute, 2013.

Behdad, Ali, and Luke Gartlan. Introduction to *Photography's Orientalism: New Essays on Colonial Representation*, edited by Behdad and Gartlan, 1–10. Los Angeles: Getty Research Institute, 2013.

Bell, Duncan S. A. 'Mythscapes: Memory, Mythology, and National Identity'. *British Journal of Sociology* 54, no. 1 (March 2003), 63–81.

Berger, John. *Ways of Seeing*. London: Penguin, 1972.

The Berkeley Daily Gazette. 'The Berkeley Girl Whose "Omar" Photos Startle the Literary Critics'. 19 March 1906.

Bilbro, Jeffrey. 'Reflective Order: Paul Muldoon's Whimsical Forms'. *ANQ* 25, no. 1 (Winter 2012), 69–74.

Blanch, Lesley. *Under a Lilac-bleeding Star*. London: John Murray, 1963.

Blyth, Caroline. 'Rumours of a Massacre'. *Times Literary Supplement*. 10 December 1993, 22.

Bošković, Aleksandar. 'Photopoetry and the Bioscopic Book: Russian and Czech Avant-Garde Experiments of the 1920s'. PhD diss., University of Michigan, 2013.

Boulestreau, Nicole. 'Le Photopoème *Facile*: Un Nouveau Livre dans les années 30'. In *Le Livre surréaliste: Mélusine IV*, edited by Henri Béhar, 164–177. Lausanne: L'Age d'Homme, 1982.

Brown, George Mackay. *The Collected Poems*. Edited by Archie Bevan and Brian Murray. London: John Murray, 2005.

Brunet, François. *Photography and Literature*. London: Reaktion, 2009.

Bryant, Marsha. *Auden and Documentary in the 1930s*. Charlottesville; London: University of Virginia Press, 1997.

Bryant, Marsha, ed. *Photo-Textualities: Reading Photographs and Literature*. Newark: University of Delaware Press, 1996.

Buckler, Patricia P. 'Letters, Scrapbooks, and History Books: A Personalized Version of the Mexican War, 1846–1848'. In *The Scrapbook in American Life*, edited by Susan Tucker, Katherine Ott, and Buckler, 60–78. Philadelphia, PA: Temple University Press, 2006.

Burckhardt, Rudy, and Edwin Denby. 'The Cinema of Looking: Rudy Burckhardt and Edwin Denby in Conversation with Joe Giordano'. By Joe Giordano. *Jacket* 21 (February 2003), http://jacketmagazine.com/21/denb-giord.html.

Burke, Edmund. *A Philosophical Enquiry into the Sublime and Beautiful.* Originally published 1757. Edited by James T. Boulton. London; New York: Routledge, 2008.

Bush, Christopher. *Ideographic Modernism: China, Writing, Media.* Oxford: Oxford University Press, 2010.

Bush, Ronald. *The Genesis of Ezra Pound's Cantos.* Princeton, NJ: Princeton University Press, 1976.

Butler, Judith. *Gender Trouble: Feminism and the Subversion of Identity.* New York: Routledge, 1990.

Cadbury, William. 'FitzGerald's Rubáiyát as a Poem'. *ELH* 34, no. 4 (December 1967), 541–563.

Calder, Angus. 'Charles Mackay (1812–1889)'. In *Oxford Dictionary of National Biography.* Oxford University Press, 2004–. Accessed 2 February 2015. http://www. oxforddnb.com/view/article/17555.

Cameron, Julia Margaret. 'Annals of My Glass House'. In *Julia Margaret Cameron: Her Life and Photographic Work*, edited by Helmut Gernsheim, 180–183. Millerton, NY: Aperture, 1975.

Carrigan, Anthony. *Postcolonial Tourism: Literature, Culture, and Environment.* New York: Routledge, 2012.

Chadwick, Nora Kershaw. *The Age of the Saints in the Early Celtic Church.* London; New York; Toronto: Oxford University Press, 1961.

Cheeke, Stephen. *Writing for Art: The Aesthetics of Ekphrasis.* Manchester: Manchester University Press, 2008.

Christ, Carol T. *The Finer Optic: The Aesthetic of Particularity in Victorian Poetry.* New Haven, CT: Yale University Press, 1975.

Clayton, Owen. *Literature and Photography in Transition, 1850–1915.* Basingstoke: Palgrave Macmillan, 2015.

Cole, Rachel Martin. 'The Rubáiyát of Omar Khayyám'. *Art Institute of Chicago Museum Studies* 34, no. 2 (2008), 40–41, 93.

Coleman, David L. 'Pleasant Fictions: Henry Peach Robinson's Composition Photography'. PhD diss., University of Texas at Austin, 2005.

Crane, Hart. *Complete Poems.* Edited by Brom Weber. Newcastle upon Tyne: Bloodaxe, 1984.

Crane, Hart. *Hart Crane's* The Bridge: *Annotated Edition.* Edited by Lawrence Kramer. New York: Fordham University Press, 2011.

Crane, Hart. *O My Land, My Friends: The Selected Letters of Hart Crane.* Edited by Langdon Hammer and Brom Weber. New York: Four Walls Eight Windows, 1997.

Crary, Jonathan. *Techniques of the Observer: On Vision and Modernity in the Nineteenth Century*. Cambridge, MA: MIT Press, 1990.

Crawford, Robert. *The Beginning and the End of the World: St. Andrews, Scandal, and the Birth of Photography*. Edinburgh: Birlinn, 2011.

Cunningham, David, Andrew Fisher, and Sas Mays, eds. *Photography and Literature in the Twentieth Century*. Newcastle upon Tyne: Cambridge Scholars, 2005.

Danly, Susan. '"Literally Photographed": Edward Weston and Walt Whitman's *Leaves of Grass*'. In *Edward Weston: A Legacy*, edited by Jennifer A. Watts, 55–81. London: Merrell, 2003.

Davidov, Judith Fryer. *Women's Camera Work: Self/Body/Other in American Visual Culture*. Durham, NC; London: Duke University Press, 1998.

Davidson, Ian. *Ideas of Space in Contemporary Poetry*. Basingstoke; New York: Palgrave Macmillan, 2007.

Deleuze, Gilles, and Felix Guattari. *A Thousand Plateaus: Capitalism and Schizophrenia*. Translated by Brian Massumi. London; New York: Continuum, 2004.

Den Tandt, Christophe. *The Urban Sublime in American Literary Naturalism*. Urbana: University of Illinois Press, 1998.

Denby, Edwin. *Edwin Denby: The Complete Poems*. Edited by Ron Padgett. New York: Random House, 1986.

Denby, Edwin. *Dance Writings & Poetry*. Edited by Robert Cornfield. New York: Knopf, 1986.

Di Bello, Patrizia. *Women's Albums and Photography in Victorian England: Ladies, Mothers and Flirts*. Aldershot: Ashgate, 2007.

Dobson, Austin. *Collected Poems*. New York: E. P. Dutton, 1913; London: Kegan Paul, Trench, Trübner, 1913.

Drayton, Michael. *The Poly-Olbion*. In *The Works of the British Poets*, edited by Robert Anderson, vol. 3. London: John and Arthur Arch, 1795.

Drury, Annmarie. 'Accident, Orientalism, and Edward FitzGerald as Translator'. *Victorian Poetry* 46, no. 1 (2008), 37–53.

Duncan, Isadora. *The Art of the Dance*. Edited by Sheldon Cheney. New York: Theatre Arts, 1928.

Dunn, Douglas. *Under the Influence: Douglas Dunn on Philip Larkin*. Edinburgh: Edinburgh University Library, 1987.

Edwards, Elizabeth. *The Camera as Historian: Amateur Photographers and Historical Imagination, 1885–1918*. Durham, NC; London: Duke University Press, 2012.

Edwards, Elizabeth. 'Photographs as Objects of Memory'. In *Material Memories*, edited by Marius Kwint, Christopher Breward, and Jeremy Aynsley, 221–236. Oxford; New York: Berg, 1999.

Edwards, Holly. 'A Million and One Nights: Orientalism in America: 1870–1930'. In *Noble Dreams, Wicked Pleasures: Orientalism in America, 1870–1930*, edited by Holly Edwards, 11–57. Princeton: Princeton University Press, 2000.

Edwards, Paul. *Soleil Noir: Photographie et Littérature: des origines au surréalisme.* Rennes: Presses Universitaires de Rennes, 2008.

Edwards, Philip. *Pilgrimage and Literary Tradition.* Cambridge: Cambridge University Press, 2005.

Ehrens, Susan. *A Poetic Vision: The Photographs of Anne Brigman.* Santa Barbara, CA: Santa Barbara Museum of Art, 1995.

Eklund, Douglas. 'The Pursuit of Happiness: Rudy Burckhardt's New York, 1935–1940.' In *New York, N. Why?* by Edwin Denby and Rudy Burckhardt. New York: Nazraeli Press, 2008.

Eliot, T. S. *The Waste Land: A Facsimile and Transcript of the Original Drafts Including the Annotations of Ezra Pound.* Edited by Valerie Eliot. London: Faber, 1971.

Evans, Walker. *American Photographs.* New York: Museum of Modern Art, 1938.

Falconer, John. ' "A Pure Labor of Love": A Publishing History of *The People of India*.' In *Colonialist Photography: Imag(in)ing Race and Place*, edited by Eleanor M. Hight and Garry D. Sampson, 51–83. London; New York: Routledge, 2002.

FitzGerald, Edward. *FitzGerald: Selected Works.* Edited by Joanna Richardson. London: Rupert Hart-Davis, 1962.

FitzGerald, Edward. *The Letters of Edward FitzGerald.* Edited by Alfred McKinley Terhune and Annabelle Burdick Terhune. 4 vols. Princeton: Princeton University Press, 1980.

FitzGerald, Edward. *Rubáiyát of Omar Khayyám: A Critical Edition.* Edited by Christopher Decker. London; Charlottesville: University of Virginia Press, 1997.

Flecker, James Elroy. 'Laurence Hope.' *Monthly Review* 81, no. 27 (June 1907), 164–168.

Flint, F. S. 'Imagisme'. *Poetry* 1, no. 6 (March 1913), 198–200.

Flint, Kate. *The Victorians and the Visual Imagination.* Cambridge: Cambridge University Press, 2000.

Fried, Michael. *Why Photography Matters as Art as Never Before.* New Haven, CT: Yale University Press, 2008.

Fry, Paul H. *Wordsworth and the Poetry of What We Are.* New Haven, CT: Yale University Press, 2008.

Fyfe, Aileen. *Steam-Powered Knowledge: William Chambers and the Business of Publishing, 1820–1860.* Chicago; London: University of Chicago Press, 2012.

Gaines, Kevin Kelly. *Uplifting the Race: Black Leadership, Politics, and Culture in the Twentieth Century.* Chapel Hill: University of North Carolina Press, 1996.

George, J. A. 'Poetry in Translation'. In *A Companion to Victorian Poetry*, edited by Richard Cronin, Alison Chapman, and Antony Harrison, 273–274. Malden, MA: Blackwell, 2002.

Gernsheim, Helmut, ed. *Julia Margaret Cameron: Her Life and Photographic Work.* Millerton, NY: Aperture, 1975.

Gifford, Terry. ' "Dead Farms, Dead Leaves:" Culture as Nature in *Remains of Elmet & Elmet*'. In *Ted Hughes: Alternative Horizons*, edited by Joanny Moulin, 39–47. London: Routledge, 2004.

Gifford, Terry. 'Gods of Mud: Hughes and Post-Pastoral'. In *The Challenge of Ted Hughes*, edited by Keith Sagar, 129–141. London: St Martin's Press, 1994.

Gifford, Terry. 'Towards a Post-Pastoral View of British Poetry'. In *The Environmental Tradition in English Literature*, edited by John Parham, 51–63. Aldershot; Burlington, VT: Ashgate, 2002.

Giles, Paul. *Hart Crane: The Contexts of* The Bridge. Cambridge: Cambridge University Press, 1986.

Ginsberg, Allen. *Collected Poems 1948–1980*. London: Viking, 1985.

Glob, P. V. *The Bog People: Iron Age Man Preserved*. Ithaca, NY: Cornell University Press, 1969.

Goddard, Linda. *Aesthetic Rivalries: Word & Image in France, 1880–1926*. Oxford; New York: Peter Lang, 2012.

Godwin, Fay. *Landmarks: A Survey*. Stockport: Dewi Lewis Publishing, 2001.

Goldsmith, Lucien, and Weston J. Naef, eds. *The Truthful Lens: A Survey of Photographically Illustrated Books 1844–1914*. New York: Grolier Club, 1980.

Graver, Bruce. 'Wordsworth, Scott, and the Stereographic Picturesque'. *Literature Compass* 6, no. 4 (2009), 896–926.

Green-Lewis, Jennifer. Review of *Victorian Photography and Literary Nostalgia*, by Helen Groth, *Victorian Studies* 46 (Summer 2004), 714–715.

Greene, Roland Arthur. *Post-Petrarchism: Origins and Innovations of the Western Lyric Sequence*. Princeton, NJ: Princeton University Press, 1991.

Greenough, Sarah, and Juan Hamilton, eds. *Alfred Stieglitz, Photographs and Writings*. Washington, DC: National Gallery of Art, 1983.

Grigsby, Gordon K. 'The Photographs in the First Edition of *The Bridge*'. *Texas Studies in Literature and Language* 4, no. 1 (Spring 1962), 5–11.

Groth, Helen. *Victorian Photography and Literary Nostalgia*. Oxford; New York: Oxford University Press, 2003.

Guimond, James. *American Photography and the American Dream*. Chapel Hill; London: University of North Carolina Press, 1991. See esp. chap. 2, 'Frances Johnston's "Hampton Album": A White Dream for Black People'.

Gunn, Thom. 'The Art of Poetry, No. 72'. Interview by Clive Wilmer. *Paris Review* 135 (Summer 1995), 142–189.

Gunn, Thom. *Collected Poems*. London: Faber, 1994.

Gunn, Thom. 'Confessions of the Life Artist'. *New Statesman* 69, no. 1783 (14 May 1965), 768–769.

Gunn, Thom. 'First Elliston Presentation Poetry Reading'. Poetry Reading, The Elliston Project from University of Cincinnati, Cincinnati, OH, 15 October 1981. Accessed 23 May 2017. https://drc.libraries.uc.edu/handle/2374. UC/697029?submit=Go&query=thom%20gunn&focusscope=&mode=search.

Gunn, Thom. 'Misanthropos'. *Encounter* 21 (August 1965), 19–25.

Gunn, Thom. *My Sad Captains*. London: Faber, 1961.

Gunn, Thom. *The Occasions of Poetry: Essays in Criticism and Autobiography.* Edited by Clive Wilmer. London: Faber, 1982.

Hagstrom, Jack W. C., and George Bixby. *Thom Gunn: A Bibliography, 1940–1978.* London: Bertram Rota, 1979.

Hakutani, Yoshinobu. *Haiku and Modernist Poetics.* New York: Palgrave Macmillan, 2009.

Hamilton, Colin. *Stone: Ten Bindings.* Edinburgh: National Galleries of Scotland, 2006.

Hamilton, Peter, and Roger Hargreaves. *The Beautiful and the Damned: The Creation of Identity in Nineteenth Century Photography.* Aldershot; Burlington, VT: Lund Humphries, 2001.

Harbison, Peter. *Pilgrimage in Ireland: The Monuments and the People.* Syracuse, NY: Syracuse University Press, 1995.

Harker, Margaret. *Henry Peach Robinson: Master of Photographic Art, 1830–1901.* Oxford: Basil Blackwell, 1988.

Harrisson, Tom, and Charles Madge, eds. *First Year's Work.* London: Lindsay Drummond, 1938.

Hartman, Geoffrey H. *Wordsworth's Poetry, 1787–1814.* New Haven, CT: Yale University Press, 1964.

Haworth-Book, Mark, ed. *The Golden Age of British Photography, 1839–1900.* New York: Aperture, 1984.

Heaney, Seamus. *Sweeney Astray.* London: Faber, 1983.

Heffernan, James. *Museum of Words: The Poetics of Ekphrasis from Homer to Ashbery.* Chicago: University of Chicago Press, 1993.

Heisel, Andrew. 'What to Do with "Southern Negro types" in Dunbar's Hampton Volumes'. *Word & Image: A Journal of Verbal/Visual Enquiry* 28, no. 3 (July–September 2012), 243–256.

Hess, Scott. *William Wordsworth and the Ecology of Authorship: The Roots of Environmentalism in Nineteenth-Century Culture.* Charlottesville; London: University of Virginia Press, 2012.

Heynen, Hilde. *Architecture and Modernity: A Critique.* Cambridge, MA: MIT Press, 1999.

Hilson, Jeff, Paul Muldoon, and Meg Tyler. 'Contemporary Poets and the Sonnet: A Trialogue'. In *The Cambridge Companion to the Sonnet*, edited by A. D. Cousins and Peter Howarth, 6–24. Cambridge: Cambridge University Press, 2011.

Holmes, John. 'Poetry Now'. *Boston Transcript*, 16 April 1938.

Holmes, Oliver Wendell. 'Sun Painting and Sun Sculpture'. *Atlantic Monthly* 8, no. 45 (July 1861), 13–29.

Horak, Jan-Christopher. 'Paul Strand and Charles Sheeler's *Manhatta*'. In *Lovers of Cinema: The First American Film Avant-Garde, 1919–1945*, edited by Horak, 267–286. Madison: University of Wisconsin Press, 1995.

Hornstein, Shelley. *Losing Site: Architecture, Memory and Place*. Farnham, UK; Burlington, VT: Ashgate, 2011.

Hubert, Renée Riese. *Surrealism and the Book*. Berkeley: University of California Press, 1988.

Hughes, Glyn. 'Myth in a Landscape'. Review of *Remains of Elmet*, by Fay Godwin and Ted Hughes. *Guardian*. 24 May 1979, 16.

Hughes, Ted. *Letters of Ted Hughes*. Edited by Christopher Reid. London: Faber, 2007.

Hughes, Ted. 'Myth and Education'. *Children's Literature in Education* 1 (March 1971), 55–70.

Hughes, Ted. 'Ted Hughes on Wolfwatching'. *Poetry Book Society Bulletin* 142 (Autumn 1989), 1–3.

Hughes, Ted. *Wolfwatching*. London: Faber, 1989.

Hunter, Jefferson. *Image and Word: The Interaction of Twentieth-Century Photographs and Texts*. Cambridge, MA; London: Harvard University Press, 1987.

Jones, Gavin. *Strange Talk: The Politics of Dialect Literature in Gilded Age American*. Berkeley; Los Angeles: University of California Press, 1999.

Kaiserlian, Michelle. 'Infinite Transformation: The Modern Craze Over the "Rubáiyát of Omar Khayyám" in England and America, c.1900–1930'. PhD diss., Indiana University, 2009.

Kaiserlian, Michelle. 'Omar Sells: American Advertisements Based on *The Rubáiyát of Omar Khayyám*, c.1910–1920'. *Early Popular Visual Culture* 6, no. 3 (November 2008), 257–269.

Kaplan, Louis. *American Exposures: Photography and Community in the Twentieth Century*. Minneapolis: University of Minnesota Press, 2005.

Karlin, Daniel, ed. Introduction to *The Rubáiyát of Omar Khayyam*, by Edward FitzGerald, xi–xlvii. Oxford: Oxford University Press, 2009.

Katz, Vincent. 'Visiting Edwin Denby's Mediterranean Cities'. In *Hidden Agendas: Unreported Poetics*, edited by Louis Armand, 63–84. Prague: Univerzita Karlova v Praze, 2010.

Kennedy, David. *The Ekphrastic Encounter in Contemporary British Poetry and Elsewhere*. Farnham, UK: Ashgate, 2012.

Kerrigan, John. 'Paul Muldoon's Transits: Muddling Through after *Madoc*'. In *Paul Muldoon: Critical Essays*, edited by Tim Kendall and Peter McDonald, 125–149. Liverpool: Liverpool University Press, 2004.

Krieger, Murray. *Ekphrasis: The Illusion of the Natural Sign*. Baltimore; London: Johns Hopkins University Press, 1992.

Laughlin, Clara E. *Reminiscences of James Whitcomb Riley*. New York; Chicago: Fleming H. Revell, 1910.

Lambrechts, Eric, and Luc Salu, eds. *Photography and Literature: An International Bibliography of Monographs*. London: Mansell, 1992.

Lefebvre, Henri. *Key Writings*. Edited by Stuart Elden, Elizabeth Lebas, and Eleonore Kofman. New York; London: Continuum, 2003.

Levinas, Emmanuel. *Totality and Infinity: An Essay on Exteriority*. Translated by Alphonso Lingis. Pittsburgh, PA: Duquesne University Press, 1969.

Loizeaux, Elizabeth Bergmann. *Twentieth-Century Poetry and the Visual Arts*. Cambridge: Cambridge University, 2010.

Longfellow, Henry Wadsworth. *The Complete Poetical Works of Henry Wadsworth Longfellow*. Boston: Houghton Mifflin, 1893.

Lopate, Phillip. *Rudy Burckhardt*. New York: Harry N. Abrams, 2004.

MacMillan, Margaret. *Women of the Raj*. New York: Thames & Hudson, 1988.

McBeath, Norman. Interview with Ryan Van Winkle. *Scottish Poetry Library*, podcast audio, 21 December 2010, http://scottishpoetrylibrary.podomatic.com/entry/2010-12-21T04_51_40-08_00.

McBeath, Norman. Interview with the author. Edinburgh, 13 February 2015.

McBeath, Norman, and Robert Crawford. 'Interview with Norman McBeath and Robert Crawford'. By Jessica Hughes. *Practitioners' Voices in Classical Reception Studies* 3 (2012), http://www.open.ac.uk/arts/research/pvcrs/2012/mcbeath-crawford.

McMillan, Dorothy. 'Here and There: The Poetry of Kathleen Jamie'. *Études Écossaises* 4 (1997), 123–134.

Mackay, Charles. *Under Green Leaves*. London; New York: G. Routledge, 1857.

Mackay, Charles. ' "Under Green Leaves;" – Lullingsworth'. *Illustrated London News*, 31 January 1857.

Manovich, Lev. 'The Paradoxes of Digital Photography'. In *The Photography Reader*, edited by Liz Wells, 240–249. London; New York: Routledge, 2003.

March, Deborah M. 'Reframing Blackness: The Photograph and African American Literary Modernism at the Turn of the Twentieth Century'. PhD diss., Yale University, 2012.

Marien, Mary Warner. *Photography, A Cultural History*. 2nd ed. London: Laurence King, 2006.

Martin, William H., and Sandra Mason. *The Art of Omar Khayyam: Illustrating FitzGerald's Rubaiyat*. London; New York: I. B. Tauris, 2007.

Marx, Edward. 'Decadent Exoticism and the Woman Poet'. In *Women and British Aestheticism*, edited by Tali Schaffer and Kathy Alexis Psomiades, 139–157. Charlottesville; London: University Press of Virginia, 1999.

Massey, Doreen. *For Space*. London: Sage, 2005.

Matthews, Essie Collins. *Aunt Phebe, Uncle Tom, and Others: Character Studies among the Old Slaves of the South, Fifty Years after*. Columbus, OH: Champlin Press, 1915.

Maxwell, Mary. 'Edwin Denby's New York School'. *Yale Review* 95, no. 4 (October 2007), 65–96.

May, Brian, and Elena Vidal, eds. *A Village Lost and Found: 'Scenes in Our Village' by T. R. Williams. An Annotated Tour of the 1850s Series of Stereo Photographs.* London: Frances Lincoln, 2009.

McCullough, David G. *The Great Bridge: The Epic Story of the Building of the Brooklyn Bridge.* New York: Simon & Schuster, 2001.

Meisel, Martin. *Realizations: Narrative, Pictorial, and Theatrical Arts in Nineteenth-Century England.* Princeton, NJ: Princeton University Press, 1983.

Michelucci, Stefania. *The Poetry of Thom Gunn: A Critical Study.* Translated by Jill Flanks. Jefferson, NC; London: McFarland, 2009.

Miller, Andrew. *Poetry, Photography, Ekphrasis.* Liverpool: Liverpool University Press, 2015.

Minogue, Sally, and Andrew Palmer. '"Horrors Here Smile": The Poem, the Photograph and the Punctum'. *Word & Image: A Journal of Verbal/Visual Enquiry* 29, no. 2 (2013), 203–211.

Mitchell, W. J. T. *What Do Pictures Want? The Loves and Lives of Images.* Chicago: Chicago University Press, 2005.

Moberg, Gunnie. 'Pamela Beasant meets Gunnie Moberg'. By Pamela Beasant. *Northwords* 34 (Spring 2004), 18–21.

Moberg, Gunnie. *Stone Built: Orkney Photographs.* Stromness, UK: Stromness Books & Prints, 1979.

Moore, Thomas. *Odes of Anacreon: Translated into English Verse.* 4th ed. London: Printed for J. Carpenter, 1804.

Morgan, Edwin. 'Images in Illustration'. Review of *Landscape Poets: Thomas Hardy*, edited by Peter Porter, and *Landscape Poets: Robert Burns*, edited by Karl Miller. *Times Literary Supplement.* 25 September 1981, 1095–1096.

Muldoon, Paul. *Hay.* London: Faber, 1998.

Muldoon, Paul. *Maggot.* London: Faber, 2010.

Muldoon, Paul. *Poems 1968–1998.* London: Faber, 2001.

Muldoon, Paul. *Wayside Shrines.* With paintings and drawings by Keith Wilson. Oldcastle: Gallery Press, 2009.

Muldoon, Paul. *When the Pie Was Opened.* With illustrations by Lanfranco Quadrio. Lewes, UK: Sylph Editions, 2008.

Newey, Adrian. 'Connections at the Keyboard'. *Guardian*, 16 May 2009.

Nochlin, Linda. Foreword to *The New Woman International: Representations in Photography and Film from the 1870s through the 1960s*, edited by Elizabeth Otto and Vanessa Rocco, vii–xi. Ann Arbor: University of Michigan Press, 2011.

Normand, Tom. 'Reconfiguring Documentary Photography in a Globalised World: Some Contemporary Projects from Scotland'. *Studies in Photography* (2012), 48–57.

North, Michael. *Camera Works: Photography and the Twentieth-Century Word.* Oxford: Oxford University Press, 2005.

North, Michael. *The Dialect of Modernism: Race, Language, and Twentieth-Century Literature*. New York; Oxford: Oxford University Press, 1994.

Nott, Michael. 'Photopoetry and the Problem of Translation in FitzGerald's *Rubáiyát*.' *Victorian Studies* 58, no. 4 (Summer 2016), 661–695.

Nott, Michael. 'Ted Hughes and Fay Godwin's *Elmet*: The Remains of Photography.' *Word & Image* 32, no. 3 (2016), 264–274.

Nye, David E. *American Technological Sublime*. Cambridge, MA: MIT Press, 1994.

O'Hara, Frank. 'Rare Modern'. Review of *Mediterranean Cities*, by Rudy Burckhardt and Edwin Denby. *Poetry* 89, no. 5 (February 1957), 307–316.

O'Keeffe, J. G. *Buile Suibhne (The Frenzy of Suibhne): Being the Adventures of Suibhne Geilt, a Middle Irish Romance*. London; Dublin: Irish Texts Society, 1913.

Oliphant, Margaret. *A Memoir of the Life of John Tulloch*. Edinburgh; London: William Blackwood and Sons, 1888.

Osborne, Peter D. *Travelling Light: Photography, Travel and Culture*. Manchester: Manchester University Press, 2000.

Oswald, Emily. 'Imagining Race: Illustrating the Poems of Paul Laurence Dunbar'. *Book History* 9, no. 1 (2006), 213–233.

Ovid. *Metamorphoses*. Translated by David Raeburn. London: Penguin, 2004.

Ovid. *Metamorphoses*. Translated by Frank Justus Miller, vol. 1. London: William Heinemann, 1916; Cambridge, MA: Harvard University Press, 1916.

Ovid. *Ovid's Metamorphoses in Fifteen Books: Translated by the most Eminent Hands. Adorn'd with Sculptures*. Translated by Joseph Addison et al. London: printed for Jacob Tonson, 1717.

Paas, John Roger. ' "Under Omar's Subtle Spell": American Reprint Publishers and the Omar Craze'. In *FitzGerald's Rubáiyát of Omar Khayyám: Popularity and Neglect*, edited by Adrian Poole et al., 127–146. New York: Anthem Press, 2011.

Parr, Martin, and Gerry Badger, eds. *The Photobook: A History*. 3 vols. London: Phaidon, 2004–2014.

Patt, Lise, ed. *Searching for Sebald: Photography after W. G. Sebald*. With the assistance of Christel Dillbohner. Los Angeles: Institute of Cultural Enquiry, 2007.

Pattison, George. *Kierkegaard, Religion, and the Nineteenth-Century Crisis of Culture*. Cambridge: Cambridge University Press, 2002.

Pauli, Lori. 'Setting the Scene'. In *Acting the Part: Photography as Theatre*, edited by Lori Pauli, 12–79. Ottawa: National Gallery of Canada, 2006; London: Merrill, 2006.

Peebles, Alistair. 'From the Air to the Shore to the Garden: The Photographs of Gunnie Moberg'. *Oar Nine* (June 1996), 10–12.

Perl, Jed. *New Art City: Manhattan at Mid-Century*. New York: Knopf, 2005.

Perry, Lara. 'The Carte de Visite in the 1860s and the Serial Dynamic of Photographic Likeness'. *Art History* 35, no. 4 (September 2012), 728–749.

Peterson, Christian A. 'American Arts and Crafts: The Photograph Beautiful, 1895–1915'. *History of Photography* 16, no. 3 (1992), 189–232.

Phillips, Constance. *So You Want to See New York?* Chicago: Rand McNally, 1938.

'Photography Applied to Book-Illustration'. *Gentleman's Magazine* 3 (February 1867), 172–183.

Picot, Edward. *Outcasts in Eden: Ideas of Landscape in British Poetry since 1945.* Liverpool: Liverpool University Press, 1997.

Pinney, Christopher. *Camera Indica: The Social Life of Indian Photographs.* London: Reaktion Books, 1997.

Pinney, Christopher. 'Notes from the Surface of the Image: Photography, Postcolonialism, and Vernacular Modernism'. In *Photography's Other Histories*, edited by Pinney and Nicolas Peterson, 202–220. Durham, NC: Duke University Press, 2003.

Porter, Peter. 'Landscape with Poems'. Review of *Remains of Elmet*, by Fay Godwin and Ted Hughes. *Observer.* 15 July 1979, 37.

Pound, Ezra. 'A Few Don'ts by an Imagiste'. *Poetry* 1, no. 6 (March 1913), 200–206.

Pound, Ezra [B. H. Dias, pseud.]. 'Art Notes: Kinema, Kinesis, Hepworth, Etc.' *New Age* 23, no. 22 (September 1918), 352.

Pound, Ezra. *Cathay.* London: Elkin Mathews, 1915.

Pound, Ezra. *The Letters of Ezra Pound, 1907–1941.* Edited by D. D. Paige. London: Faber, 1951.

Pound, Ezra. *Selected Poems and Translations.* Edited by Richard Sieburth. London: Faber, 2010.

Pound, Ezra. 'Vorticism'. In *Gaudier-Brzeska: A Memoir*, 81–94. Hessle, UK: Marvell, 1960.

Pound, Ezra. 'The Vortographs'. In *Ezra Pound and the Visual Arts*, edited by Harriet Zinnes, 154–157. New York: New Directions, 1980.

Pyne, Kathleen. *Modernism and the Feminine Voice: O'Keeffe and the Women of the Stieglitz Circle.* Berkeley; Los Angeles; London: University of California Press, 2007.

Rabb, Jane M., ed. *Literature and Photography: Interactions 1840–1990, a Critical Anthology.* Albuquerque: University of New Mexico Press, 1995.

Rabb, Jane M., ed. *The Short Story and Photography, 1880's—1990's: A Critical Anthology.* Albuquerque: University of New Mexico Press, 1998.

Richards, Agnes. 'A Genius in Art Photography'. *Fine Arts Journal* 32, no. 3 (March 1915), 104–110.

Ritchin, Fred. *After Photography.* New York: W. W. Norton, 2009.

Robinson, Henry Peach. 'Impossible Photography'. *Photographic Quarterly* 3, no. 10 (January 1892), 96–105.

Robinson, Henry Peach. *Picture Making by Photography.* London: Piper and Castle, 1884.

Robinson, Henry Peach. 'The Poets and Photography'. *Photographic News*, 5 February 1864, 62–63.

Rosen, Jeff. *Julia Margaret Cameron's 'Fancy Subjects': Photographic Allegories of Victorian Identity and Empire.* Manchester: Manchester University Press, 2016.

Rosenblum, Naomi. *A History of Women Photographers*. London; Paris; New York: Abbeville Press, 2000.

Rossen, Janice. *Philip Larkin: His Life's Work*. New York; London: Harvester Wheatsheaf, 1989.

Rossetti, Dante Gabriel. *The Works of Dante Gabriel Rossetti*. Edited by William M. Rossetti. London: Ellis, 1911.

Roy, Anindyo. ' "Gold and Bracelet, Water and Wave": Signature and Translation in the Indian Poetry of Adela Cory Nicolson'. *Women: A Cultural Review* 13, no. 2 (2002), 140–160.

Ryan, James. *Picturing Empire: Photography and the Visualization of the British Empire*. London: Reaktion, 1997.

Said, Edward. *Orientalism*. London: Penguin, 1978.

Sampson, Gary D. 'Unmasking the Colonial Picturesque: Samuel Bourne's Photographs of Barrackpore Park'. In *Colonialist Photography: Imag(in)ing Race and Place*, edited by Eleanor M. Hight and Sampson, 84–106. London; New York: Routledge, 2002.

Sapirstein, Ray. 'Out from behind the Mask: The Illustrated Poetry of Paul Laurence Dunbar and Photography at Hampton Institute'. PhD diss., University of Texas at Austin, 2005.

Sapirstein, Ray. 'Picturing Dunbar's Lyrics'. *African American Review* 41, no. 2 (Summer 2007), 327–339.

Sasidharan, Deepthi. 'A Different Stage of Existence: The Canning Album, 1855–65'. In *Aperture and Identity: Early Photography in India*, edited by Rahaab Allana, 49–61. Mumbai: Marg Publications, 2009.

'The Scene of the Rubaiyat'. *London Standard*, 28 May 1912.

Schaum, Melita. 'The Grammar of the Visual: Alvin L. Coburn, Ezra Pound, and the Eastern Aesthetic in Modernist Photography and Poetry'. *Paideuma* 24, no. 2–3 (Fall–Winter 1995), 79–106.

Schmidt, Tyler T. *Desegregating Desire: Race and Sexuality in Cold War American Literature*. Jackson: University Press of Mississippi, 2013.

Schoelwer, Susan Prendergast. 'The Absent Other: Women in the Land and Art of Mountain Men'. In *Discovered Lands, Invented Pasts: Transforming Visions of the American West*, edited by Jules David Prown, et al., 133–165. New Haven, CT: Yale University Press, 1992.

Scholtz, Amelia. 'Photographs before Photography: Marking Time in Tennyson's and Cameron's Idylls of the King'. *Lit: Literature Interpretation Theory* 24, no. 2 (2013), 112–137.

Seigworth, Gregory J. 'From Affection to Soul'. In *Gilles Deleuze: Key Concepts*, edited by Charles J. Stivale, 159–169. Montreal: McGill-Queens University Press, 2005.

Shelley, Percy, *Shelley's Poetry and Prose: Authoritative Texts, Criticism*. Edited by Donald H. Reiman and Neil Fraistat. New York; London: Norton, 2002.

Sheridan, Dorothy, Brian Street, and David Bloome. *Writing Ourselves: Mass-Observation and Literary Practices*. Cresskill, NJ: Hampton Press, 2000.

Shurkus, Marie. 'Camera Lucida and Affect: Beyond Representation'. *Photographies* 7, no. 1 (2014), 67–83.

'Simla Art Exhibition: Prize Winners and Oils'. *Times of India*, 14 August 1909.

'The Simla Exhibition: Second Notices'. *Times of India*, 19 August 1908.

'Simla Fine Arts Show: The Prize List'. *Times of India*, 13 August 1906.

Skea, Ann. 'Regeneration in *Remains of Elmet*'. In *The Challenge of Ted Hughes*, edited by Keith Sagar, 116–128. London: Macmillan, 1994; New York: St Martin's Press, 1994.

Smith, Graham. 'William Henry Fox Talbot's Views of Loch Katrine'. *Bulletin: Museums of Art and Archaeology, University of Michigan* 7 (1985), 49–77.

Smith, Lindsay. *Victorian Photography, Painting and Poetry: The Enigma of Visibility in Ruskin, Morris and the Pre-Raphaelites*. Cambridge: Cambridge University Press, 1995.

Sontag, Susan. *On Photography*. London: Penguin, 1979.

Spender, Humphrey. *Worktown People*. Bristol: Falling Wall Press, 1982.

Stabler, Jane. 'Biography'. In *Reading Douglas Dunn*, edited by Robert Crawford and David Kinloch, 1–16. Edinburgh: Edinburgh University Press, 1992.

Stafford, Andy. *Photo-texts: Contemporary French Writing of the Photographic Image*. Liverpool: Liverpool University Press, 2010.

Stella, Joseph. 'The Brooklyn Bridge (A Page of My Life)'. *transition*, no. 16–17 (June 1929), 86–88.

Strand, Paul. 'Introduction'. *Camera Work* 49–50 (June 1917).

Tagli, Philippe. *Paradise sans espoir*. Paris: le cherche-midi éditeur, 1998.

Talbot, William Henry. *Sun Pictures in Scotland*. London, 1845.

Tauvry, Andrea. ' "Little Grunts, the Grins and Grimaces of Recognition": Resistance and Exchange in Paul Muldoon and Norman McBeath's *Plan B*'. *Revue LISA/LISA e-journal* 12, no. 3 (2014). Accessed 21 April 2015. http://lisa.revues.org/6026.

Taylor, Roger. *George Washington Wilson: Artist and Photographer 1823–93*. Aberdeen: Aberdeen University Press, 1981.

Taylor, Roger. 'Topographer with Attitude'. In *Landmarks: A Survey*, by Fay Godwin, 12–18. Stockport: Dewi Lewis Publishing, 2001.

Tennyson, Alfred. *Idylls of the King*. Edited by J. M. Gray. London: Penguin, 2004.

Tiffany, Daniel. *Radio Corpse: Imagism and the Cryptaesthetic of Ezra Pound*. London; Cambridge, MA: Harvard University Press, 1995.

Tinker, Chauncey Brewster. *Painter and Poet: Studies in the Literary Relations of English Painting*. Cambridge, MA: Harvard University Press, 1939.

Trigilio, Tony. *Allen Ginsberg's Buddhist Poetics*. Carbondale: Southern Illinois University Press, 2007.

Tucker, Herbert F. 'Metaphor, Translation, and Autoekphrasis in FitzGerald's *Rubáiyát*'. *Victorian Poetry* 46, no. 1 (Spring 2008), 69–85.

Tucker, Herbert F. 'Epic'. In *A Companion to Victorian Poetry*, edited by Richard Cronin, Alison Chapman, and Antony H. Harrison, 25–41. Malden, MA: Blackwell Publishing, 2002.

Tucker, Margaret A. 'Women with Cameras'. *Popular Photography* 13, no. 3 (September 1943), 38–50, 88–89.

Waldroup, Heather. 'Hard to Reach: Anne Brigman, Mountaineering, and Modernity in California'. *Modernism/modernity* 21, no. 4 (April 2014), 447–466.

Walker, Ian. 'Between Photograph and Poem: Štyrsky and Heisler's *On the Needles of These Days*'. In *Surrealism and Photography in Czechoslovakia: On the Needles of These Days*, Krzysztof Fijalkowski, Michael Richardson, and Ian Walker, 67–84. Farnham, UK: Ashgate, 2013.

Walker, Ian. *So Exotic, So Homemade: Surrealism, Englishness and Documentary Photography*. Manchester: Manchester University Press, 2007.

Walkowitz, Judith. 'The "Vision of Salome": Cosmopolitanism and Erotic Dancing in Central London, 1908–1918'. *American Historical Review* 108, no. 2 (2003), 337–376.

Warner, Marina. 'Intimate Communiqués: Melchior Lorck's Flying Tortoise'. In *Seeing from Above: The Aerial View in Visual Culture*, edited by Mark Dorrian and Frédéric Pousin, 11–25. London; New York: I. B. Tauris, 2013.

Watt, Alison, and Don Paterson. *Hiding in Full View*. Edinburgh: Ingleby Gallery, 2011.

Weaver, Mike. *Alvin Langdon Coburn: Symbolist Photographer*. New York: Aperture Foundation, 1986.

Weiss, Francine. 'The Limited Editions Club's *Leaves of Grass* (1942) and the American Imagetext'. *European Journal of American Culture* 32, no. 2 (2013), 137–151.

Weiss, Marta. 'Staged Photography in the Victorian Album'. In *Acting the Part: Photography as Theatre*, edited by Lori Pauli, 80–99. Ottawa: National Gallery of Canada, 2006; London: Merrill, 2006.

Wells, Liz. *Land Matters: Landscape Photography, Culture and Identity*. London: I. B. Tauris, 2011.

Whitaker, Robert. Preface to *Terry Street: Photographs by Robert Whitaker, Poems by Douglas Dunn*. Hull: Kingston-upon-Hull City Museums, Art Galleries & Archives, 1996.

Williams, William Carlos. *Interviews with William Carlos Williams*. Edited by Linda Wagner-Martin. New York: New Directions, 1976.

Wills, Clair. *Reading Paul Muldoon*. Newcastle upon Tyne: Bloodaxe, 1998.

Zinnes, Harriet, ed. *Ezra Pound and the Visual Arts*. New York: New Directions, 1980.

Index